THE PAINTER'S CHAIR

THE PAINTER'S CHAIR

George Washington and the Making of American Art

HUGH HOWARD

BLOOMSBURY PRESS

New York Berlin London

Published by Bloomsbury Press, New York

All papers used by Bloomsbury Press are natural, recyclable products
made from wood grown in well-managed forests. The manufacturing processes
conform to the environmental regulations of the country of origin.

LIBRARY OF CONGRESS CATALOGING-IN-PUBLICATION DATA

Howard, Hugh, 1952–
 The painter's chair : George Washington and the making of American art / by Hugh Howard.
 p. cm.
 Includes bibliographical references and index.
 ISBN 978-1-59691-244-1 (alk. paper)
 1. Washington, George, 1732–1799—Portraits. 2. Portrait painting, American—18th century. I. Title.

 N7628.W3H42 2009
 757'.3097309033—dc22
 2008028228

First U.S. Edition 2009

10 9 8 7 6 5 4 3 2

Designed by Sara Stemen
Typeset by Westchester Book Group
Printed in the United States of America by Quebecor World Fairfield

To Denise Levertov,

Ivan Galantic,

and G. Carter Wilson,

three teachers who

encouraged

a young writer

"I am so hackneyed to the touches of the painters pencil,
that I am now altogether at their beck . . . no dray
moves more readily to the Thill, than I do to
the Painters Chair."

—*George Washington,*
writing to Francis Hopkinson,
May 16, 1785

AUTHOR'S NOTE

O NE VERSION OF America's most famous painting costs only a dollar. In fact, it *is* a dollar. Go ahead, reach into your wallet and pull out a Washington. Within the oval frame on the obverse, as they say in the world of currency, a face looks back at you. Obviously, it is the face of our first president. Less obviously, it is a 1796 rendering of George Washington by Gilbert Stuart.

From today's vantage, the eighteenth century seems a small place. As thirteen coastal colonies became a republic, the political power remained in the hands of just dozens of individuals. Like the balls on a billiard table, this finite number of men, along with the women who influenced them, repeatedly collided. The ricochet patterns that emerged shaped American society, government, and economics for everyone else.

Despite the kinetic energy of the era, its central figure maintained an awesome stillness. George Washington's decisive presence first

bowled over the "invincible" British army; later, as the Confederation threatened to spin off in all directions, the General's sheer gravitas was the unifying force that made possible the establishment of the constitutional union. Still later, as fractious political parties emerged during his presidency, Washington proved to be a long-legged colossus capable of straddling the two camps, somehow managing to remain largely above the fray but able to corral and contain the combatants.

In the country house that was American culture in the second half of the eighteenth century, the art of the time was just as Washington-centric. The revolutionary era saw the emergence of the first American high-art painters. More sophisticated than the earlier limners, these young colonials had not only a native skill at drawing but also a learned appreciation for larger artistic currents. In journeys abroad, they were exposed to great art in the western tradition—works by van Dyck, Raphael, Titian, and Rubens—as well as contemporary English portraiture and history painting. Such men as Charles Willson Peale (1741–1827), John Trumbull (1756–1843), and Gilbert Stuart (1755–1828) returned to America from foreign travels with an understanding of aesthetic theory.

This book observes Washington in their company. The conceit is simple: Seeing him through their eyes is like being in his presence during the nearly three decades he was a national figure. While looking at the artists who made likenesses of him from life, we will examine the lives of the painters. Just as they studied their most famous sitter, we will observe them in their quest to establish painting in America as both worthy of its European antecedents yet different and uniquely American.

Every detail in this book is drawn from a historic source. I have added no clouds to the sky nor a single side chair to any drawing room that was not said to have been there. Even so, not every piece of information is beyond dispute. For example, among art historians healthy debates continue to rage about the first Stuart portrait of Washington, which years later he claimed he had "rubbed out." Did he destroy that canvas, or does it survive, overpainted, as the so-called Vaughan Portrait in the National

Gallery? Charles Willson Peale was known to contradict himself in his writings, recollecting details in his *Autobiography* differently from the way he recorded them in his diary decades earlier. Whom should we believe and which is correct?

I have studied the sundry accounts and assembled a narrative that I believe to be true. In acquainting myself with the documentary, visual, architectural, and other evidence at hand, I made many new eighteenth-century friends. Their paintings and experiences offer a composite view of Washington. My hope is that *The Painter's Chair* will put a richer, deeper, more colorful, and more recognizably human expression on the austere countenance looking out at us from that one-dollar bill.

HUGH HOWARD
Hayes Hill, New York

CONTENTS

FRIENDS AND FAMILY

George Washington (1732–1799)
 General and President, retired

Martha Dandridge Custis Washington (1731–1802)
 George Washington's wife of forty years

Tobias Lear (1762–1816)
 Secretary and friend to the General

Eleanor ("Nelly") Parke Custis Lewis (1779–1852)
 Martha's granddaughter

George Washington ("Wash") Parke Custis (1781–1857)
> Nelly's brother and foster son of the General

Dr. James Craik (1730–1814)
> Washington's physician and friend since their service in the
> French and Indian War

William Lee (ca. 1751–1828)
> Washington's body servant and, despite his slave status, one of the
> General's most trusted wartime companions

The Marquis de Lafayette (later, General Lafayette) (1756–1834)
> Youthful French nobleman who arrived in America to support the
> Patriot cause

THE ARTISTS

John Smibert (1688–1751)
> A London-trained painter new to America

John Singleton Copley (1738–1815)
> The teenage son of a Boston tobacconist

Charles Willson Peale (1741–1827)
> A Maryland painter fleeing his creditors

Colonel John Trumbull (1756–1843)
> A struggling painter, recently resigned from General Washington's
> army

Benjamin West (1738–1820)
> Pennsylvania-born painter and confidant of King George III

Gilbert Stuart (1755–1828)
> Expatriate painter at work in the Painting Rooms of Mr. West

Jean-Antoine Houdon (1741–1828)
> The world-renowned French sculptor

Edward Savage (1761–1817)
> An aspiring New England limner come to New York to make his fortune

Rembrandt Peale (1778–1860)
> The seventeen-year-old portraitist son of Charles Willson Peale

OTHER FEATURED PLAYERS

George Berkeley (1685–1753) Dean of Derry
Peter Pelham (ca. 1695–1751) Painter and engraver
John Hesselius (1728–1778) Itinerant painter
John Hancock (1737–1793) President of the Continental Congress
John Adams (1735–1826) Delegate to the Continental Congress
James Peale (1749–1831) Soldier in the Continental Army
Sir Joshua Reynolds (1723–1792) President of the Royal Academy
Benjamin Franklin (1706–1790) Natural philosopher, minister to France
Thomas Jefferson (1743–1826) Minister to France
Gouverneur Morris (1752–1816) New York politician and businessman
Abigail Adams (1744–1818) Wife of the minister to the Court of St. James's

Maria Cosway (1760–1838) Artist and visitor to Paris

General Horatio Gates (ret.) (1727–1806) Comrade-in-arms of
 Washington

Sarah Livingston Jay (1756–1802) Wife of John Jay and impatient patron
 of Mr. Stuart

General Henry Lee (1756–1818) "Light Horse Harry," confidant of
 General and Mrs. Washington

Anne Willing Bingham (1764–1801) A leader of Philadelphia society

A WASHINGTON TIMELINE

FEBRUARY 22, 1732 George Washington is born to
Augustine and Mary Ball Washington.

APRIL 2, 1751 John Smibert, painter, dies in Boston,
leaving his Painting Room uninhabited.

FEBRUARY 13, 1767 Charles Willson Peale arrives in
London, seeking a place in Benjamin
West's studio.

MAY 30, 1772 Colonel Washington pays Charles
Willson Peale £18.4.0 for his first
portrait.

JUNE 10, 1774 John Singleton Copley sails for England,
 never to return to America.

JUNE 15, 1775 Washington is appointed commander in
 chief of the Continental Army.

DECEMBER 3, 1776 Peale delivers his portrait of General
 George Washington to John Hancock.

DECEMBER 25–26, 1776 Washington and his men cross the
 Delaware en route to a surprise attack on
 the British at Trenton.

JANUARY 28, 1779 The Supreme Executive Council of
 Pennsylvania commissions Charles
 Willson Peale to paint *The Battle of
 Princeton.*

JANUARY 15, 1781 Mezzotint of John Trumbull's *General
 Washington* is published in London.

SEPTEMBER 3, 1783 The Treaty of Paris is signed, formally
 ending the Revolutionary War.

OCTOBER 17, 1785 Jean-Antoine Houdon departs from
 Mount Vernon, leaving a terra-cotta bust
 of Washington.

SEPTEMBER 17, 1787 Washington and forty-one other
 delegates sign the Constitution of the
 United States of America in
 Philadelphia.

APRIL 14, 1789 The Secretary of the Congress arrives at Mount Vernon to inform Washington that the Electoral College has unanimously elected him President.

NOVEMBER 26, 1789 John Trumbull steps ashore in New York eager to pursue his "National Work."

MAY 6, 1793 Gilbert Stuart returns to America to paint George Washington.

SEPTEMBER 1795 Washington sits for Rembrandt Peale.

FEBRUARY 22, 1796 Edward Savage exhibits *The Washington Family.*

MARCH 15, 1797 Washington arrives at Mount Vernon for his final retirement.

DECEMBER 14, 1799 Shortly after 10:00 P.M. George Washington dies at Mount Vernon.

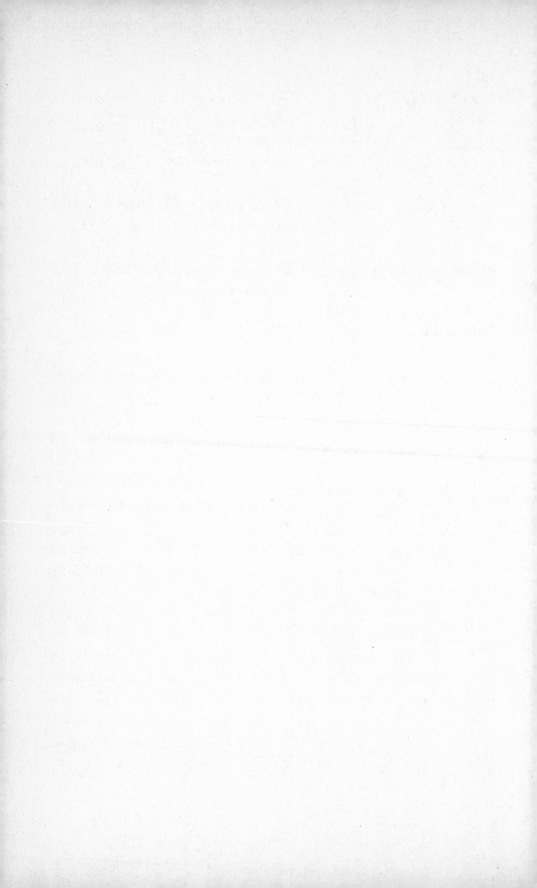

An Accidental Gallery

If Washington should appear on earth, just as he sat to Stuart, I am sure that [he] would be treated as an imposter, when compared with Stuart's likeness of him, unless he produced his credentials.
—*John Neal,* Randolph *(1823)*[1]

I.

December 12, 1799 . . . The Mansion House . . . Mount Vernon, Virginia

GEORGE WASHINGTON WAS late for dinner. This was not usual—like the crew on a well-disciplined ship, the Mount Vernon household normally ran as if on military time.

On most days the General rose early, usually between four and five o'clock. He descended to his study, lit a fire, performed his toilet, and dressed before devoting quiet hours to reading and writing letters. He expected to sit to his breakfast promptly at seven, where he took tea (without cream), and ate corn cakes with butter and honey. He called them Indian cakes; they were his preference, in part, because they required little chewing by his balky dentures. Although he had given up hunting, he was still vigorous, taking pleasure in daily ten-, twelve-, or even

fourteen-mile rides to survey his farms. This day had been no exception as he had ridden out at ten o'clock. Now, as the minutes ticked by, the accepted dinner hour of three o'clock had passed, and there was no sign of the General.

Though the moon had been visible the evening before, a northeast wind delivered a cover of clouds during the night. In the early afternoon, several hours after the horseman departed, snow had begun to fall. The mercury continued to hover near the freezing mark (Washington on rising had noted the temperature was thirty-three degrees). From the windows of the Mansion House, Martha Washington—short, round, and businesslike in her movements—could see the snowflakes had given way to hail, then to a steady, cold rain. She knew her husband would be hungry and in a need of hot food on his return. The meal would be postponed until his arrival.

Yesterday the Washingtons had entertained guests, including Lord Fairfax, a British peer and an old friend of the family. They had dined in the New Room, the large and grand dining room with its two-story ceiling. On this afternoon, however, with little more than family on hand (Tobias Lear, Washington's trusted secretary, was at his desk, laboring on the General's correspondence), a fire had been laid in the corner fireplace of the more intimate Small Dining Room. There the light from the flames reflected off the looking glass suspended between the two windows, illuminating the lacy decorations on the white plaster ceiling, brightening the brilliant verdigris of the walls. Like many of his contemporaries, Washington thought the color green relaxing. He termed it "grateful to the eye."

The delay was not so long. The General arrived shortly after the hour, and, met by Mr. Lear with the day's correspondence, he advised his younger friend, a sea captain's son from New Hampshire, that there would be no posting of letters this evening. The weather, he reported, was too bad to dispatch even a servant. Washington doffed his greatcoat, which was thoroughly wetted by the snow and rain, but assured Lear

that he himself was dry. Without a change of dress, he proceeded to his repast, by the light of tall tapers that the servants had lit on learning of his return.

When he joined Martha at the table, they became the second set of Washingtons in the dining room that day. Along with the aging Martha and George were likenesses of themselves, as recorded by artist Edward Savage. Mounted in the overmantel, in a varnished gilt frame sent to Washington by the artist himself, the copperplate engraving of the painting *The Washington Family* portrayed the uniformed general and Martha in her mobcap seated at another table, along with their two wards, Martha's grandchildren, Eleanor Custis and George Washington Parke Custis (familiarly known as "Nelly" and "Wash"). The print offered a retrospective view—Savage had begun its composition ten years earlier, when Wash and Nelly were still children. Behind the family stands a slave resembling William Lee, Washington's trusted manservant, waiting to serve. The engraving hung in a place of honor in the warm and intimate room.

Although she was in residence at Mount Vernon, this night Nelly would not join the family at the table. Washington had helped raise his step-granddaughter from infancy, and only the previous February she had done him the honor of marrying in Mount Vernon's parlor. She chose the nuptial day—it was Washington's own birthday, the twenty-second—and she had taken her vows as the sun descended. "Miss Custis was married ab[out] Candle light," wrote Washington in his diary, "to Mr. Law[rence] Lewis."[2] The groom was his nephew, son of his sister Betty.

In the months since, Nelly Custis Lewis and her husband had taken a wedding tour to visit friends, from which she returned large with child. She and her doting grandmother Martha had busied themselves that fall preparing for the arrival of the "sweet stranger," as they called the baby. On this day, the cries of the newborn could be heard echoing in the upstairs halls, and Nelly and the child, born November

27, remained confined to the second floor. Nelly's brother, eighteen-year-old George Washington Parke Custis, was also absent from the domestic scene at dinner, having ridden off on Monday in the company of his brother-in-law to review some of the property Wash had inherited from his late father.

As he ate, Washington ignored the dampness, but Lear noticed that his neck was wet, that snow still hung from the portion of his hair that had not been protected by his hat. To Washington, the storm outside mattered little. Warmed by the nearby fire, he consumed the meat, vegetables, and hot breads put before him. He was in the bosom of his family, in the house he had remade for Martha, a place that was a safe haven to three generations. Since their marriage in 1759, Martha and George had called the place home. She had arrived with her two surviving children from her first marriage; years later, after the death of Martha's last surviving child, her son Jacky, in 1783, Wash and Nelly, his two youngest children, had resided there, too, under the tender ministrations of the Washingtons. More recently Lawrence Lewis had moved in. His uncle had invited the young widower to Mount Vernon to act as a social secretary, but Lawrence and Nelly had soon been drawn to one another. Their marriage resulted in the newest arrival, newborn Frances Parke Lewis, the great-grandaughter known affectionately as Parke.

George Washington—General, President, Founding Father—was now retired after decades of public service. Here at Mount Vernon he inhabited the world as he would have it, a place peopled with the loved ones Mr. Savage's print had recorded. Issued just the previous year, *The Washington Family* was already a modest success, but, given the events that unfolded in the next two days, it would soon become one of the most popular images of the day for the saddest of reasons.

II.

Friday the 13th . . . The Mansion House . . . Mount Vernon, Virginia

THE PREVIOUS EVENING had proven uneventful, but first light revealed a landscape newly blanketed in white. Snow continued to fall throughout the morning, and three inches accumulated on the ground by midday.

The General had awakened to the realization that a cold was upon him. He complained to Martha of a sore throat. Given the inclement weather, he agreed to forgo his usual ride around his acreage. Instead, he retired to his study to tend to the correspondence and other paperwork that always seemed to await him.

If the Mansion House at Mount Vernon was the face he wanted the world to see, then his study at the building's south end was the essence of the man himself. The large room with the private stair from his bedchamber above was his architectural thinking cap, a retreat from visitors and even family. The room, grandson Wash Custis explained, was "a place that none entered without orders."[3]

A tall bookpress dominated the east wall. Through its wavy glass doors could be seen most of the 884 bound volumes in Washington's library. Like the man himself, much of his collection of books was devoted to practical matters such as military strategy, the law, geography, and agriculture. Classical authors were represented, along with such eighteenth-century contemporaries as Jonathan Swift, Robert Burns, and Adam Smith. Washington also owned a volume of Alexander Pope's translation of *The Odyssey*, its title page adorned with Washington's signature. With a certain poetic symmetry, the tale it told was of another victorious general who required many years to make it back to his beloved home.

On a shelf in his library was an early notebook in which the adolescent Washington had copied out 110 maxims from a book titled *Rules of*

Civility and Decent Behavior in Company and Conversation. The advisories ranged from matters of etiquette ("Cleanse not your teeth with the tablecloth") and economics ("The man who does not estimate *time* as *money* will forever miscalculate") to aphorisms about conscience, respect, composure, and affectation. Taken together, they amounted to a primer for an awkward young man trying to master the social graces in a colony where manners mattered a great deal.

Very much later, Washington had begun his final retirement at Mount Vernon. In March 1796, having watched wordlessly at the ceremony for John Adams's swearing-in as the second president of the United States, he had climbed into his carriage for the journey back to Virginia. As Nelly wrote to a friend shortly after their return, "Grandpa is very well, and much pleased with being once more Farmer Washington."[4] She spoke the truth, but his correspondence indicates that Washington remained in intimate contact with the political world he had shaped.

Whenever he worked in the study, he did so under the gaze of Lawrence Washington, whose portrait hung between the south-facing windows. After their father's death, when George was eleven, Lawrence had become his half brother's mentor, introducing the teenage George to aristocratic Virginia society. Lawrence had married a niece of Lord Fairfax, a Yorkshireman whose American holdings amounted to more than five million acres between the Potomac and Rappahannock rivers. The impressionable George liked almost everything that he saw at Belvoir, the Fairfax plantation just downstream from Mount Vernon. He spent a great deal of time at the grand brick house, where foxhunting and dancing parties were commonplace. The family's connections taught him much about the expectations of fashionable society and also launched George's first career. The Fairfax influence played a role in his employment as a surveyor in laying out the new town of Alexandria and mapping portions of the Shenandoah Valley.

Washington had idolized his brother. An experienced soldier, Law-

rence helped inspire in the boy a desire for military glory. When George was nineteen, the brothers had traveled together on what would be the future president's sole journey beyond the borders of the thirteen colonies. Although their 1751 trip to Barbados was intended to help cure Lawrence of his nagging cough, it served only to expose George to smallpox. Lawrence nursed him through his bout with the disease, but his own consumption advanced, and by the following year he was dead. One eventual consequence was that George inherited Mount Vernon after the premature death of Lawrence's only heir.

Although he had twice radically remodeled his brother's house—the first time to welcome his wife when he and Martha married in 1759, then later during the Revolution—he honored Lawrence's memory. When the General worked at his desk, it was Lawrence who was positioned to look over his shoulder. The painting, bearing no artist's signature, was a poor likeness. The face was masklike, and the man's red jacket and green waistcoat were suspended on the torso like paper-doll clothing. The painted likeness was recognizable as his brother, but, compared to other art in his household, its maker's skills were primitive.

Two other worthies peopled the study, both of them artworks of a more sophisticated kind. One was a workshop plaster cast of a bust of America's great naval hero, John Paul Jones. The other was no copy: It was an original bust of Washington from the hand of the French master Jean-Antoine Houdon. From its perch atop a bracket, the terra-cotta head appeared to be gazing across the room, as if musing over the books on the upper shelves in the bookpress. The Washington bust had been made on these very acres during the Frenchman's visit to Mount Vernon fourteen years earlier.

One of the world's greatest artists, Houdon had come to Mount Vernon at the invitation of Benjamin Franklin and Thomas Jefferson. After a fifteen-day stay at the plantation, Houdon returned to his Paris studio, carrying with him a plaster life mask he had made of Washington. But at Mount Vernon he left as a gift to his host his first sculpted

likeness. Made of clay dug from the Virginia soil and fired in a Mount Vernon bake oven, the bust bore Houdon's own fingerprints. The consensus among Washington's friends and family was that the Frenchman had captured George Washington as no other artist had done.

That December morning, just days before his century ended, the great man paid little attention to the images around him. Through a wide window he could gaze down the hillside, now covered in snow, sloping to the shore of the Potomac. Nearer at hand was a globe, one he had ordered from London, "a terrestrial globe of the largest dimensions and of the most accurate and proved kind now in use."[5] As the founder of a new nation, he had helped reshape the world, yet on this day Washington's thoughts were of a more immediate kind.

He composed a letter to James Anderson, his farm manager. The letter was short, little more than a cover note to accompany the detailed three-year plan for his plantation. He had drafted the document earlier in the week, laying out crop rotations for Mount Vernon's five farms. He specified plantings field by field. In some, he wished to see turnip leaves rise from the ground; at others clover, potatoes, or corn. Some were to be left as pasture. He instructed what care was to be given to the sheep, cows, mules, "horned Cattle," and hogs. As a scientific farmer, he corresponded with the leading American and English agronomists of the day, and he wished to see the best ideas employed at Mount Vernon. His latest thinking was central to this new plan.

When the storm ended that afternoon, he ignored the growing hoarseness in his throat. He ventured out for a time to mark some trees on his "pleasure ground," the manicured landscape in the vicinity of the Potomac riverside where he hoped he and his guests might soon walk upon a new gravel path. In the evening he assumed a seat in the parlor, having received an afternoon delivery of newspapers from the post office. He and Martha were joined there by Mr. Lear, once again, under the gaze of family likenesses, including an anatomically awkward picture of Martha dating from her first marriage (a recent foreign visitor had

thought it a poor painting, not least because it portrayed her with "her ears uncovered").[6] A more sophisticated companion piece had come later. A work by Charles Willson Peale, it presented Colonel Washington, the Virginia squire, as he had appeared in 1772.

At nine o'clock, the hour they usually retired, Martha went upstairs to sit for a time with Nelly. The General remained with Lear, occasionally reading out diverting or interesting tidbits from the *Pennsylvania Packet* and *Pennsylvania Herald*. The two men discussed reports in the *Virginia Gazette* about the ongoing debates of the Virginia Assembly. Washington's voice, thought Lear, was growing more gravelly by the hour, and when Washington rose to retire for the night, his friend and secretary suggested that he might take something to treat his cold.

The General declined. "You know I never take any thing for a cold," he reminded Lear. "Let it go as it came."

III.
December 14 . . . The Washingtons' Bedchamber . . . Mount Vernon, Virginia

BY MORNING, THE greatest man in the world believed to a certainty that he was dying of a sore throat. Sometime after two A.M., he awakened Martha. He was very unwell, he told her, an ague (fever and chills) having overcome him. The house was cold, and, not wanting her to catch a chill, the General insisted she remain within the warm confines of their tall four-poster bed. During the quiet hours before the housemaid Caroline arrived to make a fire at daylight, man and wife huddled together in the oversized bedstead. Purpose-built for the big-boned Washington, the mahogany bed was six feet, six inches in length and a full six feet wide with the dimity hangings suspended around them.

The General's health had scared them before. The previous year he had had one of his periodic bouts with malaria. Back in 1790, the government and the entire city of New York had waited for his fever to break

when he battled the flu and pneumonia. In 1789, a carbuncle was removed from his hip without anesthesia. Martha herself had suffered from a recurring fever, thought to be malaria, earlier in the summer of this very year when Washington's old friend, physician Dr. James Craik, had come to Mount Vernon and prescribed "the bark." This medicament, derived from the cinchona tree, was the only reliable treatment.

In the past, Washington's sturdy constitution had allowed him to fight off attacks of dysentery, smallpox, tuberculosis, quinsy (tonsillitis), and diphtheria. This day would be different.

UPON HER ARRIVAL at daybreak, the slave Caroline was immediately dispatched to summon Mr. Lear. He dressed hurriedly, and, upon reaching the bedside, he found that Washington was "breathing with difficulty and hardly able to utter a word intelligibly."[7] Dr. Craik was summoned, and, in the course of the daylight hours, Washington was bled four times. More than five pints of blood were taken from him.

By midafternoon Drs. Elisha C. Dick and Gustavus Richard Brown had also arrived. The three doctors tried everything they could think of to relieve Washington's symptoms. He was given a mixture of molasses, vinegar, and butter to soothe his throat, but he could not swallow it. His neck was bathed with sal volatile (an ammonia salt also known as hartshorn), and his feet were soaked in warm water. A blister of Cantharides (sometimes called Spanish fly) was put on his throat. He nearly suffocated when given a gargle of vinegar and sage tea.

By five o'clock, the man of the house had finally had enough. "Doctor," he told Craik, who had been his friend since their days of service to King George II during the French and Indian War, "I die hard; but I am not afraid to go; I believed from my first attack that I should not survive; my breath cannot last long."[8]

Speechless with grief, Craik found a seat by the fire. The death watch had begun.

———

JOHN ADAMS ONCE said of Washington that he possessed "the gift of silence." Even as he lay dying, tossing and turning on his deathbed, the sixty-seven-year-old Virginian kept his thoughts and emotions to himself. But he was planning for those he loved.

At Washington's request, Lear summoned Mrs. Washington. The General asked her to bring him the two wills he had drafted. When she returned from the study and handed him the documents, he examined the two sheaves of papers. One he handed back to her, and, following his instructions, she fed the "useless" version to the fire.

He had signed and applied his seal to the fair copy of his last will and testament just a few months earlier, on July 9. "To my dearly beloved wife Martha Washington," he had written, "I give and bequeath the use, profit and benefit of my whole Estate, real and personal, for the term of her natural life." There were special bequests, including the sum of $4,000 to establish a free school; sundry properties for various relatives, including an outlying farm to Nelly and Lawrence Lewis; all his books and papers, which were to go to his most trusted nephew, Bushrod Washington; and, to the surprise of almost everyone, he ordered that his slaves were to be freed after Martha's death. After she died, he further specified, most of his land and other assets were to be sold, and the proceeds distributed to his heirs in proportions laid out in the document.[9]

He had written it in his own hand. Washington was a disciplined penman, the horizontality of his lines and the slant of his script always precise. The handwriting was not overly artistic, but careful and rarely hurried. He had invested many hours in preparing the final copy of this twenty-nine-page document, and his scheme was carefully considered. He often used convoluted language to distance himself from the subject at hand, but also for clarity. This will had few ambiguities, no excesses, and little legalese (no "professional character" had been consulted). In life, this private man regarded this as the business of no other aside from himself.

Late in the afternoon he croaked a question at Lear: When was Wash due back?

Washington had held out high hopes for George Washington Parke Custis, who had become almost a son to him. But the boy had fallen well short of living up to the General's hopes, just as the lad's father before him failed to do. George Washington's own formal education had ended early with the death of his father; that was one reason for his expectations for Wash, who had been unceremoniously dismissed from the College of New Jersey, after less than a year. Custis had performed no better in a stint at St. John's College in Annapolis. In the months since returning to Mount Vernon—he was still only eighteen—he was under the tutelage of Mr. Lear, but no one mistook him for a serious student.

Wash and Lawrence Lewis, Mr. Lear advised, were not due to return for several days. The General had no choice but to accept that he would see them no more.

Washington asked a service of Lear, who immediately agreed to arrange Washington's military letters and papers and to tend to his accounts. "He then asked," Lear noted in his diary, "if I recollected anything which it was essential for him to do, as he had but a very short time to continue among us. I told him I could recollect nothing; but that I hoped he was not so near his end."

Washington smiled in response. "He certainly was" nearing his end, the General told Lear, and as that "was the debt which all must pay, he looked to the event with perfect resignation."

His manners faultless even at the end, he thanked the doctors. "I feel myself going," he told them in the early evening. "I thank you for your attentions; but I pray you to take no more trouble about me, let me go off quietly; I cannot last long."

By ten o'clock, the dying man found speaking almost impossible, but with a great effort he managed to address Lear once more. "I am just going," he began after a struggle. "Have me decently buried; and do not let my body be put into the vault in less than three days after I am dead."

His throat constricted with emotion, Lear could not speak, but he bowed in assent.

"'Tis well," said Washington.

He spoke no further, but his breathing seemed to ease. The General took his own pulse, and, after a while, Lear noticed that his expression seemed to change. He summoned Dr. Craik from the fireside.

Craik put his hands over Washington's eyes.

From the foot of the bed where she was seated, Martha asked in a firm voice, "Is he gone?"

When informed that he was, she echoed her husband's last words with a surprising calm. "'Tis well," she said, adding, "All is now over, I shall soon follow him. I have no more trials to pass through.[10]

———

IN DEATH, AS in life, Washington was surrounded by images. At midnight, barely an hour after his death, his corpse was carried down the stairs and his remains laid out in the New Room. Not far from his impromptu bier hung presentation proofs of John Trumbull's two history paintings, *The Death of General Warren at the Battle of Bunker's Hill, June 17, 1775* and *The Death of General Montgomery in the Attack on Quebec, December 31, 1775.* Washington had given the engravings a place of honor in his finest room and proudly showed them to his guests as the first of a great series commemorating the events of the Revolution. In the same room hung another portrait of the General, this one painted by Trumbull and given by the artist to Martha. The small canvas portrayed the commander in chief and his horse at a Hudson River crossing, Verplanck's Point. It was, some thought, the most majestic portrait of the military Washington.

His fame was an irresistible lure. Washington had sat for other artists besides Peale, Trumbull, Savage, and Houdon. A French noblewoman, the Marquise de Bréhan, had come in 1789, the year her country's revolution began; Joseph Wright had made a bust at Washington's headquarters

at Rocky Hill, New Jersey, in 1783. British artist Robert Edge Pine took a likeness at Washington's home in 1784. James Sharples, Walter Robertson, and even Charles Balthazar Julien Févret de Saint-Mémin had made images of Washington from life. Saint-Mémin was aided by his mechanical contrivances, the physiognotrace and pantograph, which enabled him to make a mathematically accurate outline of his subject's head. Before his death, Washington sat for at least twenty-eight different portraitists, some of them repeatedly. Not a few of the works that resulted lived at Mount Vernon as miniatures, pastels, and other keepsakes.

Two paintings Martha had commissioned were not there: Gilbert Stuart had begun portraits of both General and Mrs. Washington but had yet to complete them. Though the paired portraits would never be delivered, the images were far from forgotten.

As the family gathered at Mount Vernon the next day, Mrs. Washington employed Tobias Lear's pen to notify other family members, friends, and neighbors. Topping the list were President Adams, Alexander Hamilton, and Supreme Court Associate Justice Bushrod Washington, the man who would eventually be Washington's principal heir and owner of Mount Vernon. Notes went by express to some—one in particular was dispatched to Wash Custis, carried by Tobias Lear's personal servant, Charles, on Lear's own horse. Another of those on Martha's list was Charles Willson Peale, the artist who had painted her husband, served in the army with him, and had for years been a neighbor (in Philadelphia) and a frequent correspondent who shared Washington's curiosity about the world. Peale's likenesses of her children, both long dead, helped keep them alive for Martha.

On Wednesday, a great deal of ceremony accompanied the installation of Washington's remains in the family vault. Uniformed troops, both on horseback and on foot, led the parade, followed by the clergy. Next came the General's horse, riderless but saddled, followed by the lead-lined mahogany coffin swathed in black cloth. Much of the family followed, though Martha remained within the walls of the Mansion. In fact, she

would never leave the estate again. Abandoning the bedchamber she had shared with her husband, she slept thereafter in a garret on the third floor, where, as was the way, older and less fashionable furniture had been retired, no doubt reminding her of younger, happier days in the era when she and George were newly married. She would die there on May 22, 1802.

The nation was stunned by Washington's death; he had seemed indestructible as well as essential. In the days after his unexpected end, Congress approved a resolution, composed by his old comrade Henry "Light Horse Harry" Lee, "To the memory of the Man, first in war, first in peace, and first in the hearts of his fellow-citizens." Within a matter of weeks, the print market was awash in engravings, mezzotints, woodcuts, and etchings of Washington based upon images by painters Charles Willson Peale, Gilbert Stuart, Edward Savage, and others. The widespread sale of such prints helped transform the memory of a man into a symbol of his nation.

When he and, later, Martha died, Mount Vernon was a suitable receptacle for what was a rare and important array of original art and prints, most of them devoted to American subjects, many of Washington himself. Certainly, the portraits were historically important as a record of the general, but in a larger sense they also spoke for Washington's patient encouragement of artists, especially those native to his country. He himself was not a particularly artistic man; architecture undoubtedly was his favorite of the arts, and the only one that he himself practiced. Yet as a patron he had fostered nothing less than the birth of American painting. In his house he left a museum's worth of visual testimony to his own history and what was new in American art.

We can see Washington in these pictures, but in death, as in life, he remained a man who was easier to see and admire than to understand.

John Smibert's Shade

We were a long time blundering about the ocean.
—*Dean George Berkeley, 1729*

I.

1729 . . . Boston Harbor . . . The Province of Massachusetts Bay

WHEN HE STEPPED ashore at Long Wharf, the Scots-born John Smibert expected his stay would be brief. America was new to him after a harsh Atlantic crossing and brief visits in Williamsburg, Virginia, and Newport, Rhode Island. He imagined Boston would be just another stopover on his way to his final destination, the island of Bermuda. There he and his benefactor, George Berkeley, planned to launch what both men hoped would be a beneficent adventure.

The Anglo-Irish philosopher and churchman—Berkeley was the dean of Derry—had hatched a plan for a college in America. Back in London, he had offered Smibert the professorship of drawing, painting, and architecture at the proposed school, where they planned "to Instruct

the European and Indian children in the Christian faith, & necessary educations."[1] For Smibert, a man of fragile health and deep religious faith, the life of a don on the idyllic isle of Bermuda promised to be a happy escape from the intense competition back in Britain's capital. But the great experiment could not begin until the arrival of the promised £20,000 from the Crown's treasury. While awaiting the money, Smibert had left Berkeley's household in Newport and made the short sail north to Boston. Here he planned to paint portraits, just as he had done before traveling across the Atlantic.

The practical men of Boston tended to regard the painting of pictures as an indulgence, and some puritanical citizens even considered the making of such images utterly godless. Even so, the city held a few likenesses of ministers, royal governors, and well-to-do merchants, though the tradesmen who made them usually worked as painter-stainers, men more likely to paint houses or signs than canvases. The making of such images, often called "effigies," had been no more than an occasional pastime to their makers, and the paintings were crude. Smibert set out to change all that.

In the New World, his abilities were remarkable. He had been an up-and-coming painter of some repute back in London, and his Boston neighbors were quick to recognize in the new arrival skills superior to any they had ever seen. In a matter of weeks, dozens of the city's richest inhabitants would commission Smibert to paint them.

The forty-one-year-old Scotsman welcomed his newfound success— it followed almost thirty years of hard work. Born in the Grassmarket neighborhood of Edinburgh in 1688, he learned his colors from his artisan father, a wool dyer. At fourteen he apprenticed as a house painter and plasterer. Wallpaper was rare and expensive, so he painted decorations on walls and applied plaster elements to ceilings. After completing a seven-year apprenticeship, he made his way to London and found work as a carriage-painter, producing pastoral scenes and heraldic coats of arms on gentlemen's coaches and sedan chairs. His skill with oils and brushes

impressed art dealers in the city, and Smibert moved on to the more lucrative work of copying other people's pictures. In 1713 he enrolled in a new school for painting and drawing. His evening studies in the clublike environs of the old mansion known as the Great Queen Street Academy readied him to make another artistic leap, and in 1716 he returned to Scotland and launched himself as a portraitist.

The canny Smibert next embarked on an extended journey to Italy, spending months in Florence, Rome, and Naples. He purchased paintings, prints, and casts on behalf of sponsors back home, but the ultimate purpose of his three years in the cultural and artistic heart of Europe was to polish his skills. He gained access to private art collections, enabling him to paint copies of Old Master works and make drawings of statuary. This was the way every artist learned—by studying the great painters of the past; the premium was not on originality but on copying. Learning any craft in his time involved an apprenticeship, whether contractual or informal; for all that Smibert already knew, he still had much to learn of drawing, perspective, anatomy, the use of color, and a dozen other skills that the great artists of the past did so much better than he ever had. So Smibert painted Old Master copies, and portraits, too, often on commission to fellow Scotsmen on their Grand Tours. One of his subjects had been the Irish prelate George Berkeley.

On returning to London, Smibert soon earned a reputation as "a good ingenious man [who] paints and draws handsomely."[2] A few years later his friend Dean Berkeley sought him out at his quarters in Covent Garden, the epicenter of London's artistic community. Berkeley invited Smibert to join his Bermuda-bound band of scholars. Smibert sailed for America in 1728 together with Berkeley and his entourage.

Smibert's weeks in Boston became months. Two years passed before Berkeley finally despaired of ever seeing the funds he needed to launch his college and decided to return to England. By then, Dr. Nathaniel Williams, a physician and master of Boston's finest school (later, Boston Latin), had commissioned Smibert to paint five Williams portraits—and

Smibert had married one of his sitters, Dr. Williams's daughter Mary. When the marriage took place, on July 30, 1730, she was twenty years his junior and brought a modest dowry of £400 to their life together.

In the autumn of 1731, John Smibert waved farewell to his benefactor, Dean Berkeley, from Boston's Long Wharf. He was the father of one daughter, Allison, and a second child was on the way. As the dream of the professorship at the island college vanished once and for all, John Smibert, for better or for worse, became a Bostonian.

———

THE INITIAL FLURRY of portrait business in Boston was gratifying, but no preordained path for artistic success existed in the New World. Smibert realized he needed to proselytize. More of his puritanical neighbors had to be persuaded that commissioning images of themselves was not prideful and that owning a painting was no mere luxury.

Known as "a silent and modest man," Smibert chose to let art speak for him.[3] In early 1730 he opened his lodgings on Green Lane to the public. Local citizens who walked through his door that March encountered men they knew, rendered by Smibert onto canvas in a starkly realistic fashion. He brought back from the dead Samuel Sewall, the recently deceased chief justice of the Massachusetts Superior Court and father of the Reverend Joseph Sewall, who had presided at Smibert's wedding. Nearby hung a well-known military man, Jean Paul Mascarene. Smibert's three-quarter portrait of the Huguenot showed him dressed in his British ceremonial armor, posed before a detailed landscape of the harbor earthworks he helped design. Another Boston worthy, the bewigged and toothless Judge Nathaniel Byfield, looked at viewers from his canvas, his countenance possessed of all the certainty and sternness his neighbors knew to be in his nature.

More than familiar faces were on display. The professor-to-be had brought with him to North America a study collection he had planned to use at the proposed Bermuda college. He put on view copies of Old

Master paintings made during his years in Italy. Among them were works after Raphael (*Madonna della Sedia*), Titian (*Venus Blinding Cupid*), and Rubens, and a copy of van Dyck's portrait *Cardinal Bentivoglio*. The discipline of copying was a routine part of any artist's training, and for Smibert the copies also represented models he kept for his own reference or as a source of income. While in Italy he had sold some as souvenirs to other British and Scots visitors, who regarded a good copy of a great painting as more valuable than the original of a lesser work.

Smibert owned lay figures too, doll-sized, jointed models of the human form that were especially useful in studying the draping of clothing, essential to portraying men and women in their flowing clothes of rich fabrics. His collections of books, engravings, and drawings were also at hand. Visitors to Smibert's improvised museum encountered an art form then unknown in the colonies. His plaster casts, purchased in Italy and London over the span of a decade, were the first western sculptures to reach America. At Mr. Smibert's the gentry of Boston admired a bust of the artist's friend and fellow Scotsman, poet Allan Ramsay; a head of the greatest of storytellers, Homer; and a plaster of a standing sculpture from antiquity, the *Venus de' Medici*. The sculptures seemed so real that one Boston versifier described the Venus and Homer as "the breathing Statue and the living Bust."[4]

The eighty-line ode, titled "To Mr. Smibert. on the sight of his Pictures," soon appeared in the *London Daily Courant* and a Philadelphia newspaper. Composed by the impressionable Mather Byles, a twenty-two-year-old Bostonian, the poem announced the artist's presence in his adopted town. Doggerel though it was, the poem enthusiastically endorsed Smibert as he sought to establish, single-handedly, an important outpost of the London art world in the colonies. "Still, wondrous Artist," exhorted the poet, "let thy Pencil flow / Still warm with Life, thy blended Colours glow."[5]

The open house had been an opportunity to attract more business, but the event was more momentous than it seemed. In another of the

extraordinary firsts that seemed to accumulate around Smibert, his show that late winter day constituted nothing less than the first art exhibition in America.

11.

April 4, 1751 . . . Queen Street . . . Boston

T o a p a s s e r b y on the pebbled street out front, the store looked the same. The shelves and counters inside remained stocked with the colors, brushes, papers, palette knives, oils, and other art goods that John Smibert had sold for some twenty years. Yet one important change occurred this particular week. According to the *Boston News-Letter*, "On Tuesday last died here, much lamented, Mr. John Smibert, well known for many fine Pictures he has done here."[6] At age sixty-three, the man who fostered a taste for paintings in Boston was gone.

Failing eyesight had forced Smibert to retire from painting five years earlier, but not before he had made several hundred American portraits (in his first five years in Massachusetts, his one-hundred-plus portraits exceeded the total painted there in the previous three decades). Most of Smibert's clients wanted bust-length or slightly larger canvases called Kit-kats,* but a few ordered three-quarter or even full-sized portraits (the cost increased with the size). The price of a three-quarter portrait was equivalent to that of a fine bookcase or a silver teapot.

Smibert's painting provided him with an income roughly equal to that of a middling merchant, but his father-in-law, Dr. Williams, made possible a move to a fine house on Queen Street. Mary Williams Smibert's grandfather and great-grandfather had occupied the spacious building near Boston's commercial center, barely a thousand feet from the Long Wharf. In 1733, as Smibert reported to an old Scots patron,

* The name comes from the thirty-six-by-twenty-eight-inch portraits of members of the fashionable eighteenth-century London Kit-Cat Club, showing the head and shoulders to waist level.

"[I] have now got into a house of my father in laws, who has built me a large & handsome Painting Room & showroom in al respects to my satisfaction."[7]

In Smibert's two decades in the colonies, he had watched Boston become a city of tradesmen. The narrow and winding streets in the neighborhood surrounding Queen Street were home to dozens of skilled joiners, printers, upholsterers, tailors, and other artisans. Members of the city's gentry and even people of the middling sort had developed a taste for the china, fabrics, dry goods, tobacco, and household items sold in nearby shops. Smibert himself prospered: At the time of his death, he was a man of property. Among his other worldly goods were a sword with a silver hilt, several looking glasses, and forty-six chairs. He was indebted to his wife and her father for the access they had provided to prosperous Bostonians who wanted their pictures taken, but his retail business had succeeded, too. On the ground floor at the Queen Street house, his "colour shop" had been the first in Boston, offering a full range of painter's goods, from the most basic to the exotic, along with engravings, mezzotints, and other prints. An advertisement for the venture had claimed, "JOHN SMIBERT, PAINTER, sells all sorts of colours, dry or ground . . . with Oils, and Brushes, Fans of Several Sorts, the Best Mezotints, Italian, French, Dutch, and English Prints, in Frames and Glasses, or without, by Wholesale or Retail at Reasonable Rates."[8]

Even after its proprietor's death, his shop and studio remained. It would soon prove to be much more than a mere reminder of the man who had worked there.

———

IN SMIBERT'S TIME, the preparation of *materia pictoria* could be as time-consuming as the act of painting itself.

The canvases were made of woven flax. John Smibert, Merchant, ordered these linen "cloaths" (he also rendered the word "Cloats") from his lifelong friend, Arthur Pond, a sometime painter, etcher, and art

dealer. Pond shipped them to America from London, where back-street artisans produced the canvases in quantity. Smibert ordered the larger ones to be "rolled up & put in a case" (so as to take up less shipping space), whereas the smaller ones arrived already "strained" (stretched).

Like his London peers, John Smibert, Painter, worked on canvases that had already been sized. In preparing a canvas, a London colourman would have warmed (but not boiled) granules of hide glue (typically rabbit- or pigskin) to a thick liquid the consistency of honey. The sizing was then spread on a canvas in broad strokes using a palette knife. Once the glue dried, the surface was sanded smooth with a pumice stone.

The grounding came next. Its composition varied, with common ingredients including plaster, the sediment from a jar of brush-cleaning oil, or carbon black, as well as the essential linseed oil and white-lead pigment. Smibert preferred a grayish-green or reddish ground, but whatever the ingredients, the application of the grounding produced a smooth surface, less absorbent than raw linen but still able to retain some of the fabric's tooth and flexibility.

As a purveyor of colors, Smibert sold few ready-to-use paints; his trade was in the ingredients used to make them. These included such vehicles as oils, dryers, turpentine, shellacs and other varnishes, and the all-important pigments.

Most of the pigments Smibert sold were made from earths and minerals that had been processed (usually by firing or cooking), dried on long boards or stones, and then *levigated*, meaning they were finely ground into powders by a hand mill or with a mortar and pestle. For larger quantities, the tool of choice was a muller, a stone with one flat side that was held in the palm and worked in circles on a stone slab. Depending upon their source, iron-rich soils called ochers produced pigments ranging in color from pale yellow to orange and red. Thus *terra di Sienna*, when burned (calcined), produced an orange-red hue called burnt Sienna; a scarlet red was termed Venetian red; the brown-red was Spanish brown. The mineral copper was used to produce greens

("Distilled Verdigres," specified one bill of lading from London). Mercury ore (quicksilver) made cinnabar, a bright red vermilion pigment. Other colors that Smibert ordered from Pond in London included "French Sap Green" (made from buckthorn berries), "English Saffron" (a tincture of the spice saffron), and "Prussn. Blew . . . of a fine deep sort."[9] Prussian blue was the first chemical color of the age, made not from an earth or other natural pigment but from a salt compound of iron and potassium. The carmine that Smibert ordered ("very fine," he specified), was highly prized, having actually traveled across the ocean twice, coming as it did from Mexico or South America via London (it was derived from the eggs and body of the cochineal insect). The primary white pigment was flake white, made of white lead, favored because it was durable and tough yet flexible.

Pigments became paints when the fine powders were mixed with oil or another material to help bind the pigment to the canvas. When small quantities were required, the mixing was done on the palette itself with a thin-bladed palette knife. Larger quantities could be mixed on a stone or muller. The blended oil and pigment looked uniform, though the tiny grains of pigment were merely suspended in the liquid, like currants in cake batter. After the paint was applied, it would thicken from a paste to a solid in a chemical reaction as the oil set (oxidized). A tough film remained, dry to the touch in a matter of hours. Most paints on the palette needed to be mixed each day, as one day's batch would dry by the next day.

The painting process itself required several sittings and a gradual buildup of layers of paint in a prescribed order. Sometimes the painter began with a chalk or graphite sketch, but when the time came to begin a painting, Smibert worked in so-called dead colors. For this underpainting, he would rough out his first vision of the painting, indicating in dull tones the largest areas of form and color, perhaps the gentleman's coat or background drapery. He applied the paint with a "fitch," a rough, square-ended brush often made from the hair of the skunklike polecat

(or "fitchew"). Once he established the relationship of the biggest elements, Smibert could refine his pictorial idea, since the neutral tones of the paint enabled him to correct what he did not like, to exchange darks for lights, to rethink what he had done. By the time he completed the underpainting, the monochromatic canvas before him was usually a fair representation of the composition as it would appear in the finished painting.

When he moved on to more detailed work, he employed a good-quality pointed brush called a "street pencil." Using paints thinned with turpentine, he could render the hair and other details. He began working with brighter colors and used glazes (tinted and transparent oily mixes) and thin washes for backgrounds and detail. The tendency was to paint the sitter's clothing and surroundings more freely. A thicker, paste-like paint was used for flesh tones. Layers of paint, varying from thin and translucent to thick and opaque, were built up for visual effect, adding shading or enhancing and deepening the colors beneath. After the painting was finished, a varnish (a gum resin dissolved in spirits) was usually applied both to protect the painted surface and to give the finished product a sheen that intensified the contrasting colors. A minimum of several days was required to allow the layers of paint, glaze, and varnish to dry.

As he neared the end of his life, the infirm and nearly blind Smibert continued to sell casks of paint, pails, jars, and a wide variety of other supplies. Among the wares he imported from London, in addition to canvases and pigments, were papers, silver and gold leaf, and the makings for "Fanns" (the painting of fans was a popular ladies' pastime). For all the goods that he sold, however, it was his knowledge of painting, as well as the paintings he had made, that proved of inestimable value. Even in death, Smibert would continue to influence the artistic climate of his adopted city.

III.

1751–1795 . . . Smibert's Painting Room . . . Queen Street

THE LEGACY SMIBERT left to his wife included "The easterly half of the House and Land in Queen Street," which was valued at 446 pounds, 13 shillings, 4 pence. As prepared in February 1752, his probate inventory also listed a fourteen-acre farm on the city's outskirts (£186.13.4), silver plate (£36.6.4), linens (£34.4.5), feather Beds and Bedsteads (£29.6.8), as well as Chests, five Looking Glasses, a slave named Phillis, and other goods. He had become a man of considerable means.

After the house, the second most valuable item was the inventory of Smibert's shop, principally the "Colours & Oyls," with an estimated value of 307 pounds, 16 shillings, and 5 pence. Further down the list appeared entries for objects that, despite lesser monetary worth, would prove of surprising importance. They included the following:

35 portraits	£60.	5.	4
41 History Pieces & pictures in that Taste	£16.	0.	0
13 Landskips	£ 2.	13.	2
Conversation Pictures	£23.	6.	8
Bustoes & figures in Paris Plaister & models	£ 4.	5.	8
Prints and Books of Prints	£11.	12.	8
Drawings	£ 4.	16[10]	

Some of these were the same works of art with which Smibert had begun Boston's aesthetic education back in 1730. He had also held a sale in 1734 at which, on Monday, March 27, he offered for purchase "A Collection of Valuable PRINTS [and] . . . a Collection of Pictures in Oil Colours."[11] Some prints and frames had been sold but the majority of his collection remained in his studio, and it had become a regular stop for visitors to Boston. One out-of-towner who came to look at the "fine pictures" was

Dr. Alexander Hamilton, a fellow Scotsman then residing in Annapolis. He was so taken by what he saw during his summer call in 1744 that he visited Mr. Smibert's again a few days later. After the second survey he recorded in his *Itinerarium*, "I . . . entertained myself an hour or two with his paintings."[12]

After Smibert's will had been filed and probated, surprisingly little changed. His widow, Mary, and a nephew, John Moffatt, continued to operate the color shop. One flight up, the dead painter's art collection remained unsold and available for study. The Painting Room, its walls lined with green baize, provided a suitable backdrop for the works themselves, which amounted to something of a summary of the painter's life. It was a mingling of Smibert portraits and landscapes, together with the Old Master copies dating from his Italian sojourn. It would prove to be another of Mr. Smibert's firsts, as this well-lit room was soon to become a place of pilgrimage. Smibert's Painting Room was, in effect, America's only art museum in the days before the Revolution.

———

PETER PELHAM, ANOTHER aging English émigré, also died in Boston in 1751. Though he and Mary Copley had been married barely three years, in that time Pelham had introduced her son, John, to a world the boy had not previously known.

John Singleton Copley had spent his first ten years living over the family tobacco shop on Long Wharf before moving to his stepfather's home on Lindal's Row near the upper end of King Street. Though less than a half a mile away, Boston's commercial center seemed very different from the maritime bustle of the old neighborhood, with its transient population of sailors and the ceaseless coming-and-going of ships. On King Street, the nearby Town House was a commanding presence, the center of government in Boston. John Smibert resided in this new neighborhood, too, which was dominated by merchants, shopkeepers, and craftsmen.

Mary Copley advertised her wares in the *Boston Gazette*, proclaiming hers "the best *Virginia* Tobacco, Cut, Pigtail and spun, of all Sorts, by Wholesale or Retail, at the cheapest Rates."[13] To supplement his income, her new husband drew upon his English education, offering his colonial neighbors the chance to improve themselves. Peter Pelham taught reading, writing, and arithmetic and gave instruction in etiquette, needlework, and dancing. The adolescent John Singleton Copley absorbed everything he could from Pelham, a former Londoner who had arrived in Boston with the urban savvy of a man who had spent his first thirty-two years negotiating the teeming streets of Europe's largest city.

Among the lessons the boy learned from his stepfather was the wizardry of the mezzotint. As the first to engrave a mezzotint in the colonies, Pelham had great skill with the essential tool of his trade, the *burin*, which was used to scrape a pitted copper plate to allow areas, rather than just lines, to be inked. The technique produced prints with subtle tones that conveyed the illusion of human skin and delicate fabrics, making the medium well suited to portraiture. Although he was a competent painter in oils upon his arrival in America in 1727, Pelham set aside his brushes after John Smibert brought his superior skills to Boston. The two men had become collaborators, and Pelham's prints of ministers and other worthies of the day, many of them copied from Smibert's original oils, helped establish a local market for prints.

Not long after Pelham's death, his young stepson—Copley was going on sixteen—tried his hand at the mezzotint. After the death of a prominent Boston minister in 1753, Copley chose a plate his stepfather had made ten years before after a Smibert portrait. Using the burnisher, he obliterated part of the Smibert–Pelham likeness of another minister, leaving the clerical collar, coat, and cape in place. He substituted a new head, reworking the copper so that it bore the bewigged visage of the just-deceased reverend. Pleased with his work, the young artisan also changed the inscription, replacing the names of the original painter and engraver with "*J. S. Copley pinxt et fecit.*"

Copley soon moved to another medium—applying oil to canvas. His apprentice works included a portrait of his stepbrother Charles Pelham, but three other early paintings were what he called "Classick subjects." Copley found engravings to copy, images of the mythological Venus, Neptune, and Galatea, each one posed with an assemblage of other figures. He chose to imitate not only the subject matter but the composition as well.

Once he had completed the underpainting, the monochrome prints he mimed offered no further clues as to how to proceed. In the absence of the two Englishmen who might have tutored him, it was Mr. Smibert's painted legacy that guided him. He had been acquainted, of course, with Smibert, although the old man Copley knew was more shopkeeper than artist, since by then Smibert's vision had become too blurred and dim to pursue portraiture. But the precocious boy had visited Smibert's color shop and gone upstairs to view the art in his Painting Room, and entered in his sketchbook a drawing of Smibert's plaster cast of the Medici Venus. Now, in need of help with his "Classicks," he found inspiration in the palette Smibert had employed in copying Old Masters. On his Italian tour thirty years before, Smibert had mimicked the hues of the original canvases, among them works by Poussin and Titian. When Copley painted his Classick subjects, he made reference to Smibert's copies and imitated the brilliant colors.

Copley knew Smibert's portraits, too, among them his works in miniature. By 1755 Copley was also working "in Littell," painting as Smibert had done with oils on copper (which were then fired to affix the paints permanently to the metal surface). Copley's instincts led him away from Smibert's style as he developed his own manner of portraiture. Rather than giving his subjects the solemnity of Smibert's, he incorporated the worldly accouterments of his wealthy clients, such as imported silks, pearls, gold braid, lace, highly polished furniture, and elegant carpets. Copley still found the older man's footsteps unavoidable; as he emerged as Boston's new preeminent painter, Copley produced portraits

for families that had patronized Smibert, recording some of the same men and women later in life. When he painted Gloucesterman Epes Sargent in 1760, his painting became a pendant to a portrait Smibert had painted of Sargent's wife, Katherine Winthrop Browne Sargent, twenty-six years before.

The differences between Smibert's and Copley's work reflected their very different personalities. Smibert arrived in America with a sense of religious mission, a commitment to moral rectitude. In his obituary he was a man remembered for his "constant Resignation to the Will of God."[14] Copley, as a child of the streets who had witnessed his mother's struggles, worked toward more worldly goals. In his richly detailed paintings, he satisfied his sitters' wish to display their wealth, and, in doing so, he elevated himself. He affected a powdered wig, dressed in the latest English fashion, and married the daughter of a Loyalist family. He was savvy as well as ambitious, and he worked hard to remain apolitical in a time when dissatisfactions with the English Crown began to be heard in some quarters. He brought to his canvases the ability to see into the characters and even into the dreams of his clients. As his confidence grew, he became irritated when the merchants and power brokers in Boston treated him as if he were a mere craftsman; he came to regard himself as an "Eleustrious Artist."[15]

From Smibert and Pelham he had heard stories of the artistic life in London, and he dreamed of life abroad. He entrusted paintings to a ship's captain of his acquaintance, who delivered them to London for submission to the Royal Academy. In examining one of Copley's paintings, academy president Sir Joshua Reynolds immediately recognized the influence of Anthony van Dyck. Even at third hand—from van Dyck's portrait of Cardinal Guido Bentivoglio, transmitted through Smibert's copy to young Copley—the color and technique remained unmistakable to an expert eye. Later, when Copley himself crossed the Atlantic, he wrote from Italy in 1774 to his half brother, Henry Pelham. In examining a canvas by Raphael, Copley recognized the influence of Smibert's

collection—in the presence of the original, his reference point still remained "the Coppy at Smibert's."[16] He was quick to point out that Smibert's was "very different from . . . the Original," but Copley's memory was inhabited by individual Smibert paintings, including the van Dyck, the Raphael, and a Titian. He even remembered where some of them were hung back in Boston, belying the assertion he would later make to his namesake son, when he claimed he "was entirely self-taught, and never saw a decent picture, with the exception of his own, until [he] was thirty years of age."[17] The tobacconist's son had gained more than confidence; he looked at the world with a distinct vanity.

John Singleton Copley had sought to make himself the best painter in America, and by the time of his departure for Europe in 1774, his opulent portraits—they were unreserved and prideful displays of the wealth and worldly accomplishment of Loyalists and Patriots alike—he had earned for himself the reputation he desired. But he owed a debt to Peter Pelham and to Smibert's cache of canvases.

———

OVER THE YEARS, other painters found their way to Queen Street. In 1765, Charles Willson Peale was on the run. A slim man of short stature, the twenty-four-year-old Marylander could count among his burdens a wife and infant child back home in Annapolis. His outspokenness as a member of the newly formed Sons of Liberty—rumors of a Parliamentary plan to impose a tax on the American colonists led to its founding—had earned Peale powerful enemies. They had called in debts, forcing him to flee the threat of debtors' prison. Yet on his arrival in Boston Peale had an air of optimism about him.

In part, it was his nature, but circumstances contributed, too. Barely two years earlier, Peale had found his calling. Painting had not been his first choice; he had apprenticed as a saddler and demonstrated surprising skills in metalworking, silversmithing, and watch and clock repairs. Still, he decided that painting was his destiny. Now, as his debts threatened to

swamp him, he looked for commissions as a means of rebuilding his fortunes.

He also needed supplies since, during his travels north, his "Paint Box [had] proven very Troublesome." The box had chafed the hips of his horse, and slowed his progress northward. "Rather than be Detain'd I put all my Paints in the Bags and through away the Box and Pall[ette]."[18]

The morning after his arrival in Boston, Peale reported, "in the commencement of my painting and hunting for colours [I] found a colour-shop which had some figures with ornamental signs about it . . . Becoming a little acquainted with the owner of the shop"—that would be John Moffatt, Smibert's heir and nephew—"he told me that a relation of his had been a painter, and he said he would give me a feast. Leading me upstairs he introduced me into a painter's room."[19]

The shade of Mr. Smibert once again rose to guide a young painter. The naïve colonial came face-to-face with Smibert's versions of van Dyck, Raphael, and Poussin, as well as some of Smibert's own canvases. Peale soon departed from Boston, but not before purchasing, despite his straitened circumstances, several prints. Smibert's works were, as Peale remembered, "in a stile vastly superior to any [I] had seen before."[20]

Mr. Peale, a man of boundless curiosity and a generous spirit, would have a long and productive painting career in the decades to come.

———

WHEN JOHN TRUMBULL arrived, in 1778, he was in an ill humor. He felt his country and family had failed him.

The Revolutionary War had begun, and as a spirited patriot Trumbull had joined the cause led by General Washington. Trumbull's honorable service in the Continental Army was to have been rewarded by elevation to the rank of colonel. He observed lesser officers raised to this rank while he waited with growing impatience. When his commission finally did appear, it was misdated, further insulting Trumbull. His pride

was offended by the army's "neglect," and he promptly resigned. "Thus ended my military service," he wrote, "to my deep regret, for my mind was . . . full of lofty military aspirations." His next plan met with a different problem: His family—including his father, Governor Jonathan Trumbull of Connecticut—dismissed his notion of becoming a painter as foolhardy. Still, Trumbull was undeterred. "I . . . resumed my pencil," said Trumbull, "and . . . went to Boston, where I thought I could pursue my studies to more advantage."[21]

This worked out better than even he might have hoped because he, too, made his way to Queen Street. Not content merely to visit Smibert's Painting Room, reported Trumbull, "I hired the room which had been built by Mr. Smibert, the patriarch of painting in America." With John Moffatt recently dead, Trumbull's timing proved impeccable. In the rented space he found the collections largely intact.

Trumbull could hardly have been more different from the unassuming Mr. Peale. His carriage and posture had an aristocratic hauteur. He was darkly handsome and confident of his educated pedigree, but also conscious that he was in the novitiate stage of becoming a painter. As he summarized the experience, "Mr. Copley was gone to Europe, and there remained in Boston no artist from whom I could gain oral instructions, but these copies supplied the place and I made some progress."[22] As the Revolutionary War continued, its theater the mid-Atlantic states, he made landscapes based on engravings, copied some of Smibert's females, and did studies of his brother.

Trumbull, like Copley and Peale before him, would soon depart for Europe. But even after Trumbull had come and gone, taking with him some of the paintings, Smibert's ghost continued to inhabit his old Painting Room. The room remained a magnet for young painters. Mather Brown rented "the upper chamber" in the winter of 1780.[23] Samuel King and John Mason Furnass followed; the latter advertised in the *Chronicle* of April 28, 1785, inviting his "Friends and the Public" to call at his "Painting-Chamber" where he was "execut[ing] Portrait-Painting in Oil and Water

Colours . . . As a native of Boston he hopes for as much encouragement as foreigners and invites them to call at his Painting-Chamber."[24] After having copied it himself, Trumbull donated Smibert's version of van Dyck's *Cardinal Bentivoglio* to Harvard in 1791, where another young artist, Washington Allston, would soon copy it at the college library.

Perhaps the best-remembered painter of the revolutionary era made a cameo appearance on this little stage, as well. Some years earlier, another of Smibert's nephews, Thomas Moffatt, had ordered from London an "Engine for cutting tobacco . . . and two sieves for Scotch snuff." The equipment was to be installed at a snuff mill, one designed and operated in Newport, Rhode Island. The Scotsman whom Moffatt brought to America for that purpose, Gilbert Stuart, lived over the mill, and there his namesake son was born. Through the family's contacts, the younger Stuart later came to know some, perhaps many, of Smibert's canvases.[25]

THE LEGACY OF John Smibert, painter, shopkeeper, and collector, spanned a time of immense change in America. In the decade after his death in 1751, the memory of Smibert inspired John Singleton Copley. In the 1760s, it was Charles Willson Peale who gained from exposure to Smibert's upstairs gallery. Trumbull arrived to work there in 1778, and still other artists followed in the 1780s, including a Massachusetts goldsmith-turned-painter and engraver named Edward Savage. In the same time span, America went from a contented colony to a rebel state and finally emerged as an independent nation.

Smibert was a British painter, but those who followed him were American; he was the medium through which they gained exposure to landscapes, portraits, Old Master copies, plaster casts, and a fine arts library. Despite its location in an increasingly unfashionable part of town, Smibert's Boston studio became an artistic crossroads—no one went to the trouble of clearing it out for more than half a century—enabling many artists to experience his lingering influence. In secondhand forms,

he brought high-art European artistic culture to the colonies. If John Smibert was not the first great American painter—he was not American nor, in the opinions of most art historians, were his artistic gifts remarkable—he nevertheless left his imprint.*

Smibert's Painting Room provided younger artists with the venue; the art he left on display offered essential, if indirect, instruction to a series of aspiring painters. The dead Scotsman even found a way to remain on the premises, his watchful gaze ready to catch the eye of anyone, student, patron, or tourist, who troubled to look up at the only known image of the man himself.

He looked down from a painting that was—is this a surprise?— another American first. At the time, no one else in America had attempted a "conversation piece," as large group portraits were known. Smibert's *The Bermuda Group* pictured Dean Berkeley and those who accompanied him on the ill-fated venture to establish the school in Bermuda. The size of the painting was grand but inconvenient (it stands nearly six feet tall, and eight feet wide). Undoubtedly its large scale was a major reason the canvas failed to attract a buyer over more than three-quarters of a century in Boston. As a result it stayed where it was, impressing more than a few viewers. Despite being locked away in the upstairs room, it became by far the most influential of all Smibert's works.[26]

As first conceived, the painting featured six figures, but Smibert would add two others to *The Bermuda Group*. One was Henry, an infant child and New World arrival, born to the dean and his wife, Anne, in 1729. The eighth and final figure to join the tableau on the big canvas was a thin and sober-looking man. He seems to have just stepped into the frame, unbeknownst to the others (they were there first, settled in their

* Even Boston's architecture reflects Smibert's time in town. Another service he provided to his adoptive city was the design of Faneuil Hall, the first purpose-built market in colonial Boston. Completed in 1742, the grand two-story building consisted of an open-air market on the ground level, enclosed by an arcade of brick arches, with a second floor meeting room for public gatherings. Named for the benefactor who underwrote its construction, the building housed a full-length portrait—painted by Smibert—of Peter Faneuil.

places for who knows how long). The stranger stands apart from the main group, deeper into the picture space. No one acknowledges his presence.

Unlike the main figure of Dean Berkeley, the new arrival wears no wig. A man in early middle age, he has long dark brown hair that reaches his shoulders, though his forehead has grown tall where his hairline has receded. His dark-eyed gaze is intense as he looks straight out of the painting. He seems to be studying us, the onlookers. Or perhaps he is impatient for another painter to arrive, another to carry on what he started. Certainly his is an appraising look. Maybe he is wondering how best to render the viewer with his pencil and paint.

More likely, it is a mirror into which he is looking, because this is John Smibert, a man who usually kept to his easel or remained behind his counter. Had he stayed back home in either Edinburgh or London, however, American painting would have evolved very differently indeed. It was Smibert's spirit, refusing to go quietly into oblivion, that remained a presence whose influence was felt two full generations after his death.

The First Likeness

*Inclination having yielded to Importunity, I am now, contrary to all
expectation under the hands of Mr Peale.*
—*George Washington, May 21, 1772*[1]

May 1772 . . . Mount Vernon . . . The Colony of Virginia

THE NEW PORTRAIT was Martha's idea. The lady of the house
had walked past her own image countless times, but lately the can-
vas had begun to seem a little forlorn.

The fifteen-year-old painting portrayed a handsome young matron
dressed in a white and blue silk gown trimmed with lace. Martha knew
she had aged since the painting had been done, but it was another canvas
in the West Parlor that reminded her how much time truly had passed.
Her motherly spirits rose on glimpsing her wee children, Jacky and Patsy,
posed as a miniature Virginia gentleman and his lady, together with a
vermilion pet parrot. In life, those children now neared adulthood. John
Parke Custis, eighteen, had grown into his distinguished name, and
Martha Parke Custis was just two years behind him.

This was the time, Martha Dandridge Custis Washington had decided, to add a portrait of her second husband to the family collection. Although the notion had no particular appeal for him, George had given in to her entreaties. Here he stood, a man of forty years, posing for the painter for the second consecutive day—and feeling ridiculous, all dressed up as if he were going to war.

He could hardly blame the boy, but Jacky had been the instrument of his present discomfort. The lad's studies in Annapolis with the Reverend Jonathan Boucher, an Anglican priest and schoolmaster, meant that word of the possible commission reached Charles Willson Peale. A twenty-nine-year-old Marylander, Peale was acquainted with Boucher, both in his role as rector of St. Anne's Church and, in Boucher's off hours, at the Homony Club (Boucher was its president). There the members met to find boon companions with whom to dine. Jacky Custis had returned home to Mount Vernon for a visit several days earlier with Peale in tow, and the artist was now staring intently at Washington from his easel a few feet away.

The Washington who looked back at him wore the outdated uniform of his old Virginia regiment. Although he and his fellow colonists felt a growing discontent with Parliament's tin ear when it came to American matters, few men Washington knew had any desire to don uniforms, new or old. Besides, he himself had a large farm to run.

If not occupied by posing, he might have ridden out to inspect his fields. Or he might have gone to visit his great friends, the Fairfaxes, at their nearby seat, Belvoir. He might still be conducting business at the county courthouse, where he had been the very Monday when Peale arrived. As a member of the House of Burgesses, he could have traveled to the colony's capital, Williamsburg, as he had done in March and early April, to do committee work, as just another Virginia gentleman of property. Instead, he was spending a cool and clear spring Thursday as a captive in his own house.

The previous day had been the first sitting. Mr. Peale had chalked in a rough likeness on the canvas, and last night Washington had made a

perfunctory note in his diary, "I sat to have my Picture drawn."[2] Certain aspects of the picture were predetermined, since it would be hung along with Martha's, a life-size, three-quarter portrait that captured her person from mid-thigh upward on a fifty-inch-tall canvas. Peale's day of sketching had produced a much larger Washington—at more than six feet, two inches, he towered over Martha, who was fully a foot shorter. As a result, the master of the house filled proportionately more of his matching canvas than did his wife.

He had been a bachelor planter with substantial debts at the time of their 1759 marriage, but the Widow Custis's arrival in his life had made him solvent and had brought social connections, too. As he stood erect before Peale, his head turned slightly, the contours of his face were revealed to the painter. With the arm bent at the elbow, Washington held his right hand over his heart, his fingers resting inside his partly unbuttoned waistcoat. The other hand was swung around to the small of his back. His standing pose was that of a gentleman planter, a status that his marriage to Martha had made possible.

On this, his second day of work on the painting, Peale's task was the "Drapery." Washington wore his old company's dark blue coat, together with red breeches and waistcoat. Peale's task involved more than reproducing planes of flat color, since the coat was trimmed with silver braid and buttons. Washington's sash was a splash of lavender draped over his left shoulder and tied at the right hip. His black hat was adorned with a silver medallion, and the hilt of his fine, English-made sword was visible hanging at his waist. Washington knew better than anyone that the assemblage he wore for Mr. Peale was a painterly charade. Despite the uniform, his military days fighting Frenchmen and Indians on the western frontier were long behind him, his colonel's commission resigned thirteen years earlier. Yet if the personage emerging on Peale's canvas resembled his younger self, that was hardly a bad thing. Indeed, a much younger man had wooed the woman pictured in the portrait with which this one would be paired.

———

SURVEYING MOUNT VERNON between painting sessions, they made an odd couple. Washington was a consummate horseman accustomed to riding fine steeds in pursuit of the fox; Peale was more familiar with such nags as his old Gimblet, a small mare that represented not recreation but basic transport. Riding out to inspect the outlying farms on his Mount Vernon plantation, which soon would total more than 8,000 acres, was one of Washington's great pleasures. Looking both slight and short in the shadow of the Virginian, Peale was less familiar with open plantation acres than with the bustling streets of the port towns of Annapolis and Chestertown, Maryland. Washington wore bespoke clothing that his London agents purchased for him; Peale, still working to clear debts of many years' duration, was dressed in the well-worn clothes of a man with more mouths to feed than ready money. (Charles Willson had become head of the Peale family, and he maintained a household that included his wife, his widowed mother and her companion, two brothers, a sister, and various nieces, nephews, and cousins.)

Yet the two men had much in common. Both were children of the gentry, with all that membership in the upper class implied about manners, social position, and expectations. Each man had also attended the funeral of his father in early adolescence, events that had changed the anticipated course of both their lives. For Washington, the death of Augustine Washington meant an end to plans for the boy to follow his half brothers to England for schooling. In the same way, the passing of Peale's father, a schoolmaster with vague hopes of inheriting an English manor house, left a widow to fend for herself and her five children as best she could. Friends helped Mrs. Peale relocate her family to Annapolis, where she found work as a seamstress and dressmaker, but her eldest son's formal education had ended with writing and arithmetic. Ironically, despite the abrupt and early end of their schooling, both Peale and Washington were already proving to be vigorous and imaginative correspondents.

Of the two, Washington had more experience with horseflesh, but Peale knew the equipment of the equestrian as only a maker could. Charles Willson had been apprenticed to a saddlemaker when he was twelve. A naturally curious man with a gift for craftsmanship, he easily mastered the diverse skills required of making harnesses and traveling equipment. He carved beechwood and worked leather. He cast and polished iron, brass, and silver. His Annapolis master, Nathan Waters, exposed the boy to other businesses, too, as a merchant and planter buying and selling goods and lands.

When the apprentice's lack of money had made repairing his own timepiece a necessity, he taught himself clock- and watchmaking. Upon completing his term of service making saddles for Waters, he branched out into upholstering carriages, and, in his first advertisement in the *Maryland Gazette* in January 1762, announced his presence in Annapolis. "CHARLES WILLSON PEALE, *SADDLER, at his shop in* CHURCH-STREET . . . HERE gives Notice, That he has now set up in his Business of Saddle-making, Harness-Making, Postering and Repairing Carriages, &c. . . . [and] he hopes to have the Employ of his Friends, who may depend upon being well and faithfully served."[3]

None of that explained his presence at Washington's side, although his first step toward Mount Vernon could also be traced back to 1762. Reveling in his newfound freedom, Peale had traveled to Virginia, "with a view to purchasing that necessary article of [my] Saddlery business." In Norfolk, he found more than the leather supplies he needed when, in the home of a new acquaintance, he gazed upon several landscapes and a portrait. Their execution was unremarkable. "They were miserably done," remembered Peale, "[and] had they been better, perhaps they would have smothered . . . [the] faint spark of Genius." Instead, Peale found "*the idea of making Pictures*" took possession of him.[4]

Back in Annapolis, he tried his hand at painting. His friends and family admired his first effort, a landscape. Next he painted a self-portrait in his clockmaker guise, surrounding his likeness with the pieces of a

dismantled clock. His experiments at recording the countenances of his wife, siblings, and friends proved presentable enough that they led to a paying commission, a pair of portraits of a local ship's captain and his wife. By December 1762, hoping that painting might become his livelihood, he ventured to Philadelphia, returning with paints bought at a color shop and a book, *Handmaid to the Arts*, to guide his paint mixing.

He found himself a teacher who was willing to barter. Mr. Peale offered one of his best saddles, and a deal was struck. John Hesselius, the son of a Swedish emigrant painter and himself an itinerant portraitist, agreed that Peale might watch him as he executed two portraits. They also agreed Hesselius would paint half a face, which Peale would then complete under the older man's watchful eye.

For the pupil, these lessons "infinitely lightened the difficulties of the new art." It was decided: Charles Willson Peale would be a painter.[5]

⁓

PEALE'S PORTRAIT WAS a first for Washington. Despite the novelty of the experience, he found no joy in having his picture taken. The process, he said, put him in a mood that was both "grave" and "sullen."[6]

Even so, Washington was coming rather to like Mr. Peale. He couldn't help but wonder whether, given his own inability to concentrate, the painter would be able to capture much of his character. "I fancy the skills of this Gentleman's Pencil, will be put to it, in describing to the World what manner of Man I am." Washington's concern was well placed, as his lethargy was revealing itself on the canvas in his bland, expressionless look. He was a man whose eyes flashed with intelligence when he became engaged in a conversation, but whose gaze went dormant when his mind wandered. (As a trusted adjutant later observed, "[H]is countenance when affected either by joy or anger, is full of expression, yet when the muscles are in a state of repose, his eye certainly wants animation.")[7] It was indeed the detached Washington that Peale recorded.

Washington's laconic pose for Peale betrayed little of the physical presence that impressed those who met the Virginia colonel. When he entered a room, he filled the doorway. He stood taller than most of his contemporaries, but his stature only partly explained the sense of quiet power he exuded. He had the shoulders of a woodsman. Though he was thin through the chest, having suffered from a "pulmonary affection in early life," his long, box-like trunk was wide and unmistakably solid.[8] He had very large hands and feet, thickly muscled limbs, and bulky thighs strengthened by countless hours straddling a horse. Yet the man in the picture seemed unfocused, his body slack. He was not in peak physical condition (Peale faithfully recorded a missing button on Washington's waistcoat, the fabric strained by the soldier's growing midlife girth). But his sitter's pear shape was also the result of Peale's penchant for sweeping curves. Anatomical accuracy was less interesting to the artist than an appealing picture with overall grace and appeal.

That Peale failed to capture the colonel's physicality was a little surprising since the painter had witnessed a demonstration of Washington's athletic prowess during his visit to Mount Vernon. His stay had been extended when his brief was broadened to include the painting of watercolor miniatures on ivory of Patsy, Jacky, and Martha. He also found the Washingtons' home a welcoming and social place, since at dinner most days there were a dozen or more at the table, including family, friends, and other visitors. In general, he observed, "the Character of the Virginians for Hospitality" was higher than that of his patrons in "Pensilvania." What he left unsaid was that the former provided him room and board at their cost, a kindness not extended to him in the northern colonies.[9]

One day during his stay Peale and several other guests at the Mansion were outdoors playing a round of "pitching the bar." A contest akin to traditional log- and pole-throwing, the game involved heaving a heavy iron bar as far as possible. One man would throw, and the distance he achieved was marked with a stake. Then another competitor would have

a go. On this day, the man who threw it the farthest wasn't even in the competition.

Washington unexpectedly appeared amidst the men, who were standing on the lawn stripped to their shirts of white linen, their sleeves rolled up for ease of movement. He inquired into the progress of their game. When the markers indicating the distances achieved were pointed out to him, his somber visage broke into a confident smile.

"[W]ithout putting off his coat," Peale reported, "[he] held out his hand for the missile. No sooner did the heavy iron bar feel the grasp of his mighty hand than it lost the power of gravitation, and whizzed through the air, striking the ground far, very far, beyond our utmost limits."

The onlookers were amazed. Washington soon left them to their exertions but promised to return. "When you beat my pitch, young gentlemen, I'll try again."[10]

If Peale's portrait didn't capture the latent power of the Virginia colonel, certain physical details were accurate. The hair that appears from beneath his hat is reddish brown. The nose is long and broad and the face ruggedly handsome. The eyes, though hooded, are identifiably bluish-gray. In life Washington was forty years of age, but in Peale's portrayal the age of the soft-featured man is uncertain. Out of kindness, perhaps, Peale also chose not to mar Washington's fair complexion with the scars around his nose, evidence of his bout of smallpox in Barbados. Yet the boredom of the sitter comes through; as he himself reported to Boucher, while posing he felt himself "under the influence of Morpheus," feeling at times as if he were falling asleep on his feet.[11]

The setting Peale chose for his canvas was not the Virginia plantation where he painted Washington. The backdrop for the dashing officer in the regimental blue and red uniform suggests not the cultivated tobacco fields of Tidewater Virginia but the Ohio country, with a mountain stream and Indian camp on the frontier where much of the war had been fought. Years earlier, Washington's exploits there had brought him to the attention of King George II.

Washington's service to the king during the 1750s had had mixed results. The 1754 ambush by Washington's men of a detachment of French soldiers, during which the enemy's commanding officer, the Sieur de Jumonville, was killed, helped kindle the French and Indian War. Afterward, the twenty-two-year-old Washington had confided in a younger brother, "I heard the bullet's whistle and, believe me, there is something charming in the sound." When his remark was published and brought to attention of the king, Washington's boast led George II to remark that "he would not think so if he had been used to hear many."[12] Later that summer, Washington suffered the ignominy of having to march out of Fort Necessity with his troops in full surrender to the French.

The recapture of the smoking remnant of Fort Duquesne in 1758 by Washington and his men was an anticlimax (the French garrison had abandoned and burned their stronghold), but Washington's years of service in the frontier war left him with more military experience than any other colonial officer, as well as a reputation for bravery under fire (he had two horses shot from beneath him, and four bullets rent his clothing). Both would be invaluable credentials years later when the colonists decided to muster their own army.

By the end of the month, Peale had completed his work at Mount Vernon. He and Washington had not become close friends; friendship was a rare gift to which few of Washington's many acquaintances could lay claim. But they found common ground. Recognizing his guest's mechanical cleverness, Washington had given Peale a personal tour of the new Mount Vernon gristmill, which had gone into operation only the year before.

During the evenings at Mount Vernon, the easy sociability of the household meant that Peale had occasion to enjoy the Potomac breezes in Washington's company, and even to dance with the sixteen-year-old Patsy Custis, Martha's daughter, who he believed "did not enjoy a good state of health."[13] His insight was sound: Twelve months later, as Washington reported to a brother-in-law, "she was seized with one of her usual

[epileptic] fits and expired in it in less than two minutes without uttering a word, a groan, or scarce a sigh." As Washington said sadly, "the sudden and unexpected blow . . . almost reduced my poor wife to the lowest ebb of misery."[14]

By then, Peale had gone other places and painted other portraits. On his departure from Mount Vernon on May 30, 1772, after a most enjoyable stay, Peale had received full payment from Washington. The bill amounted to £18.4.0 for the 50½-inch-by-41½-inch Washington portrait, and £13 for the three miniatures (each was just 1½ inches high, 1⅟₁₆ inches wide). The two men, their first transaction complete, could not have guessed that this first image of George Washington, portrayed as a soldier in service to the Crown, would be the first of many portraits Peale would paint of Washington as his role in the world evolved.

The General

*I am well acquainted with Gen.l Washington who is a Man of very few
words but when he speaks it is to the purpose, [and] what I have often
admired in him is he [has] allways avoided saying any thing of the actions in
which he was Engaged in the last War . . . [H]e is uncommonly Modest, very
Industrous and prudent.*
—*Charles Willson Peale, August 29, 1775*[1]

I.

1775–1776 . . . The Pennsylvania State House . . . Philadelphia

CHARLES WILLSON PEALE wrote the recipe in his diary. "To
make a Vernish," he noted, "Take Mastick & Seed Lac [and] deso[l]ve
them in Terpintine . . . mix this with the Oil." The mastick and lac were
imported resins extracted from mastic trees and the shell of the lac bee-
tle, respectively; turpentine and linseed oil were made in America. Once
he had prepared it, Peale applied the dense liquid to his finished oil
paintings to protect them.[2]

Over time, such varnishes tend to *saponify*, to yellow as they oxi-
dize. Linseed oil requires years to dry completely, which means that dust
adheres to the varnish. The result can be the appealing patina of age or,
more often, a darkening and ever-more-opaque membrane on a painting's

surface. This makes Mr. Peale's varnish a useful metaphor for considering the several portraits he painted of General Washington in the 1770s. To understand the pictures, we must look through not only the haze of the varnish but through a layering of propaganda and perception.

———

IN MAY 1775, delegates to the Second Continental Congress convened in Philadelphia. As they gathered at the Pennsylvania State House, the men were forced to digest the disturbing news of bloody confrontations at Lexington and Concord the previous month, as well as word of the confiscation of Virginia's powder stores at Williamsburg. Angry calls for separation from England were offered and quickly countered by arguments for reconciliation.

Events demanded that the Continental Congress act. The Provincial Congress of Massachusetts was raising an army and sought support from the other colonies. Though he had sat largely mute and served on no committees during the First Continental Congress in 1774, George Washington began to assume new prominence under the altered circumstances. As one of the few experienced military officers at hand, he worked on three committees in the next three weeks. His labors on defense strategies and munitions impressed his fellow delegates. He had arrived prepared, bringing along "five books—military."[3] As he came to accept that the cause of one colony (namely Massachusetts) required a response from all thirteen, Washington also changed his costume. By the end of May, as John Adams noted for posterity, "Colonel Washington appears at Congress in his uniform."[4]

As military plans began to take shape, no clear consensus existed as to the nascent army's command structure—or who should be its commander in chief. One man in attendance certainly coveted the job as military leader, and perhaps desired it more than the Virginian in military garb. John Hancock, president of the Continental Congress, could claim no military experience. The orphaned son of a minister, he had ascended to wealth and influence in Boston after inheriting his uncle's

booming merchant business. But Hancock, who had helped finance the rebellion and become an outspoken critic of British rule, saw himself as general material. It fell to another Massachusetts delegate, John Adams, to advance the cause of revolution by one long Virginia stride.

Adams spoke for many when he confided in his wife, Abigail, that Colonel Washington, "by his great experience and abilities in military matters, is of much service to us."[5] Despite his diligent work, however, the master of Mount Vernon himself was very much of two minds about the job. He would have preferred returning home (as he wrote to Martha a few days later, "I should enjoy more real happiness and felicity in one month with you, at home, than I have the most distant prospect of reaping abroad, if my stay was to be Seven times Seven years").[6]

Even as he confided in Martha his feelings about his domestic life, more than mere duty kept him in Philadelphia. The military life he lived during the French and Indian War twenty years earlier had been exhilarating and ultimately frustrating, since he had been denied what he regarded as a well-deserved promotion in the king's army. On the one hand, then, a chance was in the offing to fulfill his military ambitions. Against this, he weighed the odds of succeeding and the understanding that military service would mean time—and who knew how much?—away from Mount Vernon.

On June 14, John Adams rose from his seat in Congress and made a recommendation. He opened the session that morning by offering a motion to the Second Continental Congress to adopt as its own the army assembled in Massachusetts. The suggestion had been floated some days before, but this time Adams added a staffing recommendation. A general would be required, said Adams, and his choice would be "a gentleman from Virginia." For Hancock, watching the proceedings from the president's chair, this was indeed a blow (Adams: "When I came to describe Washington for the commander, I never remarked a more sudden and striking change of countenance. Mortification and resentment were expressed as forcibly as [Hancock's] face could exhibit them").[7]

In contrast, Washington was suddenly nowhere to be seen. The

chair in which he had been sitting near a side door was vacant; the moment he realized that Adams referred to him, Washington had disappeared into the library. Not so many years earlier, the younger and more ambitious Washington had resigned his commission during the French and Indian War for lack of a promotion. Now that a generalship was at hand, it would be ungentlemanly of him to remain in the room when he was clearly to be the topic of conversation.

In Washington's absence, reservations about him were expressed by some members of the body, chief among them being the appropriateness of putting a Virginian in charge of an army of New Englanders. But this and other minor objections were soon overcome, and the following day a unanimous resolution was passed electing him "to command all the continental forces raised or to be raised for the defense of American liberty."[8]

Washington took the floor the next day to accept the appointment. With characteristic formality, he began by bowing to the chair and the assembled body. He thanked his colleagues for "the high Honour done me in this Appointment." To the surprise of many, he then expressed his doubts about his ability to handle the job.

"[L]est some unlucky event should happen unfavourable to my reputation," offered Washington, "I beg it may be remembered by every Gent[lema]n in the room, that I this day declare with the utmost sincerity, I do not think my self equal to the Command I am honoured with." In the next breath he gave a turn to still others by stating his refusal to accept any pay for his generalship. "[A]s no pecuniary consideration could have tempted me to have accepted this Arduous employment at the expense of my domestik ease & happiness I do not wish to make any profit from it."[9] He would submit expenses, he allowed, but accept no salary.

At a time of high anxiety among his peers, Washington met their hopes with no grand promises; if John Hancock was a man who was impressed with himself, Washington felt obliged to downplay both his experience and what he thought people might reasonably expect of him.

He agreed to accept a generalship he didn't exactly want (though he had presented himself in uniform, his impulse seems to have had less to do with military ambition than his desire to jar his fellow delegates into sharing his recognition that military action was unavoidable). He would take the job, but he wanted it understood he would not profit from it.

He had arrived that May in Philadelphia a well-to-do *farmer* (a description he himself favored), one among dozens of Patriots committed to the cause and seeking a solution, preferably a peaceful one. Now, in all prudence, he dispatched a draft of a last will and testament to Martha, along with a note of both reassurance and resigned acceptance. "[I]t has been a kind of destiny that has thrown me upon this Service," Washington wrote. "I hope that my undertaking of it, is designed to answer some good purpose—You might, and I suppose did perceive, from the Tenor of my letters, that I was apprehensive I could not avoid this appointment, as I did not even pretend to intimate when I should return—that was the case—it was utterly out of my power to refuse this appointment without exposing my Character to such censures as would have reflected dishonour upon myself, and given pain to my friends . . . I shall rely therefore, confidently, on that Providence which has heretofore preservd, & been bountiful to me, not doubting but that I shall return safe to you in the fall . . . I therefore beg of you to summon your whole fortitude & Resolution, and pass your time as agreeably as possible—nothing will give me so much sincere satisfaction as to hear this, and to hear it from your own Pen."[10]

He soon departed for Massachusetts on a strange errand, having been reborn as the most conspicuous man in America. He was the figurehead chosen to lead an ad hoc army into an undeclared war on behalf of a country that did not yet exist.

———

ONE YEAR LATER, Charles Willson Peale sought to render Washington on canvas again. This time his task was to record a reluctant general who, through a concatenation of happenstance, personal style, and

physical prowess, had begun his very long run, ongoing to this day, as America's first and most essential symbol. Peale began a new portrait of Washington on May 29, 1776, one day shy of four years after his departure from Mount Vernon.

George Washington's place in the world had continued its radical transformation. No longer was he a provincial aristocrat who, according to his own diaries, had grown soft while devoting his time to playing cards, foxhunting, and surveying his plantations. The man before Charles Willson Peale had emerged as a figure of national and even international note—*and* a victorious military commander.

The first important military victory of the war had occurred less than three months earlier. A brilliant military stratagem devised by Washington and his youthful artillery commander, Colonel Henry Knox, had stunned the British forces then occupying Boston. Moving on the night of March 3 under a "moon shining in its full luster," as Washington described it, his troops positioned cannons atop Dorchester Heights, turning captured British artillery pieces on their owners (undetected by the British, Knox and his men in the preceding weeks had dragged fifty-nine cannon and mortars some three hundred snowy miles from Fort Ticonderoga, New York). The British awoke on March 4 to the daunting realization that the guns pointed at them from the bluff above meant that defending the town and their ships at anchor was virtually impossible. Ten days later, a great flotilla nine miles long headed out to sea as the British military forces evacuated Boston, taking with them more than a thousand Tory sympathizers.

Though Washington surely experienced a mixture of exultation, relief, and amazement at this turn of events, he managed, as usual, to keep his feelings to himself. To those around him, his countenance remained unreadable as he watched the sails disappear at the horizon like a distant clothesline hung with ladies' handkerchiefs. The General had promptly marched his army to New York, wondering whether the British Navy would get there first. Fortunately for the colonials, the British

military commander, Lord Howe, had set sail for Halifax, Nova Scotia, enabling Washington's troops to ready for another siege. This time their positions were reversed, as the Americans, not the British, held a city surrounded by water.

Yet now Washington was in Philadelphia, a three-day ride distant from his troops, who, accustomed to his everyday presence, watched nervously for the arrival of British ships in New York harbor; they knew very well indeed that they were betwixt battles. Continental Congress President John Hancock had summoned the General, desiring a report on the big victory at Boston. Washington's visit had also seemed to Hancock an auspicious moment to record him on canvas for his personal collection, so he had summoned Mr. Peale, too.

John Hancock was far from being a fond relation (recall that Martha commissioned the previous portrait in 1772). His order to Peale to make a three-quarter-length portrait of the General and another of his wife was a conspicuous public gesture. Hancock's motives were uncertain (some wondered, *Does he still desire a military commission for himself?*), but at the very least, Hancock wished to compliment the man in whom the entire nation had placed its trust.

In obeying the congressional summons, Washington spent fifteen busy days away from his army. Only with difficulty did he fit Mr. Peale into his schedule with the other social, political, and military demands on his time. For much of the General's first week, Peale had to content himself with working on the matching portrait of Mrs. Washington, who had traveled to Philadelphia to obtain an inoculation for smallpox (George himself was immune from further bouts, having survived his infection with the deadly disease at age nineteen). Peale could manage only two sessions with the General, on Wednesday and Friday, May 29 and 31, probably at Peale's new Arch Street studio.

In the finished painting, Washington's features may be read as expressing disgruntlement. If that is so, the emotion probably stemmed both from his impatience to rejoin his troops and from the fact that the

portrait was destined for Hancock's home. Hancock was one politician for whom Washington had no particular affection.

———

AT AGE FORTY-FOUR, Washington had begun to go gray, and Peale painted him with his hair powdered white. The face Peale rendered on canvas is oval, its forehead high. The General wears no hat. His nose is long and straight, the mouth closed (Washington had long since begun to lose his teeth). The expression is nervous or, perhaps, impatient. This man is certainly not relaxed, but, gazing distractedly back at the viewer, the uniformed man with the pale blue sash looks the part of the commander in chief.

Washington wears a military uniform, but the bright Redcoat red has been banished to a trunk at Mount Vernon. In place of the Virginia regimentals is a dark blue coat, a buff-colored waistcoat, and breeches that extend just beyond the knee. There is no insignia, though the General has the air of a man in charge. His buttons are brass (not silver), and his costume no longer identifies an obedient subject of the English king. He has become a revolutionary, proud to wear the uniform of the Continental Army.

Peale was unable to complete the painting in May and June, but found some hours in July, August, and September to devote to both General and Mrs. Washington's canvases. During the summer of 1776, both portraits were on display in his Painting Room, where John Adams admired them. Others who saw the paintings liked them, too, and the artist fielded orders for full-size copies, as well as miniature versions for Mrs. Washington. By December 3, he completed the original transaction with Hancock, receiving from him payment "in full for General Washington and Lady, 28 guineas."[11]

Hancock took his paintings to Boston, where the following year the Washington portrait became the source of the first published images of the General. Line cuts, mezzotints, and other engravings would appear

during the next decade, many of which drew upon the 1776 portrait. Beyond the few who had seen the man in person, most of those who had begun proudly to call themselves Americans became acquainted with George Washington through Mr. Peale's eyes.[12]

II.

1767–1769 . . . Castle Street . . . London

ALMOST TEN YEARS earlier, Charles Willson Peale had painted another icon. This one he did not dress in a uniform; rather, he wrapped "the Great Commoner" in a toga. English statesman William Pitt was a hero in the colonies. In January 1766 he got to his feet in the House of Commons to oppose the Stamp Act, the first direct tax on the colonists, enacted by Parliament the year before. "I rejoice that America has resisted," the former prime minister proclaimed. His speech anticipated the repeal of the act a few months later and, for revolutionary-minded Americans, earned Pitt a place in the pantheon.

Peale's route to England—and the commission to paint a life-size Pitt for several Virginia gentlemen—was a circuitous one. In the mid-1760s, his newfound enthusiasm for art and his financial difficulties had combined to make him something of a pilgrim. Already a married man when he took up painting at the advanced age of twenty-one, he found his debts threatened to overwhelm him. In order to escape the unanswerable demands of his Maryland creditors, he left Annapolis, sailing north in 1765.

His peregrinations took him not only to John Smibert's Painting Room but to the studio of John Singleton Copley, where he received a few painting lessons. Among other assignments, the Bostonian instructed Peale to copy a "head painted by candlelight."[13] After a subsequent stay in prosperous Newburyport, some miles north of the Massachusetts capital, Peale painted his way home. A twelve-dollar fee earned for a Boston

portrait paid his passage as far as Virginia, where he paused in the town of Accomac, awaiting the conclusion of negotiations to permit him to return home while staying out of debtors' prison.

England could hardly have been further from his mind at that moment. After months of separation, he was about to be reunited with his wife, Rachel, and their infant son, but the prolific Mr. Peale worked at two presentation pieces based on English prints during his stay on Virginia's Eastern Shore. When he finally returned to Annapolis, he gave them to potential patrons, and the recipients quickly recognized the young man's talent. The notion dawned on them that it would be desirable to have a fine painter at hand to record portraits of the ladies and gentlemen of their self-consciously genteel town. Eleven Annapolitans of means contributed a total of £85.12. to Mr. Peale's coffers, a sum sufficient to underwrite a year's journey to England. There, it was decided, Peale could best advance his art.

Barrister Charles Carroll made the most generous contribution (the sum of twenty-five guineas), and added his influence to the venture, too, writing to his London agent, "The Bearer hereof Charles Wilson Peale [is] a young man . . . who has a Turn for Limning."[14] Barely two months after returning to his family from his New England venture, Peale boarded the *Brandon*, a merchant ship bound for London. Fittingly, the ship's hold held a consignment of the stamped paper rendered obsolete by the repeal of the hated Stamp Act.[15]

Peale carried a second letter of introduction that would make the Pitt portrait possible. This missive was addressed to Benjamin West, an American-born painter recently settled in London. West got the opportunity to size up his pupil-to-be when Peale turned up at his studio unannounced, outfitted in a new blue suit, beaver hat, gloves, and black stockings, a fine London outfit that had diminished the Marylander's capital by more than seven pounds.[16] The door on which Peale knocked was, in effect, the portal to an art school for aspiring American artists.

In the coming twenty-five months, Peale repeatedly benefited from

his new mentor's artistic generosity. As another of West's protégés would write, "[West] had no secrets or mysteries. He told all he knew . . . every American was as a brother to him, and his open doors and open heart ever received them as such."[17]

Although the Pennsylvania-born West was only three years Peale's senior, he was already an acclaimed painter in London. He had begun to take himself seriously as an artist as a young boy and, by age seventeen, was getting paid to paint portraits. In 1760, the twenty-one-year-old West became the first American-born artist to travel to Italy. He spent three years in Rome, Florence, and Venice, where he studied and, in the habit of the day, made careful copies of paintings by such masters as Raphael and Poussin. West's work impressed his European contemporaries (he was elected a member of academies in Florence and Bologna), but he resolved to return to America, hoping (as he put it) "to cultivate in his native country that profession in which [I] had already acquired so much celebrity."[18] A stopover in London led to a sudden change in plans. Finding his skills very much in demand in Europe's wealthiest and most populous city, West settled into a studio on Castle Street near Leicester Square. Though born to humble Quaker farmers in Pennsylvania, West rapidly won the admiration of the London art world and even the attention of the king. By the time Peale arrived in 1767, West was a London fixture known as "the American Raphael."

Benjamin West painted portraits and an occasional landscape, but his chosen milieu was history painting. Drawing upon events from the classical past, the Bible, and even mythology, the history painter portrayed complex scenes featuring multiple figures set in panoramic landscapes. To West and his contemporaries, a history painting had to be more than a well-executed canvas; it also had to be an enlightening and dramatic visual experience for those who saw it. The viewer who contemplated a history painting encountered a story at its climax. From the actions of those in the painting, a moral or intellectual message was to be gleaned. History painting was regarded as the highest art to which a

painter might aspire, requiring wide knowledge of anatomy, classical sculpture, Renaissance painting, and a broad familiarity with literature and history.

The cachet of West's Italian training and the novelty of his American birth set him apart from other London artists. He was well on his way to becoming a conspicuous success when Peale arrived. Perhaps intimidated by West, Peale began painting miniatures, which supplemented the monies his Maryland benefactors had given him. He posed occasionally, too, standing in for the Roman consul Marcus Atilius Regulus in a canvas that West was painting for no less a patron than George III, commissioned to decorate the king's personal apartment at the royal palace, Buckingham House. Summoned by the king to Buckingham House, West had agreed to paint the departure from Rome of the brave general. With a beard added by the artist, Peale impersonated the Roman consul, who was returning to Carthage as he had promised his former captors he would do, despite the fact it meant almost certain torture and death. For a time, Peale visited West's studio daily to pose as Regulus.

Peale, ever adaptable, copied paintings for West, repaired locks (nothing mechanical seemed beyond him), and once even mended a favorite wooden palette that West had cast aside. Peale enjoyed his subservient role as a studio assistant and tended to London errands for various Maryland friends and benefactors. He sought out Benjamin Franklin, who welcomed him and explained to the curious young man the electrical experiments with which he was engaged. Peale was a man difficult not to like, his easy disposition endearing him to both plain people and the famous. Despite the many diversions of the great city, however, Peale was homesick for his wife, Rachel, and "always felt . . . alone, even amidst the crowds that are found at all public places."[19]

Peale's chance to put his own hand to a history painting did not come from the monarch, but from another American. Edmond Jenings, an English-educated attorney working in London, hired Peale to paint William Pitt (Benjamin West could hardly have accepted such a com-

mission, given Pitt's championing of American resistance to the Crown). Peale had no royal connections to protect (in fact, Peale prided himself on his refusal to doff his hat when the king's carriage rolled by). The opportunity to make a life-size likeness of the popular William Pitt for an American audience seemed tailor-made.

Peale could get no sitting with the great man and contented himself with basing his portrait on a plaster cast. Made from a statue by Joseph Wilton, the plaster portrayed a standing Pitt with the Magna Carta in hand. Peale added a variety of other allegorical elements, among them the figure of British liberty and, in the background, the rising walls of the Banqueting House, Whitehall, the London landmark where King Charles I had been beheaded a century earlier. To Peale and his intended American audience, a warning to a tyrannical king was clearly implied.

This busy painting became Peale's first major work. He portrayed the English lord (by 1768 Pitt had entered the House of Lords as the Earl of Chatham) in what he called a "Consular Habit." Despite being very much a man of the Enlightenment, the declaiming and gesturing Pitt appears without his wig, bare at the knees and neck, his attire a red Roman toga, pale yellow tunic, and sandals. Such raiment was a convention of history painting, serving to associate contemporary figures with the heroes of antiquity. During his time in London, Peale also worked at mastering a variety of other artistic skills, including the making of prints, and he produced a mezzotint based on his Pitt portrait (he sent one impression to Copley, who admired it and thanked Peale copiously). When back in America, Peale would sell them for years afterward, making a modest profit.

Despite his studies with West, their growing friendship, and the opportunity to explore the great city of London, Peale still thought of himself "as an exile from his friends."[20] Longing for his wife, he departed for home after two years and one month in England. An added stipend of £30 from his Maryland benefactors helped underwrite the purchase of art supplies in London. Among them were "Picture frames," fine brushes

called "pencils," a palette and palette knives, "canvis," a miniature paint box and palette, prints, books, and "Fraim and Glass." He bought pigments, too, including carmine ("vivid red Lake"), "ullemarine" (ultramarine), "Prussian Blue," and "Peach Black." Even if he couldn't spell, he had come to recognize what painting materials he needed and desired.

He had acquired advanced technical knowledge, too, of grinding pigments and the use of a thin layer of transparent paint (glaze) to add shadows to flesh tints. He learned how to add luminosity to reds by painting them over whites, and how to use a heavy layering of paint (impasto), often applied with a palette knife, to add emphasis and richness to his linear style, which tended to rely upon draftsmanship. He returned to America with training beyond that of anyone in the colonies.

When he sailed for home in March, Peale's baggage included two important gifts from Benjamin West. One was a canvas West had painted of his student. His second gift was an unusual armchair, large and square in form. Beneath the seat was a pivot that fastened to a platform, which elevated the whole some eighteen inches above the floor. The mechanism allowed the occupant to rotate in place without shifting position. It was purpose-made for use in a portraitist's studio, enabling the painter to adjust his subject's relationship to daylight without shifting drapery or costume.[21]

This was, of course, a Painter's Chair. After returning from England in 1769, Peale worked to clear his Maryland debts, painting more than 150 portraits in the next six years of Virginians, Marylanders, and other gentlemen and ladies. He established his reputation as the foremost portraitist in the mid-Atlantic region, and after Copley embarked for England in 1774, Peale was left with no serious rival anywhere in America. By then, more than a few members of the emerging revolutionary generation had already taken a seat in his Painter's Chair.

III.

Winter 1776–1777 . . . Crossing the Delaware . . . Pennsylvania and
New Jersey

THE POPULAR PORTRAITIST is fated to be forever in search
of new customers. By 1776, Charles Willson Peale had long since
fulfilled the needs of his original Annapolis patrons. His ongoing search
for clients had already taken him on several occasions to Philadelphia,
where he found many new sitters; as a result he had resolved in early 1776
to relocate to America's most prosperous metropolis to service them. The
Hancock commission to paint General and Mrs. Washington that spring
served to affirm the wisdom of his decision, so work on their portraits
had been regularly postponed by his journeys back and forth to Mary-
land to organize the move of his family and business to Philadelphia.

On June 19, 1776, the Peale entourage finally arrived in Pennsylva-
nia's capital. The painter counted among his ten dependents his wife,
Rachel; a baby daughter (Angelica); a two-year-old son (Raphaelle; their
first son had died while Peale was in England); a motherless nephew and
niece; and other extended family, including Charles Willson's mother.
The move brought them to the city in time for him to record a momen-
tous event in his diary on July 2. "This day the Continental Congress
declared the United Colonies Free and Independent States."[22]

The news was supposed to have been subject to a "bar of secrecy,"
but within hours the vote had become the talk of Philadelphia's coffee-
houses. A strong supporter of the Patriot cause, Peale joined the ranks of
the military early the following month over the strenuous objections of his
mother. Brother James was already a member of a Maryland battalion,
but now, as a Pennsylvanian, Peale chose to join the Philadelphia Asso-
ciators. The city militia was run democratically, and Peale, though a
relative stranger, proved a popular and resourceful leader. By November
he was elected a first lieutenant.

The fortunes of the Continental Army had plummeted following the British evacuation of Boston. After posing for Peale, Washington rejoined his troops in New York in June 1776, and his ragtag band of volunteers had proved no match for the most sophisticated military force in the world. The Americans had been outflanked on Long Island in August, outgunned in Manhattan in September, and overmatched in almost every way since. As winter approached, the Continental Army was in full retreat across New Jersey, and Washington sought to save what remained of a force reduced by casualties, desertion, sickness, and the expiration of enlistments. The Associators received their marching orders in early December 1776 to join the retreating army in New Jersey, but within hours of arriving in "Trent-Town" (as Peale labeled Trenton in his diary), the Philadelphians were retreating, too, heading back across the Delaware River. Peale described a "hellish scene," with bonfires on both shores illuminating a nighttime crossing, as boats returned again and again to New Jersey, ferrying men, horses, and artillery to the hoped-for safety of Pennsylvania.[23]

The Associators could only watch as their battle-weary brethren shuffled past. The Philadelphians were simply dressed (established decades earlier by Benjamin Franklin, the Associators had agreed that their uniforms, in order to minimize class distinctions, would cost no more than ten shillings). But their plain brown and gray woolens seemed like luxury itself in comparison to what the retreating soldiers wore. Peale noticed in particular one man who "had lost all his cloaths. He was in an Old dirty Blanket Jacket, his beard long, and his face so full of Sores, that he could not clean it."[24] The man, who had once been dressed in the finery of a silk-stocking Annapolis regiment, was in rags. Charles Willson did a double-take: He recognized the haunted and hungry face of his brother James.

As the men reached Pennsylvania, Washington redeployed his troops along the west bank of the Delaware. He placed them at strategic points where the British might attempt to cross, but in the days before

Christmas Washington also found himself pondering the where and when of the forthcoming winter encampment. War was a warm-weather affair, he knew, but he wrestled with black thoughts of a long winter spent contemplating the disastrous results of the preceding months. While Lieutenant Peale, his portable paint box on his lap, painted a miniature of his commanding officer, Captain Lawrence Birnie, Washington and his generals conceived the bold stroke that would carry them back across the Delaware after darkness fell on Christmas night 1776. Very much later, a German immigrant named Emanuel Leutze would make an enormous painting, *George Washington Crossing the Delaware*, which captured something of the spirit of that long night. Despite its inaccuracies, it would become a part of American mythology. But that's another story entirely.[25]

The surprise attack on Trenton on the morning of December 26 succeeded brilliantly. In the face of a violent nor'easter that dumped rain, hail, and snow upon them, Washington and some twenty-four hundred Continentals accomplished the heroic nighttime crossing of a river nearly choked with ice. Having then marched more than ten miles to Trenton, the Americans routed the Hessian mercenaries holding the town, taking some nine hundred of them prisoner. But the victory was far from complete. Only half of Washington's forces had been able to cross the river, because an ice jam downstream had prevented eight hundred members of the Pennsylvania militia from crossing to Trenton, while violent currents kept Peale and twelve hundred of his fellow Associators along with six hundred New England Continentals on the Pennsylvania shore still farther south. Recognizing how exposed his position was, Washington ordered the troops accompanying him to retreat once more across the Delaware, along with the Hessian prisoners.

Safely back in Pennsylvania, he convened a council of war to decide "what future operations may be necessary."[26] As his military advisers assembled, a messenger arrived. The letter from General John Cadwalader, commanding officer of the Philadelphia Associators, advised Washington

that Cadwalader and his men had successfully crossed the river—but had done so a day late. Peale and his fellows were, in short, marching around New Jersey, virtually surrounded by a vastly larger enemy force.

Washington and his counselors decided to seize the opportunity to make one last military strike before retiring for the winter. Yet again, the Continentals would cross the river, this time to Princeton, and attempt to retake south Jersey. For one of the few times in the war, Washington committed his entire army to the effort, and Peale was there to witness the events, leading his men into battle since Captain Birnie's various injuries had led to Peale's taking charge of his platoon.

Peale—in a literary voice as colloquial and unpretentious as the man himself—recorded the events in plain language in his diary:

At One oclock this morning [January 2, 1777] began a march for Trent Town. The Roads are very muddy, almost over our Shoe Tops . . . a very tedious march. The Sun had Risen more than an hour before we Reached the Town [but] . . . at last we were provided and had made a fire. I took a short nap on a plank with my feet to the fire. I was suddenly awakened by a Call to Arms, that the Enemy was advancing, and at small distance from the Town . . .

We now was ordered to take our arms. The Sun appeared to be hardly ½ hour high. We then marched in Platoons back towards the Town [and] . . . Platoon firing was now perty frequent. When we had almost got out of the Woods . . . word was brought that the Enemy gave way, which at different times was the case. However, they had no[w] got possession of the greatest part of the Town. A very [heavy] firing was kept up on the Bridge, and great numbers of the Enemy fell there. Some of our Artilery stood their ground till the Enemy advanced within 40 Yds. And they was very near loosing the Field Piece . . . I really expected a retreat.

At one oclock [the next] morning we began to move . . . By this I expected we were going to surround the Enemy, but after marching some miles . . . the Sun had just risen just before we See Prinstown. We proceeded as fast as possible and was within a mile of the Town when we were informed that all was quiet. A short time after, the Battn. just ahead of us began a Exceeding quick Platoon firing and some Cannon . . . I carried my Platoon to the Top of the Hill & fired, tho' very unwillingly, for I thought the Enemy rather too far off, and then retreated, Loading . . . The 3rd time up, the Enemy began to Retreat. I must here give the New England Troops their due. They were the first who regularly formed . . . and stood the fire without regarding [the] Balls which whistled their thousand different notes around our heads, and what is very astonishing did little or no harm . . .

We now advanced towards the Town, & halted at about ¼ of a mile distance till the Artilery came up and our men were collected in better order. Amediately on the Artilery firing, a Number [of the enemy] that had formed near the College began to disperse, and amediately a Flag was sent, and we huzared Victory.[27]

Peale claimed no great glory for himself, then or later, as he recollected his war experiences in his *Autobiography*. In retrospect, he described himself as "totally unfit to endure the fatigues of long marches," before offering an aside that aptly sketched his character, humbly referring to himself, as he did throughout his *Autobiography*, in the third person. "Yet by temperament and by a forethought of providing for the worst that might happen, he endured this campaign better than many others whose appearance was more robust. He always carried a piece of dryed Beef and Bisquits in his Pocket, and Water in his Canteen, which, he found, was much better than Rum."[28]

Temperate and sensible, a man of modest expectations, Peale

survived the Battle of Princeton. His memories would later serve him well on canvas as well as on the printed page.

IV.

January and February 1779 . . . Mr. Peale's Painting Room . . . Philadelphia

THE TIME FOR another painting had come. Washington's success at Princeton had been galvanizing, but it had been followed by two years of military ups and downs. The Americans had lost the Battle of Brandywine in September 1777, allowing the British to occupy Philadelphia; balancing that disappointment, the Continental Army had defeated the enemy at the Battle of Saratoga in October. A brutal winter followed for Washington's troops at Valley Forge, but spirits lifted when later in 1778 the news arrived that the French had joined the war against Britain. Philadelphia was once more in American hands—that summer the British had shifted their base of operations to New York City—and optimism was rising on the American side.

On Monday evening, January 18, 1779, the Supreme Executive Council of Pennsylvania approved a resolution calling for a Washington portrait. It was to hang in the council's chamber, an expression of confidence in the new nation's military prospects and a celebration of the country's central figure. Mr. Peale was just the man to make the portrait of the General, and the painter chose the Battle of Princeton as the pivotal moment to portray. It had been won at the expense of veteran British regulars, on their terms in an open field, unlike the midnight maneuver at Boston and the surprise attack at Trenton. Peale decided to portray the events in a big picture, one of monumental size to suit the subject. The canvas, fully eight feet tall and five feet wide, would be the first full-length portrait of the man.

This time Peale painted a determined Washington. The vague look of the Virginia gentleman was gone, as was the distracted character of the

1776 Philadelphia portrait for John Hancock. The man in the new image was large-bodied, his head small, but the impression conveyed was of a man very much in possession of himself. His pose wasn't aggressive but full of confident authority. In part, Peale was merely doing what was asked of him, since the resolution that led him to make the painting specified that its purpose was to "perpetuate the memory . . . [of] how much the liberty, safety and happiness of America in general and Pennsylvania in particular is owing to His Excellency General Washington."[29]

The work would also be the making, once and for all, of Charles Willson Peale, Painter. He had gotten the important public commission, of course, but another reason the painting proved to be a show-off moment was that the artist himself had witnessed the battle. Copies of the painting would enable denizens of the Old World to see not only what Washington had done but also what Peale could do. In 1776, the artist had sold a few replicas of the Washington Portrait he painted for Hancock, but in 1779 orders poured in for canvases of Washington at Princeton. French ambassador Gérard purchased one for presentation to Louis XVI, and five copies were ordered to go to the Spanish court. The American envoy bound for Holland took a copy with him. Peale painted at least eighteen replicas, along with a number of three-quarter-length variations.[30] This was Washington, icon of America, suitable for diplomatic use, and to the eighteenth-century European, Peale's image of "His Excellency" portrayed not an upstart revolutionary but the undisputed leader of the new American republic.

The multiple commissions could hardly have come along at a better moment. Peale continued to need money to feed his growing family (Angelica and Raphaelle had been joined by another son, Rembrandt, barely a year old). Charles Willson sent one copy of the big painting on consignment to Spain, entrusting it to William Carmichael, the new chargé d'affaires for the American legation. Carmichael sailed across the Atlantic on the frigate *Aurore* in October 1779, carrying a letter from Peale. "I have directed a long packing case for you which contains a

whole length of Gen. Washington," Peale had written, "begging your favor in putting it into the hands of some person who will sell it on commission."[31] The artist had hoped it would sell quickly "as I am in want of necessaries for painting, and clothing my family."[32] Even when business seemed to be booming, Peale collected no windfall profits; his living was still a portrait-by-portrait affair.

One reason for the international appeal of the painting was Peale's use of what he had learned in London. In his influential *Discourses*, Sir Joshua Reynolds, the president of the Royal Academy, had declared there was no need "to be confined to mere matter[s] of fact"; rather, a painter ought to aim for the classical ideal of perfecting nature. When working in what Reynolds liked to call the "Grand Manner," the artist aimed to represent the nobility and seriousness of human action, as Raphael had done in the sixteenth century and Poussin in the seventeenth. Although the faces of the figures might seem strangely impassive, the artist looked to express in his composition what Johann Joachim Winckelmann, a contemporary who busied himself inventing the discipline of archaeology, termed "noble simplicity" and "calm grandeur."[33]

Peale employed some of the conventions of history painting, which his old master Benjamin West had only recently reinvented when he painted a scene from the French and Indian War in contemporary dress. The tradition held that classical costume—such as the toga in which Peale had dressed his William Pitt—brought order and logic to the conception. As a result, the London painting establishment had been shocked at the unveiling in April 1771 of West's *The Death of General Wolfe*, in which General Wolfe was portrayed in his own British uniform, a brilliant crimson in color, at the Battle of Quebec. Wolfe's prone figure was surrounded by officers at the center of the canvas, all of whom also wore their regimentals. To Peale, the notion of a realistic portrayal of a contemporary figure seemed like received wisdom, an obvious means of serving a hardscrabble new nation that aspired to dignity, honor, and virtue but saw no need for the pretense of dressing up in the costume of an ancient era.

Reynolds had promptly dismissed West's approach as unworthy of an artist's imagination and invention. Ever the pragmatic American, however, West had patiently explained the logic of his painting: "[T]he event . . . commemorated took place on the 18ᵗʰ of September 1758 in a region of the world unknown to the Greeks and at a period of time no such nation and heroes in their costume any longer existed."[34] Even if West had difficulty with the chronology (he was a year off in dating the battle, which took place in 1759), his *The Death of General Wolfe* had been a great sensation, and prints of it became bestsellers.

Following West's lead, Peale decided his George Washington at Princeton was to be more than a portrait. To be certain he got the context just right, in February 1779 Peale "set out on a journey to take perspective Views of Trent[on] & Prince Town." He made sketches of the battlefield terrain and of cannons.[35] Returning to his studio, he added in Nassau Hall, the principal building in Princeton. To one side of the canvas he painted Washington's horse to remind the viewer of Washington's skills as a rider (Thomas Jefferson called him "the best horseman of his age and the most graceful figure that could be seen on horseback").[36] Holding the horse's bridle is William Lee, the General's body servant, who served as both valet and wartime companion. Peale left the canvas untitled, but it was easily distinguished by the mise-en-scène around the tall figure as the Battle of Princeton (it became the prototype for the "Princeton Portrait," thereby distinguishing it from the "Continental Type," like Hancock's, and the 1772 "Virginia Militia Type," like Martha's). Given the events memorialized by the big 1779 canvases, the name was inevitable.

At front and center stands Washington, his hand on a cannon; a second cannon behind the first refers to the victory a week earlier at Trenton. As he painted Washington from life for this commission—in the days between January 20 and February 2, 1779, the General sat for Peale—he brought to bear years of on-again, off-again exposure to his subject. Peale had been to Washington's home, painted him from life at

least three times, and had had intermittent exposure to the General as a soldier and officer in his army, including service during the long winter of 1778 spent at Valley Forge. He had made copies of his own Washington paintings numerous times, producing life-size canvases and miniatures on ivory. Even if Washington never learned to relax for those charged with taking his picture, Peale knew how to give Washington's painted likeness a sense of relaxed power. No doubt it stemmed, in part, from the military confidence that flowed from the big victory at Princeton, an event that even in its own time was a recognizable turning point in the colonials' fortunes on the field of battle. But Peale's knowledge of the man informed his brushwork, too.

The martial figure at center had seen a whirlwind of change in the seven years since Peale first painted Martha's husband at Mount Vernon. His citizenship had changed: He was an American now, no longer a subject of the English king. He had been promoted by the unanimous vote of his peers in the Continental Congress from the rank of a Virginia militia colonel to general and commander in chief. Although his battle-field successes had been outnumbered by the failures, his fellow citizens trusted him as they did no other. On numerous occasions, he had led his men into battle, ignoring the bullets whistling by, winning his soldiers' trust and admiration.

Almost in spite of his elevated status, he had become a man the men of the middling and lower sorts trusted. After the Battle of Trenton, many of his troops were just days from the expiration of their enlistments. The imminent departure of these soldiers to return to their farms and families threatened to thin the already dangerously reduced ranks of his army, and Washington saw that he had to take a direct approach. Only hours before the New England regiments were free to go home, he assembled the troops and spoke to them from horseback. An offer was already before them for a bonus of ten dollars for added weeks of service, but almost no one had been persuaded by the money. Without rhetorical exaggeration—he would never be a man given to passionate speechifying—Washington spoke to his men:

My brave fellows, you have done all I asked you to do, and more than could be reasonably expected; but your country is at stake, your wives, your houses, and all that you hold dear. You have worn yourselves out with the fatigues and hardships, but we know not how to spare you. If you will consent to stay one month longer, you will render that service to the cause of liberty, and to your country, which you probably can never do under any other circumstances.[37]

Washington had found his voice on the banks of the Delaware and nearly all the soldiers fit for duty stepped forward, making the victory at Princeton possible.

As for Peale, his 1779 *The Battle of Princeton* was a high point in his painting career. In the years after the Revolution, he never quite recaptured his preeminence as an artist. Mr. Peale would try out various other roles. He devised patriotic displays to celebrate founding anniversaries. He invented gadgets. He excavated the prehistoric skeletons of two mastodons, which he took on an exhibition tour. In various ways he proved himself one of the first and greatest of American showmen, not least by establishing a museum of natural history and art, which he opened in July 1788. Though originally conceived as a means of displaying his portraits (Washington's among them), Peale's Museum housed collections of natural history specimens (birds outnumbered the fish and quadrupeds), as well as mechanical objects, books, and his paintings. Unlike European museums of the time that aimed to attract the educated and privileged few, Peale's Museum welcomed any member of the general public willing to part with two bits.[38]

Distracted by his many interests, Peale would cease public painting for a time, although he later returned to it. Perhaps the picture that best conjures up the Peale-and-Washington connection isn't a painting at all but an imagined tableau of the painter and the poser. Washington is in the Painter's Chair. Although seated, he somehow overshadows Peale, who, by his own account, was "a thin, spare, pale faced man." But the

sanguine Mr. Peale is doing the talking, his subjects ranging from seeds to saddles (Peale sticks to nonpolitical and nonmilitary subjects, knowing that horses and agricultural innovation are among Washington's delights). He smiles often, and his intelligent banter keeps Washington's attention from drifting. Washington listens and absorbs. He will engage Peale, questioning and probing; but he does so only, as he himself once wrote, after "balancing in my mind and giving the subject the fairest consideration."[39]

These men liked and respected each other. After 1779, Washington would take more turns in Peale's Painter's Chair for portraits taken at the time of his resignation as commander in chief (1783), as the Constitution began to take shape (1787), and as president (1795). Peale painted a great many other men, women, and children of his time; in his most prolific period, the two decades after his return from England in 1769, he made some seven hundred portraits during war, peace, and political upheaval. Many were more revealing of the characters he painted, perhaps, than his Washingtons; his family pictures, in particular, and those of his friends are character studies in which human emotions can be read clearly. Yet his sequence of canvases portraying Washington offers a collective sense of their enigmatic and distant subject. More than any of his portraitists, Peale had the chance to observe the evolution of the planter-colonel who became a general and president.

John Trumbull Takes His Turn

[H]aving a natural taste for drawing, in which he had already made some progress, Colonel Trumbull resolved to cultivate that talent, with the hope of thus binding his name to the great events of the time, by becoming the graphic historiographer of them and of his early comrades. With this view he devoted himself to the study of the art of painting, first in America, and afterwards in Europe.
—John Trumbull, 1832[1]

I.

1780–1781 . . . Tothill Fields Bridewell . . . London

A S O N E O F his fellow prisoners might have advised him, the twenty-four-year-old Mr. Trumbull would have done well to learn how to keep his gob shut. For the proud colonel, however, that was not his way, and his intemperate outburst had assured him his place in prison.

One didn't have to be a Connecticut governor's son to appreciate that the jail was well below John Trumbull's station. Almost fifty years earlier William Hogarth had memorialized Tothill Fields Bridewell in his "Harlot's Progress," a popular series of engravings. Hogarth had illustrated the prostitute Moll, a fallen woman in a crowded cell, making hangman's nooses of hemp at her jailer's command. In the years since, little had changed at Bridewell, although the prison's unsavory

population had ballooned, and the walled edifice had become home to an even larger array of prostitutes, runaway apprentices, and petty criminals.

John Trumbull's crime loomed very much larger. No common felon, he stood accused of nothing less than high treason, a crime punishable by death. As Trumbull saw it, the charge had arrived on November 19, 1780, like "a thunderbolt falling at my feet." A man unknown to him, name of Mr. Bond, had knocked at the door of his London lodgings on George Street, asking for Trumbull by name. Adjudging him a respectable man, Trumbull invited him into his parlor.[2]

Once there, Bond announced, "I have a warrant . . . to secure your person and papers, Mr. Trumbull, for examination." The American, rarely at a loss for words, was dumbstruck.

At his arraignment the following morning, he was ready to defend himself. Despite having spent a night in a room with the door bolted and an armed officer for company, he made an impressive appearance, standing five feet, nine inches tall with a recognizably military bearing from his days in the Continental Army. His treatment as little more than a common criminal offended his sense of propriety—he was, after all, an officer and gentleman—jolting him back to his usual manner. He confronted the three police magistrates who looked down at him at the eleven o'clock court proceeding.

From the dock, he addressed them heatedly. "You appear to have been much more habituated to the society of highwaymen and pickpockets, than to that of gentlemen," he told them. "I will put an end to all this insolent folly, by telling you frankly who and what I am. I am an American—my name is Trumbull; I am a son of him whom you call the rebel governor of Connecticut; I have served in the rebel American army; I have had the honor of being an aid-du-camp to him whom you call the rebel General Washington.

"These two," he continued, his anger still carrying him, "have always in their power a greater number of your friends, prisoners, than you

of theirs . . . I am entirely in your power; and after the hint which I have given you, treat me as you please, always remembering that as I may be treated, so will your friends in America be treated by mine."

Whatever temporary effect his rebuke had (to Trumbull, his treatment thereafter seemed more respectful) it was insufficient to secure his release, and the bench issued a warrant of commitment. Months after the arrest, here at Bridewell, he remained a prisoner, his fate uncertain, despite the fact that his crime consisted of nothing more than having been a partisan of the American cause.

When Trumbull arrived at Tothill Fields, his manner and his ready cash had served him well. Mr. Smith, the keeper of the prison, recognized a gentleman when he saw one, having himself once been butler to the Duke of Northumberland. Eager to extend a genteel civility to a paying prisoner, whatever his crimes, Mr. Smith agreed to rent the American a room in his own house, which stood within the walls of the prison. It was a spacious parlor room some twenty feet square. As Trumbull noted, "The room was neatly furnished, and had a handsome bureau [folding] bed." For a guinea a week, he lived comfortably, with the freedom to take daylight walks in a "pretty little garden."

Despite the creature comforts, there was no denying he remained a prisoner. The two windows in his cell looked out upon the prison yard and, at night, Mr. Smith locked and bolted the door, leaving the American to muse on his unfortunate timing. Just days before his arrest and his incriminating outburst, word had reached London of the execution in New York of the British officer Major John André as a spy in connection with Benedict Arnold's treachery; for some loyal British subjects, the execution of Trumbull would have seemed a perfect symmetry. Trumbull knew full well he had been less than circumspect in his conversations, and in his captured correspondence his words betrayed a warmth "to the cause of America" that his captors regarded as evidence of treasonous intent.[3]

There was also the matter of his military service back in the colonies.

As a man supremely confident of his own rectitude, he would hardly have denied his association with General George Washington five years earlier, in the months before the big victory at Boston.

II.

Summer 1775 . . . Roxbury, Massachusetts

THE GENERAL DESPERATELY needed to learn the topography. A trained surveyor, he trusted maps, having grown accustomed to taking the measure of a place. In his new posting in coastal Massachusetts, with British-occupied Boston frustratingly near at hand, Washington could only peer through his spyglass at the unfamiliar city on its peninsula in Boston harbor. Most of the surrounding mainland was under his control, but the British warships in the tidal waters of the harbor and the River Charles meant he could get no closer to the city itself than the headlands across the bay.

On his arrival earlier in the month to take charge of the army, Washington inherited a stalemate. After losing more than a thousand men in the battle at Breed's Hill and Bunker Hill in June, British commanders demonstrated little appetite for assaulting an entrenched colonial force. For his part, Washington was wary of confronting the British military—he had been one of them, not so many years earlier—and he knew almost nothing of his own enthusiastic band of irregulars. Most of them were New England country boys with little training. For the moment, then, he would seek to understand the lay of the land.

He wished to know in particular all he could about the fortifications that protected Boston Neck, the narrow spit that linked the city to the mainland like the handle of a serving spoon. John Trumbull, just nineteen but already a graduate of Harvard, learned of the commander in chief's desire from the commissary general (who happened also to be his brother, Joseph). The ambitious adjutant recognized his chance to

ingratiate himself with George Washington, hoping that producing a chart would prove "a mean[s] of introducing myself (probably) to the favorable notice of the general."

From the Roxbury line, where his Connecticut regiment was encamped, Trumbull made his way to the shoreline, creeping like a cat "under the concealment of high grass" to a lookout within firing range of the British. Unseen, he got close enough to study the disposition of the British defense and to count the guns mounted on the bastion facing his position. He returned to camp and prepared a drawing of what he had seen.

Trumbull delivered his map into Washington's hands only to find it had already become redundant. The General nevertheless went to the trouble of looking with care at young Trumbull's sketch. He compared it with the crude plan of the entire installation that a British deserter had just provided. Washington recognized the accuracy of Trumbull's work, and the handsome, soft-spoken governor's son standing before him made a good impression. The General Orders for July 27, 1775, reflected his approval, recording the appointment of "John Trumbull Esqr" as "aid de Camp to his Excellency the Commander in Chief."

With a young man's fervor, Trumbull had desired just such an appointment. He found it surprising when, as the newest member of Washington's military family, he was intimidated by life at Vassall House. Even with rough-and-tumble infantrymen bivouacked all over the neighborhood, the royalist residence that had been commandeered by the Colonial Army after the battles at Lexington and Concord bespoke wealth and style unfamiliar to Trumbull. His father was indeed governor of Connecticut (Jonathan Trumbull was the only colonial governor to remain in office and support the Patriot cause after independence), but the family fortunes had plummeted a decade earlier when four ships in which the Trumbulls had invested were lost at sea, taking their crews and cargoes to the bottom. In Washington's Cambridge house, John Trumbull encountered many "of the first people of the country," officers,

merchants, and politicians who came to dine with the General. A vain man, the youthful Trumbull felt self-conscious in such august company, not least because he plainly lacked the resources to dress as others did. He soon decided he was "unequal to the *elegant* duties of [his] situation," and, when promoted to major that August, he departed headquarters with few regrets to assume command of a brigade at Roxbury.[4]

A few months later, Trumbull and his men helped occupy Dorchester Heights and watched the outmaneuvered British from their perch over-looking the harbor. "Within a few days the enemy abandoned Boston," he wrote, "and we entered it on St. Patrick's day, the 17th of March."[5] Later that year, he was made a colonel at just twenty years of age and served with distinction in a military campaign that took him to Lake Champlain and Fort Ticonderoga. Then a fit of temper overcame him when the formal commission from Congress confirming his appoint-ment as a colonel arrived. It bore a date three months after he had been granted a field commission, and the angry Trumbull promptly resigned.

"Thus ended my regular military service," Trumbull would write.[6] That left him free to resume his pursuit of another goal—to become an artist—and chase it he would. But his encounter with his commander in chief during the siege of Boston would remain with him, a proud memory—and a lingering danger.

III.

Winter 1781 . . . Tothill Fields Bridewell . . . London

THE TALL MAN, his reddish brown hair unkempt, strode across the prison yard. His broad frame and angular features gave him the appearance of purpose and power. Yet when he spied Trumbull peering out at him through the bars on his window, his intensity gave way, as it often did, to his fondness for a bon mot. It was irresistible, really. How could he not address his friend by the nickname he had just conceived? In the visitor's mind, John Trumbull had become *Bridewell Jack*.

At first Trumbull couldn't quite bring himself to think the name "Bridewell Jack" remarkably funny. On the other hand, he knew full well that one had to take his friend Gibby as he was, foibles and all. The man drank too much, was profligate with his money, habitually used snuff, and wore his irreverence like an officer wore his uniform sash. Who else would dare to refer to the big, dramatic historical paintings of their mutual benefactor, Benjamin West, as "*ten-acre* pictures"?[7] To amuse himself and those around him was his way, and, infuriating as he could be, Gilbert Stuart had become Trumbull's stalwart friend. He was impossible to dislike.

As usual, Gibby brought news and gossip, but this day, he brought an idea as well. Stuart was determined to take Trumbull's portrait. It would amuse both of them, the expatriate Rhode Islander decided, for him to record the imprisoned Connecticut Yankee on canvas.

They had known each other a few months, just since Trumbull had knocked on the door of the Newman Street studio the previous summer. Like Charles Willson Peale, Stuart, and other aspiring American painters before them, Trumbull had inevitably made his way to the large house of Benjamin West on coming to England. As the most accomplished American painter of the era—he had been appointed history painter to the court and completed a portrait of King George III only the previous year—West welcomed other Americans, giving them the run of his two towering Painting Rooms as well as the sculpture garden and the gallery at the rear of the house. The older painter made himself available in the morning to his protégés, advising them on their work. Either he or one of his students would instruct newcomers in the proper procedures for preparing a canvas, grinding and mixing pigments, and laying out a palette. The pupils who sought him out stayed for periods ranging from a few days to several years, but West consistently encouraged them not to imitate him but rather to follow the tilts of their own talents. Unlike Joshua Reynolds, West was open with his students, who found him accessible. "He had no secrets or mysteries," remembered one, "he told all he knew."[8]

West had assigned Stuart to show Trumbull where "to find the necessary colors, Tools, &c," and the two younger men painted together in the same Painting Room.[9] Stuart had arrived in the city more than four years earlier and his familiarity with London helped Trumbull's adjustment to what seemed to his colonial eye a vast metropolis. His easy manner counterbalanced Trumbull's nervous stiffness.

The two friends had been inconvenienced by Trumbull's legal difficulties. They were no longer the lighthearted jokesters in West's studios, and to perform the flute duets they so enjoyed, Stuart was required to visit his incarcerated friend. But Trumbull's life was hardly one of deprivation. He purchased his breakfast and dinner from a nearby public house, drawing upon his own funds. He gave his two-penny-a-day allowance from his jailers to the turnkey, who brushed his hat, cleaned his shoes, and tended his clothes.

His jailer permitted Trumbull to practice his art in his cell. That meant materials were at hand for a portrait. A prepared canvas, roughly two feet wide, two and a half feet high, was duly set upon the easel. Trumbull assumed the unaccustomed role of sitter for the more experienced man. Stuart, who was already winning Londoners' admiration as a maker of fashionable portraits, picked up his brush and went to work.

———

ALTHOUGH HE WAS new to the great city of London, John Trumbull's artistic desires were of long standing. At age fifteen, he had begged to be apprenticed to John Singleton Copley in Boston, but his father had summarily rejected the idea. The lad was told that, as his brothers and father had done, he would enroll at Harvard. The day before the admission test at Cambridge, temptation was dangled before him when one of his brothers arranged an audience with Copley at the artist's fine house overlooking Boston Common.

The visit was brief, but the youngest of the Trumbull brood left Beacon Street deeply impressed. He long cherished the dual memory of

"[Mr. Copley's] dress and appearance—an elegant looking man, dressed in a fine maroon cloth, with gilt buttons—this was dazzling to my unpracticed eye! [and] his paintings, the first I had ever seen deserving the name, [which] riveted, absorbed my attention, and renewed all my desire to enter upon such a pursuit."[10]

Across the river in Cambridge, Trumbull was admitted the following day as a junior. As a Harvard student, he studied moral philosophy as well as natural philosophy (as mathematics and the sciences were then identified). He had arrived so proficient in Latin and Greek that he sought out a French-speaking family in the neighborhood and obtained instruction in that language, too. He continued to find time, as one of his tutors reported to his father, to exercise his "natural genius and disposition for limning . . . an art I have frequently told him will be of no use to him."[11] From Harvard's library, he charged out volumes on perspective, painting technique, and aesthetics. He found engravings to copy and even showed one such imitation to Copley, who admired it. As if to return the compliment, Trumbull studied works of Copley's that were in the "philosophical chamber" at Harvard.

After earning his degree, he worked for a time as a schoolmaster back in Connecticut, but with revolution in the air, the young man soon joined his state's First Regiment, which took him to Boston and his term of service in the army.

Upon his resignation from the military in 1777, he returned for a time to the family home in Lebanon, Connecticut, where he resumed painting. His family continued to exert pressure on him to pursue something more important than art. Undeterred, he produced portraits of relatives, friends, and even himself. He tried his hand at history painting, too, on canvases portraying biblical, mythological, and classical personages such as Elisha and Brutus. These varied experiments helped him realize how much he had yet to learn. His figures were ill-proportioned, their eyes too big. His canvases lacked a sense of depth, sharing more with the dry, flattened character of the engravings he was

copying than with Copley's richly detailed paintings. That man, from whom he might have learned the most, was now gone (Copley had sailed for England in 1774), but Trumbull moved to Boston, hoping to find instruction and perhaps a few painting commissions. Once there, he took his turn at Mr. Smibert's.

He found the Painting Room on Queen Street a ready-made artist's milieu (he paid as rent for Smibert's "Chamber" the sum of £61.6. "in Old Emission Currency"). He made copies of the Old Master paintings, including van Dyck's *Cardinal Bentivoglio*, Raphael's *Madonna della Sedia*, and Poussin's *Continence of Scipio*. He made drawings from life. Given access to the art collection of the wealthy merchant John Hancock, he even painted a "Half length portrait of Washington," a copy of the portrait Charles Willson Peale had painted for Hancock, then president of the Continental Congress, in the summer of 1776.

His time in Boston produced other dividends. He dabbled in the family merchant business during those months, buying and selling commodities and investing in three shipping vessels. His investments proved profitable, and he used some of the proceeds to purchase a number of Smibert canvases. Whatever social inferiority he had felt at Washington's Vassall House headquarters was gradually forgotten as he gained membership in an informal circle of Harvard alumni. Trumbull, now aged twenty-three, had attained a new maturity; he felt at ease with these up-and-coming gentlemen, men possessed of aspirations to power and influence in politics, law, diplomacy, or other professions. Trumbull's rooms became their meeting place, and there he painted their portraits and engaged the young aristocrats in conversation.

By the fall of 1779, he reached a new resolve: He would travel abroad. The combination of his modest success in trade and the pressure exerted by his friends and family finally persuaded Trumbull, as he put it, "to undertake the management of a considerable speculation, which required a voyage to Europe, and promised (upon paper) great results." Another Boston friend had obtained assurances from the British foreign

secretary that, despite the state of war, Trumbull might study art in England, as long as he avoided the taint of politics. So the artist-merchant sailed across the Atlantic, bound first for France, with two goals in mind. First would be his "mercantile project"; should that prove a failure, he acknowledged, it would leave "the road . . . open for pursuing my study of the arts."[12]

———

TRY AS HE might, Gilbert Stuart was having little success in capturing his imprisoned friend Trumbull on the canvas. He prided himself on his gift for entertaining his sitters with his anecdotes, but the spirits of the man sitting opposite him seemed quite earthbound, entirely unavailable to his most imaginative flights of conversational fancy. That meant the face emerging ever so slowly lacked expression, and the eyes had a dim and faraway look. Gone were the bracing enthusiasm and seriousness Trumbull had brought to West's studio on his arrival the previous summer.

Stuart was unaccustomed to finding it so difficult to spark a sitter's interest. After all, he had no trouble in casting Trumbull's circumstances in a warm and optimistic light. His friend still hadn't been formally charged, and, although he was confined, his quarters were comfortable and spacious enough to enable him to work. When not posing, Trumbull worked at the easel, and he was progressing nicely on his copy of Benjamin West's own copy of Correggio's *Saint Jerome at Parma*. His life was hardly solitary, as he had numerous guests. Things really could be a great deal worse.

Stuart also knew very well that there is no substitute for having friends in high places, and even Trumbull had to admit he had his share here in Europe. To start with, there was Benjamin Franklin. Trumbull had made his wartime crossing of the Atlantic on a French ship, *La Négresse*. Almost as soon as he stepped ashore in France, he had discovered that his commercial venture was doomed, since news of the British

capture of Charleston, South Carolina, had led to a precipitous decline in the valuation of his American securities. So Trumbull had resorted to his backup plan of finding proper instruction in painting. He sought out Benjamin Franklin, minister plenipotentiary to France, who provided him with a letter of reference to another highly placed American, namely, Benjamin West.

Stuart had been at hand when Trumbull arrived at West's studio and witnessed the great painter's open-armed hospitality, the same welcome with which Stuart had been greeted two years earlier. His European mission being mercantile in nature, Trumbull had arrived without portfolio. West set him to work to make a "specimen" painting. Trumbull chose a small roundel of a mother and two children to copy. Unbeknownst to him, it was a copy of a work by Raphael, and West was immediately impressed with his new pupil's taste. Stuart had helped settle the stranger into the well-equipped studio, and he watched Trumbull's progress. When the copy was finished, West examined it with care and declared, "Mr. Trumbull, I have no hesitation to say that nature intended you for a painter."[13] By then, the two younger men were friends, and Trumbull was settling into his new place, preparing to learn both from his new master and from Stuart, who worked at the next easel. Just weeks later, his arrest abruptly interrupted his tutelage.

Upon learning of his student's imprisonment, West had sought an audience with King George III. He hurried to Buckingham House, concerned for his own status as the king's history painter and for the life of his young countryman. He soon received assurances on both counts, though the king would not agree to intervene and order Trumbull's release. Someone else would have to be found to plead his case, but as he worked on his portrait of Trumbull, Stuart knew that a powerful Parliamentarian named Charles James Fox was sympathetic and had already been to visit Trumbull. Though Fox's Whig party was out of power, as part of the loyal opposition to Prime Minister Lord North the man still carried wide influence. Yet, for all John Trumbull knew, he might re-

main "Bridewell Jack" indefinitely, and his hours of solitude in his prison room allowed him to contemplate the paradoxes of his own character. He was a man who seemed forever in conflict with himself, always looking to balance the competing impulses of his sense of duty and his artistic sensibility, even as he wrestled with the rectitude of his patrician upbringing and his native curiosity.

The dull-eyed, long-nosed, and expressionless sitter before Gilbert Stuart displayed such sullenness that, after a week of on-again, off-again attempts to capture the character of his Connecticut friend, Stuart decided to give it up. As Trumbull explained, he "could make nothing of my damn'd sallow face."[14]

IV.

July 1781 . . . The Manse De Neufville . . . Amsterdam

TRUMBULL'S SENSE OF relief at his release must have been palpable. In the comfortable confines of his new accommodations, he could peacefully contemplate his first twenty-five years. In a life already full of incident, he had tried on the roles of *scholar, teacher, soldier, merchant, painter,* and *prisoner.* At this moment, however, the description he cherished above all was his most recent. Once again, he had become a *free man.*

His release had come about after Trumbull wrote to Charles Fox's fellow Whig, Edmund Burke, saying, "I am ignominiously imprisoned as a felon."[15] Burke was already sympathetic to the American cause (from the floor of Parliament he had repeatedly gone on record as a harsh critic of the war), and he turned up at Bridewell a few days later. After agreeing to take Trumbull's side, he negotiated a deal for the American's release. The king would order Trumbull freed if, in return, the painter promised to leave England within thirty days and not to return until the war was over. Trumbull accepted the offer and promptly paid the £400

surety (£100 came from West, £100 from the coffers of John Singleton Copley, and Trumbull was able to raise the rest). Soon after he settled his bill for room and board at Bridewell, Trumbull traveled to Kent and there boarded a ship in the port town of Deal to cross the Strait of Dover, heading for Amsterdam.

"Immediately on my arrival here Mr. De Neufville invited me to his house," Trumbull wrote to his father, "where I am at present very hospitably and elegantly entertained." The De Neufvilles, proprietors of the banking house John De Neufville & Son, had presented him on arrival with letters from Governor Trumbull, who hoped his son would be able to secure a loan in Amsterdam on behalf of the state of Connecticut. Though politically disposed to the American side, the Dutch bankers refused the request out of concerns over wartime uncertainties. On a more modest scale, they did agree to provide the young American with the sum of £100, enabling him to contemplate his homeward journey, as he reported to his father, "without the necessity of being under obligations to any person in England."[16]

—

THOUGH THE DE NEUFVILLES gave him money, of far greater import than a mere £100 was the presence of what was undoubtedly the most important painting of Trumbull's young career. Trumbull had arranged to get this, his first portrait of Washington, out of England and into the hands of his Dutch friends. Executed in London the previous autumn, this canvas would be the basis for the first prints made from his work. The meticulously executed mezzotint version of the painting would both establish Trumbull's reputation and, for the first time, make the face of America's most essential man recognizable to many Europeans.

Despite the absence of a sitter, Trumbull had painted the likeness of the General soon after his arrival in England the previous year. He worked from memory, but as Washington's former aide-de-camp, Trum-

bull had clear recollections of his subject. He had observed him on horseback, at his spyglass, and dictating letters to his clerks. Trumbull had dined at his table and joined the General and his officers in conference. Not only were the man's visage, carriage, and demeanor well known to him, he had earlier made a practice copy of Peale's 1776 portrait of Washington, the one painted at Hancock's behest. In the De Neufville *George Washington*, one could see a bit of Peale as well as signs of the emerging Trumbull.

The canvas was of medium size—three feet high, twenty-eight inches in width—with the full-length figure of the statuesque General George Washington at its center. Once more his body servant, William Lee, stands behind him, his hand on the mane of the General's large chestnut horse. Even if the formula was new to Trumbull, he was coming to know something of the conventions of British portraiture. The arrangement of the elements—the hero, his turbaned groom, the horse, all set in a deeper landscape—was popular in London at the time.[17] Despite the contrived pose, Washington's posture and his direct gaze give him a look of serene confidence. The meticulous details of the uniform—its buff and deep blue fabrics are highlighted by gold braid—add to the sense that the man portrayed is cool despite the battle raging below.

Even as Trumbull had waited in prison, the painting had been in the London shop of Valentine Green. The mezzotint engraving Green produced was inscribed, "Painted by J. Trumbull, Esq. of Connecticut 1780. Engraved by V. Green, Mezzotinto, Capital Engraver to His Majesty." The Green engraving proved popular, as many Europeans were curious about the man who led the Americans. Another mezzotint of Trumbull's painting was produced in Brussels later that year, followed by other editions published in Dublin, London, and Paris.[18] Trumbull profited little from the exploitation of his work, which soon included frontispieces in books and even the appearance of his Washington likeness on cotton fabric used for bed-curtains.

The De Neufville *George Washington* would prove to be the sort of

painting Trumbull did best. It wasn't too big: Benjamin West, in fact, had imposed an "injunction" on the size of canvas Trumbull was to attempt based on the younger painter's physical limitations. Stuart had once remarked of a Trumbull painting, "Why, Trumbull, this looks as though it was drawn by a man with one eye"—and, indeed, it had been.[19] Trumbull had lost virtually all the vision in one eye in a childhood accident, a tumble down a flight of stairs at age five. His monocular vision meant that this one-eyed Jack would be better off painting small pictures than big ones.

—

JOHN TRUMBULL'S RETURN trip to America proved nightmarishly long. The crossing took more than double the usual time. Gale winds blew the frigate on which he sailed into the North Sea, and Trumbull sketched seascapes at such unexpected destinations as the Shetland Islands and, later, Bilbao, Spain. A full six months passed before Trumbull once again set foot on American soil in January 1782, and during his extended sea journey, the deciding battle of the war had been fought at Yorktown. Even as treaty negotiations got under way across the Atlantic, Trumbull arrived in New York with little to show for his first European journey, his business ventures having come to nothing. As for his painting, he had been dragged off to Bridewell almost as soon as he had settled into West's studio.

Though greeted by a nor'easter that blocked the roads with snow, Trumbull remembered, "I returned to Lebanon, as soon as possible, and occupied myself with closing all accounts respecting my unfortunate mercantile experiments. My recollections were painful—I had thrown away two of the most precious years of life—had encountered many dangers, and suffered many inconveniences, to no purpose. I was seized with a serious illness, which confined me to my bed, and endangered my life; and it was autumn before I had recovered strength sufficient to attempt any occupation."[20] The man's sense of divided allegiance, as it so

often would, had left him with a sense of frustration. He had fallen short of accomplishing his goals as both merchant and painter. That said, he did return with one public painting to his credit that would prove a key source of propaganda, a secret weapon of an oddly public sort. Trumbull had left his Washington portrait in the hands of Valentine Green, and the original canvas had made its way to Trumbull's first patron, the banker De Neufville. Admittedly, Mr. Trumbull was but one unarmed man who assaulted his enemy with nothing more than a graven image. But pictures, especially those of inspiring men such as General Washington, can have surprising power.

"The Finest Statuary of the World"

Mr. Houdon . . . comes now for the purpose of lending the aid of his art to transmit you to posterity.
—*Thomas Jefferson, writing to George Washington, July 10, 1785*

I.

September 14, 1785 . . . Aboard Ship . . . The Delaware River

EVEN AS HE emerged from a deep sleep, Jean-Antoine Houdon knew in an instant where he was. Far from his Paris atelier in the Bibliothèque du Roi, the Frenchman floated toward consciousness in a world of constant motion. In the blink of an eye, he recognized the familiar but cramped quarters below decks on the *London Packet*.

Just two days before, sailors and passengers alike had welcomed the sight of land at the horizon. Although the weather had favored the travelers for most of the transatlantic crossing, one violent wind had torn the foresail from its stays, sending it to the deck with a violent crash. Now, with Philadelphia close by, Monsieur Houdon anticipated tying up at the quay, bringing to a close the longest leg of his trip, a seven-week crossing

from Southampton. A shorter, overland journey by stage would follow, one that would take him to Virginia, where his new challenge awaited him.

Once on deck, Houdon made an amusing sight. Aged forty-four years and short of stature, he looked more like a scamp in a Molière comedy than a man accustomed to the company of the nobility. His eyes were set deep beneath a tall, protruding brow, and he wore neither wig nor powder. His motley clothes were not of his choosing, consisting of a shirt, breeches, and stockings loaned to him by fellow passengers. He had come aboard carrying only his *sacs de nuit* (overnight needs), though his journey had begun with vastly more baggage.

In July he and three assistants assembled 128 cases, bales, boxes, hampers, casks, and baskets on the Paris riverside. With his clothes, tools, and other goods readied to float down the Seine on a barge loaded with freight, Houdon had mounted a *diligence* (stagecoach) bound for the port of Le Havre. From there the four men sailed to Southampton, making a disagreeable two-day crossing of the English Channel during which winds and rain buffeted the ship, producing an epidemic of seasickness among the passengers. The baggage failed to catch up with his party by July 28, when the *London Packet* sailed for America at 5:00 A.M.

Forty-eight days later, Houdon surveyed the calm waters of the Delaware River. He expected no difficulty in finding a tailor, hatter, and shoemaker upon reaching shore, but if dressing himself and his attendants seemed a simple matter, he could not help but wonder whether other missing items might be more difficult to replace in America. He needed the tools of his art, the calipers, brushes, chisels, spatulas, hawks, scrapers, clay cutters, gouges, knives, molds, bowls, and other modeling and mixing tools, as well as sculptor's clay and casting plaster. He could only hope that the shops of Philadelphia, in a land where the art of sculpture was little known, would have all that he wanted. But America's largest metropolis, the city on the bluff ahead, looked to the worldly Parisian like a provincial place.

A modest, plain-spoken man, Houdon had risen far above his origins to reach the pinnacle of his profession. Born the son of a *domestique* in 1741, Houdon had benefitted from an unexpected turn of fate when his father had become concierge at the École Royale des élèves protégés, the Paris preparatory school linked with the French Academy in Rome. Scraps of sculptor sticks and modeling clay became eight-year-old Jean-Antoine's toys; making recognizable shapes out of them became his preoccupation. Engaged by what he saw at the school and encouraged by the artists who peopled this world, he earned himself an official place at the school by the time he turned fifteen. Thereafter his student work regularly won prizes, culminating in the Prix de Rome fellowship to the French Academy in Rome in 1764.

In early manhood, he produced sculptures on grand historical and mythological themes, but at age thirty he had begun the work that brought him wide renown. The first of his many busts of great men was a portrait of encyclopedist Denis Diderot, exhibited at the Paris Salon of 1771. A full member of the Royal Academy of Painting and Sculpture by 1777, Houdon counted among his patrons members of the French and German nobility, as well as Catherine the Great of Russia.

Houdon arrived as a head-hunter, a *bustier*, having made the Atlantic journey to take a bust of a new and different kind of aristocrat. For nearly a year he anticipated arriving at the plantation home of the mysterious man—a farmer, really, and a retired soldier—and that rare personage who engaged the curiosity of Europe beyond other men. Described by a contemporary as being "above all modern artists," Houdon hoped to capture in his sculpture the essential genius of the enigmatic man who had helped reshape the world.[1]

⸺

GENERAL GEORGE WASHINGTON had led his country to victory at the last major military conflict of the war, the Battle of Yorktown. Virginia's favorite son had marched his combined American and French

troops to Virginia from his base in New York. Together with troops already in Virginia and the French fleet that arrived to control the Chesapeake, they surrounded British commander Lord Cornwallis and his men. After a three-week siege, the British had surrendered on October 19, 1781. At the time almost no one recognized the significance of the events at Yorktown, but in the months that followed the British evacuated Charleston, South Carolina, and on September 3, 1783, the Treaty of Paris was signed, formally acknowledging the independence of the United States of America.

One of the signatories to that document, Benjamin Franklin, joined Jean-Antoine Houdon on the voyage to America in 1785. The previous year Virginia's General Assembly had resolved "to take measures for procuring a statue of General Washington, to be of the finest marble and the best workmanship."[2] Since no American sculptor possessed the skills to fulfill such a commission, Governor Benjamin Harrison deputized his predecessor, Thomas Jefferson, to select the right man for the assignment.

The task of finding a sculptor and acting as Virginia's commissioning agent suited Jefferson. He consulted Franklin, the man he was succeeding as the American Minister to the Court of Louis XVI, and soon wrote to tell Harrison of their choice. "There could be no question raised as to the Sculptor who should be employed, the reputation of Mons. Houdon of this city, being unrivalled in Europe."[3] Jefferson wrote to Washington, too, at Mount Vernon, to assure the General that Houdon was "the finest statuary of the world."[4]

While awaiting Jefferson's reply—an exchange of letters between Europe and America typically required several months to cross and re-cross the Atlantic—Governor Harrison had asked Charles Willson Peale "to draw a full-length picture of [Washington] immediately, and, as soon as it is sufficiently dry, to have it packed up in the most secure manner and shipped in the first ship bound for France to the address of the hon[ora]ble Thomas Jefferson." Peale's previous experience in painting the General from life enabled him to dispatch the requested canvas

in short order, along with his bill for thirty guineas. Of his own initiative, the ever-expansive Peale added a scene in the foreground from the decisive Battle of Yorktown. It featured, explained Peale, "French and American officers with their colors *displayed*, and between them the British with their colors *cased*." He thought the battle view might be useful "if any pieces of history are to be made in bas-relief on the pedestal of the Statue."[5]

In France, neither the likeness of the man nor the battle scene proved to be what the sculptor needed. Houdon condescended to tell Jefferson that a sculpture "cannot be perfectly done from a picture." Previously ignorant of the art of sculpture, Jefferson came to understand Houdon's refusal to work from Peale's portrait. As he explained to his Virginia colleagues, "On conversing with [Houdon], Dr. Franklin and myself became satisfied that no statue could be executed so as to obtain the approbation of those to whom the figure of the original is known . . . Statues are made every day from portraits; but if the person be living they are always condemned by those who know him for want of resemblance."[6]

Though he dismissed the painting, Houdon expressed his eagerness to make the sculpture. The men negotiated a fee of 25,000 livres (equivalent to a thousand English guineas or five thousand dollars), plus expenses and a life insurance policy of 10,000 livres. Houdon would travel to Mount Vernon, where, as Jefferson put it, he would "take the true figure by actual inspection and mensuration." After visiting Mount Vernon, Houdon was to return to his Paris studio, where, it was agreed, three years would be required to execute a full-size, standing figure in marble for the Virginia State Capitol.[7]

On that brisk, clear October morning, Franklin made one final entry in his travel diary before emerging from below decks to see his "dear Philadelphia" for the first time in almost a decade. As the *London Packet* approached the busy city, Franklin knew this would be his last homecoming. At seventy-nine, he had passed much of the voyage in his cabin.

His party, which included two grandsons, Benny and Temple, and a grandnephew, Jonathan Williams Jr., had occupied all of the ship's "elegant and convenient accommodations."[8] During the trip, the old man reveled in his newfound leisure—the weight of his diplomatic duties had been lifted with the responsibilities left in Mr. Jefferson's capable hands—and he happily returned to the practice of science. One of America's foremost natural philosophers, he picked up where he left off nine years earlier on his last transatlantic voyage, his passage to France in 1776. With his grandnephew taking daily readings of the wind, air and water temperature, latitude, and longitude, Franklin incorporated the findings into a learned paper titled *Maritime Observations*. He also completed two other treatises during the voyage, *On the Causes and Cure of Smoky Chimneys* and *Description of a New Stove for Burning of Pitcoal*. Though his aging body grew infirm, Franklin remained curious, his mind sharp.

Despite seeing little of him during the voyage, Houdon knew Franklin's physiognomy well. The American had stood out from what he called "the powdered heads of Paris."[9] With his plain Quaker clothes, thinning gray hair, omnipresent spectacles, and fur cap, Franklin had been a popular figure in the city's salons, an admired eccentric often seen in drawings, paintings, and pastels. His likeness had been widely published in engravings and mezzotints, his miniature portraits reproduced in rings, snuffboxes, and clocks. Monsieur Houdon himself had joined the parade of artists who recorded Franklin, producing a bust that had gone on view in his studio in 1778. Though both were members of the same Masonic lodge, the men had not formally met at the time (Houdon worked from published prints and sightings of the famous Dr. Franklin).[10] Even so, Houdon's terra-cotta bust of the memorable American had been much admired at the Paris Salon of 1779.

Word of Franklin's return preceded him, and as the ship entered the harbor, a gathering crowd on the Market Street wharf came into view. Houses were hung with flags—even England's—and as the *London*

Packet drew closer, cannons were fired and bells rung. The people's *huz-zahs* soon became audible.

In the tumult surrounding the grand welcome extended to Dr. Frank-lin, Monsieur Houdon, a fellow of unremarkable appearance dressed in other people's clothing, became the forgotten man. While Franklin's friends and family welcomed him home with tears and cheers, the most celebrated sculptor in the world, the first artist of international note to cross the Atlantic, stepped onto American soil almost entirely unno-ticed.

II.

October 1785 . . . The Mansion House . . . Mount Vernon

A SEPTEMBER LETTER from Franklin had advised Wash-ington that Houdon planned to travel south after reequipping himself. Thus prompted, the General wrote by return mail to the sculp-tor: "I wish the object of your mission had been more worthy of the masterly genius of the first statuary in Europe: for thus you are repre-sented to me. It will give me pleasure, Sir, to welcome you to the seat of my retirement, and whatever I have and can procure that is necessary for purposes or convenient to your wishes, you must freely command."[11]

Washington's custom was to retire at nine o'clock, but it was much later that Sunday night when the barking of dogs and a household commotion on the first floor woke him. "After we were in bed (about eleven o'clock in the evening)," Washington noted in his diary, "Mr. Houdon . . . and three young men assistants, introduced by a Mr. Perin, a French gentleman of Alexandria, arrived here by water from the lat-ter place."[12]

Houdon spoke little English, so Joseph Marie Perrin, a merchant and storekeeper who ran a store opposite the Alexandria courthouse, was enlisted as translator. Soon Houdon and Perrin, along with the three

élèves (Houdon's student assistants, two young Frenchmen and an Italian lad named Micheli), were shown to their quarters. Then the Washingtons and their other visitors, who included a variety of family members, several friends, and two clergymen, settled down once again for the night.

In the morning Houdon produced a letter of reference from the Marquis de Lafayette. A decade earlier, the nineteen-year-old French aristocrat had outfitted a ship, *La Victoire*, at his own expense and sailed to America in support of the American cause. A captain in the French dragoons, the marquis brought valuable military training, but the friendship that developed between him and Washington went well beyond their military bond. Although a devoted stepfather, Washington had no children of his own. Lafayette had lost his father on the battlefield before the boy turned two. A fond friendship developed, as Washington and Lafayette came to regard each other as father and son.

The marquis had become well acquainted with Houdon a few months before when the sculptor had been commissioned to make a bust of him, and the unfinished marble awaited the artist's return to his Paris workshop. Lafayette wrote of Houdon, "Nothing but the love of glory and his respect for you could induce him to cross the seas." Yet Washington's feelings about the artist's presence in his house remained mixed. In truth, his attitude toward each of the string of artists who came to him ranged from philosophical acceptance to irritation and impatience. The imposing Virginian had long ago grown accustomed to public attention—whenever he walked into a room, raised his sword in battle, or simply stepped from a carriage, all eyes seemed drawn to him. He felt obliged to accede to artists' requests for sittings, but he retained a strong dislike for having his picture taken.

For three days after Houdon's arrival at Mount Vernon, mild autumn temperatures and the faultless Virginia skies enabled the self-effacing artist to follow in his subject's wake, while the older man (Washington was a hearty fifty-three) went about the business of managing his

plantation. Aside from the temporary presence of the unfamiliar French artist with whom he could communicate only with difficulty, Washington's circumstances at Mount Vernon brought him genuine joy. He had come home after eight-and-a-half-years of war, during which he had spent less than two weeks on the land he loved. When at last he was able to return to civilian life, after the English evacuation of New York, the General had resigned his commission as commander in chief in Annapolis, climbed onto his horse, and galloped home.

He reached Mount Vernon on Christmas Eve 1783, firm in his resolve to stay there. "At length my Dear Marquis I am become a private citizen," he had written to Lafayette, "under the shadow of my own Vine and my own Figtree free from the bustle of a camp & the busy scenes of public life . . . I shall be able to view the solitary walks, & tread the paths of private life with heartfelt satisfaction . . . until I sleep with my Fathers."[13]

A demanding taskmaster, the squire of Mount Vernon monitored work on his estate. The day before Houdon's arrival a crew of carpenters had raised scaffolding over the front door of the Mansion House, preparing to reshingle a portion of the roof and install copper guttering. A landscaping project was under way, with slaves working to smooth the earth in front of the house into a lawn that Washington called a "Bolling Green."

In these unfamiliar environs, Houdon watched and waited.

———

THE OPPORTUNITY HOUDON wished for arrived with Thursday's dank, gray skies. The weather was "dripping of rain, more or less all day," and the stocky Frenchman persuaded Washington to settle into the sitter's chair. On that day and the next, a resigned Washington posed "for Mr. Houdon to form my Bust."[14] The artist and his subject were left without a translator, Perrin having returned to Alexandria, but Houdon could at last get to work on the task for which he had crossed an ocean.

The days Houdon spent waiting had not been entirely wasted. He grew familiar with the General's long-legged gait, studied his enormous hands, his broad face, and his courtly but quiet manner. He watched Washington with his family and friends, and one morning observed a revealing exchange with a man little known to the General. A messenger had arrived at the breakfast table that day, bringing word that a farmer waited on Washington at Mount Vernon's western gate. The message was that he had brought two horses Washington wished to buy.

When Washington rose from the table, so did Houdon; he remained within earshot of Washington's conversation, too. The visitor quite evidently hoped to consummate a deal for the horses and, after a time, the General asked the man to name his price. When he did, Washington reacted by throwing his head back and uttering a strong but indecipherable sound of outrage. At that moment, the artist saw the pose he wished to record. He would portray Washington with his chin raised, head tilted slightly, with a certain firmness to the jaw. Houdon had watched Washington go about his daily life, his features unreadable—but in a conversational moment the mask had cracked, and Houdon glimpsed the expression he would use to give his *Washington* a tension, a mobility, even a vitality.

In his makeshift studio Houdon's medium was clay. The Frenchman gradually built up the soft and pliable material, starting with large chunks. As a vaguely ovoid form began to resemble a human head, he added thinner layers. The moist clay had a soft, plastic quality that lent itself to modeling, and Houdon manipulated the material with his hands and with tools that seemed like extensions of his fingers. As he worked the surface, he added more clay. In areas where he had too much, he trimmed and sliced.

Washington's hair was pulled back and tied in a braid at the nape of his neck, revealing a lengthening forehead. Houdon took regular measurements from his sitter, using calipers, a measuring device consisting of a pair of legs fastened at a hinged joint. The Washington bust was to

be life-size, so Houdon could measure the breadth of Washington's brow, the length of his jaw, the distance from nose to cheekbone. Calipers of differing sizes allowed for determining larger or smaller distances as Houdon moved from the man to the soft clay mass, transferring his measurements.

For two days, Houdon worked to capture not only the structure of Washington's head, neck, and chest but also his facial features, blending actual appearance with his own sense of the man's character. The hair he left unfinished, shaping it roughly with his tools and fingers, but he worked the face and neck to a smooth texture. The eyes he shaped had holes for the pupils, drilled deeply into recesses suggesting irises. The likeness was there—the strong jaw, the lined forehead, the large nose—when, on Saturday, the sun reemerged and Houdon lost his model. Washington happily resumed his normal routine and that mild fall day saw to the sowing of grass seed imported from England in the ornamental front lawn. On Sunday, Washington, Houdon, and several men in his household rode to a nearby plantation to attend a funeral. Meanwhile, back at Mount Vernon, the clay head remained atop bare shoulders.

The sculpture was not a highly polished effort—Houdon planned to fulfill the Virginia commission working in marble upon his return to Paris—but in this first bust, the connection between artist and subject could hardly have been more immediate. Houdon captured in clay his fleeting impression of the great man.

⁓

GEORGE WASHINGTON LEARNED from life. While fellow Virginian Thomas Jefferson had collected and read thousands of books, Washington's literary exposure was more limited. Lacking a college education, he remained self-conscious about his lack of formal education, but he possessed keen powers of observation and regularly recorded what he saw and thought in detail in his letters and diaries. Typically, on Monday, October 10, Washington found himself fascinated by the process of preparing "Plaister of Paris."

To begin, Washington noted, Houdon's assistants broke chunks of gypsum into lumps that were no larger than "the size of a pullets egg." In the absence of a kiln, the visiting artist adapted a kitchen bake oven to dehydrate the plaster. A wood fire was built in the oven to preheat the dome-shaped masonry mass; after the fuel burned down, the coals and ash were raked out. Having built a larger fire than was usual (the plaster needed to reach higher temperatures than did household baked goods), Houdon's assistants put the plaster into the oven, closed the door, and left it overnight. "[S]ufficiently calcined by this operation," Washington noted in his detailed diary entry, "[the Plaister] was pulverized (in an Iron Mortar) & sifted for use through a fine lawn sieve, & kept from wet."[5]

Houdon's artistry with clay had produced a bust, but he was acutely aware that upon his return to Paris, he would have to complete his commission of the standing sculpture of General Washington—*and* he would have to do so without the man himself to refer to. The bust would be invaluable, but he also wanted a life mask to measure and study.

The plaster was ready for use by Thursday. Mount Vernon's servants' hall had become Houdon's workroom and, when Washington came to him, the General's hair was once again pulled back, and this time covered with a towel. Washington reclined on a large table and a sheet was spread over him to protect his clothing from dollops of plaster. To ease the removal of the plaster mask, his face was lubricated with oil, a thorough dose of which was applied to his eyebrows and lashes.

The fine powdered plaster was swiftly sifted into a basin containing water and mixed with a flat iron spoon. The plaster was ready, as Washington observed, when "the water is made as thick as Loblolly or very thick cream." Before the application of the plaster, two quills were inserted, one into each of Washington's nostrils, so he could breathe. Instructed to remain motionless, Washington lay quietly with his lips pursed and eyes closed.

The plaster was daubed on by hand and smoothed with a common Philadelphia painter's brush. No time could be wasted: The creamy plaster soon began to stiffen; with the passage of five or six minutes, it would

become difficult to work with. The setting plaster generated heat, and the sculptor and his subject alike could feel the warmth of the crystallization process on their skins.

While the process was proceeding, six-year-old Eleanor Custis (Nelly) happened past the doorway to the servants' hall. A daughter of Martha Washington's son Jacky, Nelly and her younger brother Washy (George Washington Parke Custis) had become wards of the Washingtons. In the four years since her father's death she had come to regard the General as her father, so Nelly was alarmed at the sight of him laid out on the table, covered with a sheet as if dead. She was soon offered reassurances that all was not as it seemed, and, to her relief, the General shortly reemerged from behind the hardened plaster mask, which was gently removed from his face, lifted from the forehead, then off the chin. When he rose from the table, he was very much alive and well.[16]

———

BEFORE HOUDON AND his apprentices could begin their journey home, several additional tasks remained to be completed.

The mold of Washington's face was invaluable, but it was precisely the reverse of what Houdon actually needed, since it was a negative of the General's features. After curing for some hours, the mold would be lubricated, and freshly mixed plaster poured into it. Once the plaster had set, the negative mold could then be chipped away with the light, slanting blows of a chisel driven by a wooden mallet. In this way, the negative mold would be destroyed, but the plaster cast that emerged from beneath would be an exact reproduction of the General's face, which Houdon could have at hand to measure and refresh his memory when he returned to his Paris studio.

The clay bust also needed further attention. It was slowly air-drying, but in order to be made more durable, it needed to be fired into terra cotta (literally "baked earth"). Houdon and his men also wished to make a piece mold of the bust. Fashioned in several sections, the piece mold

would leave the original bust intact while making it possible for the sculptor to produce multiple copies.

In the next several days, Houdon and his men completed their work. They toted the bust to Mount Vernon's kitchen to fire. The lower temperatures of the bake oven drove off the remaining moisture more slowly than Houdon's much hotter Paris kiln would have done, thus avoiding the buildup of steam inside and the risk of cracking. After its firing, the surface remained somewhat soft and fragile but intact.

Houdon departed on Monday, October 17. Washington bade him farewell, noting in his diary, "Having finished the business which bro't him hither, [he] went up . . . with his People, work and implements in my Barge, to Alexandria, to take a Passage in the Stage for Philadelphia."[17] On arriving in Philadelphia three days later, the sculptor presented a copy of the bust to Benjamin Franklin. Impatient to return to Paris, Houdon soon traveled to New York and sailed for Europe, carrying the life mask in his baggage, leaving his workmen to bring the mold of the bust and another positive cast when they followed. He reached his home on Christmas Day 1785.

The original terra cotta bust remained in America, a gift from Houdon to the General. In making the piece molds, his assistants marred the bust slightly, leaving trace adhesions around the eyes. Houdon himself had intentionally left his mark on the bust's right rear shoulder, incising his signature, *Houdon F. 1785*. The terra cotta soon found a place of honor in Washington's study and a reputation in the family as "the best representation of Gen. Washington's face."[18]

III.
1786 and After . . . Houdon's Atelier . . . Palais des Beaux-Arts . . . Paris

IN JANUARY 1786, Jefferson reported Houdon's safe return from America and that he came armed "with the necessary mold and measures" to make the full-length statue of Washington.[19] But Houdon

still required a bit of help. For one thing, he needed a decision: What would be the appropriate apparel for the Washington marble?

"Permit me," Jefferson wrote to Washington, "to ask you whether there is any particular dress or any particular attitude which you would rather wish to be adopted?"[20]

As usual, Washington sought other people's counsel before expressing his own opinion. The standard approach in Paris, Washington learned, was the classical. In sculpture, as in buildings and paintings, the dress of antiquity was in vogue, meaning his marble representation might be wrapped in a Roman tunic or toga. The prevailing assumption among artists was that truth and beauty were best served by the idealized dress of the ancients and that, in contrast, contemporary clothes would be vulgar and distracting.

Washington wasn't so sure. From an old aide-de-camp turned diplomat, David Humphreys, he learned of *The Death of General Wolfe*, the Benjamin West portrayal of General Wolfe in his own British uniform. That painting had persuaded a new generation of painters—among them Charles Willson Peale—of the rightness of contemporary dress. George Washington tended to see the argument in the same way. "A servile adherence to the garb of antiquity might not be altogether so expedient as some little deviation in favor of the modern costume," Washington wrote back to Jefferson, employing his usual epistolary manner of writing in quiet understatement rather than making overbearing demands. "This taste which has been introduced in the painting by Mr. West I understand is received with applause and prevails extensively."[21]

Houdon considered both options, executing two scale models, each perhaps eighteen inches high. In one Washington was in modern military costume, carrying a walking stick, his sword hung from a column beside him. In the other, he wore a cape, his lower legs uncovered, his feet clad in sandals. Jefferson favored the notion of modern dress and replied to Washington that not only West but such other Americans

abroad as John Singleton Copley and John Trumbull shared his view. It was decided.

Deciding and *doing*, though, were different things. Washington's bust and life mask had been at hand to measure and contemplate for the head, but Houdon wished a life model to stand in as he shaped the statue's legs, arms, and torso. After his fortnight at Mount Vernon, Houdon knew that not just anyone would do. Few men of their time stood as tall as the General, but his stature alone did not account for his powerful presence. He was made of large parts yet he moved with a lightness and grace that belied his size.

In June 1789, Jefferson arrived for one of his periodic progress visits to Houdon's studio, this time with New Yorker Gouverneur Morris at his side. Despite his peg leg (years earlier, Morris had endured an amputation after a carriage accident), he carried himself with an easy grace, and he was a strikingly handsome six-foot-four. He was renowned for his charming way with the ladies and his gift for business. He and Washington were friends (at Washington's behest, he had drafted much of the Constitution), but the gregarious Morris did not share his friend's diffident personality. He did share Washington's gift for turning heads—even dressed in his dark, unornamented American suit, Morris had an élan that stood out on the streets of Paris—and Houdon immediately recognized him as a suitable double for the General.

Morris stood for two lengthy modeling sessions. After the first, on Friday, June 5, 1789, he noted in his diary, "I stand for [Houdon's] Statue of Genl. Washington, being in the humble employment of a Manakin." Four days later he reported, "This morning [I went] to Mr. Hudon's . . . to stand for the Statue of the General until I am heartily tired."[22]

Still another three years would pass before Houdon completed the statue. Because of construction delays at the Virginia State Capitol, an additional four years elapsed before the statue and its tall plinth, together weighing thirty-six thousand pounds, were loaded into three cases and

shipped to America on the ship *Planter*. And it wouldn't be until 1803 that James Monroe, minister to France, paid Houdon his full fee. But Houdon had captured George Washington at Mount Vernon. Pensive and inward-looking, the man seemed to nurture no dreams of executive power. In Washington's own memorable turn of phrase, the tall American whom Houdon visited had retired into himself.[23]

Three Friends of Mr. Trumbull

The greatest motive I had or have for engaging in, or for continuing my pursuit of painting, has been the wish of commemorating the great events of our country's revolution.
—*John Trumbull to Thomas Jefferson, June 11, 1789*

I.

1784–1785 . . . At Mr. Benjamin West's . . . London

WITH AN UNEASY confidence in own destiny, John Trumbull remained true to his promise not to set foot on British soil until peace was restored. After his return to America, he lived for a time with his family in Lebanon, Connecticut. Next he worked for his brother David in New York, helping provision the Continental Army, but he continued to struggle to find his proper place.

His father still wished him to engage in commerce or perhaps the law. "With proper study," the old governor told him, "[you] should make a respectable lawyer." But Trumbull felt a passionate urge to pursue the arts. As he tried to justify his leanings, he once more debated the matter with his father. "I . . . entered into an elaborated defense of my predilection," he

later wrote, "and dwelt upon the honors paid to artists in the glorious days of Greece and Athens." His father dismissed the argument simply. "You forget, sir," he told his son, "that *Connecticut is not Athens.*"¹ In the face of his father's insistent urgings, Trumbull determined to resume his artistic apprenticeship as soon as possible, and in December 1783 that moment arrived. The end of the war permitted him to resume his pursuit of instruction in England.

The speed of his journey back across the Atlantic seemed a good omen. No great wind blew the traveler off course, and the winter passage required an unremarkable forty-one days. The trip had a certain symmetry, too, as the good ship *Mary* sailed from Portsmouth, New Hampshire, and made landfall at Portsmouth, England, on January 16, 1784. Even as he made his way from the port city on England's south coast to the British capital, the Continental Congress back home prepared to ratify the Treaty of Paris in Philadelphia. With the war at an end, Trumbull's military rank could once more safely precede his name, and he vowed never again to relinquish the title of *Colonel* Trumbull.

The momentum from his journey carried over into his new life in England. The returning student devoted himself to his training, rising each day at five o'clock to study anatomy and to tend to his correspondence before his eight o'clock breakfast. As Trumbull had hoped, Benjamin West welcomed him back to his studio at 14 Newman Street, and, after making the twenty-minute walk into the city each morning from his quarters near outlying Paddington Square, he worked all day at his easel at West's, pausing only for an afternoon dinner about two o'clock. His friend Gilbert Stuart, though no longer at Mr. West's, was nearby, having established his own Painting Room at No. 7 Newman Street. Stuart's reputation as a portraitist brought him much custom.

Trumbull began spending evenings at the Royal Academy in drawing classes. Most of his fellow students there were mere boys, lads very much younger than the twenty-nine-year-old Trumbull. He discovered to his dismay that many of them drew better than he, but his disciplined

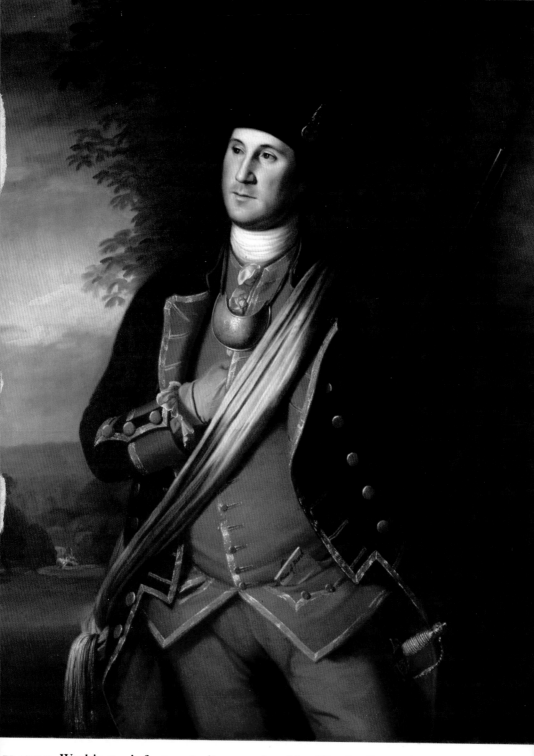

PLATE I. Washington's first portrait was painted by Charles Willson Peale, in 1772, at Mount Vernon. Note the rifle hanging from Washington's shoulder, a fowling piece used for shooting birds and the occasional fox. It is a touch out of keeping with the uniform—no officer in the king's army would have carried a shoulder arm, much less a hunting weapon—but then warfare in the New World had proved a strange matter for the British army.

Washington-Custis-Lee Collection, Washington and Lee University, Lexington, Virginia

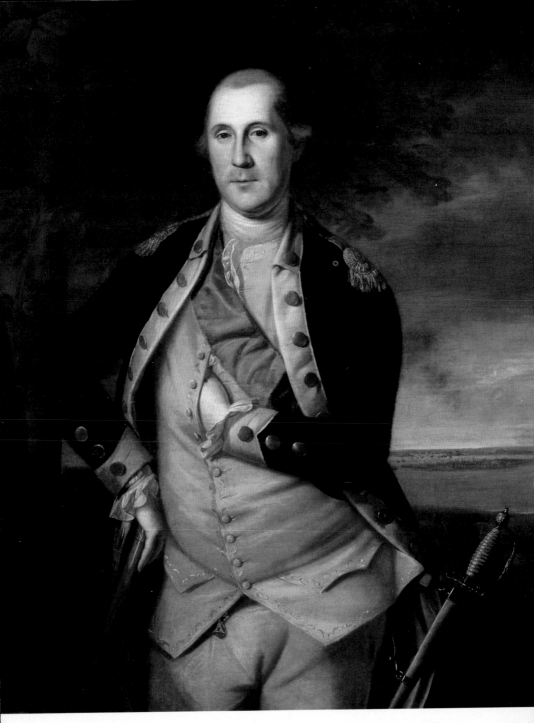

PLATE 2. Not so many years after his first likeness of Washington, Peale was called upon to paint the man again. By 1776, however, it was not a colonial colonel but the Continental Army's commander in chief who occupied the sitter's chair. Look closely: Peale has painstakingly rendered a view of the Boston skyline at the distant horizon, and a cloud of smoke rises from Charlestown, the site of the Battle of Bunker Hill. This Washington portrait, painted for John Hancock, celebrates the series of early battles fought in Hancock's native city.

Brooklyn Museum

PLATE 3. In Peale's 1779 view of Washington, *The Battle of Princeton*, the central figure towers over captured Hessian battle flags in the foreground; on the muddy ground nearby is another flag, a British ensign. Overhead the American battle colors wave in the breeze.

Colonial Williamsburg Foundation. Gift of Mr. John D. Rockefeller, Jr.

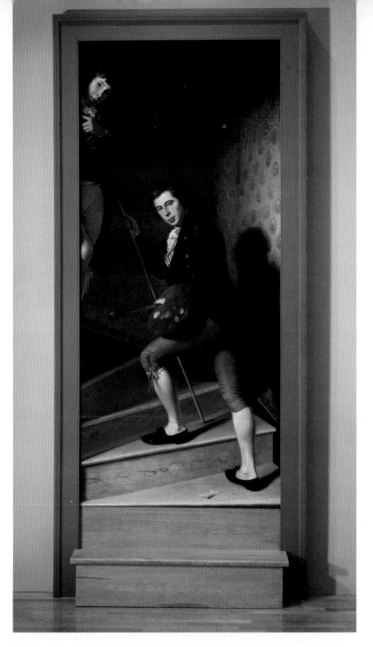

PLATE 4. In 1795, Charles Willson Peale painted this trompe l'oeil, which is titled *Whole Length: Portraits of Two of His Sons on a Staircase* (the painting is also known as *The Staircase Group*). The canvas comes down to us complete with a Washington anecdote.

Charles Willson had dispatched his son Rembrandt to extend an invitation to view some waxwork likenesses of costumed Indians that he wanted the old veteran of America's first frontier war to see. Washington accepted, and, walking through the house on his way to inspect Peale's productions, the ever-correct General Washington paused to bow to Rembrandt's brothers, Raphaelle Peale and Titian Ramsay Peale, who, it seemed, had paused on the staircase to look back at the visitor. Only when advised that he had acknowledged not flesh-and-blood boys but an oil on canvas cleverly installed within the frame of a closet door, complete with a real step that extended into the room, did Washington realize he had been deceived by this "eye fooler."

Philadelphia Museum of Art: The George W. Elkins Collection, 1945

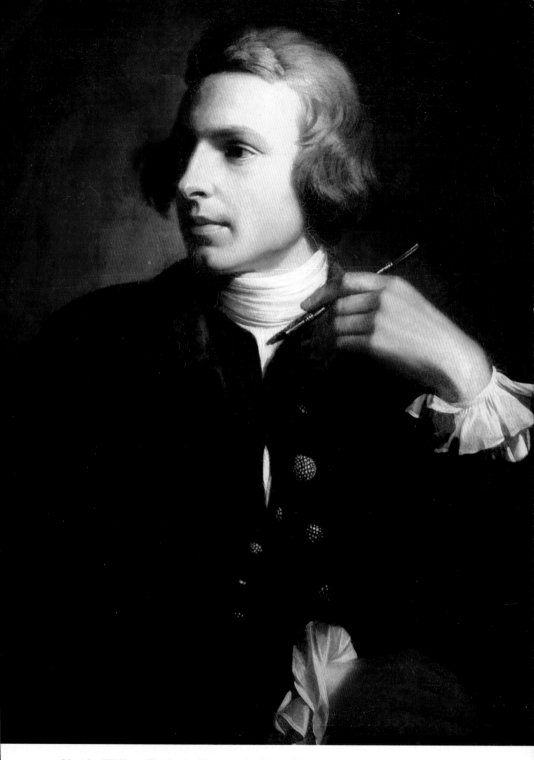

PLATE 5. *Charles Willson Peale*, by Benjamin West. The younger man holds his *porte-crayon* poised (the *porte-crayon* was a cylindrical metal pencil holder). His look is appraising and open, and the likeness is of a man studying his subject, undoubtedly an artist captured in the midst of sketching. West painted his protégé in London during Peale's 1767–69 London visit.

Collection of New-York Historical Society

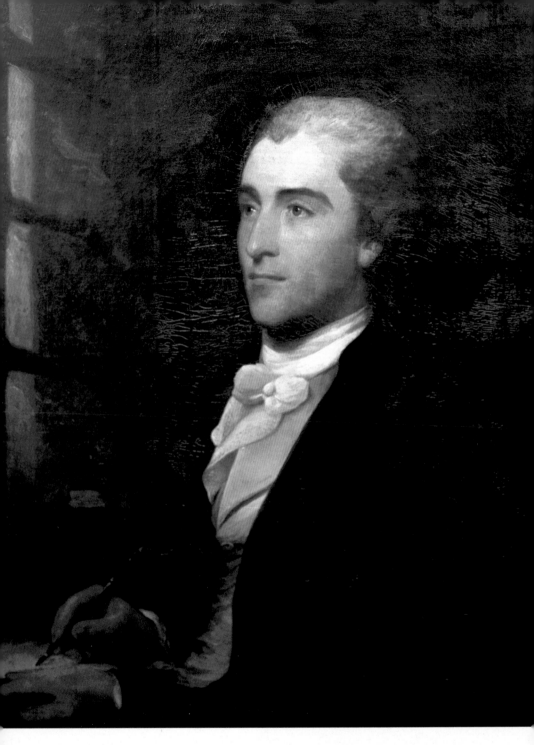

PLATE 6. John Trumbull left his unfinished likeness behind on his hurried departure from London; on his return to England in 1784 he completed *John Trumbull in Prison*, the portrait that Gilbert Stuart started three years earlier. Trumbull added the body, a hand with *porte-crayon*, and the barred window. He said of the painting much later, "I may not be a judge of the likeness—they say no one is of his own—but this I know, the face looks exactly as I felt then when Stuart used to come and greet me through the bars as 'Bridewell Jack.' "

Pilgrim Hall Museum, Plymouth, Massachusetts

PLATE 7. In this portrait of the artist as a young man—*Edward Savage: Self-Portrait*—the Massachusetts-born artist is seen in miniature, probably in his late twenties. This watercolor on ivory is just 1 $7/16$ inches high.

Worcester Art Museum, Worcester, Massachusetts, museum purchase

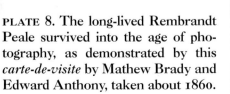

PLATE 8. The long-lived Rembrandt Peale survived into the age of photography, as demonstrated by this *carte-de-visite* by Mathew Brady and Edward Anthony, taken about 1860.

Library of Congress/Brady-Handy Collection

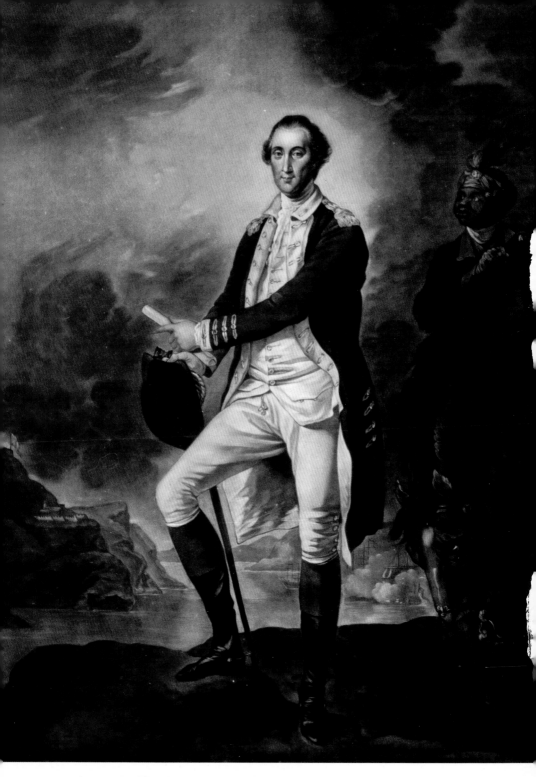

PLATE 9. A gangly Washington is on display in Valentine Green's engraving of John Trumbull's 1780 portrait. In the background is a Hudson River landscape, with a steep escarpment beneath a brightening sky that highlights the General's dignified countenance and bare head (he holds his tricorn hat in hand). Behind him a naval battle is being fought.

National Portrait Gallery, Smithsonian Institution

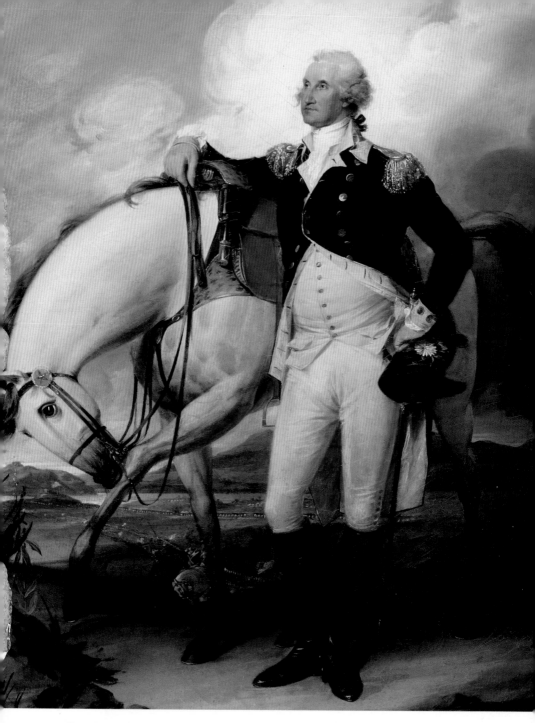

PLATE 10. So often admired by his contemporaries for his carriage and poise, the colonel in Peale's 1772 portrait (see Plate 1) appeared better prepared for the drawing room than the battlefield. In this later painting by John Trumbull, *General Washington at Verplanck's Point, New York* (1790), the General stands at ease, his right arm draped over his horse's saddle, the reins in his hand. His left arm, elbow akimbo, rests lightly on the hilt of his sword. The set of Washington's jaw suggests a fixed determination. This is no dandy of the foxhunting set; his is a commanding presence.

Courtesy Winterthur Museum

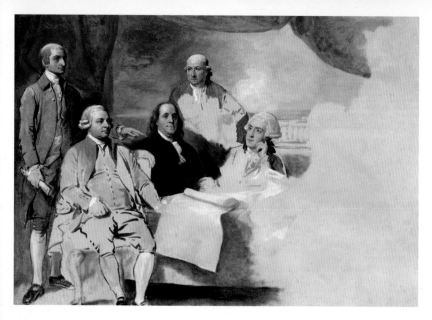

PLATE 11. A roll of paper on the table before the American representatives is the treaty-to-be in this unfinished history painting by Benjamin West, *The American Peace Commissioners* (1783). Not a word has been written on the sheet that hangs off the front edge of the table, and, untouched by the master's pencil, the entire right-hand side of the canvas remains unfinished, reflecting the absence of the British participants.

Courtesy Winterthur Museum

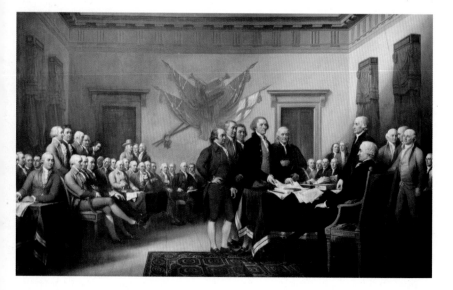

PLATE 12. In his reimagining of the nation's founding moment, John Trumbull treated Jefferson well, inserting his small but vivid portrait into the large cast of characters. The tallest man in the room, he stands for once with his shoulders square (Jefferson was more often known to slouch). He alone holds the precious document in *The Declaration of Independence, July 4, 1776*, offering it to John Hancock in his large hands, his eyes determined, the high color of his cheeks akin to that of his reddish hair.

United States Capitol Historical Society

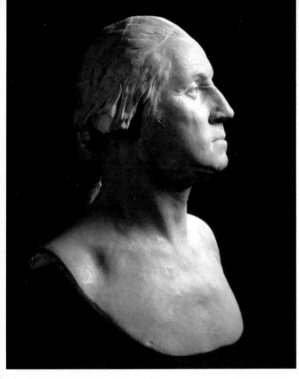

PLATE 13. Jean-Antoine Houdon had little time to rework, so his bust of George Washington has the freshness of a sketch. He and Washington inhabited the same space at the same time and, like a Renaissance painter making a chalk cartoon in preparation for a large canvas, Houdon recorded his first vision in this 1785 terra cotta.

Courtesy of Mount Vernon Ladies' Association

PLATE 14. Despite the distinction of many of his guests and clients, Houdon's attire is informal in this painting by Louis-Léopold Boilly, *Houdon in His Studio* (1803). Houdon liked to be comfortable, often working in short smocks and long pants. His preference for *pantoufles*, open-heeled slippers, provoked comment, then imitation. "Many people who found my shoes ridiculous have changed their opinion," he said. "Some among them have even had shoes made in my style."

Cherbourg-Octeville, musée d'art Thomas-Henry

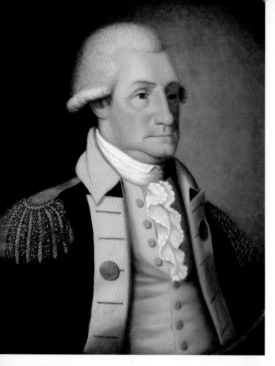

PLATE 15. Although he had been sworn in as president the previous spring, the General still wore his military uniform in this Edward Savage portrait, executed in March and April 1790. Along with a pendant portrait of Martha, the canvas was painted to order for Washington's vice president; when John Adams died, it descended to his son and on to ensuing generations. It remains today in the Adams family's Old House, hanging in John Adams's chosen site in the dining room.

National Park Service,
Adams National Historical Park

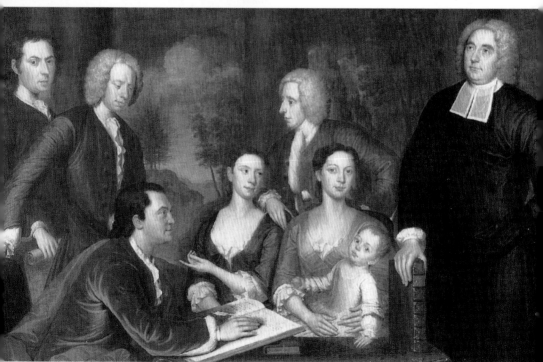

PLATE 16. In this large painting by John Smibert, Savage and many others found inspiration. Dean Berkeley and his fellow adventurers are pictured on the canvas that came down to us bearing the title *The Bermuda Group.* Among the seven individuals grouped around a low table, covered with a boldly patterned Turkish carpet, two or perhaps three streams of conversation seem to have momentarily come to a halt. The eighth figure, staring directly at the viewer, is Mr. Smibert himself, who painted it between 1729 and 1731.

Yale University Art Gallery

PLATE 17. The group apears to have assembled indoors—the foreground is a checkerboard floor—but in *The Washington Family* the General wears his spurs, as if he has just returned from his daily survey of his Mount Vernon properties. He is accompanied by Martha and their wards, her grandchildren George Washington Parke Custis and Eleanor ("Nelly") Custis.

The original canvas by artist Edward Savage was a composite, painted over a period of years (1789–96). The copperplate engraving reproduced here was one of the first impressions printed, which the artist sent directly to the General. After Washington's death in 1799, this image helped define the nation's "founding father" for generations.

Courtesy of Mount Vernon Ladies' Association

PLATE 18. *The West Front of Mount Vernon*, attributed to Edward Savage, is undated, but the architectural details make clear they were recorded about the time of Savage's trip to the South in 1791.

Courtesy of Mount Vernon Ladies' Association

PLATE 19. In this small sketch, *Mr. Stewart, Painting Mr. West's Portrait* (1783), the sitter recorded his protégé in action. An intense Gilbert Stuart, brush in hand, concentrates on the canvas before him. Note the tin of snuff at hand. Stuart, the child of a snuff miller, was addicted to the stuff for life.

British Museum

PLATE 20. This is one of the numerous replicas of Gilbert Stuart's first take on Washington, dating from 1795, and now known collectively as the "Vaughn portraits" after the first owner of the original. The canvas was originally the property of General Henry "Light Horse Harry" Lee, a trusted military advisor and the man who famously eulogized his old friend Washington with the words, "First in war, first in peace, first in the hearts of his countrymen." Stuart wasn't satisfied with this image, in which the president seems to be regarding him with bored impatience.

Colonial Williamsburg Foundation. Bequest of Mrs. Edward S. Harkness

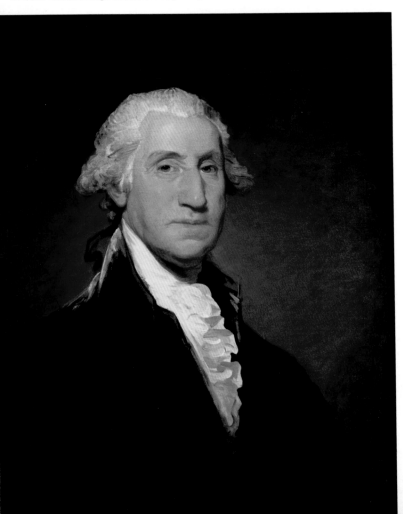

PLATE 21. In one of those strange coincidences that alter events in memorable ways, a new Washington commission played a role in Stuart's failure to finish the previous one. Paradoxically, the grand picture he made next (the "Lansdowne Portrait," see Plate 22) would never capture the American imagination as did the humbler—and unfinished—"Athenaeum Portrait" (1796).

National Portrait Gallery, Smithsonian Institution; owned jointly with the Museum of Fine Arts, Boston

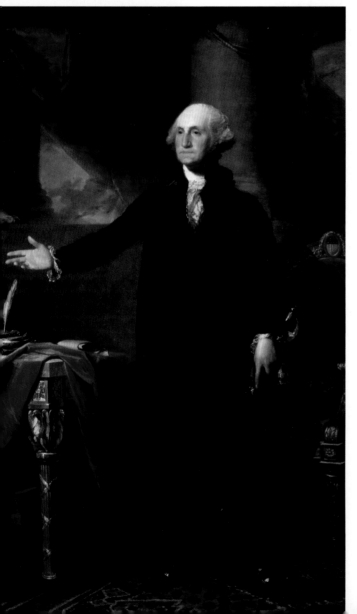

PLATE 22. Though a man of good carriage, the president's body double for this 1796 painting by Stuart was shorter than he. While other candidates have been suggested, the most likely was Stuart's landlord's son, a small man named Smith. This, the last of Stuart's Washington triple-header, is called the "Lansdowne Portrait," after the British peer to whom the first version was given.

National Portrait Gallery, Smithsonian Institution; acquired as a gift to the nation through the generosity of the Donald W. Reynolds Foundation

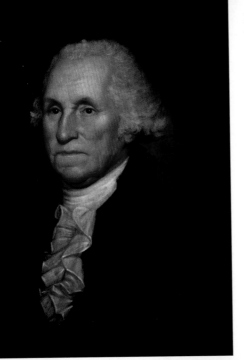

PLATE 23. His eyes hooded, the General looks tired in Rembrandt Peale's 1795 *George Washington*. In this replica painted by Peale in Charleston, South Carolina, shortly after he executed the original from life in Philadelphia, his sitter's mouth is set, and the lower lip protrudes (the primitive dentures, unmoored, required an effort to contain them). Washington seems to be staring at the unproven Rembrandt while the young man paints the man as he sees him, not as the world wished Washington to appear.

National Portrait Gallery, Smithsonian Institution; gift of the A. W. Mellon Educational and Charitable Trust

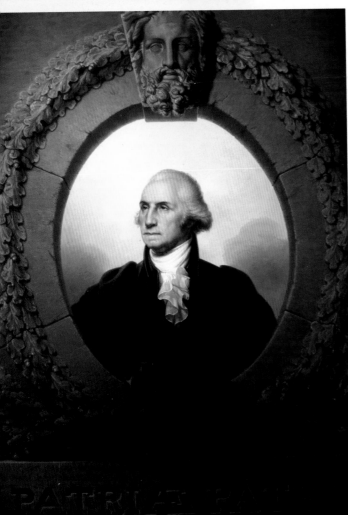

PLATE 24. In painting this flat canvas, Rembrandt Peale strove to make *Patriae Pater* (1824) appear three-dimensional. In the distance, a misty and cloudy sky seems almost in motion, a perpetual backdrop that is changeable yet constant. The firm face of the man looks out of the frame, his gaze intent. He seems ready to act—heroically, no doubt—if the situation demands. Of this canvas Rembrandt Peale made some eighty replicas.

United States Senate Collection

approach paid off. Trumbull was soon able to write home to his brother Jonathan, "Judges of the Art declare that I have made a more rapid progress in the few months I have been here than they have before known."[2]

His daytime labors in West's studio produced portraits. The first of them was a likeness of Sir John Temple, an aristocratic Englishman whom Trumbull knew from his time in Boston (Temple was married to the daughter of the Bay State's governor, James Bowdoin). When Trumbull asked West to appraise the work, his mentor expressed admiration for *Sir John Temple*, and the canvas was submitted to the Royal Academy, where it was exhibited later that year. A picture he finished in June 1784, a father-and-son portrait of an old Connecticut merchant friend, *Jeremiah Wadsworth and His Son, Daniel*, won fewer plaudits. No less a personage than Joshua Reynolds offered Trumbull his critique. "The moment he saw it," the colonel reported, "he said in a quick sharp tone, 'that coat is bad, sir, very bad; it is not cloth—it is tin, bent tin.'" Though he accepted the correctness of the observation, Trumbull made a point thereafter of not "expos[ing] my imperfect works to the criticism of Sir Joshua."[3]

Even so, Trumbull's overall progress pleased him. Just eight months into his second English sojourn, he felt confident enough to confide in his brother, "If I chose to give myself entirely to portraits I could more than support myself, as I receive ten guineas for what I can easily finish in a week."[4] But he felt a rising dissatisfaction, too, sensing that his strong puritan streak could never be satisfied with painting mere likenesses of men wealthy enough to pay his fees. Even as he began to fulfill his long-held desire to succeed as an artist, he felt a need to perform a public service for his country across the sea. He would soon explain to a newfound patron, Thomas Jefferson, that portrait painting is "little useful to Society, and unworthy of a man who has talents for more serious pursuits."[5]

Fortunately for Trumbull, Benjamin West was at hand to show him another path.

FOR TWENTY YEARS, West had been making history paintings. Some of his early canvases portrayed mythological scenes drawn from classical sources, while others featured more recent English battles. When the Pennsylvanian had first arrived in London, he painted as other contemporary history painters did, in the Grand Style, before he shocked the London art world with *The Death of General Wolfe*.

Even before the public unveiling of that painting in 1771, word had reached his patron, George III, of the radical five-by-seven-foot canvas on West's easel. The king let it be known that he had no interest in acquiring a painting in which the heroes were dressed in coats, breeches, and cocked hats. In an equally dismissive mood, Reynolds had come to call at West's studio. On seeing at first hand the work in progress, Reynolds urged West to abandon "the modern garb of war" for "the classic costume of antiquity, as much more becoming the inherent greatness of [the] subject."[6] West disregarded the advice and completed his painting without regard to one of the essential tenets of neoclassicism; instead, he dressed the officers and soldiers at the 1759 Battle of Quebec in their actual costume.

When Trumbull heard the story in the next decade, he also learned that from the first day the completed canvas was exhibited, on April 29, 1771, *The Death of General Wolfe* was almost universally admired. The public had queued up along Pall Mall to file through the Royal Academy gallery in which the painting hung. Politician William Pitt, actor David Garrick, and even Sir Joshua himself expressed their admiration. Reynolds's response, in particular, was gratifying. "I retract my objections," Reynolds said ". . . and I foresee that this picture will not only become one of the most popular, but occasion a revolution in the art."[7] Though the picture had already been sold privately for £400, King George reversed his earlier judgment and requested a copy for his personal collection. Trumbull also learned that sales of the engraving of *The Death of General Wolfe* had proven even more profitable.

In the years since, other history paintings found a ready market, too, among them new works by West and others by his fellow American John Singleton Copley. The independent-minded Bostonian had himself broken a long-established precedent when he chose not to exhibit his *Death of the Earl of Chatham* at the Royal Academy, instead installing the painting, which portrayed the collapse of William Pitt on the floor of the House of Lords, in a private pavilion. More than twenty thousand people paid admission to view the ten-foot-wide canvas for which fifty-five noblemen had sat during Copley's two years of work. He netted some five thousand pounds. Copley also refused an offer (fifteen hundred guineas) to purchase the picture outright, opting instead to commission a run of twenty-five hundred impressions of a large-scale engraving, which quickly sold out.

The son and brother of merchants, Trumbull knew the ring of commerce when he heard it. Since boyhood, he had also recognized in himself a deep desire to paint, and now, as he neared his thirtieth birthday, he was finally producing paintings that people of taste and training esteemed. He was also acutely aware that his means of making a living was at best tenuous. Further, he felt burdened by the need, as a patriot and a member of a family with a long history of public service, to make some larger contribution.

In late 1784, Benjamin West approached his pupil with a most flattering request. The older man desired a copy of one of his own history paintings, *The Battle of La Hogue*, which commemorated a British victory over France in a naval battle fought in 1692. *Would Mr. Trumbull be interested in executing it for him?* It was an immense compliment as, quite explicitly, the student was being invited to pick up his master's brush. Trumbull agreed, explaining to his father in a letter, "West's pictures are almost the only example in Art of that particular style which is necessary to me—pictures of modern times and manners."[8] He expected a year would be required to copy the big picture, but he managed to complete it in just three months. "The work," Trumbull acknowledged, "was of inestimable importance to me."[9]

⁓

THE GRAND IDEA came to Benjamin West first. News had arrived from Paris of the signing of the preliminary articles of peace, so he had already been musing on the new notion when a letter from his old student Charles Willson Peale arrived in mid-1783. Peale wrote to ask whether his old friend and teacher might help him sell one of his portraits of Washington. West wrote back saying he would be delighted to see "a whole-length portrait of that greatest of all characters, *General Washington* . . . that phinominy among men." Washington was indeed a phenomenon, and was well on his way to becoming the best-known man in the world.

In his reply West also asked a favor of Peale. "[W]ould you procure for me the drawings or small paintings of the dresses of the American army," he wrote, "from the officers down to the common soldier . . . and any characteristic of their armies or camps." He confided in Peale his plan to paint "pictures of the great events of the American contest." He proposed to call the series "The American Revolution."[10]

By the time Trumbull returned to West's studio six months later, West had already abandoned the plan (to pursue it might have jeopardized his standing with his most important patron, King George III). Before jettisoning the idea, however, he had begun one painting, and the unfinished canvas rested near where Trumbull worked, attesting to what, at least at first, seemed to West like a wonderful notion. The oil sketch had been almost forgotten, set aside in the clutter of the busy studio. When Trumbull saw *The American Peace Commissioners*, he realized what it represented.

Five men were pictured, Americans all, three seated at a table, the others standing. Trumbull took in the unmistakable tomahawk nose of John Jay, the plump figure of John Adams, the aging Ben Franklin, Franklin's secretary (and grandson), William Temple Franklin, and South Carolinian Henry Laurens. As a man who made a point of keep-

ing current with American politics, Trumbull knew these men had been the American commissioners sent by the Continental Congress to negotiate the peace with England. The other side of the negotiation—in life, British commissioner Richard Oswald and his secretary, Caleb Whitefoord, had represented the Crown—was nowhere to be seen.

Though he had told Peale that he regarded the Patriots as having earned a place "among the greatest characters of antiquity," West's American Revolution series had ended abruptly with this half-finished study for a much larger painting. But during 1784 he came to recognize that he had an apprentice whose emerging skills and commitment to the American cause might enable him to make the series his own. He broached the idea, and Trumbull wrote to his brother late that year, "Mr. West has mentioned my doing . . . the great events of the revolution."[11]

Trumbull began to veer away from portraiture. After completing his copy work for West, Trumbull put his hand to a historical composition based on Homer's *Iliad*. The picture, *Priam Returning with the Body of Hector*, cost Trumbull another three months and an investment of ten guineas to pay for its frame and the models he employed.[12] It proved a valuable practice piece in the historical vein and was well received by the London critics (one of them termed it "a considerable advance" on his earlier work).[13] West hired him to help with a large royal commission for a set of paintings at Windsor Castle. His apprenticeship advanced, as he continued learning the language of high art under the guidance of West.

The opportunity "to take up the History of Our Country," as Trumbull put it, seemed a noble venture, an opportunity for both honor and, he hoped, profit. He foresaw a chance to do good for his country and the opportunity to do well for himself.

———

TRUMBULL BEGAN WITH what he knew. While stationed with his Connecticut regiment years earlier he had witnessed the Battle of Bunker Hill from afar. Even on the other side of Boston harbor, the

cannonades had echoed like peals of thunder. He had seen the flames in Charlestown and the smoke from the battle that smudged the sky. The memory inspired him a decade later to paint *The Death of General Warren at the Battle of Bunker's Hill, June 17, 1775*, a canvas that also paid homage to his mentor's *The Death of General Wolfe*.

Trumbull worked in West's studio under the eye of the veteran painter. His painting would not be a precise record of the events at Bunker and Breed's Hills, but Trumbull had talked to participants and, at other times, seen his fellow Colonials in combat. In a series of careful sketches, he created a staged composition that represented an imagined moment in time that, though it never quite happened, was still historically accurate in many of its particulars. In short, he grasped that the essence of history painting is to mix the *real* and the *idealized*. The scale of his new painting was small compared to West's mural-sized histories. Trumbull's canvas was a mere thirty-four inches wide, twenty-five high. It was no accident that the canvas size would also suit future engravers, who would be able to make a same-size rendering of the painting on their plates.

As Trumbull's *Battle of Bunker's Hill* neared completion, in early 1786, West made an occasion of asking Trumbull to a dinner party. "I have invited some of our brother artists," West explained, "and I wish you to be of the party." When the appointed hour came, the host welcomed his guests to the Painting Room, where, as Trumbull recalled years later, the battle painting had been carefully situated at West's instruction to catch the best light. Upon seeing it, reported Trumbull, Reynolds "ran up to my picture,—'Why, West, what have you got here?—this is better colored than your works are generally.'

"'Sir Joshua,' (was the reply,) 'you mistake—that is not mine—it is the work of this young gentleman, Mr. Trumbull.'"[14]

Another who saw the painting was moved by its portrayal. Abigail Adams, whose husband, John, had become the American minister to the Court of St. James's, saw the painting in London in early 1786. "Looking

at it my whole frame contracted, my blood shivered, and I felt a faintness at my heart." She, too, had witnessed the battle at a distance, in her case from a Braintree hilltop some nine miles away, where she stood holding the hand of her seven-year-old son, John Quincy. The painting had added meaning for her since General Warren, the young Boston physician who lay dying in Trumbull's canvas, had been a dear friend for years. In writing to her sister back in America, Abigail described Trumbull as "the first painter who has undertaken to immortalize by his pencil those great actions, that gave birth to our nation."[5]

By February, Trumbull was at work on the second of the revolutionary paintings, *The Death of General Montgomery in the Attack on Quebec,* using some of the reference material that Peale had provided West. This canvas would portray the bravery of Richard Montgomery in his attempt "to attack the enemy at the heart," according to Trumbull, on December 31, 1775. The plan for that night called for Colonel Benedict Arnold to advance on the city of Quebec from one direction, while Montgomery approached from another. Although Arnold's men captured their objective, Montgomery and several of his officers were felled by grapeshot from a naval cannon. The assault on Quebec ended almost before it had begun, but Trumbull wanted to memorialize the moment for its "brilliancy of conception and hardihood of attempt." As the painting began to emerge, Trumbull's debt to West's great canvas, *The Death of General Wolfe,* became evident.

With two paintings in the proposed series well under way, West suggested that Antonio di Poggi, an artist-turned-publisher, might help Trumbull find an engraver on the continent (for obvious reasons, English engravers were reluctant to celebrate the recent war). Di Poggi and Trumbull reached an understanding, and the Italian soon crossed the Channel to look for a suitable artisan.

The city of London in 1786 was a diverse place, but to Americans abroad their social world was small. American painters, diplomats, and merchants dined together often. One afternoon that spring Trumbull

was invited to dine with John and Abigail Adams. At their table that day he made the acquaintance of another Patriot, a red-headed Virginian whose learning and manner charmed the shy Yankee. Thomas Jefferson, who had traveled to England from his post in Paris to consult with John Adams on diplomatic matters, seemed to be interested in everything. They found a shared passion in the arts, and Jefferson sought Trumbull's educated opinion on the pending matter of whether Monsieur Houdon should dress his statue of General Washington in a classical or modern mode. Trumbull, in turn, told the American minister to France of his plan for the series of commemorative engravings. Jefferson, wrote Trumbull, "highly approved my intention of preparing myself for the accomplishment of a national work."

The promising young American painter, his character vouched for by his old friend Adams, intrigued Jefferson. The minister to France issued an invitation: Trumbull ought to come to Paris, "to see and study the fine works there, and to make [Jefferson's] house my home, during my stay."[16]

Colonel Trumbull's luck, it seemed, had truly turned.

11.

August 1786 . . . With Mr. Jefferson . . . Paris

MONSIEUR CHEFERSONE," AS he was known to one Left Bank merchant, had recovered himself. The painful recollection of his wife's death, in 1782, was still fresh when his friend James Madison had arranged Jefferson's appointment as minister to France. For the master of Monticello, the diplomatic posting possessed a double appeal: He hoped he could quiet the persistent sense of loss and fulfill his long-held desire to visit what he called "the vaunted scene of Europe."

Jefferson found all the distractions he wished for. He immersed himself in the art and culture of Paris, its food, and its society. He exam-

ined the architecture, sculpture, and painting, gloried in the music, and delighted in the wines. He reveled in the city's bookstores, often indulging his tendency to "Bibliomanie," as he termed his book-buying passion. He made the acquaintance of artists and architects. He hired Houdon to make a Washington sculpture for the Commonwealth of Virginia, and, in collaboration with the French antiquarian and architect Charles-Louis Clérisseau, he designed a monumental Capitol for Richmond in which Houdon's pedestrian statue was to be installed.

When John Trumbull arrived in France, late in July 1786, after more than two years of intensive study and work at Mr. West's, he, like Jefferson, envisioned Paris as a holiday. He brought with him the first two in his projected series of American history paintings, in order that he, with the assistance of Signor di Poggi, might contract with an engraver for their reproduction.

Jefferson liked nothing better than offering tutelage to young men who entered his circle. This had become a pattern with nephews, secretaries, and bright young Americans of all sorts (in the years to follow, this inclination would further blossom with his mentoring of a generation of young architects and in his dream of a state university for Virginia). The arrival of Trumbull that summer provided an opportunity to expose a promising young American to French artists and European art. The lack of great art in his homeland worried Jefferson. As he had written to James Madison the previous year, to fail to improve the "national good taste" would be to risk "barbarism."[17] He recognized in Mr. Trumbull and in his national work a chance to elevate American tastes.

After some months in central Paris, which he found too busy for his liking, Jefferson had moved to a large house on the outskirts of the city. The Hôtel de Langeac—it wasn't a hotel at all, but a mansion—had become the American Legation, serving as the minister's place of business. There he tended to concerns of trade, the passports of American travelers, and a multitude of other official matters. The house was also Jefferson's home away from home, the site of "family dinners" (when his

daughter, Patsy, was home from her convent boarding school) and "great dinners," at which Jefferson entertained an ever-widening circle of friends at his table.[18]

When Trumbull stepped through the gate at the corner of the Champs-Elysées and the rue de Berri, he entered a large courtyard. Before him stood the grand entrance to the stately three-story house, its height emphasized by the floor-to-ceiling windows on the ground floor. Originally designed to accommodate a duke's mistress, the stylish *hôtel* included within its walled perimeter a range of buildings, including stables, servants' quarters, and a coach house. As Jefferson had written to Abigail Adams a year earlier, "it has a clever garden to it."[19] A bit wistful for flavors of home, he was attempting to propagate "Indian corn for the use at my own table, to eat green, in our manner."[20]

Jefferson welcomed Trumbull warmly to his spacious house. Within its walls were three separate suites, one of which would be his guest's home for the weeks to come. In Trumbull's time at the Hôtel de Langeac, both Jefferson and Trumbull gained more from their new acquaintance-ship than they could possibly have expected.

———

TRUE TO JEFFERSON'S promise, doors all over Paris opened for Trumbull as he sought to examine the city's art. Early on in his tour he visited the Louvre ("fine, *very fine* indeed, the very best thing which I have as yet seen," he noted in his journal). He thought the Palais-Royal "magnificent." He visited palaces, cathedrals, churches, the Sorbonne, and Versailles.

On some days Jefferson accompanied him, but Monsieur Houdon and his pretty bride Marie (they had married only the previous month) also took a turn as Trumbull's guides. The Houdons took him to see some of Jean-Antoine's sculpture and to a waxworks to view a surgeon's collection of anatomical models of the human body. At the Louvre they looked at statues, casts, and bas-reliefs. In the gallery of the French

Academy, Trumbull admired Charles Le Brun's *History of Alexander the Great*, a series of history paintings he thought "among the finest things which have ever been produced—*perhaps the finest.*" He was unimpressed by the academy's drawing room, which he thought less convenient than those he knew at the Royal Academy in London.[21]

In his zigzag five-week tour of Paris he saw paintings by Correggio, Raphael, Titian, Rembrandt, van Dyck, Fragonard, Tintoretto, Veronese, Poussin, and "Michael Angelo." But it was *The Death of Henry IV*, by Peter Paul Rubens, at the Luxembourg Palace that he thought "the most perfect of all . . . splendor and harmony are here wonderfully united—the truth of nature, and the glow of a nature superior to ours."[22] He saw works by Jacques-Louis David, then emerging as the most admired painter in Paris. When he met the man himself in his studio in the Louvre, David became his "warm and efficient friend" and provided access to still other artists, collectors, and collections. Trumbull tended to business, too, meeting engravers, among them the auspiciously named Heinrich Güttenberg ("a plain honest German, industrious, and ambitious of fame, and one of the best engravers at present in France").

A few days into his Paris visit, Trumbull was joined at Mr. Jefferson's home by another guest, a boyish-looking young Harvard graduate named Charles Bulfinch. A Grand Tourist nearing the end of an eighteen-month tour that had already taken him to England and Italy, the young Bostonian had architectural aspirations and was intent upon seeing the sights of Paris. Soon the three Americans became acquainted with two other visitors to the city. Trumbull first met Mr. and Mrs. Cosway at the studio of his new friend, Monsieur David. Richard Cosway was an English miniature painter who had come to paint portraits of the children of the influential Duc d'Orléans. His wife, Maria, was younger, possessed of both artistic and musical gifts—and as beautiful as her husband was homely. For much of August and into September, these companions and a varying cast of French aristocrats, artists, and friends went on daily excursions.

On his return to the Hôtel de Langeac in the evenings, Trumbull made entries in "a journal of each day's occupation." He listed places visited, artworks seen, and those with whom he had traveled that day. More than half a century later, he employed this diary in compiling his *Autobiography, Reminiscences and Letters of John Trumbull from 1756 to 1841*. Even then, despite having been edited by the elderly sensibilities of the eighty-something Trumbull, the retrospective text still managed to convey a youthful hunger for beauty in his wide-eyed reactions to the art, architecture, and gardens. The *Autobiography* also proved to be an invaluable text for historians attempting to understand Trumbull, the Paris of the day, and his host, Mr. Jefferson. Yet what the painter left unsaid in his day-to-day accounting of events leaves the attentive reader curious, even querulous.

Trumbull himself interrupts his exacting account with an apology. He explains that, beginning with August 19, 1786, "[M]y manuscript fails me; I presume that one if not two sheets, have perished entirely." For a man who left an immense trove of documents at his death, as well as his thorough *Autobiography*, the loss is perplexing—particularly since the lacuna coincides with the days of Mr. Jefferson's now famous flirtation with Maria Cosway. Trumbull acknowledges the couple's friendship: "Mr. Jefferson joined our party almost daily [during these twenty days]; and here commenced his acquaintance with Mrs. Cosway." Then he moves on, dispassionately, to describe other people and places.

The dalliance between Jefferson and the radiant Mrs. Cosway—in her portraits, one sees a tousle of blonde hair, porcelain skin, perfect features, and dark, intelligent eyes into whose depths a lonely man might well fall—is today mysterious only as to the extent of the couple's physical intimacies. From their letters, most of them published long after Trumbull's death, the passion on both sides is apparent to any reader. As Jefferson himself wrote to Cosway in the most famous of those letters, he felt acutely the emotional heat, having learned "how imprudent it is to place our affections, without reserve, on objects you must so soon lose."[23]

The philosopher-politician composed the letter as a debate between his head and heart, with reason prevailing in the end.

Even at the remove of a half a century, Trumbull must have known more about the Jefferson-Cosway relationship than he admitted. He had joined them in their coach, walked the same garden paths, and been privy to their conversations on many occasions in those days and weeks. Jefferson shared his home with Trumbull during this time, too, and upon returning there each evening, one might reasonably conjecture, the smitten Virginian might have shared confidences or, at the very least, been unable to mask all his feelings.[24] Jefferson later trusted Trumbull as his go-between, to deliver letters he was reluctant to send by less secure means, some of them to Mrs. Cosway. Yet when he came to describe the relationship he closely observed, the elderly Trumbull chose silence over indiscretion. A man of his time, he left the provocative interlude in Mr. Jefferson's life to the conjectures of later writers.

———

WHEN JEFFERSON LEASED the Hôtel de Langeac, its rooms were empty, from the large bedchambers to the grand oval salon with the trompe-l'œil rising sun on its ceiling. He refused to rent what he needed, since the fee for furnishings and other household equipment would have amounted to 40 percent per year. Instead, he went shopping in an urban landscape dense with artisans, shops, and merchants.

As was his punctilious habit, he recorded his purchases in his *Memorandum Books*. These included bed linens and blankets, along with an armoire in which to store them. He bought mattresses, carpets, stoves, andirons, and wood. For his kitchen and dining room, he purchased a coffee mill, teapots, silver flatware, and china. He acquired furniture, too, including two *lits de repos* (daybeds), easy chairs in which to relax, and both arm- and side chairs for dining. Mirrors, *biscuit* figurines, gaming tables, chandeliers, white porcelain vases, girandoles, silk damask draperies, and other goods came later. Not satisfied with the choices in

Paris, he wrote to his friend Abigail Adams, asking her to purchase napkins and a tablecloth for him in London. Acquisitive by nature, he relished the entire process, feeding his appetite for and appreciation of craftsmanship, elegance, and the neoclassical taste of the day.[25]

Within months of his arrival, he began acquiring objets d'art, too, both at auction and from dealers. Although his friendship with Houdon led him to purchase a number of the sculptor's terra-cotta patinated busts, he tended not to buy original works by living artists but chose instead to seek copies of great works from the past by the likes of Raphael, Leonardo, Titian, Rubens, and others. He favored portraits of the great and estimable, and a good many pictures still remained on his desiderata by the time his guest arrived. He sought Trumbull's guidance for images of Shakespeare, Columbus, and others.

A bond developed between the two men, growing by the day. They found they shared a reverence for the thinkers Isaac Newton and John Locke (Trumbull had copied their portraits years earlier, and Jefferson wanted to include them in his pantheon). After long days shared seeing the sights of Paris together, they would return to the Hôtel de Langeac with impressions of the art and architecture they had seen. A man famed for both his curiosity and his courtly manners, Jefferson was more interested in learning from others than in hearing the sound of his own voice. Here he had Trumbull to himself, in effect an artist-in-residence. Many of their enthusiasms beyond the world of art overlapped, too, as they saw in the signs of political unrest in France a welcome echo of the revolution in individual freedom that American independence represented.

When the colonel arrived in Paris, his baggage included the two completed canvases that portrayed the battle scenes at Bunker Hill and Quebec. Primed by their earlier exchange in London, Jefferson was eager to see what Trumbull had wrought, and, as the painter reported, his host very much approved of "the first fruits of my national enterprise" and offered his "warm approbation."[26] Jefferson went further, insisting the artworks be displayed to others in Paris, too. He spread

the word across the Atlantic, writing some days later to Ezra Stiles, president of Yale College. "A countryman of yours," he advised Stiles, "has paid us a visit here, and brought with him two pictures which are the admiration of the Connoisseurs. His natural talents for this art seem almost unparalleled."[27]

Trumbull laid out his plans in detail for Jefferson. His hope was that he and the publisher di Poggi would be able to find a skilled artisan to engrave the images, in order that affordable prints could be offered for sale in America. His aspiration went beyond these two early battles, at both of which the British had prevailed. Trumbull planned to paint other revolutionary military scenes, specifically those at Princeton and Trenton, along with the surrenders at Saratoga and Yorktown, all confrontations from which the Continental Army emerged victorious. Jefferson became a partisan, believing whole-heartedly in Trumbull's national work. He recognized that the paintings could open the eyes of countless Americans to the merit of history painting and enable them to contemplate the late, great days of the fight for independence.

———

IN THE COMMODIOUS house near the city's wall, a fresh idea came to them.

They were seated in Mr. Jefferson's library. Even when the sun had set, the room remained surprisingly bright, with candlelight reflecting off the decorative gilding, the lightly painted walls, and the mirrors in the room. Books were everywhere, since Jefferson was acquiring them at a rate approaching a book a day.

As they talked of Trumbull's series, a question made its way to the surface. It was a bit provocative in that it was contrary to the tradition of history painting. The general notion they floated was whether or not the subject matter of all of Trumbull's history paintings had to be military.

Both men knew the history of the war very well; in truth, General Washington's genius had been to play the fox more often than the lion,

choosing to disappear on numerous occasions rather than confront the superior force of his enemy. The Revolution certainly had had its essential military moments, but didn't politics and even philosophy loom as large as the scenes filled with cannon and encampments? The war wasn't an end in itself, after all, but a means of advancing the larger cause of individual freedom. Yet history paintings had traditionally relied upon well-known stories from classical antiquity, the Bible, or the pathos of a death scene or battle to provide emotional content.

Perhaps the particular idea was Jefferson's brainchild; undoubtedly it arrived with the power of an epiphany. But here it was: *Why not record the events of July 4, 1776?*

The formulation suited both men nicely. For Jefferson, it was a memory, a defining moment for him and his country. He had fought in no battles, yet here he was the central figure in a truly heroic scene. For Trumbull, it became a great pictorial possibility. They talked of the circumstances. Jefferson volunteered as a witness and a participant to help Trumbull bring the scene to life on canvas. The challenge was, as Trumbull saw it, "to convey an Idea of the Room in which congress sat."

Jefferson, no artist but eager to help, put pen to paper. On a small sheet, he drew a crude floor plan of the assembly room on the ground floor of the old State House in Philadelphia where the Continental Congress gathered. He indicated the position of the doors and the dais. Having examined what Jefferson sketched, Trumbull took up the pencil. Working on the facing half of the same sheet, he added to Jefferson's rudimentary plan, and a more sophisticated rendering of the room emerged. Jefferson told Trumbull who had been in attendance, who played what role, and the artist began to people the sketch with the players. There were Adams and Franklin; and Jefferson; and John Hancock, too, the president of the Congress. When he needed a model for the president's chair, Trumbull looked around him, and chose an oval-back fauteuil at hand in Jefferson's salon at the Hôtel de Langeac. The two men, enraptured by the moment, planned the painting.

The impromptu exchange that August day in 1786 was unprecedented. The chief image of the republic's founding moment was conceived by a principal player and the man who would be the era's most celebrated "graphic historiographer." The work would prove to be Trumbull's best remembered (today it is reprinted on the back of the two-dollar bill) and the keystone of his reputation. It helped elevate the presentation of the founding document to the status of a heroic battle. Trumbull's carefully modulated history picture, with its array of Signers, imparts a sense of history being made.

———

THOUGH CONCEIVED IN a moment, the painting took very much longer to complete. Trumbull returned to London in November by way of Frankfurt, Cologne, Liège, and Brussels, as he continued his search for an engraver. Once ensconced back at Mr. West's studio in London, he set to work in earnest.

"I resumed my labors . . . on the history of the Revolution," he wrote, "arrang[ing] carefully the composition for the Declaration of Independence, and prepared it for receiving the portraits."[28] He wanted his new history painting to be admired both as art and as a historically accurate record of the event commemorated. It wouldn't be easy: The canvas, designed to be engraving-ready, was small, only twenty-one inches high and thirty-one inches wide, and it had to accommodate a crowd of Continental Congressmen. In the end, Trumbull would portray forty-six figures; fifty-six men signed the document, but Trumbull chose to incorporate the faces of four notable patriots who did not, omitting fourteen others.

Most of these men were entirely unknown to Trumbull, and almost none was on the same side of the Atlantic as he. The following summer he painted John Adams directly onto the canvas, just prior to Adams's return to America. The next winter Trumbull returned to Paris and painted in Jefferson. Only upon returning to the United States, a journey

he was not yet ready to take, could he finish the painting; in fact, the work of completing *The Declaration of Independence, 4 July 1776* would be central to the next several years, the most productive of Trumbull's artistic life.

As for the man who helped Trumbull conceive the painting, Jefferson benefited, too. He had had little fame when he journeyed across the Atlantic in 1784. No portrait had been painted of him, and, if his ship had sunk, no likeness from life would have existed to remind us of his physiognomy. At the time his name was not well known to Europeans, unlike those of George Washington or the widely popular Benjamin Franklin.

In helping Trumbull plan the painting, Jefferson had played the dramaturge; in the painting itself, his was the lead role. The combined intelligence and experience of the two Americans in Paris, reveling in a rich artistic culture new to them, produced a unique work of art. Coming from a pragmatic land where drawing skills were more likely to be employed in surveying land than seeking beauty, a nation where painters were regarded as limners because almost no one saw the merits of any art beyond portraiture, Trumbull and Jefferson recognized that art could perform an important public function. Although it records a legislative moment rather than a military confrontation, *The Declaration of Independence* would ring out over the centuries louder than a cannon shot.

III.

1789–1792 . . . With General Washington . . . New York

I ARRIVED IN New York on the 26th of November, 1789," Trumbull wrote in his *Autobiography* many years later. He returned to America a more sophisticated artist, his six years of tutoring in the studio of Benjamin West at an end. As the *Montgomery* sailed into harbor, Trumbull's confidence was at high ebb, buoyed by the enthusiasm of Jefferson. In

the voluminous baggage stowed below decks were the several canvases of his planned "great work." He had come home to complete them and to lay claim to the title of Artist of the Revolution.

Once ashore, he called at No. 3 Cherry Street, the house Congress had rented as the presidential residence. Trumbull arrived with the perfect entrée, since, on a brief trip to Paris immediately before his return to America, he had met with the Marquis de Lafayette. Washington's old comrade-in-arms and surrogate son had asked Trumbull to seek out Washington on his return. When he sat down with the man who had become the nation's first president less than eight months earlier, Trumbull "lost no time in communicating to him the state of political affairs, and the prospects of France, as explained to me by M. La Fayette."[29] Just as Trumbull had been, Washington was curious about the storming of the Bastille, Lafayette's new role as commander of the National Guard, and other particulars of the unfolding revolution in France.

When they met that late November day in the three-story square house overlooking the mouth of the East River, Trumbull's professional preoccupation was with the past. His desire was to obtain portraits to fill the "pockets" in the unfinished canvas of his *Declaration of Independence*. He had painted in the torsos of the players, arranging them as Jefferson recollected them, and now anticipated a series of journeys up and down the United States coast to Philadelphia, Charleston, Boston, and Newport, to Virginia and New Jersey. He wanted to paint the surviving participants from life, fitting their faces to the figures on canvas.

Washington's concern was the present. As they met that day on St. George's Square, George, like his wife, Martha, was still adapting to large changes. She continued to refer to him in her letters as "the General," a designation she preferred to others that had been bandied about of late (among those were two notions of John Adams's, "His Elective Majesty" and "His Mightiness").[30] Washington understood the title chosen for the office really would mean something. Symbolic though it might be, it had to describe the role that Washington inhabited, in deliberate

contrast to King George III. It was also a part no one had ever before played.

While Trumbull had been working at his *Declaration* in Georgian London, the second of his nation's momentous documents, the United States Constitution, had been drafted at Philadelphia. Since then it had become the supreme law of their homeland, and Trumbull's old commander in chief had assumed an unwanted and ill-defined set of responsibilities.

⁓

ON HIS RETIREMENT to Mount Vernon at the war's end in 1783, Washington had happily accepted the role of a latter-day Cincinnatus. Having led his army to victory, just as the Roman consul Lucius Quintus Cincinnatus had done in the fifth century B.C.E., Washington returned to farming, content to let others rule. He kept his distance from the political life of the country, although visitors to Mount Vernon in the mid-1780s met a man quick to cross-examine them on such subjects as Congress, commerce, and foreign relations. Washington, a habitual reader of newspapers, also maintained a copious correspondence with those still in the political fray, both at home and abroad. One of them, a former aide and sometime secretary, Colonel David Humphreys, recognized both the joy with which Washington welcomed his withdrawal to the "shades of private life" and the General's near compulsion to be *the focus of political intelligence* for the new world."[31] While Washington had relinquished all claims on power, the progress of the political experiment he made possible continued to preoccupy him.

The perspicacity of General Washington was hardly required to recognize how ineffectual the American government was. Under the Articles of Confederation, the central government had little money and less power. Though Washington dismissed the Confederation Congress as "a nugatory body," when a convention was finally called to consider changing it, he spent months deciding whether or not to accept nomina-

tion as a Virginia delegate. At last he did, and, after traveling to Philadelphia, he was met with the inevitable (and unanimous) draft as its president on the convention's first official day.

From May to September 1787, he officiated at Pennsylvania's State House in the same room where he had been appointed commander in chief of the Continental Army. This time he occupied the president's chair on a low dais. Though he could have done, he did not dominate the proceedings; as presiding officer he took no liberties and made only one minor speech during the deliberations. He set the tone in subtle ways, always arriving punctually and missing no sessions. Behind the scenes he exerted influence (he maintained a close rapport with, among others, James Madison, one of the Constitution's masterminds). Even so, as America's peculiar experiment with democracy took shape, George Washington maintained a stoical public silence.

Thirty-nine of the fifty-five constitutional delegates, including George Washington, eventually signed the draft document (three in attendance refused to endorse it, while another thirteen had departed prior to the ceremony). The deed done, an impassive Washington climbed into his carriage and returned to Virginia. He did his best to stay out of the political crossfire, leaving the infighting to Madison, John Jay, and Alexander Hamilton, who penned *The Federalist Papers*, writing collectively under the pseudonym Publius. Even without Washington's intervention, month by month and state by state, the powers-that-be convened to consider ratification. Before the year ended four states (Delaware, Pennsylvania, New Jersey, and Georgia) had voted to ratify the document.

The final adoption of the Constitution was by no means a foregone conclusion; intense opposition had to be overcome in some states. Yet as 1788 passed, the process seemed to be gaining momentum—January and February brought word of acceptance in Connecticut and Massachusetts— but Washington had very mixed feelings. Certainly he believed the approval of the Constitution was essential (he had earlier written to Patrick

Henry, a potential opponent of the measure, "I wish the constitution, which is offered, had been more perfect; but . . . if nothing had been agreed on by [the federal convention], anarchy would soon have ensued, the seeds being deeply sown in every soil").[32] As state conventions approved the draft document (Maryland joined the list in April), Washington recognized the looming, if indistinct, shape of a potential obligation. He wondered whether he could avoid being drafted as chief executive of the revised union.

He was hardly alone in worrying about the matter; his implied candidacy was apparent even to an observer three thousand miles away, the Marquis de Lafayette. Replying to the man whom he regarded almost as a son, Washington wrote in April 1788, "In answer to the observation you make [in your last letter] on the probability of my election to the presidency, knowing me as you do, I need only say, that it has no enticing charms and no fascinating allurements for me. However, it might not be decent for me to say I would refuse to accept, or even to speak much about an appointment, which may never take place . . . [but] at my time of life and under my circumstances, the increasing infirmities of nature and the growing love of retirement do not permit me to entertain a wish beyond that of living and dying an honest man on my own farm."[33] Five months later the Constitution had become law, and Washington wrote to another old friend, General Henry Lee: "[M]y inclinations will dispose and decide me to remain as I am, unless a clear and insurmountable conviction should be impressed on my mind, that some very disagreeable consequences must, in all human probability, result from the indulgence of my wishes."[34] As the elective mechanisms of the new document swung into motion, Washington's thinking evolved; *I'd really rather not* became *Must I?*

He continued to wait at Mount Vernon as if the outcome was in doubt, assuming the guise of a typical farmer occupied by concerns about atypical weather conditions and the estate's disappointing harvests. Yet in answering the many inquiries from old friends about the presidency,

he gradually assumed a tone of resigned acceptance. In a January 1789 letter to Lafayette he wrote, "Should circumstances render it in a manner inevitably necessary, . . . I shall assume the task with the most unfeigned reluctance."[35] He repeated the same sentiment in other letters, but by March he wrote to a nephew, "[I]t is probable I shall be under the necessity of quitting this place, and entering once more into the bustle of publick life, in conformity to the voice of my Country and the earnest entreaties of my friends, however contrary it is to my own desire or inclinations."[36] *If* had become *When*.

The Secretary of the Congress, Charles Thomson, arrived on April 14, 1789, to read him the Senate president's letter informing him of his official election. Ever conscious of propriety, Washington had drafted an acceptance speech. He read it to Thomson as they stood, face to face, in the New Room, the grandest space at Mount Vernon.

Two days later Washington embarked on a week-long journey to the nation's capital in New York. Along the way he was met at almost every hamlet and crossroad by speeches, parades, toasts, banquets, and huzzahs. In Philadelphia alone twenty thousand people turned out to cheer the new president, who, mounted on a white charger, passed beneath a celebratory arch of triumph designed by Charles Willson Peale.

Washington was sworn in as the nation's first president on April 30, 1789, though even in the days before, he confided his reluctance to a friend. He wrote to his old artillery commander, General Henry Knox (soon to become his secretary of war), "My movement to the Chair of Government, will be accompanied by feelings not unlike those of a culprit who is going to the place of his execution."[37]

As the year 1789 ended, Washington was peopling his cabinet, delegating responsibilities to able men (Hamilton had accepted treasury with alacrity, though Jefferson remained coy about the office of secretary of state). He worried over his advancing age. Though not yet fifty-eight, the previous summer he had been forced to consider his mortality when a persistent fever and a growth on his thigh had meant

surgery. The procedure to remove the large tumor required a deep incision, without anesthesia. At the time, Washington told Dr. Samuel Bard, "I am not afraid to die and therefore can bear the worst." Almost as soon as he returned to work (he spent forty days reclining painfully on a settee, unable to sit at his desk) word reached him of his mother's death of cancer of the breast.

———

TRUMBULL WAS A man on a mission, and he seemed to be progressing nicely toward his objective.

His completed canvases for the two battles early in the war were at hand, together with his *Declaration*, a work in progress. Three other American history paintings were under way too, each commemorating a well-remembered victory. The first, *The Capture of the Hessians at Trenton*, would portray the victorious General Washington at Trenton on the morning after the nighttime crossing of the Delaware on December 26, 1776. In the second, *The Death of General Mercer at the Battle of Princeton*, Mercer's horse has been shot from beneath him, and, his sword raised, he attempts to defend himself against a British grenadier poised to deliver the mortal wound with his bayonet. Washington is at center, in the middle distance, where the battle rages. Mercer will die, but Washington, with a fearless disregard for his own safety, will lead his men to a crucial victory. The third canvas, *The Surrender of Lord Cornwallis at Yorktown*, depicts the British forces marching between two lines of the victorious American troops under Washington's watchful gaze.

While still in Europe, Trumbull had sought out Rochambeau, Lafayette, and other French officers and recorded them for *Yorktown*, just as he had done with Jefferson and Adams for his *Declaration*. Now, back in America, he desired a variety of other American likenesses, too. After a visit to his family in Connecticut (during which he worked in India ink at a sketch for *Trenton*) he returned to New York in the company of his brother Jonathan, a member of their state's delegation to Congress.

With the House of Representatives in session, Trumbull was able to begin recording elder statesmen and some of the military personages who had fought at the battles he was putting on canvas. With the graying of the Founding Fathers (fourteen Signers were already dead), Trumbull had grown "fully sensible of the precariousness as well as the value of many other lives," so he worked as quickly as he could.[38] But the figure he needed most of all—for *Princeton*, *Trenton*, and *Yorktown*—was General Washington on horseback.

On January 14 a dinner invitation brought Trumbull back to Cherry Street, where he was the president's guest along with two senators and nine members of the House of Representatives (including his brother). Although he was the only guest not in the government, he managed to advance the cause of his historic work by returning the kind invitation of his host and hostess, asking them to do him the honor of inspecting his paintings. The following week, on January 23, Washington recorded in his diary, "Went with Mrs. Washington in the forenoon to see the Paintings of Mr. Jno. Trumbull." Washington liked what he saw, and that very day Trumbull went public with his project.

In a New York newspaper, *Gazette of the United States*, the artist announced his plan to print thirteen engravings.[39] Having agreed to lend his likeness, Washington assumed the Painter's Chair for Trumbull for the first time on Wednesday, February 20, noting in his diary, "Sat from 9 until 11 o'clock for Mr. Trumbull to draw my picture in his historical pieces." They resumed that Friday, then had three more sessions the following week. Work slowed slightly as the Washingtons moved housekeeping to 39 Broadway. With its two drawing rooms, the much larger Macomb House better suited the family's entertaining needs. Washington received diplomats, politicians, and other visitors at the weekly Presidential Levees on Tuesday afternoons, while Martha greeted ladies and gentlemen for more casual conversation at Drawing Room Receptions Friday evenings. There was even space for a Painting Room for Trumbull when he came to work.

For the March 1 session, they varied the process. "Exercised on horseback this forenoon," noted Washington in his diary, "attended by Mr. John Trumbull, who wanted to see me mounted." Trumbull was closing in on what he needed, and on April 2 he published a broadside that described in full his big project and solicited buyers. He needed subscribers to underwrite the production costs of the engraving. The artist and di Poggi had commissioned Johann Gotthard von Müller of Stuttgart, Germany, to commence work on the plate for *Bunker's Hill*, a deal that had been reached before Trumbull returned the previous fall. The cost would be more than a thousand guineas, and Trumbull hoped that people would order in advance, putting money down and enabling him to commission more engravings as he completed the paintings.

Trumbull waited. When, after three days, he had received no subscriptions, he experienced what he himself described as "a fit of the Dumps."[40] His spirits rebounded when the first orders did arrive and, in the days thereafter, his subscription list came to include the names of the president, vice president, New York's Governor George Clinton, and various senators and representatives. Emboldened by the sales and his ten painting sessions with Washington, Trumbull went off to Philadelphia for two months, looking to collect both missing likenesses for his *Declaration* and to solicit additional subscribers.

———

WHEN TRUMBULL RETURNED, he prevailed upon Washington again, and on July 6, Washington wrote in his diary entry, "I sat for Mr. Trumbull to finish my pictures in some of his historical pieces." After a fashion—both men were reserved—they had become friends. As a student of the world, Washington found the well-traveled artist an informative and thoughtful companion. Trumbull appreciated that, during the time spent with Washington, he had been the recipient of "many civilities which added the endearment and affection of personal feelings to the reverential respect which his public character always commanded

from all men."[41] Trumbull also recognized that the best way to thank Washington for his time and trouble was to gratify Mrs. Washington.

With her husband's cooperation Trumbull began work on a canvas that, though small, portrayed a full-length image of Washington. In a sense, it was to be a painted-from-life version of his London portrait a decade earlier, only this time he didn't have to work from memory or imagination. He now knew the look of this man intimately, after having watched him at his own table managing a roomful of politicians. He had studied his maneuvers on horseback, seeing for himself the grace and ease with which Washington rode. While remaining somewhat in awe of him, Trumbull had come to know Washington as a social peer. Trumbull had seen Washington at war and in government; he had observed him charming the ladies and listening in stony silence to the words of his advisers.

For his gift to Martha, Trumbull chose to paint Washington not on horseback but standing beside a tall white steed. He selected as his backdrop Verplanck's Point on the Hudson River, some thirty miles above New York, where King's Ferry linked New England and the colonies to the south. It had been a strategic site during the Revolution when the British held New York, but Trumbull rendered it as a quiet waterscape on a low horizon. In Trumbull's *Trenton*, *Princeton*, and *Yorktown* scenes, Washington was one officer among many. In this portrait nothing would distract from Mrs. Washington's husband.

As he had with his histories, Trumbull took great pains with the minutiae of Washington's military dress. He always accumulated research, working from detailed sketches and notes regarding the landscape, the soldiers, and their equipment. This time, with Washington front and center, he could concentrate on such details as the uniform buttons, the spurs, and the straps and buckles on the horse furniture. He was able to paint from one of Washington's actual uniforms. (Once a soldier, always a soldier: In his first public appearance after recovering from his surgery he had come to the door of his Cherry Street house on July 4, 1789, dressed "in a suit of regimentals.")[42]

Still, it was the man, not his uniform or other accouterments, that made this painting an instant heirloom, one that Martha would leave as a specific bequest to a granddaughter and that would later pass from one family hand to another. The artist signed his named simply—"*J. Trumbull | 1790*"—before presenting the canvas, as he said, "*con amore . . .* as an offering of grateful respect . . . to Mrs. Washington."[43] He had succeeded in rendering on canvas better than anyone the latent physical power of Washington.

———

EVEN BEFORE TRUMBULL completed the gift for Martha, the painting won the plaudits of others. Mayor Richard Varick was among its admirers, and he decided New York needed its own *George Washington*. Only his desire was less modest in scale: The big city needed a life-size version, he told Trumbull. The painting he commissioned would stand nine feet tall and six feet wide.

Although the New York version portrayed the General and his handsome mount much as Trumbull had painted them for Mrs. Washington (Washington did not sit for this public portrait, so Trumbull copied Mrs. Washington's smaller version), the painter did vary the mise en scène. He portrayed lower Broadway in ruins and British ships leaving the shore. He was commemorating the evacuation of New York in 1783 by the invading forces that had occupied the city since 1776. It was Washington the victorious, towering over the retreating vanquished.

Trumbull received commissions for other Washington portraits in the next several years, among them one for the city of Charleston, South Carolina. He painted the battle at Trenton into the immediate background, blending his portraiture and history painting styles. He was pleased with the result, calling the painting "the best certainly of [the Washington portraits] I painted, and the best, in my estimation, which exists in his heroic military character."[44] The town fathers disagreed and rejected the painting. They wanted a more placid Washington. Trumbull obliged.

His history paintings progressed slowly (*The Declaration of Independence* wasn't completed until 1820). Although his labors as a painter were widely admired, the results still proved disappointing to the sensitive artist. Had he been able to find just five hundred subscribers willing to pay a guinea and a half for each of the prints as his engravings became available, he might have been able to live comfortably, though not opulently, in the manner of the social class he had been brought up in. When he did not, after investing some twenty years in becoming a painter, he abruptly abandoned painting in 1794. He accepted an invitation from John Jay to become his secretary on the Jay Treaty Commission in London and sailed back across the Atlantic. He would remain abroad for ten years.

His long-promised engravings of *Bunker's Hill* and *Quebec* appeared in 1797, and, though he resumed painting in 1800, he would never regain his artistic passion. As he confided in a letter to a Connecticut friend, "I feel at times not a little anxiety on the Subject of *picture making.*" It would never provide him a sufficient income ("I have by no means money eno: to live comfortably without business of some sort"), and he hated the fact that art remained unappreciated in America. As he summed it up, "my Countrymen care very little for the only thing which I pretend to understand."[45]

"The Washington Family"

The Likenesses of the young people are not much like what they are at present . . . [but] the portrait of your Self and Mrs. Washington are generally thought to be likenesses.
—Edward Savage,
writing to George Washington, June 3, 1798

I.

Winter 1789–1790 . . . 3 Cherry Street . . . Manhattan Island

LIKE MANY ANOTHER New England country boy, Edward Savage set off to make his fortune in New York. Born on a farm in central Massachusetts, he had spent several years in Boston learning to paint, and his facility was such that he found patrons willing to pay him to copy other people's canvases, including the sophisticated work of John Singleton Copley. He had begun to receive local portrait commissions, too, but as he walked along Cherry Street in early December 1789, his twenty-eighth birthday a recent memory, he had a bigger plan in mind.

Savage had adopted the fashion of powdering his hair. When the goldsmith-turned-artist arrived at the doorstep of the President's Mansion, the whiteness of his hair set off his dark brown eyes. He felt confi-

dent of his reception since he carried a letter of introduction from Joseph
Willard, president of Harvard College. The addressee was George
Washington.

"When you were in the Philosophy Chamber of the University in
this place," Washington soon read, "you may perhaps remember, that I
expressed my wishes, that your Portrait might, some time or other, adorn
that Room. Since [then], Mr. Savage, the Bearer of this, who is a painter
and is going to New York, has called on me and of his own accord has
politely and generously offered to take your portrait for the University, if
you will be so kind as to sit."[1]

Washington, by now all too familiar with such requests, sent Wil-
lard a courteous letter. "I am induced, Sir, to comply with this request
from a wish that I have to gratify, so far as with propriety may be done,
every reasonable desire of the Patrons and promotors of Science."[2]

To accommodate Willard, Washington took a seat in the Painter's
Chair several times during that holiday season for the unknown Mr.
Savage. The third and last of the sessions before the easel occurred on
the morning of Twelfth Night, January 6, 1790, George and Martha's
wedding anniversary. By then a recognizable likeness had emerged on
the canvas, with the deep-set dark blue eyes, long nose, and the fleshy
jowls of a man married thirty-one years.

The thirty-inch-by-twenty-five-inch oil would be delivered to Har-
vard later that year. Many who saw it expressed their admiration. Josiah
Quincy thought the portrait "the best likeness" he had ever seen of Wash-
ington, even though he went on to observe that "its merits as a work of art
are but small."[3] But well before the bust portrait made its way to Cam-
bridge, Savage had conceived a plan whereby that first picture, executed
gratis, might be the means of launching a more profitable enterprise. A
man of entrepreneurial instincts, he recognized that a market existed for
images of this admirable man, about whom so many were curious.

John Adams soon offered encouragement. His was a double request,
as the vice president wanted portraits of both Martha and George. The

chief executive duly obliged both the painter and Adams, sitting again on April 6, 1790. Savage made quick work of the assignment, and, just eleven days later, he delivered the pair of canvases. Along with the finished paintings came a bill to "The Vice President of the United States [for] forty Six Dollars & 2/3rds for a portrait of The President of the United States & His Lady."[4]

During that winter Savage also took images of George and Martha's wards, Nelly and Wash, then ages eleven and nine. He also made a third version of the General's portrait, which he kept for his own reference. But it was another canvas, one that drew upon all of Savage's Washington family images, which would distinguish the work of the enterprising artist in the years to come.

Like most of the other painters in his generation, Savage had felt the influence of the late John Smibert. His indebtedness was more direct and, in a literal sense, even larger than that owed by some of the other painters. The picture that gained Savage enduring fame (and substantial profit) can be traced directly back to the grandest of Smibert's canvases. Savage's great notion was inspired by *The Bermuda Group*. He would echo the painting's composition (framing his foreground figures with columns, together with a landscape view at the back of the picture space) and even its palette (the muted reds, browns, greens, and blues).

Savage knew the big oil that remained longer than all the others in Smibert's Painting Room on Queen Street. To that address, then, we must return.

II.

1729–1731 . . . Group Portrait . . . Dean Berkeley and His Entourage

GEORGE BERKELEY LOOKS distracted. Only a moment ago, it appears, he waxed philosophical while his admiring friend, John Wainwright, scratched the older man's thoughts into a manuscript book.

Now, still leaning forward in his chair with quill in hand, the scribe waits for Berkeley to resume his discourse. But the churchman—a tall, heavy-set man in black cassock and long clerical collar—stares into the distance.

The two men are not alone. Anne Foster, Berkeley's wife, sits next to her standing husband, attired in an elegant yellow dress. Their young son, Henry, plays on his mother's lap, a peach in his hand. Anne's companion, Miss Handcock, sits on her other side, looking at mother and child, and two gentlemen stand behind the seated figures. One leans on the back of Miss Handcock's chair; the other looks over Mr. Wainwright's shoulder at his jottings.

Believable as it may appear, this scene never could have taken place. The "Large picture," commissioned by "Mr. Wainwright, Esq.," was begun by John Smibert in England in "Juley" of 1728.[5] After making some preliminary portraits (including Wainwright's), Smibert packed up his sketches and departed with Dean Berkeley's entourage when they embarked on their transatlantic voyage on September 4. Wainwright, an admirer of Berkeley and a patron of Smibert, gave Smibert ten guineas as a first payment for the painting, but he did not accompany the group on their journey to the Americas on their educational mission.

After the party reached America, the painting remained unfinished for several years. In that time young Henry Berkeley joined the party—the small boy had not even been conceived in the summer of 1728, since Anne Foster gave birth to him late the following spring in Newport, Rhode Island. Smibert probably added the toddler to the composition when he visited Berkeley and company in January 1731. That would have been shortly before the other members of the Bermuda group made their journey back across the Atlantic. Smibert's picture thus became a record of an imaginary moment, fixing in time the life and death of a dream. Wainwright had commissioned the group portrait to commemorate Berkeley's great adventure, but by the time he forwarded to Boston the balance due Smibert for its completion (thirty guineas), Berkeley's grand plan for a North American university had been abandoned.

Still, Smibert's conversation piece had its own closely reasoned plan. The artist located his friends in front of the shafts of three classical columns. Seen in the distance is a rocky seascape with tall pine trees. Quite simply, the cultured Europeans standing before us, shaded by a classical building, have arrived in an untamed landscape. The painter's friends are actors in a play that was halted halfway through its composition.

While Berkeley's grand scheme faded like a sailor's red sky, the big painting—it was the largest American canvas of its time—remained on view in Smibert's studio. The canvas was much more than just big. Writ large in its pigments were Berkeley's ambitions, conveyed in a work that, for its day, was highly sophisticated. Smibert himself must have recognized its greatness, as it is the one of his hundreds of American works that he chose to sign.

For decades, the life-size figures on the canvas witnessed a parade of visitors strolling past, although the never-to-be college in Bermuda faded into obscurity. If sheer size was part of the picture's power, it was singular in other ways, too. Before *The Bermuda Group*, no artist in America had succeeded in painting a group portrait. Almost no one else had even tried to paint more than two people on a single canvas. The usual preference was for single figures painted actual size. It made more sense to paint paired or "pendant" portraits, rather than to memorialize a couple together, given the average life expectancy and, in particular, the frequency with which women died in childbirth. Smibert's big picture was an exception, a sophisticated illusion, an entirely plausible rendition of a scene with life-size figures. His portrayal of his brave English band was so persuasive that at least two young American artists in Smibert's lifetime were inspired to paint large family portraits that were unmistakably derived from *The Bermuda Group*.[6]

When Copley began to paint in earnest after Smibert's death, the small range of artistic references available to him included the works in Smibert's studio. From *The Bermuda Group*, he unashamedly borrowed the pose of the two women for an early painting. Charles Willson Peale

and John Trumbull also painted conversation pieces of their families af-
ter seeing Smibert's canvas. Though they didn't copy Smibert's work, his
vision of his Bermuda-bound colleagues was certainly their first intro-
duction to a group painting.[7] For each of them the experience of Mr.
Smibert's group painting made such a painting seem a natural conceit.

Not so many years later, along came another painter, the young
Massachusetts-born Edward Savage. He would turn out his own con-
versation piece, but his subject would be a grander family—not his but
the nation's—and his painting and the uncounted prints and other copies
made of it would help define America's indispensable man for his
countrymen.

III.

1791–1793 . . . London

E DWARD SAVAGE MOVED to London to advance his new
craft. Like other aspiring American artists, he sought out Benjamin
West, who had just been elevated to the presidency of the Royal Acad-
emy. In that foreign capital, Savage thought he could master the profit-
able art of engraving. When he arrived, his skills were no more than
rudimentary, but by early 1792 he was able to publish a good-quality
stipple engraving based upon the *George Washington* he had painted for
Harvard College. The General looked his age (Washington turned sixty
just as the print was issued), with a somber dignity.

Savage continued his painting, making a variant portrait of Wash-
ington, this one portraying the Virginian as a statesman rather than a sol-
dier. The uniform has vanished; instead, Washington wears a black velvet
coat, with wrist ruffles and a lace jabot at the neck. In this three-quarter
view, he is seated at a table and holds in his hands a document distinguish-
able as the plan for the new Federal City (though the man himself would
always have difficulty bringing himself to call it "Washington," the new

capital had recently been given that name). Savage published this portrait, too, as a print, extending his artistic reach once more by engraving the image as a mezzotint. But its significance would prove to be as a stage in the development of a much bigger painting.

Prior to leaving New York two years earlier, Savage had begun work on an easily portable oil study—it was eighteen and a half inches high by twenty-four inches wide—of a very different picture. This was the Washington family group, which, he later told Washington, he had also begun transferring to a copper plate. The image was still taking shape in his mind, and, during his London days, Savage kept the canvas and the copper plate near at hand. At odd moments he returned to them, altering the figure of Washington to coincide with the three-quarters portrait. He incorporated the map of the Federal City, and the mezzotint of Washington and the canvas also came to share the same backdrop. He added the base of a Doric column and a bulky swagged curtain to the work in progress. During his stay in London, Savage added a fifth figure, too, a slave in livery standing at the periphery of the family group. For a model he used the black manservant of the American minister to the Court of St. James's.

This project—Savage called it *The Washington Family*—became the one on which he placed his greatest expectations. His hopes for *The Washington Family* grew as he observed the newest currents in the London art world. He was learning about more than engraving, taking careful note of the fashion for mounting an exhibition that consisted of a single large work, usually a history painting, which portrayed a contemporary hero. One of the most successful practitioners of the painting show was Savage's émigré countryman, John Singleton Copley, who had taken to installing his newest large-scale painting in a grand frame that resembled the proscenium arch of a theater. Savage had arrived in London in time to join the queue to see Copley's *Siege of Gibraltar*. Some sixty thousand customers that spring had paid to see the immense canvas (it was eighteen by twenty-three feet) that commemorated a 1781 naval

battle, in which the English garrison holding the strategic Rock of Gibraltar had held off the combined forces of forty-eight French and Spanish ships. George III and his queen had been among those who viewed the heroic painting in its eighty-five-foot-long "magnificent Oriental tent" in Green Park. To Savage, the notion of audiences numbering in the thousands paying a shilling each to view such a spectacle seemed an appealing business model, particularly when compared with his recollections of his father's struggle to extract a thin living from the rocky soils of Princeton, Massachusetts.[8]

IV.

February 22, 1796 . . . The Columbian Gallery . . . Philadelphia

WASHINGTON'S BIRTHDAY? To Savage, it seemed the perfect symmetry. While Savage was abroad, the President had been reelected for a second term, and, despite growing political disagreements between his Federalist Party and the opposition Democratic-Republicans, Washington's status had hardly diminished. It was Savage's profound hope that the birthday timing would benefit a project that had required six years to mature. Now, with its paint still drying, the canvas was going on display.

Savage had returned to America with big plans for promoting his art. In May 1794, Savage opened an exhibit in Boston that he called the Columbian Exhibition of Pictures and Prints. Later that year, with his fortunes on the rise, he married a Boston girl, Sarah Seaver. By 1795, when he opened the doors to his Columbian Gallery in Philadelphia, he and Sarah were the proud parents of a namesake son, Edward. His brother was already established as a successful merchant in Philadelphia, and Savage had decided to try the American capital, too, welcoming the public to a display that featured "a large collection of ancient and modern Paintings and Prints."[9]

There being no equivalent of the Royal Academy in the United States, public art exhibitions were virtually unheard of in America. Charles Willson Peale had hung the upper walls of his Museum with his portraits, but his painted worthies were often overlooked by patrons absorbed by the natural history specimens and other curiosities in the cases beneath. Mr. Savage's exhibition also featured something quite new and different. As his countryman Copley had done in London, Savage would display a large canvas that offered viewers an almost life-size experience. The centerpiece of Savage's Columbian Gallery was to be his magnum opus: On its patriarch's birthday, *The Washington Family* would have its debut.

He had completed *The Washington Family* in a new incarnation. Years earlier he had begun small, but during his two years abroad, his ambition—and a second version of the painting—had grown larger. He now hoped to make a splash in America as great as Copley had done in London. The Washingtons on his new canvas were as big as life, and the canvas itself stood seven feet tall and nine and a half feet wide.

Upon his return to Philadelphia in 1795, he found much had changed in America, including two of the players in his big conversation piece. Wash and Nelly, the Washington grandchildren, were no longer the youngsters they had been in 1790. Nelly had become a young woman, widely admired for her beauty and intelligence, and Wash, just entering his teens, had grown perhaps a foot taller. In order to make his painting current for the public, Savage had scheduled new sittings at which he overpainted the earlier likenesses, making the girlish Nelly taller and giving her a more womanly figure (her seventeenth birthday was just a month away). Savage modified her younger brother's countenance. He also changed the portrayal of the servant, making him taller and older so that he would resemble more closely Washington's trusted wartime servant William Lee.

The painting's long gestation had allowed Savage to incorporate an array of symbolic elements into the picture, which he hoped would add

to its allure. He had conceived it in the tradition of *The Bermuda Group* and other group portraits he had seen in his travels, but he wanted his conversation piece to have the appeal of a grand history painting, too. Washington had become one of the world's most admired personages, and nowhere was he more esteemed than in America, where, in that brief historic moment before political parties evolved, he had been unanimously elected the nation's president. So Savage larded his canvas with reverential clues to Washington's world. In a later description he offered his own gloss on the painting's iconography.

"The General is seated by a table," explained Savage, "drest in his uniform, which represents his Military Character; his left arm rests on papers which are suitable to represent his Presidentship; Mrs. Washington, sets at the other end of the table, holding the Plan of the Federal City, pointing with her fan to the grand avenue; Miss Custis stands by her side assisting in showing the plan; George Washington [Custis] stands by the Gen. his right hand resting on a globe."[10]

Savage dared hope that picture-viewing could become a popular diversion in America, just as it had in England. He announced that his gallery show would open on "Chestnut-street, third door West of Tenth-Street." He sought to up the ante for his show by opening on Washington's birthday, a date that was already emerging as a suitable day of recognition for the aging General. Washington neared retirement—despite uncountable entreaties, he had refused to be a candidate for president a third time—so barely a year remained before another man would take the oath of office, assuming the role that no one else had held and that Washington had defined.

Those who attended on February 22, 1796, were asked to pay an admission fee of "one quarter of dollar." They came to look and to celebrate the President's sixty-fourth birthday, but they got something they did not expect. The experience of the Washington group portrait was unprecedented; there were few such conversation pieces in America, and no other of public figures. Its creator had advertised the event two days

before the opening as "the President and Family, the full size of Life."[11]

As Smibert had done with Dean Berkeley, Savage had placed Washington off center. The old General sits back in his red, brocade-upholstered chair, his legs crossed at the knees, with his left hand resting on the tabletop before him. His body appears relaxed but his face does not; Washington's jaw is set and he stares determinedly away from the viewer (remember, he never lost his dislike of having his picture taken). Sitting opposite her husband, Martha is her gracious self, wrapped in the voluminous folds of a fine silk dress and a black lace shoulder scarf. Her upright posture and beribboned mobcap make her seem taller than she appears in her other portraits. Like her husband, she looks distracted, but her composed features nevertheless convey the kindness for which she was renowned. Nelly stands at her grandmother's side, a pretty young woman with thick red hair and a fair complexion. Still a boy, the standing Wash barely reaches the shoulder of his seated grandfather. This casual arrangement of the family gives the vignette a relaxed air. So does the fifth and final figure, the liveried slave half hidden in the shadows behind Martha.

For those who came to see it, the effect of Savage's *Family* was unique and fresh, and not just because of its size and the presence of the assembled Washingtons. The audience found a larger American vision. Here was Washington as general, president, planter, world figure, and, perhaps freshest of all, as paterfamilias, all rolled into one. This was Washington, a childless man yet a father to these children and a Founding Father too. The attentive viewer perceived that the subject of the painting was twofold. Behind the people, the country is represented; it's not George Washington at the center of the piece, but a vista of America's natural beauty that is the focal element. The grander theme of America and its possibilities adds depth to an image that, initially, appears to be a portrait of a family unit, one with which almost any father and husband could identify.

The painting was widely admired. It was an immediate hit in Phil-

adelphia, and in later exhibitions when Savage took it on the road, New Yorkers and Bostonians found it admirable and even moving. Savage saw to it that his work was soon on view even for those unable or unwilling to travel. In the spring of 1798, he announced publication of the copperplate engraving of *The Washington Family*. "The print, representing General Washington and Family, all whole lengths in one groupe, will be ready for delivery by the 15th of March." The plate that went to press bore not only the image but also an identifying label, in English, that was repeated in French. Savage hoped his work would gain international distribution, and he employed a skilled engraver, David Edwin, a young English émigré who had trained in London and Amsterdam. Finished prints would cost one and a half guineas for those who subscribed in advance; latecomers would pay two guineas.[12]

Announcements appeared in March in the *Pennsylvania Gazette* and the *Time-Piece* (published in New York). In August 1798 Bostonians who read the *Columbian Centinel* learned that "A number of plates of the elegant picture of the *Washington* family, are expected to arrive from *Philadelphia* in all *September* . . . The execution is wholly American; and . . . this plate is worthy to adorn the parlours of every house in the U. States.—It represents our late beloved PRESIDENT, his amiable Lady, and her two Grand-children . . . The likenesses are correct, and impressive— the drapery exact—and the engraving throughout masterly."[13]

Washington himself ordered four freshly printed copies of the copperplate engraving. They came to him at Mount Vernon directly from Edward Savage. Per the general's orders, the images had been mounted in "handsome, but not costly, gilt frames, with glasses."[14] In the letter that accompanied the prints, Savage explained, "I Delivered four of the best impressions of your Family Print. They are Chose out of the first that was printed. Perhaps you may think that [they] are two Dark, but they will Change light after hanging two or three months. The frames are good Sound work. I have Varnished all the Gilded parts which will Stand the weather and bare washing with a wet Cloth without injury."

His explanation delivered, the artist could not help but confide in the man responsible how good business was. "[A]s soon as I got one of the prints Ready to be seen I advertised . . . that a Subscription would be open for about twenty Days. Within that time there was three hundred and thirty one Subscribers to the print and about one hundred had subscribed previously, all of them the most respectable people in the city. In consequence of its Success and being generally approved of I have continued the Subscription. There is every probability at present of its producing me at least ten thousand Dollars in one twelve month. As soon as I have one printed in Colours I shall take the Liberty to sent it to Mrs. Washington for her acceptance. I think she will like it better than a plain print."[15]

Just a few years earlier, John Trumbull had encountered a great deal of trouble earning what he regarded as an acceptable living at the painting game, but Edward Savage demonstrated that it could be done. His artistic aspirations were less than those of some of his contemporaries. Compared to the likes of Peale and even Trumbull, he sought out less instruction and devoted less energy to mastering the art of painting. His likenesses seem competent, at best, when compared to the expressive paintings of his New England contemporary Gilbert Stuart. Even in his own era, his work was disparaged by America's first art historian, William Dunlap. "Savage published prints from his own *wretched* pictures," wrote Dunlap in his compendious two-volume *History of the Rise and Progress of the Arts of Design in the United States* (1834).[16]

Edward Savage may fall short of greatness as a painter—neither *The Washington Family* nor, for that matter, its antecedent, *The Berkeley Group*, is an inspiring painting. On the other hand, both grand paintings exist and have endured because of inspiring men. Following a path established by Smibert, Savage was able to do something his predecessors could not do: He found an immense audience for his work. He became an art impresario, as much an entrepreneur as artist. His personality may have helped. In the miniature watercolor on ivory that he painted of

himself, his complexion is ruddy, and he appears possessed of a sanguine disposition, with a smile at the ready. But his memory is ensured not by his character but for the popular appeal of his domestic view of Washington and the wide currency it achieved after the general's death.

—

IN THE BIG painting of *The Washington Family*, Wash and Nelly looked like their current teenage selves, but in the Savage engraving begun years earlier, they reverted to childhood. The fifth member of *The Washington Family*, Washington's valet and war-time companion, William Lee, hovers at the edge of the image, an almost spectral presence. In the caption printed at the foot of the engraving he isn't even mentioned. His figure, set deeply into the picture space behind Martha's chair, seems a worthy metaphor for the less-than-human status of a slave.

In October 1767 a Virginia widow sent some of her property to the auction block. Washington attended the sale and purchased "Mulatto Will" for sixty-one pounds, fifteen shillings, along with the boy's brother, Frank, for fifty pounds. At the same auction, he also bought the "Negro boy Adam" for just nineteen pounds.[17] The disparity in prices was probably a function of skin color, since the destiny of dark-skinned slaves was usually to work in the fields, while those of mixed race were often favored for greater responsibilities as craftsmen or house servants.

Will's precise birth date is uncertain, but he was about sixteen when Washington acquired him. Known as "Billy," the young man soon won a position of trust. By 1770 he was traveling to Williamsburg at "publick time," attending his master as his personal body servant during sessions of the House of Burgesses. He went to Philadelphia for the First Continental Congress in 1774, and gradually acquired a degree of freedom few slaves were granted. A superb horseman like his master, he traveled with the General throughout the war, accompanying him on horseback and on foot, well armed and mounted, entrusted with carrying Washington's

telescope in its leather case. For twenty years he remained almost constantly at Washington's side. He brushed his master's long hair in the morning and tied it back firmly with a ribbon in the military manner. Depending upon Washington's circumstances and needs, Will was his valet, huntsman, waiter, and butler. Respecting the man's wishes, Washington took to referring to him as William and indulged the addition of the surname "Lee." After the slave's marriage during the war, Washington even attempted to arrange for Lee's wife, Margaret Thomas, a free woman from Philadelphia, to come to Mount Vernon.

William Lee was helping Washington to survey his Four Mile Run tract in 1785 when the slave fell carrying the hundred-foot surveyor's chain. According to Washington, Will "broke the pan of his knee." He was able to accompany Washington to Philadelphia in 1787 for the Confederation Congress, but the following year he injured the other knee in a fall at the Alexandria Post Office. When Washington became president in 1789, Will set out for the new capital in New York. He got as far as Philadelphia, but his damaged knees forced him to quit the presidential caravan. After seeking medical treatment, he reached New York, but eventually he returned to Mount Vernon where, immobilized by his injuries, he practiced the cobbler's craft. His singular status earned him a house near the Mansion. Probably an alcoholic, certainly crippled by his injuries, Lee in the coming years welcomed veterans of the late war who came to visit Washington but also stopped to converse with Will, reminiscing about battles or winter hardships.

The presence of an African-American servant in Savage's picture bespoke artistic convention and an attempt to demonstrate the means and comfort of the Washingtons' lives. Even so, it is impossible for us to look at this image without thinking of the General's struggle to countenance human bondage in an era of new freedoms. The sitter certainly never discussed such matters with his recorders, but he felt the weight of the devoted service of "Mulatto Will" and of the bravery of black soldiers in the Continental Army. He had considered the passionate arguments

of Lafayette and Lear, both of whom made cogent arguments for manumission. By the time Savage went public with his family portrait, Washington regarded Will Lee and all his slaves differently from the way he had been taught as a boy.

Few in the world into which George Washington was born had any scruples about slavery. It was legal in all thirteen colonies, but in the course of his life Washington wrestled with conflicting and evolving thoughts. As an adult he resolved never to break up a slave family, a practice that was all too widespread. He treated his slaves well (Lear: "The negroes [at Mount Vernon] are not treated as blacks in general are in this Country, they are clothed and fed as well as any labouring people whatever and they are not subject to the laws of a domineering Overseer—*but still they are slaves*").[18] Washington worried about intermarriages between his slaves, over whom he had absolute control, and Martha's. He was moving toward the stunning resolution to free all his slaves, but he had no legal right to free Martha's dower slaves unless he could persuade the Custis heirs (to whom they would revert at her death) to manumit them. That he was unable to do, and he knew it would divide families.

In Washington's last will and testament the second person mentioned by name—after Martha—was a slave. "And to my Mulatto man William (calling himself William Lee) I give immediate freedom."[19] Washington's unambiguous words hang in the air when the viewer examines the slave in Savage's image, dressed in livery, a little-noticed dark face.

IV.

1802 . . . The Columbian Gallery . . . The Pantheon . . . New York

THE PRESENCE OF someone else's museum in Philadelphia—our old friend Charles Willson Peale operated his natural history and portrait museum in the Pennsylvania State House—helped persuade

Edward Savage to try his luck in New York in 1802. He entered his name in the *New York Directory* that year as a "historical painter, at the Pantheon." His new gallery, in a circular building formerly used as a circus on Greenwich Street, one block north of the Battery, soon outclassed the competition. Not only did he have his *Washington Family* on view, but his curiosities included a stuffed polar bear and an electric battery. The latter he used to deliver deliciously surprising shocks to his visitors.[20]

The Washington Family was among the two-hundred-plus paintings and prints he displayed; some were his own work, some not. They included a double portrait of John Hancock and his wife, one of the Philadelphia astronomer and mathematician David Rittenhouse, and another of Benjamin Franklin. A self-portrait of Benjamin West and a John Trumbull full-length of John Adams were also in the show, along with a rich mix of other images, including two Savage engravings of eruptions of Mounts Vesuvius and "Aetna."[21]

Savage claimed the show offered "the richest collection of valuable paintings ever exhibited on the shores of Columbia."[22] A writer in the newly established *Morning Chronicle* took issue with the installation. "The Proprietor of the Gallery['s] . . . best pictures are placed so *low* as to render it impossible to have a good view of them, *without lying flat on the floor.*" That said, however, the pseudonymous Jonathan Oldstyle concluded, "The present collection is . . . in a good state of preservation and sufficiently interesting."[23]

For admirers of George Washington, two items in addition to *The Washington Family* held especial interest. Architectural images were a rarity, but Savage displayed two oils of Mount Vernon. The renderings were primitive, their perspective askew and the scale distorted. But they offered a curious northern public the chance to view the General's much admired Virginia property.

Washington had traveled to South Carolina in 1791 on a trip to the southern states (in 1789 he had ventured north) in which he sought to measure public opinion on the new government. At the same time Sav-

age had been in Georgetown, outside Charleston, completing a portrait commission. Having resumed his acquaintance with Washington early that summer, Savage was undoubtedly among the stream of visitors who sought Washington's hospitality at what the Virginian called his "well-resorted tavern" on his return north. During that visit, it seems, he drew the imposing house the president called home.

In composing one of the paintings, the artist placed the house almost in the background. The structure is central to the image but not large, seen from afar on its elevated site overlooking the Potomac. A sunrise sky, pastoral landscape, and multiple outbuildings suggest the manorial character of the general's plantation. In turn, the fence and stone wall of the ha-ha help explain Washington's marriage of the wild and civilized.

The second painting offered a reverse angle on the house. It reveals the west front overlooking the green expanse of Washington's "bolling green." The squire of Mount Vernon was consciously working in the tradition of such great English landscape gardeners as Lancelot "Capability" Brown (who got his name because he told clients that their grounds had unrealized "capabilities"). Washington, too, used plantings, the lawn, fences, outbuildings, and other elements as part of his composition.

The house is rendered with such care that it appears Savage's original intention was to make a pure landscape; the two sets of figures on the green seem to be an added flourish and are crudely painted. Approximations of George and Martha stand with Nelly. A short distance away, Wash, two dogs, and a uniformed figure walk toward them. The composition is such that one's eye is strangely drawn to the fuzzy oil splotches that are George and Martha. The grand house is framed by trees, but all has become a backdrop for the family.

For the New York audience the two-hundred-plus pictures must have seemed almost overwhelming, an unprecedented tide of images, wave upon wave of places and people. With the pictures hung floor-to-ceiling, with adjacent frames so close as almost to touch one another, a close examination of any one of them would have been difficult.

Taken together, however, Mr. Savage's unique images of Mount Vernon and the Washingtons make them of inestimable value. The later addition of the figures to *The West Front of Mount Vernon* casts the painting in a distinctive historic light. Paintings appear to be permanent and static; but Savage peopled this landscape over time. He recorded the Mansion House first in 1791 on his Virginia visit, but he must have added (or at least amended) the figures that walk toward the viewer much later, many miles from Mount Vernon (Nelly and Wash are quite evidently older than ages ten and twelve, as they would have been in 1791). Savage didn't merely illustrate what he saw; the image has been staged in the way a scenic director imagines his design.

The genius of the piece for which he is best remembered, *The Washington Family*, offers Savage's most essential insight: He understood that his public—which was merely a slice of Washington's much larger constituency—wanted to see Washington in his context. *The Washington Family* and *The West Front of Mount Vernon* are very different paintings. One is a modified architectural, the other a conversation piece, but together they provide a sense of Washington at home, and a picture of his home at a distance. The same figures are seen, but they are distributed and portrayed differently. The artist has provided two dumb shows, different yet complementary, which offer an original and dynamic interplay.

Those who saw Mr. Savage's images came away with the sense that they knew the General a great deal better: This was no monarch; no formal audience was required to see this man. He was a family man, not so different from the million other men in households in America at the turn of the nineteenth century. To understand the General, who revealed so little about his private feelings, it was a useful, if imperfect, portal.

Stuart Slouches
Toward Philadelphia

I heard West say that "he nails the face to the canvas."
—*William Temple Franklin*

I.

1793 . . . A Sunday in the Country . . . Stillorgan Farm

WHEN HE LOOKED at his pigs, the ruminative Gilbert Stuart could not help but recognize how well his time in Ireland had served him. The fields and animals on his modest farm were reminiscent of the life he had known as a boy in Rhode Island. Within the confines of his own gates, he tended his gardens and flowerpots. Here he was a farmer, more concerned with feeding his pigs (he gave them apples from his own fruit trees) than with the Dublin bailiffs who might come knocking to collect some overdue debt.

For Stuart, this cottage in a nobleman's deer park was the perfect escape from Ireland's capital. As other droll companions had in London in previous years, Dublin's poets, musicians, actors, and authors had

proved irresistible to Stuart, and he had the bills to show for it. He owed the butcher, the baker, and the wine merchant. But his new life here in the country, though hardly solitary, suited him and his wife, Charlotte, and their growing brood of children. Another man might have been happy to remain on the farm on this headland at Black Rock, but as he looked out at the Irish Sea toward Holyhead, Stuart knew that circumstances were conspiring to send him back to America.

Arriving from England six years before, he had been utterly charmed by Ireland. Like the artist himself, Dublin was on the threshold of world-class status. The rationalized grid of wide streets that he walked was dotted with construction sites. Almost everywhere he saw grand neoclassical buildings. Trinity College had an elegant new face, almost one hundred yards long, with a tall portico at its center. Nearby stood the columned arcades of Parliament House. The Rotunda Hospital had been the first purpose-built lying-in hospital in the British Isles, and the costs of its operation were defrayed by the sumptuous Assembly Rooms, where the landed gentry met to eat, dance, and amuse one another in the elegant Round and Supper Rooms. On the banks of the River Liffey stood the grandest building, the Custom House, with its tall dome. New buildings all, they redefined the port city and its growing prosperity.

Stuart had journeyed to Ireland at the behest of no less a personage than Sir Joshua Reynolds, still one of the leading portraitists in England and president of London's Royal Academy of Arts. The aging Sir Joshua, already deaf and with his eyesight fading, was reluctant to embark on the long trip over land and sea, so he asked Stuart to go in his stead to execute a commission for one of his patrons. The thirty-one-year-old Stuart agreed and, though the portrait of the lord lieutenant of Ireland, the Duke of Rutland, never came to pass (no sooner had Stuart appeared in Dublin in the fall of 1787 than the duke died suddenly of a "putrid fever"), Stuart's prospects hadn't been diminished. The painter's fortuitous arrival had proved to be just what the city's nabobs desired, and within weeks the Dublin *Evening Herald* proclaimed, "Mr. Stewart, an English

gentleman lately arrived in the metropolis, excels in his delicacy of coloring and graceful attitudes . . . and has a happy method of disposing his figures and at the same time preserving a strong resemblance."[1] The writer spelled his name incorrectly and confused his country of origin (Stuart had arrived from a twelve-year residence in London), but had no difficulty finding the words to praise the painter's talents.

At first Stuart established his Painting Room in a rented house on Pill Lane. The neighborhood was respectable, near the Liffey and not so far from another of the city's impressive new buildings, the immense legal edifice known as the Four Courts. He shared the house with his family, but he threw himself into his work and a gregarious social life that his temperament and his profession seemed to demand. They lived, it was said, in a very good style. Stuart was a voracious consumer of good food, drink, and conversation. He liked nothing more than to entertain guests with his wife's lovely contralto singing voice, and he often accompanied her on his flute. The daughter of a Berkshire apothecary, Charlotte Coates Stuart was pretty and intelligent and a fervent believer in her husband's talents.

His patrons included the new lord chancellor of Ireland, for whom he executed a life-size canvas, portraying the regal ruler in the style of royal portraiture, with his mace, luxuriant robes, and other symbols of power. He also recorded the faces of the speaker of the Irish House of Commons, a miscellany of lords and ladies, and many churchmen, including bishops and deans. He even consented to make likenesses of dogs and children, although he could not resist offering an implied commentary on the attitude of his patrons toward their painter. He rarely signed his works, but on the collar of a large Newfoundland dog in one portrait he penciled in "G. Stuart." He resented the notion that he was to be regarded as anyone's lapdog.

In Stuart's newfound home, the commissions had come from the Anglo-Irish ascendancy, the ruling class dominated by the British and a mix of old Protestant Irish families (under the Penal Laws, no Catholic

was permitted to vote, hold office, or own land). The city's elite inhabited the spacious downtown squares, living in new row houses fronted by doorways with sweeping fanlights. Visitors climbed to the second floor, the *piano nobile*, to find spaces decorated with fine stucco work applied by Italian artisans. At some of the better addresses, original Stuart portraits soon hung. More than a few of his old London clients had large land holdings in Ireland, so Stuart's renown preceded him. The very year he left England's capital, one of that city's newspapers had labeled him "The Vandyke of the Time."[2]

According to a painter friend, everyone who was anyone in Dublin wanted a Stuart, as "a rage to possess some specimen of his pencil took place."[3] He had no peer in Ireland's capital; aspiring younger painters sought his guidance, and older lesser artists moved elsewhere. His commissions were numerous, and at first the half-fees he collected from his sitters (monies were paid in advance) made possible his gracious lifestyle. Within two years of his arrival, however, he was cast into Marshalsea Prison in the summer of 1789. Unlike his friend John Trumbull, incarcerated for treason a few years earlier, Stuart found himself in a debtors' prison, his obligations having far exceeded his income. Even so, the spirited Stuart remained undaunted, turning his time in jail to advantage. Just as Trumbull had done, he set up his easel. He welcomed "men of wealth and fashion . . . who wanted portraits from his hand," and, after he had collected enough half-fees to clear his outstanding debt, he regained his freedom, at least for a time. He liked to tell the story of another episode in another prison when, having painted both the jailer and his wife, he was set free by the grateful sitter.

Stuart's spirits could change like the tides of the Irish Sea; when "in the humor," he painted with great verve, but at other times his temperament varied from the manic to the depressed.[4]

Given the chance to try living in a village on Dublin's outskirts, Stuart had packed up his family and started afresh. At Stillorgan Park the Stuart family's cottage was located on an estate owned by the Earl of

Carysfort, an English nobleman and a friend of Sir Joshua. Stuart was away from the everyday temptations of Dublin but close enough that, by taking the short walk down a narrow lane to the inn at Black Rock, he could travel the several miles to Dublin in a public coach. There he maintained a Painting Room for the convenience of the Dublin customers on whom his livelihood depended.

From the high ground of his acres in Stillorgan, Stuart could take in the waterscape around him. This rural interlude was among the happiest times in his life, but Mr. Stuart could hardly deny that it would soon be necessary to move on once more. His ever-growing debts were one consideration; so was his emerging dream of creating a great painting that would make his penurious past merely a memory.

———

THE SMELL OF salt air was well known to Gilbert Stuart. By birth he was a Rhode Islander, a child of the tiny colony of islands with a mile of coastline for every three of land area. The sound of freshwater rushing by had accompanied Stuart's early years, along with the creaks and groans of an undershot waterwheel. That wheel drove the milling machine in the family's downstairs kitchen, its wooden teeth and gears grinding tobacco into snuff.

He was the namesake of his father, Gilbert Stuart of Perth, who had come from Scotland in 1751 to establish the first snuff manufactory in America. Gilbert the younger was born in the millhouse in 1755 and lived in the wood-framed homestead on the banks of the Mattatuxet Brook until Gilbert, age five, his older sister, Ann, and their parents moved to nearby Newport.

The business of making snuff proved disappointing once the growth of transatlantic trade made snuff cheaper to import than to produce. A small inheritance from a maternal relative enabled the Stuarts to move to Newport, and their means were sufficient that they owned two slaves (a mother and child) and enough land to maintain a garden and livestock.

Gilbert the elder set up shop on Banister's Wharf, where his wares included mustard flour, earthenware cups, writing paper, hats, shoe buckles, linen, silk, and sewing supplies.[5] The parents rented a pew at Trinity Church, and the boy learned his reading, writing, and sums under the tutelage of the clergy at Trinity's grammar school. His scholarship was unremarkable (he was, said a childhood friend, "a very capable, self-willed boy . . . habituated at home to have his own way in everything with little or no control from the easy, good-natured father").[6] The young Gilbert excelled as a musician. As a pupil of the church's organist, a disciplined German named Johann Ernst Knotchell, he mastered the pipe organ. Made in London, the instrument had been a gift to the parish from John Smibert's benefactor, Dean George Berkeley.

Gilbert began drawing at an early age, too, thanks in part to rudimentary instructions provided by an African slave named Neptune Thurston. When Stuart was barely into his teens, he painted a likeness of two spaniels for a local physician, who, recognizing the boy's ability to draw, provided him with painting materials. The animals were posed beneath another of Dr. Hunter's proud possessions, a fine locally made side table in the house's handsomely appointed parlor. The doctor engaged a second artist at the same time to paint portraits of people, and Stuart made the acquaintance of the itinerant Scots artist Cosmo Alexander. He hired on as his apprentice. From his master he learned to grind and mix pigments, lay out a palette, prepare canvases, and wash brushes. This training provided Stuart's first "lessons in the grammar of the art . . . [of] drawing—and the groundwork of the palette."[7]

The son of an artist (his first name honored one of his father's patrons, the Tuscan Grand Duke Cosimo III), Cosmo Alexander had trained in Italy and was well connected in London. With Stuart in tow, the worldly artist soon embarked on travels to Philadelphia; Norfolk and Williamsburg, Virginia; Charleston, South Carolina; and thence overseas to Edinburgh. The apprenticeship ended prematurely after less than three years with Alexander's sudden death in Scotland. For a time Stuart

continued his training in Glasgow with another painter, Alexander's brother-in-law, Sir George Chalmers, and he briefly attended university there. By the fall of 1773 he made his way back to America and began producing portraits on his own.

Not yet eighteen, Stuart wrestled with his talent, learning from every exposure to other artists. His father's onetime partner in the snuff business, Thomas Moffatt, was John Smibert's nephew. It seems that the connection enabled Stuart to visit the deceased Smibert's color shop (and the Painting Room above), then being operated by Smibert's widow and John Moffatt. Along the way, Stuart studied engravings based on the work of European masters. As others before him had done, he recognized that such images were models from which to borrow poses, pictorial composition, and miscellaneous details.

During these years Stuart's eye also fell upon the work of John Singleton Copley, then *the* artist of Boston. Copley's portraiture incorporated lovingly painted clothing, furniture, and other objects, but all very much in the service of inner dramas that seemed to be unfolding on the canvas. Stuart, too, began incorporating props—not merely costumes but books and quill pens and furniture as well—and he labored to capture his subjects in midgesture. Instead of depicting them as if frozen in place before his easel, he sought to create the illusion that these people were going about their business. His sitters' faces glowed. Far from being imprisoned by their pictures, their eyes looked beyond, their expressions vital, curious, and thoughtful. The crude and wooden people of his early paintings were transformed into alive and engaging characters.

When the nineteen-year-old painter felt ready to record the ruling class, he witnessed first hand the strength of the revolutionary winds swirling through the colonies. Stuart was in Boston in April 1775 when word reached the city of the opening battles of the war in nearby Lexington and Concord. A few days later, when the same news reached Philadelphia, the Continental Congress began the debate on who should lead the volunteer army that was assembling near Boston. The friction

between Loyalists and Patriots in New England threatened every trans-action conducted by merchants and artisans, and potential patrons had already begun to scatter. John Singleton Copley had left the growing divisions behind when he sailed for London almost a year earlier, and by the summer of 1775, Stuart's Tory father, mother, and sister were gone, too, settling on property they owned in the safety of the royal province of Nova Scotia. Left alone in Newport, Stuart recognized that the call for portraits, never an essential, could only diminish in the war that had now begun. The youthful artist made a pragmatic decision.

For years he had talked of his ardent desire to visit London and, lacking the sense of revolutionary outrage that animated many of his American friends, he decided it was time to go. He refused an opportu-nity to paint a full-length portrait of one of Newport's most influential men, Abraham Redwood, founder of the town's Redwood Library. By September he had sailed for London aboard the *Flora*.

Stuart would not return to America during the Revolution or for another decade thereafter. In his absence, the man who arrived in Boston to assume command of the Continental Army in 1775 rose to become the lodestar of the Republic. The first meeting of the General and his most important portraitist would occur only after the passage of another two decades.

———

GILBERT STUART'S EARLY days in London could hardly have been less encouraging. He had no particular plan, little money, and a single letter of introduction. On reaching the city, in November 1775, he discov-ered that the one friendly face he expected to see, his old schoolmate from Newport, Benjamin Waterhouse, had recently decamped for medical school in Edinburgh. Stuart's ill-conceived notion of making his living as a painter in a city full of artists quickly proved unrealistic. His customers were few and his fees so small that they barely paid for his daily bread.[8]

For a time, another of his talents helped to keep him solvent. A few months after his arrival Stuart was already in arrears to the landlord at

his cheap lodgings over a tailor's shop. He rambled through the city, his pockets empty and his desperation rising. One day as he walked along Foster Lane, he was drawn by the familiar sound of an organ. Though the majestic dome of St. Paul's Cathedral was within sight, the music he heard emerged from the more modest St. Catherine's Church. Stuart had no pennies to spare for the pew-woman's fee, but he ventured to inquire what occasion was being celebrated. None at all, he was told; rather, the vestrymen were present to judge candidates for the position of church organist. Despite his youth and shabby attire, he talked his way into an audition and won the position, along with a salary of thirty pounds per annum. The temptation to pursue his musical talents was great (he took flute lessons in those months from a German member of the king's band), and, for a time, he "lived on biscuit & music."[9]

His pursuit of a painting career gained new momentum with the return to London of his childhood friend that summer. Through Benjamin Waterhouse, Stuart gained a new source of commissions, and he began painting portraits of his friend's scientific colleagues. The two expatriate Americans also devoted a day each week to seeing London's sights. They favored the pictures in the Royal Collection at Buckingham House above the rest. Waterhouse, who knew him better than anyone, saw in Stuart the unpredictability that had led him to refuse the Redwood commission back in Newport. He left some of his London commissions unfinished and failed even to begin others. "With Stuart it was either high tide or low tide," Waterhouse observed. "In London he would sometimes lay abed for weeks, waiting for the tide to lead him on to fortune."[10] The painter became dependent upon Waterhouse, but his friend had neither sufficient means to maintain him nor the influence to get him to mend his ways.

Stuart himself finally managed to identify the necessary agent of change and wrote an uncharacteristically humble—even, groveling—letter. One meandering sentence of the undated inquiry, its syntax as tortured as the ego of the man who composed it, sums up its author's plight:

Pitty me Good Sir I've just arriv'd att the age of 21 an age when most young men have done something worthy of notice & find myself Ignorant without Business or Friends, without the necessarys of life so far that for some time I have been reduc'd to one miserable meal a day & frequently not even that, destitute of the means of acquiring knowledge, my hopes from home blasted & incapable of returning thither, pitching headlong into misery I have only this hope I pray that it may not be too great, to live & learn without being Burthen.[11]

Sent from his friend Waterhouse's rooms at 30 Gracechurch Street, the supplicating letter produced a change of fortune. Its recipient, Mr. Benjamin West, welcomed Stuart to his Painting Rooms. With Waterhouse's departure for the University of Leyden to complete his medical studies (he would find lodging there in the home of John Adams, then American minister to the Netherlands), Stuart took up painting draperies for West. More than Neptune Thurston and Cosmo Alexander, this painter, teacher, and mentor would provide Stuart with the opportunity he needed to make himself into a painter with a reputation for likeness.

⁓

FOR FIVE YEARS, Stuart worked at West's Painting Rooms at 14 Newman Street. At first, his work as a drapery painter was rewarded with half a guinea a week and, upon occasion, he posed for his master. After a time, he earned the privilege of making copies of some of West's paintings, and was also assigned to work on subsidiary elements in West's large-scale history pictures.

As a result of West's influence, a painting by Stuart of an unnamed woman hung in the 1777 annual exhibition at the Royal Academy of Arts. Three more Stuart canvases were accepted for the 1779 show, but the newspapers made no mention of the young American. Then, in 1781, his portrait of West was singled out by the press. "An excellent portrait," ob-

served the reviewer in the *St. James's Chronicle*, "I do not know a better one in the room."[12] Given the presence of pictures by Thomas Gainsborough and Joshua Reynolds in the same gallery, this was high praise indeed.

Stuart attended Sir Joshua's "Discourses on Art," a series of lectures given at the Royal Academy of Arts, but he did not attempt to join the Academy. If he had used West's influence to become a member, he might have enrolled in drawing classes. Instead, he worked at developing a style that was peculiarly his own. "Drawing the features distinctly and carefully with chalk [is a] loss of time," he observed. "All studies [should] be made with brush in hand."[13]

When Stuart regarded his sitters, he didn't see lines; he saw three-dimensional forms that he could better render in colors and tones. He started with the face, but not by underpainting in neutral tones. He began with pigmented oils, though his faces were thinly painted, almost translucent. Elsewhere on the canvas he began to apply more paint, raking it with his palette knife and leaving the thicker pigment to suggest fabrics rather than to re-create precisely the sheen and textures. The colors he used for his sitters' faces (the rosy pinks, soft orange, and creamy yellow) weren't blended on the canvas into a uniform complexion. Instead the viewer's eyes had the task of melding the pigments. When he worked for West, he painted as West did, but he employed a more painterly style on his own works.

Just how far Stuart had progressed became clear to both men one day in West's Painting Room. As painter to the king West was periodically obliged to provide a portrait of the monarch, and on this particular occasion a likeness was required for the new governor-general of India, whose ship was soon to set sail. His energies occupied with what Stuart called one of his "*ten-acre* pictures," West decided upon a shortcut. He asked Stuart if he might have a canvas his protégé had completed of the king. "I will retouch it," explained West, "and it will do well enough." Stuart resented being condescended to, but the canvas was duly delivered to West's personal Painting Room.

According to Stuart, West worked at it for an entire day. The result did not please him, so the following morning he asked for Stuart's palette, complete with Stuart's choice of colors, and went to work on the canvas once more. "In the afternoon," Stuart reported, "I went into his room and . . . I saw that he had got up to his knees in mud. 'Stuart,' says he, 'I don't know how it is, but you have a way of managing your tints unlike every body else,—here,—take the palette and finish the head.'"[14]

By 1782, Stuart was growing beyond the protégé-mentor relationship with West. According to London newspaper commentary on that year's Royal Academy exhibition, "Mr. Stuart is in Partnership with Mr. West." The writer, an undoubted insider with his tongue firmly in his cheek, went further: "Mr. West [says] that Mr. Stuart is the only Portrait Painter in the World; and . . . Mr. Stuart that no Man has any Pretensions in History Painting but Mr. West."[15] West would remain his stalwart supporter, but Stuart was ready to become his own man.

In the days after that show, a fellow portraitist, Nathaniel Dance, visited West's Painting Room. He and Stuart were strangers, but Dance, a founder of the Academy and himself a portraitist, was also a man known for his candor. After an introduction by West, he observed for a time as Stuart worked at his easel. He approved of what he saw and said so. In the absence of West, Dance remarked to Stuart, "You are strong enough to stand alone . . . [T]hose who would be willing to sit to Mr. West's pupil will be glad to sit to Mr. Stuart."[16]

Stuart didn't have to be told twice, and soon he took rooms at 7 Newman Street, a few doors from West. Having recently married a wealthy widow, Dance was retiring his brushes and offered Stuart the contents of his studio. Stuart came to look and took only a few pencils and a palette. The palette he took had previously belonged to the portraitist Thomas Hudson, with whom Sir Joshua himself had studied.

Stuart's first major commission as an independent London artist came from London's most successful print seller, John Boydell. If the assignment lacked prestige—the likes of Reynolds, Gainsborough, and

George Romney would hardly have stooped to do it—Stuart needed the money. The bust-length portraits for Boydell also represented a means for Stuart to insinuate himself further into both the fabric of London artistic life and the lives of its major figures.

There were to be fifteen canvases, and the list of the subjects was a Who's Who of the London art scene—or, at least, of the significant circle that did business with Mr. Boydell, an entrepreneur, newly elected a London alderman, and one of the first English publishers of engravings. Eight of the subjects, in fact, were engravers in his stable, another was Boydell himself. The other six were painters, including Benjamin West, Reynolds, and Copley.

Boydell had a gift for anticipating what the public wanted. It had been he who published *The Death of General Wolfe* and made a windfall profit for both Benjamin West and himself. He planned to update his store, located at 90 Cheapside, at the corner of Ironmonger Lane, in London's most prestigious shopping neighborhood. He envisioned more than just a retail shop. Upstairs from his ground-floor sales rooms, he would open a long gallery, some eighty by seventeen feet. There he would display canvases in order to sell prints downstairs. As part of the pitch, he planned to display Stuart's portraits of the artists and engravers whose work was represented.

The Boydell portraits Stuart produced were informal. One was of William Woollett, the best engraver of the day and author of the mezzotint of West's *The Death of General Wolfe*. Stuart portrayed him in his working attire, a voluminous red robe and velvet turban. The likeness of Woollett he produced was so effective that Stuart's dog, Dash, who barked uncontrollably at the engraver when he came to Newman Street, growled at the portrait, too.[17] Stuart's John Singleton Copley was, according to Copley's son, "the best and most agreeable [Copley] likeness ever executed."[18] He painted the aging Sir Joshua with a pinch of snuff between his thumb and forefinger. Stuart described the use of snuff as "a Pernicious, vile, dirty habit," but he himself, like Reynolds, was addicted to the

stuff.[19] To some, the portrayal of the grand old man of English painting might have appeared unseemly, but Sir Joshua favored the warm portrayal, as fond as it was true.

In his paintings for Boydell, Stuart made no attempt to elevate his subjects above their station. He put a burnisher in Woollett's hand and a metal plate on the desk before him. West had a *porte-crayon* in hand; behind him Stuart sketched a cartoon of Moses, an allusion to West's biblical paintings. Stuart painted his fellow artists sitting in the same upholstered armchair. They were members of his profession, neither patrons nor aristocrats. They were his peers, and by choosing to see them in their native milieu, Stuart hoped to convey their personalities as well as their features.

By 1786 Stuart's income had risen to £1,500 a year—and he had reinvented himself. He rented a large London house at 3 New Burlington Street, off Regent Street, which cost him a hundred guineas a year. After the fashion of his mentor West, he transformed some of his rooms into galleries with a permanent exhibition of his own canvases. His haphazard wardrobe gave way to the showy. He had his clothes tailored, and he favored colorful waistcoats with gold buttons.

Stuart not only looked the part of a prominent society painter; he mastered the social niceties. His friend Dr. Waterhouse, back from abroad, attested to Stuart's social ease. "In conversation and confabulation he was inferior to no man amongst us. He made a point to keep those talking who were sitting to him for their portraits, each in their own way, free and easy . . . To military men he spoke of battles by sea and land; with the statesman, on Hume's and Gibbon's history; with the lawyer on jurisprudence or remarkable criminal trials; with the merchant in his way; with the man of leisure, in his way; and with the ladies, in all ways."[20] He charged thirty guineas for a head-and-shoulders portrait.

Years earlier, he had attended lectures given by Dr. William Cruikshank, a noted anatomist. Stuart was there for artistic reasons, but most of his fellow listeners were medical students. One of them, William

Coates, soon to be a navy surgeon, would bring Stuart some custom in the persons of fellow naval officers. He also took Stuart home to Berkshire, where he met Coates's younger sister, Charlotte. Despite her apothecary father's reluctance to permit a marriage to a painter, Gilbert and Charlotte wed in 1787. She was nineteen, a dozen years younger than he. Charlotte soon gave birth to their first child, a son they named Charles.[21]

The most revealing of Stuart's London works was the smallest, painted on a scrap of canvas barely ten inches tall. The subject was Gilbert Stuart himself. The unfinished painting bore just the ghost of a head atop a collar and a fog of scumbled pigment that suggested a shirt, all surrounded by a field of green grounding. The face is both pale and ruddy, with an ashen forehead and reddish nose and cheeks. The hair, brown and unruly, hangs over the ears. The thin lips are taut and the chin set—but it is the dark eyes, little more than shadowed slits, that give the face its brooding intensity.

Stuart once said, "[T]he true and perfect image of man is to be seen only in a misty or hazy atmosphere."[22] In a sense, his sketchy, thinly painted portrait suggests his working style ("He commenced his pictures faint, like the reflexions in a dull glass," wrote one observer). Consisting as it does of a few dashing strokes, it also demonstrates the ease and speed with which Stuart could record with terrible accuracy the character—and in this case the torment—of the man portrayed. Whatever his own demons, he was a painter who could, in a few inspired moments, capture the emotion of a sitter.

⁓

AFTER HIS DOZEN years in London, Stuart passed six more in Dublin. His time on Newman Street had made him a portraitist, and his practice blossomed in Ireland, making a Stuart portrait de rigueur in fashionable circles. But his improvident ways continued to undermine his success.

An Irish friend named James Dowling Herbert—a painter and, later, a writer—recalled a pair of encounters in 1793 that anticipated Stuart's departure for yet another city. The two men were friends, and, when in town from his farm, Stuart frequently dined at Herbert's Dublin house. There they ate, Herbert remembered, "in the family way," even on occasions when the great painter had received an invitation to fancier tables at grander houses. "He had all the equalizing spirit of the American," said Herbert, "and he looked contemptuously upon titled rank."[23]

Herbert's arrival for dinner one Sunday afternoon at Stuart's farm in Dublin was occasioned by an encounter a few days earlier with bill collectors. The two men had been walking along a Dublin street near Stuart's in-town Painting Room when Stuart suddenly averted his face. In a low voice that Herbert could only just hear, Stuart called his attention to three men who were approaching them. They were bailiffs, he explained, who undoubtedly sought to collect upon one or more of his unpaid bills.

Herbert became Stuart's accomplice as they hurriedly entered Stuart's accommodations. As Stuart instructed, Herbert remained at the front door. With the men within earshot, he called into the house, "Stuart, are you coming?" His words and apparent impatience made it appear that the two soon would walk out again. Falling for the feint, the bailiffs positioned themselves nearby to collar Stuart when he reemerged to join his friend. Inside the house Stuart made his way to a rear door and the stable. There he mounted his horse, but before riding off he could not resist calling back to his friend from a nearby corner, inquiring whether or not the three poised bailiffs were Herbert's companions. Then, with a clap of spurs, he was gone. The would-be captors departed empty-handed.

Before he made his escape, Stuart had issued his friend an invitation to dine the following Sunday, so a few days later Herbert made his way to Stuart's door. Once there, he met up with Stuart's pigs and was given a tour of the farm and Painting Room. The visitor also inquired

about the bailiffs. Given the burgeoning business Stuart did in Dublin, he was perplexed.

"You are not in debt in this country, I hope?"

"My good friend," said Stuart, "you are mistaken, I am deeply in debt." Stuart then regaled him with tales of his confinements in debtors' prison and the various means by which he had regained his freedom.

He went on to confide the master plan he was shaping for his future, one that he hoped would help him balance his books at last.

"I'll get some of my first sittings finished," he began (both men knew that meant he could then collect his half-fees). "When I can nett a sum sufficient to take me to America, I shall be off to my native soil. There I expect to make a fortune by Washington alone." George Washington's fame being international, Herbert could appreciate the good sense in a gifted American painter taking the General's likeness.

Stuart continued. "I calculate upon making a plurality of his portraits, whole lengths, that will enable me to realize; and if I should be fortunate, I will repay my English and Irish creditors. To Ireland and England I shall bid adieu."

Herbert, knowing something of Stuart's pending commissions, not to mention the proposed new ones, asked, "And what will you do with your aggregate of unfinished works?"

Stuart had an answer. "The artists of Dublin will get employed in finishing them. You may reckon on making something handsome by it, and I shan't regret my default, when a friend is benefited by it in the end."[24]

A few months later, eighteen years after he had left, Gilbert Stuart returned to America, sailing from Dublin in March 1793.

I I.

1793 . . . 63 Stone Street . . . Lower Manhattan

G ILBERT, CHARLOTTE, AND four little Stuarts, their
worldly goods packed and ready, had planned a transatlantic jour-
ney to Philadelphia. That city had become the seat of the new govern-
ment in 1791, and the painter knew he would find George Washington's
residence in the capital. But Stuart, all in a moment, decided to alter the
plan.

At the port of Dublin he learned that a traveling circus had booked
passage on the same Philadelphia-bound ship. Stuart, a man whose
character contained healthy measures of both whimsy and decisiveness,
decided on the spot that the prospect of being cooped up for weeks on
end with "horses and dancing devils and little devils" was simply too
much.[25] Berths were soon booked on another ship, the *Draper*, despite
the fact that it was bound for a different American destination.

By the time they reached New York harbor, on May 6, 1793, Stuart
had resolved to remain awhile in the burgeoning commercial city before
proceeding to Philadelphia. He was little known in his homeland, and,
though Manhattan seemed small compared to Dublin and London, Stu-
art thought that the island city might be just the place to establish his
American reputation.

New York's population had more than quadrupled, to nearly sixty
thousand inhabitants, in the ten years since the Revolution ended. It was
a prosperous place with wealthy merchants, a well-established Hudson
River aristocracy, and other rich and powerful men and women to paint.
The competition posed no challenge, as Trumbull still worried his his-
tory paintings and New York had no other portraitist of note. Stuart
rented a house in a reputable neighborhood filled with small merchants
and tradesmen who catered to a comfortable clientele. The proprietor of
one nearby business, Thomas Barrow, operated a color shop purveying

the canvas, pigments, linseed oil, and other supplies Stuart would require.

His first commission came from John Shaw, a mariner by trade. Captain Shaw was the skipper of the *Draper*, the large ship on which Stuart and his family had spent almost eight weeks crossing the Atlantic. The two portraits Stuart painted for the Irish-born New Yorker—one an original from life, the second a copy—were made as partial payment for their passage.[26]

Although his baggage contained a portfolio of engravings, Stuart had arrived in New York without examples of his own painting. All his recent works remained across the Atlantic, in the hands of his English and Irish patrons. When he set a first blank canvas on the easel in his Painting Room, with the sounds of his four children echoing in their rented house at No. 63 Stone Street, he welcomed the opportunity to paint a ship's captain (or just about anybody else) in order to launch his new American venture. He vowed he would soon have canvases to show.

For once the moody Mr. Stuart painted as if in a frenzy. To suggest the range of his talent, he revisited the canine canvas of his Newport youth and painted a small, picturesque scene of three spaniels flushing woodcocks in a pretty woodland setting. His circle of acquaintances in New York was small, but he regarded John Jay as an old friend. They had known each other in London when Benjamin West had painted Jay into his unfinished *The American Peace Commissioners*. At that time Jay had also invited Stuart to paint two portraits of Jay himself. Stuart completed neither one and, in need of funds prior to leaving London for Dublin, had pawned them. Despite Stuart's failings, however, Jay admired his talents. Stuart sought him out soon after arriving in the city, and Jay once more commissioned a portrait. He also extolled Stuart's talents to other New Yorkers, as did their mutual friend John Trumbull.

Stuart painted Chief Justice Jay, Senator Aaron Burr, and New York chancellor Robert R. Livingston, the man who had administered the oath of office to the newly elected President Washington a few years

earlier. Stuart's English and Irish connections led merchants to his door, too. Judges, wealthy visitors from Spain and Charleston, and his new clients' wives, children, and extended families were recorded on his canvases. He painted to suit his patrons; some wanted plain, others wanted fancy. As a fellow painter who had known Stuart in London the previous decade reported, "Here [in New York] he favoured the renowned, the rich, and the fashionable, by exercising his skill for their gratification; and gave present éclat and a *short-lived immortality* in exchange for a portion of their wealth."[27]

One of his subjects, Horatio Gates, gave him the opportunity to practice what he had come to America to do: to paint a retired warrior, an aging military hero in whose likeness one could read the verities of war and peace. Born in England, Gates, along with George Washington, had served in General Braddock's forces during the French and Indian War, then retired to Virginia after taking an American wife. He had been one of the first officers to offer his services to Washington in 1775. His military record in the Continental Army had been mixed (as head of the Northern Department, his forces had prevailed at the Battle of Saratoga; later, as head of the Southern Department, his army had been routed at the Battle of Camden). By 1793 the aging Gates was living in honorable retirement at Rose Hill Farm, his ninety-acre estate in central Manhattan.

Stuart painted the old military man in full regalia, sword in hand. Against the deep blue and buff uniform the general's decorations stood out, among them the gold epaulettes with the two stars of his rank, along with a large medal commemorating the victory at Saratoga that hung from his neck on a royal blue ribbon. But what "nailed the man to canvas," as his old mentor said of Stuart's ability, were the head and face.

When Gates came to Stuart's Painting Room, the two men found they enjoyed each other's company. Both liked their drink, and together they imbibed "glass after glass of the celebrated painter's plentiful Madeira."[28] Gates's complexion on the canvas is flushed, his gray

hair mussed, its thinning strands curling over his ears. But the gaze is clear, the expression firm. Stuart captured the man's intelligence, his patient acceptance, his pride.

Together with his other successes in New York, Stuart's portrait of Gates buoyed him. The foolhardy boy who had left America at nineteen had returned with the manners of a gentleman, the melancholy look of a poet, and a distinctly roguish spirit. In his eighteen months in New York, Stuart made himself the artistic equivalent of a shooting star. As he remarked to a friend, "In England my efforts were compared to those of Vandyck, Titian and other great painters—but here! They compare them to the works of the Almighty!"[29] *Now* he was ready to go to Philadelphia to take the likeness of the new country's greatest citizen.

A Plurality of Portraits

The deeper nobler aim [of portraiture] is the personification of character.
—*Henry Fuseli,* Fuseli's Lectures, *No. IV, 1805*

I.
Autumn 1794 . . . Letters from home . . . New York to London

L IKE MORE THAN a few of Gilbert Stuart's patrons, Sarah Jay grew impatient. "Would you believe that Stuart has not yet sent me your picture?" she wrote to her husband that August.

John Jay was in London, having left his post as chief justice of the United States to negotiate a treaty with England. (The English harassment of American shipping had become intolerable, and, aided by the dispirited John Trumbull as his secretary, Jay was attempting to avoid another military conflict.) In her husband's absence Mrs. Jay launched her own negotiations with Mr. Stuart. "I call upon him often," she wrote to John. "I have not hesitated telling him that it is in his power to contribute infinitely to my gratification, by indulging me with your portrait."

Her persistence seemed to be producing results. "[H]e has at length resumed his pencil . . . and [the portrait] is nearly done and is your very self. It is an inimitable picture and I am all impatient to have it."[1]

Mr. Stuart also wanted something, and he was not bashful about raising the matter in his conversations with Mrs. Jay. "[Stuart] begged me to remind you of the promise you made him the day he breakfasted with you," she advised her husband. Jay's connection with President Washington, Stuart knew, could be just the entrée he needed, and a letter of introduction from the chief justice would surely open presidential doors to him. Still, neither Mrs. Jay nor the letter he desired could compel Stuart to complete the portrait posthaste.

More than two months passed before Mr. Stuart arrived at teatime on November 15, armed with the portrait. Admittedly, Stuart hadn't *quite* managed to complete it—part of the expansive red and black academic robe in which Jay was draped remained unpainted—but Stuart promised Mrs. Jay "a better one."[2] She was happy enough to have an unfinished version in hand, and, as she wrote to her husband, she soon hung the picture in a place of honor in their dining room. In return, Mr. Stuart got his letter.

That month Stuart wrote to his uncle, Joseph Anthony, a Philadelphia merchant, confiding his schedule. "I should have been with you before this time had not a smart attack of the fever and Ague prevented me," he explained, choosing to omit mention of unfulfilled commissions. "The object of my journey," he concluded, "is only to secure a picture of the President, & finish yours."[3]

With his letter of introduction from Mr. Jay to Washington in hand, Stuart could depart for "the London of America," as one English visitor described Philadelphia.[4]

II.

Winter 1794–1795 . . . The President's House . . . 190 Market Street

BY THE END OF November, Gilbert Stuart's footfall was heard on the streets of Philadelphia. One of the first calls he made was at the President's House, just a block from Congress Hall. There he left Mr. Jay's letter along with his own card.

He had traveled to Pennsylvania alone. The success of his Philadelphia venture was hardly assured, leading him to decide that, at least for the time being, his family should remain in New York. He spent a day in the nearby countryside, and on his return he found a note awaiting him from Bartholomew Dandridge, Martha Washington's nephew. Dandridge was the president's secretary, and he had written to invite Mr. Stuart to the President's House that night. This, thought Stuart, was a good omen.

As he approached his destination that Friday evening, the red brick structure stood out as one of the grandest mansions in Philadelphia. A double row house built as one, it was forty-five feet wide and contained three full stories plus a garret lit by the two dormers. The large dwelling was home to George, Martha, Nelly, and Wash, and it also housed the offices of the executive branch. On the third floor were offices for clerks; on the second was Washington's study. From the street Stuart could see little over the tall brick walls that flanked the house, but the narrow lot also contained a long kitchen ell attached to the main block, a brick stable, coach house, washhouse, and icehouse. Servants' rooms accommodated the two dozen members of the house staff, which included indentured servants and several Mount Vernon slaves.[5]

When Stuart climbed the three white stone steps to the entrance, he faced a doorway framed in a bold carved frontispiece topped with a triangular pediment. Just above the door he could see streaks of candlelight from within that shone through the fanlight. He heard the bustle of

activity inside, and when the door opened, a servant ushered him into a long entrance hall carpeted in green baize. To his left, through a set of arches, stood a towering staircase. He was directed down a long narrow hall and through a tall doorway.

Robert Morris, the president's friend, a financier and a U.S. senator from Pennsylvania, had leased the house to the city of Philadelphia for the use of the nation's chief executive. Washington had required certain alterations and additions to adapt the property for his use, and one change—a bow window—was evident when Stuart entered the state dining room. The far end of the space had the shape of a long, gracious curve, punctuated with three windows. In front of one of them a group of gentlemen stood engaged in conversation, while a mix of men and ladies milled around elsewhere in the room.

Stuart assumed this was an anteroom. Having spent years visiting formal houses in London and Dublin, he expected that guests would be distinguished by their rank, with some proceeding to more exclusive spaces deeper in the house, others not. Unsure of the proper etiquette in this unfamiliar city, he waited for his cue, surveying the crowd of perhaps two dozen guests with whom he stood in the large room, which was twenty-four feet wide, thirty-four long.

He had yet to engage anyone in conversation when he saw a man detach himself from the circle of gentlemen at the far end of the room. The tall stranger, dressed formally in a black velvet suit, his hair powdered, walked toward the painter. Though he wore no sword, the man carried himself with the erect posture of a soldier. When he reached Stuart's side, he addressed him by name.

The president's directness threw Stuart into a stunned silence. He had expected more elaborate protocol, perhaps that an intermediary would do introductions and there would be a courtly exchange of bows. He was surprised, even embarrassed at the president's attention, and "so intimidated as to lose, for the moment, all self-possession."[6]

Washington, of course, recognized Stuart's state of shock. Over the

years, the General had met many overawed men and women, people fro-
zen in place and made speechless by the mere sight of him. To put Stuart
at ease, "he entered into easy conversation with him until he recovered."[7]

Stuart soon learned that the event that evening was one of Martha's
Drawing Rooms, a casual gathering where guests of a certain station
were received without the formality of George's Tuesday-afternoon Le-
vees (at those the president, wearing yellow gloves, his long sword in its
white polished leather scabbard, and carrying a cocked hat with cockade,
spent the three o'clock hour receiving gentlemen and engaging them in
formal and mannered conversations.[8] At a Drawing Room, one could
expect between the hours of eight and ten to encounter well-dressed
women, the powers of Philadelphia society and of the federal govern-
ment, and to be offered plum cake and tea or coffee in a more relaxed and
social atmosphere.

Washington that day introduced Stuart to some of the members of
the company, but the painter's brief exposure to Washington could not
help but change his view of the man. Stuart had met royalty and landed
lords, he had visited castles and palaces, he had conversed with the rich
and the powerful of the Old World. All of that made his encounter with
America's chief aristocrat seem strange indeed. He had little regard for
pretense, hauteur, or the trappings of wealth, but the impact of Wash-
ington's presence wasn't simple to explain. "[H]is figure was by no means
good," Stuart later observed, "[and] his shoulders . . . high and narrow,
and his hands and feet remarkably large." In fact, thought Stuart dismis-
sively, Washington had "aldermanic proportions." Nevertheless, he con-
cluded, despite "all these drawbacks, his appearance was singularly
fine."[9]

Now that he met the man in the flesh, he saw how considerable his
challenge would be. Somehow he needed to render the intangible quali-
ties of the great man onto a piece of canvas. But Stuart remained fully
confident that he was just the man for the job.

III.

Winter 1794–1795 . . . The Painter's Studio . . . Fifth and Chestnut

STUART SETTLED INTO rooms just a block from the State House. He had sufficient space for his Painting Room, as well as quarters for "Tom," as he had taken to calling his wife, and their children, all of whom he brought down from New York. It was during that "winter season" that he had his first sitting with Washington.[10]

When the president arrived to take his place in the Painter's Chair, he brought with him the air of a man who had done this very thing too many times before. "It annoyed him exceedingly to sit at all," his grandson reported. "After every sitting, he was wont to declare this must be the last."[11]

The president had turned sixty-three a few weeks before. When Washington assumed a pose looking left, exposing the right side of his face, Stuart could see that the firm features of a young man had given way to a certain looseness beneath the chin and fleshy jowls. Stuart regarded his sitter from behind his easel, on which he had positioned a standard three-quarter canvas, roughly thirty by twenty-five inches, one that had been prepared in London by the firm of James Poole. It was smaller than the half-lengths he had used for the likes of General Gates and Chief Justice Jay, but its size also meant it could be more efficiently reproduced—and Stuart wanted to be in the business of selling replicas of the president for a tidy profit. First, though, he had to get the likeness right, and the man seemed from the outset something of a conundrum.

Though a sometime planter, Washington pointedly did not use tobacco. Still, his dignity seemed suspended about him like a wreath of smoke, defending him from Stuart's penetrating gaze. From long habit, Stuart launched into conversation. He was of the opinion that, by conversing with his subjects, he "could draw out the minds of his sitters upon

that surface he was tasked to represent." As his attempt at conversation fell flat, it seemed to Stuart that "Washington's mind was busied within."[12]

Stuart used his gift for anecdote in an attempt to divert his sitter, to try to animate his features, to relieve the fixed, masklike aspect. Stuart was a raconteur, a punster, a wit, and a man of varied experience. Many of his noble, wealthy, and educated subjects in years past had found his company engaging. Yet what he sought in talking to them and Washington was more than mere smiles or appreciative laughter.

Certainly he wanted Washington and the others to relax. He wanted them at their ease, and he wanted Washington's manner and expression to seem unaffected. But he wished to reach deeper. He wanted involuntary reactions. He wished to glimpse what he regarded as the man's *natural character*. He wanted to loosen the restraints and penetrate through the manner to the man. Along with many of his contemporaries he believed that a sitter's physiognomy could be read like words on a page. Washington's outward appearance could reveal his inner qualities, and the man's thoughts, his genius, and even his soul could be got on canvas if only Stuart might be permitted to glimpse them.

As if to make the task all the more intriguing, Stuart discovered that he beheld a man, as he confided to an English visitor to Philadelphia, whose features were unlike any he had "ever observed in any other human being; the sockets of the eyes, for instance, are larger than what he ever met before, and the upper part of the nose broader." The characteristics he discerned in Washington's face were, he surmised, "indicative of the strongest and most ungovernable passions, and had he been born in the forests, it was his opinion that he would have been the fiercest man amongst the savage tribes."[13]

Stuart set to work to put the man on canvas. He began, as he always did, with the face. He believed that the nose, more than the eyes, mouth, or other facial features, anchored the face. He worked quickly—three or even as few as two sittings were not unusual for Mr. Stuart—as he applied thin layers of paint. He began with white, blocking in an approxi-

mation of the features. Once he had outlined the face, he added thin, dark lines to define the mouth and eyes.

After the face assumed a satisfactory shape, he brushed in the hair, which was swept back into a queue tied with a black ribbon in Washington's usual fashion. When he got to the man's chest and shoulders, Stuart was careful not to let them distract from Washington's face. In his portrait of General Gates, Stuart had labored over the general's military regalia—the epaulettes, sword, a medal, and other adornments—but he portrayed this general in a very plain costume. Aside from the shirt ruffle at the throat and the narrow hair ribbon that curved at the back of the neck, the clothes were unremarkable. Stuart chose to leave the background unadorned, and the sitter's hands were off the canvas, so nothing would draw the viewer's attention away from the president's face and head. Stuart set his painted Washington high on the canvas, so as to draw the eye up to the quite evidently tall and stately figure. Stuart softened the features on the left side of the face, adding shadows. When he finished, Stuart was not entirely happy with the somewhat empty expression on the likeness's face. But it would have to do.

Word of the portrait soon reached many ears. Inevitably, the match of the newcomer and the president produced great curiosity, and as the time came for a public viewing of the new portrait, the public was hungry to see what the "Modern Vandyke" had made of His Excellency. The portrait "created a great sensation," and Stuart's expectations for a business in Washington likeness were soon met.[14] His studio became a meeting place for important members of Philadelphia society, including Generals Knox and Lee, the British minister and his wife, members of the French nobility, and others. Many of these notables wanted portraits of themselves; more than a few desired copies of his *George Washington*.[15]

On April 20, 1795, Stuart put pen to paper. He had been taking orders for some time, even before coming to Philadelphia, but enough had now accumulated that it was becoming difficult to keep track. He titled the sheet: *A list of gentlemen who are to have copies of the Portrait of the*

President of the United States. Then he wrote down the names of those who had requested replicas, all thirty-two of them. Some of these men were friends from his English days, including Benjamin West, and many were Philadelphia merchants. There were New Yorkers, too, including "Col. Burr" and "Mr. Chief Justice Jay." Some customers had already made deposits (he recorded the $200 paid by "I. Vaughan, Esq."; that was the merchant Joseph Vaughan, who wanted two). When he added up the orders, the total amounted to thirty-nine replicas.[16]

Stuart busied himself in the coming months, spending much of 1795 making more *Washingtons*, at times painting more than one at a time. On some canvases, he added a curtain in the background with a splash of pink in a blue sky. In others he emphasized the face with a red background that brightened in the area of the head. He varied the neck ruffle and the hair ribbon. He switched to painting Washington in his more regal black velvet suit.

He took on an assistant, John Vanderlyn, a young man he had met in New York, an aspiring painter who had previously worked in Thomas Barrow's color shop. Vanderlyn blocked out the basic shapes on some of the Washington canvases and painted copies of several other Stuart subjects. Even with help, however, Stuart failed to fill all his orders.[17] As Abigail Adams observed, "Genius is always ecentirck, I think . . . [T]here is no knowing how to take hold of this Man, nor by what means to prevail upon him to fulfill his engagements."[18] But Stuart did collect his $100 fees from more than a dozen of his customers for completed replicas.

An early version was delivered to Joseph Vaughan of Philadelphia, who sent it on to London to his father, Samuel, a friend and admirer of Washington. The elder Vaughan had presented the General with an elegant mantelpiece of carved marble for Mount Vernon, which, at first, Washington thought "too elegant and costly by far . . . for my own room and republican style of living" (he installed it anyway in his New Room). An engraving of Vaughan's *Washington* soon appeared in a translation of the book *Essays on Physiognomy* by the Swiss theologian Johann Caspar Lavater. Lavater was a chief proponent of the science of physiognomy,

believing passionately that temperament and character could be read in facial features and expressions. (In examining busts of William Pitt, the same "Great Commoner" whom Peale had memorialized years before, Lavater recognized the eyebrows "of a seer, a thinker, a political prophet"; in the nose, forehead, lips, eyes, and even Pitt's warts, Lavater saw revealed to him an *"eagle's face humanized . . .* it is a hovering, gliding eagle, high over the nations of Europe; London is its eyrie, Parliament in its view, England under its wings").[19] Of Washington's image he observed that the eyes did not seem to possess the "heroic force . . . inseparable from true greatness." While he had never seen the General in the flesh, Lavater still offered his interpretation of Washington. "Every thing in this face announces the good man," Lavater observed, "a man upright, of simple manners, sincere, firm, reflecting and generous."[20]

Not everyone liked Stuart's portrait, of course. The Peale family of painters—most notably Charles Willson—saw imperfections. As son Rembrandt reported, "We all agreed, that though beautifully painted and touched in a masterly style, as a *likeness* it is inferior to its merit as a painting—the complexion being too fair and too florid, the forehead too flat, brows too high, eyes too full, nose too broad, about the mouth too much inflated, and the neck too long."[21]

The Peales, themselves partisans in the portrait game, might be expected to snipe at the new competition in town. But Stuart, too, remained discontented with this portrait of a preoccupied president whose mind looked to be elsewhere, and he was far from finished with taking Washington's likeness.

III.

Winter 1796 . . . Philadelphia

GEORGE WASHINGTON WELCOMED *anything* that reminded him of retirement. Eight years before, he had agreed to become president because he felt obliged to bow to the common wisdom

that he wasn't merely the best man for the job but the *only* one. Several years later, having promised himself he would serve but one term, he had asked his trusted colleague, Congressman James Madison, to draft a valedictory address. He hadn't banked on the pressures that soon arose and that seemed to come from all directions. His old friend, Eliza Willing Powel, a favorite dinner partner and the wife of a prominent Philadelphia merchant and former mayor, put it persuasively when she spoke truth to power. If he were to retire after one term, she advised him, he would be "quitting a trust, upon the proper execution of which the repose of millions might be eventually depending." She described him as "the only man in America that dares to do right on all public occasions."

She didn't stop there. "You have shown that you are not intoxicated by power or misled by flattery," she continued. "You have a feeling heart and the long necessity of behaving with circumspection must have tempered that native benevolence which otherwise might make you too compliant . . . the soundness of your judgment has been enriched on many and trying occasions, and you have frequently demonstrated that you possess an empire over yourself. For God's sake, do not yield that empire to a love of ease."²² Thus chastised, Washington felt bound to remain in office, and he accepted the unanimous vote of the 132 members of the electoral college for a second term.

Now, however, as he contemplated a new notion of Martha's to commission pendant portraits of the two of them, the idea seemed a way of commemorating his much anticipated "return to the walks of private life." There would be no third term—on that matter he was utterly firm—and in a year's time, his successor chosen, he would climb into his carriage and leave Market Street, bound once and for all to his acres overlooking the Potomac. So why shouldn't they depart with a remembrance of the presidency, just as Martha wanted?

They had been married thirty-seven years, and reminders of their early time together awaited them in Mount Vernon's Parlor. Since then the narrow-waisted girl in the portrait John Wollaston had painted in

1757 had matured into a plump and widely admired matron. The open-faced country colonel pictured in Charles Willson Peale's first portrait of Washington had subsequently endured eight years of war, the birthing of the Constitution, and another eight years playing the demanding role of president. The young horseman's athleticism had given way to the pallor and softness of late middle-age.

Yes, he agreed, new portraits of the white-haired president and his lady should decorate the walls at Mount Vernon, despite the fact that his previous experience sitting for Mr. Stuart hadn't been entirely pleasurable. But all of Philadelphia seemed to agree that Stuart made the best likenesses. Most important of all, Martha was among them.

———

LIKE GEORGE, MARTHA had taken many turns in the Painter's Chair. She had sat before he did, posing in 1757 as the wife of Daniel Parke Custis. As Mrs. George Washington, she had looked back at many of the same artists who rendered likenesses of her husband. Just the previous year, she had posed for both Mr. Trumbull and Mr. Peale, and not for the first time.

The marriage of George Washington and Martha Dandridge Custis had been characterized by warmth and civility. Certainly they had grown fond of each other during their nine-month courtship back in 1758, but complementary circumstances rather than passion had disposed them to take the vows of marriage. Both bride and groom had been bruised by love, Martha having watched death take her husband and two young children. George's heart still ached for Sally, the unattainable wife of his friend and neighbor, George William Fairfax. It had been their compatible worldly needs that made the match of George and Martha seem logical. The Widow Custis's large inherited estate required knowledgeable and careful management; though he was an eligible bachelor and a dashing soldier, George possessed only a small fortune, and his finances were tight. If their courtship was conceived of convenience—she

brought him wealth and status, he would manage her estate with skill and good faith—their union had proved a partnership of abiding affection, respect, and cooperation. Many years later Washington himself would describe his marriage in a letter to his old friend Lafayette's wife Adrienne as "the dearest of all . . . resources of happiness."[23]

To sit for Mr. Stuart required no special preparation of Mrs. Washington. She would bring no airs to the chair, any more than she did to her role as First Lady. She dressed simply, spoke plainly, and affected no superiority. She avoided display and ostentation. As Abigail Adams wrote to her sister after her first meeting with Martha, "She is plain in her dress, but that plainness is the best of every article . . . Her manners are modest and unassuming, dignified and feminine, not the Tincture of ha'ture about her."[24]

Martha had been brought up to be a Virginia hostess and household manager, roles she had fulfilled at Mount Vernon for the first fifteen years of their marriage. She had invested herself in caring for her two surviving children, and George had proved a devoted stepfather. They both had watched in horror when Patsy collapsed and died of a violent seizure in 1773; she indulged her surviving son, Jacky, only to see him die prematurely, too, in 1781. Although the union of George and Martha produced no children, Martha's mothering had been extended in 1779 when the baby Nelly had come into her grandmother's care, since the child's own mother, Jacky's wife, Eleanor Calvert Custis, was too ill to care for her. Two years later, Nelly's six-month-old brother Wash had come to Mount Vernon, too. With the death of Jacky, a new family was formed, as Nelly and Wash became the children of Mount Vernon.

Now, in Philadelphia, Martha was the nation's hostess. As the first to perform the role of First Lady, she followed her instincts, conducting herself and her household much as she had done as the wife of a planter and a general. Like so many jobs of apparent power and influence, her role came with surprising limitations. She was expected to entertain all visitors, but in order to avoid the appearance of favoritism the First Fam-

ily accepted no invitations to the homes of others. "I live a very dull life here and know nothing that passes in the town," she confided to a niece. "Indeed I think I am more like a prisoner than anything else."²⁵ But the Martha that Gilbert Stuart was to paint was nothing if not a practical woman, one who had learned to weather life's surprises. As she explained to one correspondent, "[T]he greater part of our happiness or misery depends upon our dispositions, and not upon our circumstances."²⁶ A mother and grandmother, she was also a devoted aunt and adviser to many young women. She ran her kitchens with care, at Mount Vernon and on the road, often relying on a cookbook, a gift from her first mother-in-law, that she herself revised and updated.

She was happy in her fashion in a durable marriage that was a mix of public and private. She and George rarely dined together as a couple. When away from Mount Vernon, the Washingtons had either a military or a presidential "family" around them, complete with officers, advisers, clerks, lieutenants, foreign and political visitors, and others who joined them at the table. At home, it was much the same, as they inhabited what Washington described as a "well resorted tavern" with a constant flow of daily visitors. Yet Martha was central to the private life that her husband cherished, and her devotion to him sustained him. She came to him in winter camp for each of the winters of the war—in Cambridge during the siege of Boston, at Valley Forge, to Morristown in 1779–80 during the most brutal winter of the eighteenth century. These "winterings" were, for Washington, the closest thing to normal life between the spring of 1775 and the turn of 1784.

Martha was a fixture and a constant in the eyes of the painters. Unlike her husband who always seemed to look somehow different from one portrait to the next, Martha remained remarkably the same, whether the portraitist was Mr. Trumbull, Mr. Peale, Mr. Savage, or, as in this case, Mr. Stuart.

TO STUART, THE commission negotiated with Mrs. Washington amounted to more than a piece of business. Many of his previous portraits featured ambitious merchants, idle aristocrats, or their wives (when one husband complained of Stuart's rendering of his spouse, the painter had angrily retorted, "What a———business is this of a portrait painter—you bring him a *potatoe* and expect he will paint you a peach!").[27] If many of his sitters failed to spark his genius, certainly some of the men and women who had come to his Painting Room had charmed and engaged him.

Yet none had posed the ineffable challenge that Washington did. The world believed that this man possessed an inner sublimity of nature that, perhaps beyond any other of Stuart's subjects, demanded recording for posterity. Stuart knew he needed to look at this man anew and capture his moral power and authority.

He wasn't quite certain how to go about accomplishing his goal, but the commission called for half-lengths that approximated, at least in size, the existing pair back at Mount Vernon. But as he considered Martha Washington's commission, Stuart's basis for comparison was less the two earlier portraits, which he had never seen, than his own recent likeness of Washington. As the painter-physiognomist contemplated rendering his subjects, his intent was to do as Mr. West had said: *This* time he would truly nail the president (and his lady) to the canvas.

He chose to employ one of the conventions of pendant portraits, arranging his sitters so that when the finished paintings were hung together, the husband and wife would face each other. George's pose upon assuming the Painter's Chair was the reverse of his previous portrait, and he sat with his head and shoulders turned slightly to the painter's left, thereby revealing the left side of his face. Martha would do the opposite. Unlike Stuart's earlier and smaller head-and-shoulders bust portrait of Washington, in these Martha and George were to be seen from the waist up.

When Washington entered Stuart's house for the sitting, the paint-

er's wife was just stepping into her parlor. She caught a glimpse of the president as he passed through the hall door, bound for the Painting Room. To Mrs. Stuart, the man in the black velvet suit and lace ruffles— she had never laid eyes on him before—was "the most superb looking person [I] had ever seen."[28]

With Washington in the Chair, Stuart tended to the task at hand. He noticed some differences in his sitter from his small portrait. His sideburns had grown longer. As if Stuart needed another challenge in painting the president, he observed that Washington, even more than usual, had a "constrained expression . . . about the mouth and lower part of the face."[29] His face seemed somehow more square, and his mouth appeared to bulge. It was no wonder: He had acquired new dentures.

When young, Washington had cracked walnuts with his teeth; as he aged, his once firm and healthy bite had deteriorated. He suffered painful abscesses, and he began losing teeth at just twenty-two. By 1781 he had begun wearing a partial dental plate, and over the decade that followed, his dental condition continued to worsen. In 1789 a dentist named John Greenwood had fabricated him a lower plate out of hippopotamus ivory and human teeth, but this very year the president had lost the last of his own teeth, which had anchored his dentures. A new set of false teeth, these from a Philadelphia dentist, incorporated animal and human teeth mounted on lead upper and lower plates that were connected by a spring. These dentures, Washington reported, were "uneasy in the mouth and bulge my lips out in such a manner as to make them appear considerably swelled."[30] They were uncomfortable, inefficient, and difficult to keep in position.

During the several sittings required, Stuart found that one way to keep Washington both relaxed and awake was to have guests in the Painting Room to amuse and distract him. In addition to the sometime presence of Mrs. Washington, other Painting Room visitors included her granddaughter, grandson, and Washington's old military colleagues, General Henry Lee and Secretary of War Henry Knox. The pretty and

pert Harriet Chew, of the powerful Chew clan, was welcomed, too; Washington himself admitted "her presence always gave him his most agreeable expression."[31]

With friends present he relaxed a bit—even if he refused to acknowledge it. When the Scots wife of the British minister, Henrietta Liston, remarked upon the happiness that was to be seen in his expression when he talked of his retirement, he was quick to disagree ("You are wrong! My countenance never yet betrayed my feelings!"). Despite the uncharacteristic abruptness of his retort, Mrs. Liston still thought the world of him: "He possesses so much natural unaffected dignity, and is so noble a figure as to give always a pleasing impression."[32]

Having company at hand while he worked benefited Mr. Stuart in another way. Virtually all of these personages would go on to commission portraits of themselves. His Washington association was proving every bit as valuable to him as he had anticipated.

Stuart painted Martha and George separately, but their two canvases resembled each other. At the start both were blank, the weave of the fabric covered by a "fog-color" ground.[33] Stuart strove in his first session with each sitter to lay in the major forms of the head, to rough in the nose, the features, the shape of the face. "The first idea," Stuart believed, was to create "an indistinct mass of light & shadows, or the character of the person as seen in the heel of the evening[,] in the grey of the morning, or at a distance too great to discriminate features with exactness."[34] Only after he had created a strong facial likeness did Stuart paint in the eyes.

With the face coming to life, he added the hair and encircled each head with dark paint, a drab green that contrasted with the light flesh tones and helped give the viewer the illusion that the heads were three-dimensional. As he worked to make Mr. and Mrs. Washington's portraits more lifelike, he added pink-complexioned skin tones with light brushstrokes. To do it, Stuart barely touched the canvas, applying touches of pure, unblended color.

As he went about painting Washington, once again Stuart attempted to engage his sitter. He had some success, thanks to a fortunate accident. During a sitting, Stuart noticed that Washington's usually somnolent features suddenly seemed to awaken, and the painter realized the cause was a horse passing by outside. Though he had tried talking of farming to Washington—to no avail—Stuart now turned the talk to horses. For a time, at least, the sitter seemed more animated.

The more Stuart looked at this man—and, by now, Washington had sat for him a number of times—the more confident he felt of his insights into his character. The painter was now certain, though he had not witnessed it personally, that the president's temper was prodigious. He confided as much to General Henry Lee.

Lee, who served with distinction in the Continental Army and earned himself the sobriquet "Light Horse Harry" for his deft horsemanship, breakfasted with his old commander a few days later. "I saw your portrait the other day—a capital likeness," he told George and Martha. Then he added, "Stuart says you have a tremendous temper."

Mrs. Washington, offended on her husband's behalf, replied, "Upon my word, Mr. Stuart takes a great deal upon himself, to make such a remark."

Lee, concerned that his words had offended, added, "But, stay, my dear lady, he added that the president had it under wonderful control."

Smiling slightly, the man himself remarked, "He is right."[35]

Lee knew of Washington's temper. He had heard tell of Washington's tirade when he discovered Continental troops retreating at the Battle of Monmouth Courthouse. An officer on the scene, General Charles Scott, remembered that Washington swore "till the leaves shook on the trees . . . Never have I enjoyed such swearing before, or since . . . he swore like an angel from heaven."[36] Washington then had turned his ire on the enemy and personally rallied the troops. The man rarely lost control—since childhood he had disciplined himself to contain his anger when it rose—but Mr. Stuart was quite right that it sometimes simmered

dangerously.

A brilliant likeness of Washington could be seen on canvas; Martha's, though less developed, was emerging, too. Before Stuart could finish them, another commission came to him.

IV.

Spring 1796 . . . The Painter's Studio . . . Philadelphia

ON APRIL 11, 1796, a hand-delivered letter from the President's House confirmed an agreed-upon appointment. "Sir, I am under promise to Mrs. Bingham, to set for you tomorrow at nine oclock . . . I am Sir Your Obedient Servt, G. Washington."[37]

The president had long before demonstrated his appreciative eye for the ladies, and Anne Willing Bingham—sensual, confident, always dressed to advantage—was perhaps Philadelphia's most beautiful woman. She was proud of her beauty and wore au courant French fashions with short sleeves and plunging necklines; her exposed elbows and cleavage earned her both admiring looks and, in some quarters, words of disapproval. Yet no one dared speak too harshly of Nancy, as she was known. She was the daughter of a wealthy merchant and, in the way of the city's elite, virtually all of Philadelphia's rich and powerful families were either her blood relations or linked with her by marriage.

She had married well at sixteen. Her husband, William Bingham, twelve years older and her father's business partner, had become one of America's richest men, profiting in the war trade and thereafter succeeding mightily in shipping, land speculation, and international banking. As Abigail Adams observed, "Money, Money is his sole object, and he feels the weight of it."[38]

What Nancy desired, Nancy usually got—even from President Washington. As the wife of the newly elected Senator Bingham, she was charged with managing the social side of their world. She had a gift for

conversation (her cleverness with English was remarked upon and she spoke French fluently), and her manners were highly polished. Having traveled abroad and resided in Paris and London, on returning home she worked to raise the elegance of the society in her city (during the Constitutional Convention almost ten years earlier, Washington noted in his diary, "Dined, and drank Tea at Mr. Binghams in great Splender"[39]). She was not bashful about expressing her opinions—even political ones—and the Binghams' in-town home, Mansion House, was the site of lavish entertainments. At her balls and receptions the city's and the nation's powerful men and their wives gathered. George Washington was a frequent guest, known to walk arm-in-arm with Mrs. Bingham, deep in conversation.

Nancy and William Bingham had known Gilbert Stuart in London during their six years abroad. They knew how great were his gifts and how unpredictable his personality (the family portrait the Binghams had commissioned of themselves and their two daughters had come back to America unfinished). Now they wished to commission a truly regal portrait of George Washington, a gift worthy of a powerful English ally, the Marquis of Lansdowne.

From the first, the new portrait was understood to be both new and not: The unfinished head Stuart was painting for Martha would be the basis of the Washington head in the proposed portrait, which meant inconveniencing Washington for perhaps as little as one additional sitting. But this new picture would be very much more, too, as befitted the intended recipient.

Born William Petty, Lord Lansdowne inherited large estates in Ireland and became the Earl of Shelburne upon his father's death. During his career in British politics he had won the admiration of Americans as an opponent of the war, and, as prime minister in 1782–83, he shaped policies that led to the Treaty of Paris, which had officially brought the American Revolution to an end.

In 1784 he had been created the Marquis of Lansdowne. During the

Binghams' London years, they had been introduced to Lansdowne by Joseph Vaughan, and a friendship was born. Nancy and her husband had been made welcome at Lansdowne's London town house on Berkeley Square, where they talked trade, politics, and art. Lord Lansdowne's art collection included paintings by Titian, Tintoretto, Reynolds, and Gainsborough. Stuart, too, was known to Lansdowne, as the American had painted his portrait during his London years, and the Englishman had also been one of the thirty-two men who desired a copy of Stuart's first Washington portrait.

The Binghams, Nancy in particular, were determined with this commission to make a grand statement about America, its most important hero, and even the status of its artistic culture. Their English friend's house merited something greater than a mere bust portrait, and Nancy was just the person to make it happen.

——

STUART UNDERSTOOD THAT expectations for his Washington portraits had been elevated once again. Mrs. Bingham always did things in grand style, and this new portrait of her friend Mr. Washington would be no exception. She wanted a life-size standing portrait.

The commission provided the artist with another fine chance to profit from the worldwide admiration of Washington, as Stuart recognized that copies of a big portrait could be an ongoing and lucrative source of income. Further, the very nature of the image would make it suitable for engraving—from the moment of conception, everyone expected Stuart to paint Washington in a grand setting, surrounded by a richly detailed collection of objects that represented his accomplishments and his legacy. The sale of prints from such a painting, Stuart knew, would provide welcome revenue.

Although he gladly contemplated the potential returns from such a portrait, the actual execution of the canvas for the Binghams and Lord Lansdowne intimidated him in a way that commissions rarely did. Paint-

ing torsos and, in particular, the legs of his subjects for full-length portraits did not come so easily to him. His lack of confidence in his ability to reproduce a full-length human form was, in fact, one reason that, at age nineteen, he had refused the prestigious commission to paint the Newport worthy Abraham Redwood. True, in London and Dublin in later years, he had had some successes in painting subjects head to toe, but his gift was for painting heads and faces, and he knew it.

To help assure he would succeed with this very public assignment, he rifled through his collection of engravings, looking for a model on which to base his composition. The new canvas would be an official portrait, not a family portrait like the new conversation piece, Savage's *The Washington Family*, of which his fellow Philadelphians now gossiped. Nor would he look to portray the General as his friend Trumbull had done a few years before, posed in military regalia as if for battle. His plan was to capture George Washington as statesman, as president, with certain of the trappings of that office. When he came across a portrait by the French artist Hyacinthe Rigaud of a noted seventeenth-century preacher, Bishop Jacques-Bénigne Bossuet, that seemed to fit the bill nicely.

The 1723 engraving of the Rigaud portrait had just the right mix of elements, including a luxurious setting with columns, drapery, and ostentatious furniture, all of which added grandeur to the imposing figure in the center. Adopting Rigaud's composition, Stuart concluded, would save him a great deal of time and trouble in resolving how the pieces would fit together.

Yet the large opportunity at hand remained freighted with other pressures, some of the sort that Stuart habitually sidestepped. He was a master at ignoring deadlines, but this time there would be the persistent and powerful Mr. Bingham hurrying him to complete the painting. Uncharacteristically, Stuart worried about what people would say. He wanted his old friends in the London painting world, many of whom would surely see the finished canvas, to think highly of it. He remembered, as well, the

"extreme fastidiousness of the English nobility," and it made him apprehensive to think that not only Lansdowne but others in London society might find his tall Washington a disappointment. The pressure was on, and Stuart set to work to make a masterpiece—and to do it quickly.[40]

⌒

BY AUTUMN, HE had done it. He had fallen seriously ill in the process, recovered, and completed the canvas.[41] Martha had given him lace for the neck ruffles, and he borrowed Washington's sword to copy it precisely, complete with its gold tassel and ribbon. He purchased an expensive Turkish-made rug for the foreground. He carefully planned the pictorial elements to send the right messages: Such pieces should, he believed, "illustrate the character of the person. The eye should see the application of the parts as to illustrate the whole, but without separating or attracting the attention from the main point . . . [T]he person should be so portrayed as to be read like the bible without notes."[42]

On October 29, 1796, William Bingham composed a note to accompany the large crate ready to begin its journey across the sea; inside, a bold and elegant Philadelphia-made frame had been fitted to enclose the five-foot-by-eight-foot canvas. "I have sent by the present opportunity a full-length portrait of the President," Bingham wrote to Rufus King, the American minister to the Court of St. James's, who was charged with seeing the gift through customs. "It is intended as a present on the part of Mrs. Bingham to Lord Lansdowne. As a warm friend to the United States and a great admirer of the President it cannot have a better destination."[43]

Once it reached Berkeley Square, the picture very much pleased its recipient. "[T]he picture . . . is in every way worthy of the original," Lansdowne wrote, comparing the canvas to Washington himself.[44]

When he examined Mr. Stuart's creation, Lord Lansdowne could not help but feel as if he were looking upward. Stuart had recorded the presidential figure—it wasn't Washington who posed for the body but a

stand-in—from a low angle. Thus the president towers over the on-looker. Behind him, adding monumental scale, are the bases of two pair of Doric columns and tasseled drapery (an architect friend had helped Stuart sketch the arrangement). In the distance, a beclouded but clearing sky can be seen, and Stuart painted in a pale rainbow. The storm has passed, and the figure at center, his gaze distant, looks into the future.

The setting is a fiction, more nearly resembling the earlier French canvas than any scene in Philadelphia. Beneath Washington's out-stretched hand stands a table, draped with a rich red cloth, its leg shaped like a human knee and well-turned calf. At the crest of the state chair behind the standing figure is a shield, an element derived from the Great Seal of the United States. An inkstand on the table bears the Washing-ton family coat of arms; beneath the table are three books, with titles that allude to the General's service (*General Orders* and *American Revolu-tion)* and his political leadership (*Constitution & Laws of the United States*). The sitter hadn't planned the painting, but the retiring president took symbols very seriously indeed. He, perhaps better than anyone, un-derstood that he was one.

The painted president is frozen in midgesture, his right arm ex-tended, palm up (his left hand rests on the sword at his hip). To Lans-downe, schooled in the classics, this was recognizable as the *ad locutio* gesture, a proper pose since the time of Augustus Caesar for statesmen and heroes. Here was Washington as orator; and in educated London as in ancient Rome, the gesture conveyed the rhetorical power of the man's speech and his authority. (In fact, he wasn't remarkable as an orator—Mrs. Liston: "Washington Writes better than He reads, there is even a little hesitation in his common speaking.")[45] As Stuart's brushstrokes revealed him for his admirer Lord Lansdowne, he very much looked the part.

When Stuart painted his president, the man himself was preparing for his departure from public life. The man in the portrait is clearly giv-ing a speech; in life, Washington was working on one, namely, his fare-well address to the nation, in which he sought to explain his decision to

decline a third presidential term.[46] He would never read the speech to an audience (it was published in Philadelphia on September 19, 1796, in the *American Daily Advertiser* and widely reprinted across the country thereafter), but that only made the pairing of the portrait and the speech inevitable. The combination offers a window into Washington's state of mind as he contemplated retirement.

His speech had been carefully crafted over a period of years. In May of 1792 he had asked James Madison to provide a retirement address, a time when he hoped to return to Mount Vernon after just one term. His old friend Eliza Willing Powel and others had then persuaded him of the necessity that he serve four more years, but some of his thoughts, as articulated by Madison back in 1792, still applied. Washington himself had worked at the prose and in May of 1796, he asked Alexander Hamilton, a political ally and old hand at speechifying, to review a new draft that was a blend of Madison's words and Washington's. Hamilton added some rhetorical flourishes, but the finished speech was pure Washington.

The man in the picture is aging; the man who wrote of retirement was conscious of his own mortality. Washington did not wish to die in office. He wanted to avoid mimicking the monarchical precedent of the head of state who served until the moment of death. An orderly transition of power was preferable, he thought, and it would deflect the oft-published accusations by the anti-Federalists that he was a king in all but name. Till his last days in office, Washington concerned himself with appearances and precedents.

In his speech he reminded his readers "that the free Constitution, which is the work of your hands, may be sacredly maintained; that its administration in every department may be stamped with wisdom and virtue; that, in [time], the happiness of the people of these States, under the auspices of liberty, may be made complete by so careful a preservation and so prudent a use of this blessing as will acquire to them the glory of recommending it to the applause, the affection, and adoption of every nation which is yet a stranger to it."

Don't take this for granted, he seemed to be saying. Washington wanted his fellow Americans to understand that the man was less important than the document that had made possible his election to the office of president. It was vintage Washington. With the simple regard for continuity of a farmer born to the cycles of the land, he pled for the restraint, respect, and patience to allow the new country "to settle and mature its yet recent institutions, and to progress without interruption to that degree of strength and consistency which is necessary to give it, humanly speaking, the command of its own fortunes."[47]

Lord Lansdowne gave his new painting a place of honor. He hung it in his library, a grand room with domes at each end, where the Washington likeness was in excellent company. Among other works of art, the room also contained ancient marble statues of Hercules and, appropriately, Cincinnatus, the latter bending to tie his sandal. There were also paintings by Rubens, Claude, Murillo, and Poussin.

The London press offered encomiums. Typical was the *Oracle and Public Advertiser,* which proclaimed on May 15, 1797:

> The portrait presented . . . to the Marquis of Landowne is one of the finest pictures we have seen since the death of Reynolds . . . To many a description of the person of General Washington will be new: the picture enables us from its fidelity to describe it very correctly. The figure is above the middle height, well proportioned, and exceedingly graceful. The countenance is mild and yet forcible. The eye, of a light gray, is rendered marking by a brow to which physiognomy attaches the sign of power. The forehead is ample, the nose aquiline, the mouth regular and persuasive. The face is distinguishable for muscle rather than flesh, and this may be said of the whole person . . .
>
> The liberality of his Lordship [the Marquis of Lansdowne] has consigned it to the [en]graver, but we cannot resist the pleasure of describing the effect which the picture produced upon us.[48]

Just as Washington readied to depart once more for private life—this time for good, he hoped—Stuart's regal likeness of the man established him abroad as the republic's most important public figure.

v.

1796–1797 . . . The Painter's Studio . . . Germantown

M<small>R. STUART, HAVING</small> risen to a great challenge, rode the crest of the wave. To judge from the flow of the curious through his Philadelphia Painting Room, Stuart's American fame was assured. In fact, he was so "inundated with visitors" that he "found it impossible to attend to his profession."[49] The hoped-for significance of the Lansdowne commission had come to pass, both for his reputation and his pocketbook. The original Lansdowne alone had enriched him by $1,000.

He had been engaged to make a replica for Mrs. Bingham. That one he signed *G. Stuart, 1796*. The signature was unusual (when asked why he so rarely marked his canvases with his name or initials, he replied it was because "I mark them all over").[50] Perhaps he made an exception for the Binghams as a way of expressing his appreciation to his patrons. Other people wanted replicas of the full-length portrait, and, given the practice of charging by canvas size, that meant more money for Stuart.

He now had important work to do, and desiring fewer distractions, he found himself a new place to work in the countryside. Located in Germantown, across the Schuylkill River and a half-dozen miles northwest of the busy downtown streets of Philadelphia, the village was a pleasant two-hour carriage ride from the capital. His house was far from grand, given that "most of the town's houses were of dark, moss-grown stone, and of somber and prison-like aspect, with little old-fashioned windows." But the two-story barn behind suited Stuart's needs perfectly.[51] He adapted the structure, bringing in lathers to plaster the walls of the second floor, which he converted into his Painting Room. He opened

new windows in the walls to provide "top light," and ordered the outside painted red.⁵²

Gratifying as it was that people desired copies of the big portrait, Stuart still had some old customers knocking at his door desiring earlier commissions he had yet to complete. One of them was Mrs. Washington: She still wanted her smaller canvas of her husband and its pendant.

Nearly a year had passed since she and her husband had sat for Mr. Stuart. In that time he had completed the big paintings for Mrs. Bingham but not the two for Mount Vernon. Martha was growing impatient. Together with her imposing husband she visited Mr. Stuart at his new address. Washington noted in his diary that day, "Road to German Town with Mrs. Washington to see Mr. Stuarts' paintings."⁵³ It was January 7, 1797.

This wasn't their first follow-up visit to Stuart—they had called often. On this visit Martha was again disappointed. The couple saw their likenesses, but each remained little more than a head afloat on an expanse of bare canvas, like a boat becalmed on an empty sea. Even so, the likenesses each had a surprising humanity. In a way, the very incompleteness of the paintings seemed to imply the presence of the artist, ready to add the highlights to the eyes that were his trademark (Washington's eyes in life were light blue; in this likeness, they were dark). These were, of course, unfinished portraits, but the visible brushwork seemed to suggest the painter was near at hand, palette and brush ready. Stuart hadn't blended his colors as Copley would have done; to do so he felt was to risk giving "the flesh the consistency of buckskin."⁵⁴ The paradox was how lifelike two disembodied heads could be.

In no sense was Martha's painting done; they could see that. Her mobcap remained little more than sketchy zigzags of white paint that framed her face. Though closer to completion—enough of Washington's shoulders were painted that the image resembled a Roman bust—the president's portrait was also far from ready. Mr. Stuart made a plea for his maintaining possession, and not only because they were unfinished.

He needed the originals, he told his clients, in order to make copies from them. Everyone present understood that in the absence of a willing sitter—and Washington was quite uninterested in another session in the Chair—then the next best source would be to copy the canvas that had been made from life.

The portraits were so good that Martha was eager to have them, but the president accepted Stuart's explanation. As they prepared to leave, with Martha out of earshot, Washington told the artist, "Certainly, Mr. Stuart, if they are of any consequence to you; I shall be perfectly satisfied with copies from your hand, as it will be impossible for me to sit again at present."[55]

Neither he nor Martha (or even their descendants) would ever take delivery of copies, not to mention the originals. However, a great many other people would.

—

NOT SO MANY months would pass before Stuart's run of good fortune ebbed. Lansdowne responded to the public admiration in London for his painting by consigning the work to an engraver for reproduction. James Heath, who was among the artisans Stuart had painted for Alderman Boydell a decade earlier, produced a large engraving, but Stuart received no financial benefit from it. Stuart thought Heath's engraving not only unauthorized but a poor job. As if to underscore the insult, the artist was listed as "Gabriel" Stuart.[56]

The artist blamed Bingham for not protecting his interests and asked him to compensate him for his losses. The confrontation ended their relationship, and Stuart lost an important patron and, undoubtedly, access to Bingham's social network. Too often, that was Stuart's way: As another Philadelphia merchant confided in his diary, "Like many other men of preeminent genius . . . his passions are impetuous, nor does he appear very regardful to control them."[57]

Still, the Washington paintings remained a franchise, and Stuart

made many replicas. Using a common copying method, he would lay a porous fabric over an existing painting. The image beneath could be read through this "tracing cloth," enabling Stuart to make a chalk copy for transfer to a new canvas.[58] One visitor to his studio, a young Baltimore merchant named Robert Gilmor, admired the copy he was completing for Mrs. Bingham. Stuart told him that "he had engaged to finish copies to amount of 70 or 80,000 Drs at the rate of 600 Drs a copy."[59]

Perhaps remembering good days in Stillorgan, Stuart invested the proceeds from "five whole lengths of Washington, and twenty others of different sizes" in a farm further into the Pennsylvania countryside. He planned to import Durham cows and breed them on the estate. He hoped it would be "a home for his declining years and provision for his family."

For a time business was good, though probably not as good as he told Gilmor. Even with assistants, Stuart could not have painted so many replicas—and he did not. His finances, like his personality, continued to fluctuate—he couldn't any more moderate his manner of living than he could control his moods, which ranged from light and high spirits to dark and gloomy lows. As a young man, he had amused himself by outwitting bill collectors and charming his jailers in debtors' prison. Even when, as now, the tide of his income rose, the money trickled though his fingers. His dream of a retiring to a farm in the country got away, too, since he failed to secure proper title to the property. He lost his entire investment of $3,442 when the seller died and his heir refused to honor Stuart's claim.[60]

It wasn't in his nature to repeat himself like some kind of machine. He admitted that in making copies "he worked mechanically and with little interest."[61] He varied the big canvases, producing versions in which Washington rests his hand on the table, atop a document. He elongated the president's physique, restoring Washington's own stature, producing a more elegant pose. Over time he tired of making copies of his *Washingtons*, and his financial fortunes took a steep downturn. On May 6, 1801, the Germantown sheriff, in pursuit of payment for an old debt, attached

the Stuarts' worldly goods for auction. Fortunately for Stuart, the writ did not extend to the contents of the Painting Room. He reopened a studio in Philadelphia for a time, before following the federal government to Washington, and for several years he worked in the new Federal City.

———

THE ARTIST AND the president seem to have been predestined to play paramount roles in each other's legacy. Not so many years after Washington's death, the unfinished head had *become* George Washington; in 1823, the English art critic John Neal observed, "[If] a better likeness of him were shown to us, we should reject it; for, the only idea that we have now of George Washington, is associated with Stuart's Washington."[62] As for Stuart, remove Washington from his oeuvre, and, despite his status as the first world-class American painter, his standing would be greatly diminished.

Theirs was a pairing of opposites: Washington, the man who kept himself under tight control, and Stuart, a man of mood swings, his nose swollen from his addiction to snuff and reddened by his fondness for drink, whose impulses were rarely contained. Stuart's daughter remembered him as frequently profane ("my father did swear at times: he was very faulty in this respect") and often "out of temper."[63]

Yet there are the three portraits. The first was the small portrait that disappointed the artist, which we now know as the "Vaughan Portrait," for the English owner of the copy from which an engraving was made. (Of the original Stuart himself said he "rubbed it out.")

The next was the floating head left unfinished but, it seems, resolved to his satisfaction. Stuart would retain possession of the original until his own death three decades later, after which it went into the collection of the Boston Athenaeum (thus attaching to the canvas the name "Athenaeum Portrait"). The big painting, known as the "Lansdowne Portrait," added ceremony and symbolism.

For Stuart, however, the face of his sitter was the truth; by employ-ing the "science of physiognomy," he believed his likenesses enabled the viewer to read temperament and character in the facial features and ex-pression he limned. Of that one cannot be sure, but he was indisputably the best American painter of his age. For Stuart, the face *was* the paint-ing; the rest of it was just wrapping paper.

Rembrandt's Washington

I am now the only painter living who ever saw *Washington.*
—*Rembrandt Peale, "Lecture on Washington and His Portraits," 1858*

I.

September 1795 . . . Philosophical Hall . . . Philadelphia

IN ONE HOUR, opportunity would knock at the Painting Room door. His father had arranged the appointment for seven o'clock in the morning, and a further understanding had been reached for the customary second and third sessions in the days to come. Though the arrangements had been agreed upon, the painter found little consolation in his routine as the light of day began filtering through the high windows.

The young man—this Mr. Peale was seventeen—had risen before daylight. Now, as the minutes marched toward the appointed hour and he set about mixing his colors, his concentration wavered and his hands felt unsteady. Before he could prepare his palette, his agitation grew to unease. He began to fear that he would fail, that he would be unable

to render a likeness onto his canvas of the august presence about to appear in the doorway.

The portrait he was to paint, he knew, could elevate his artistic fortunes. A likeness of Washington in his hand would draw people's attention, gain him income from replicas, and, once and for all, set him on the path that since birth his father had hoped he would take. His very name—in 1778 he had been christened Rembrandt—implied how high were the expectations.

He had shown a precocious talent for drawing at just eight years of age, and a few years later he constructed his own easel, paint box, and chair in order to pursue his vocation.[1] He apprenticed in his father's Painting Room, making copies of portraits, historical prints, and landscapes, and demonstrated such promise that the senior Peale had announced that he himself had "bid adieu to portrait painting."[2] Future commissions, Charles Willson Peale announced in a paid notice in the pages of Philadelphia's *Daily Advertiser*, should be referred to his sons, Rembrandt and his older brother, Raphaelle, "whose likenesses, and the excellency of their coloring . . . will give general satisfaction." The elder Peale, having painted many of the Founding Fathers as well as Washington in the preceding quarter century, was devoting himself to his Museum of natural history (and, not coincidentally, of American history, too, as many pictures of Patriots were suspended over cases filled with nature's curiosities).

The sitter that morning was well known to young Rembrandt. They seemed to be linked as if by some sort of historical umbilical. Although he came along forty-five years later, Rembrandt had been born, as he himself put it, on "the 22d of February, the Birth-day of Washington."[3] This accident of chronology had long excited in the boy a particular fascination with the General. On the occasions during his boyhood when he had seen "the Man, distinguished above all Men," his eyes had locked on the tall figure, even when Washington marched amid a multitude of other soldiers at celebrations enacted at Philadelphia's

Centre Square. The young painter held in his mind the vivid recollection of one such morning when, despite the cover of clouds and fog, he observed "the peculiar effect of the misty light on the visage of Washington. His cocked Hat threw but a narrow shadow on his forehead, but his projecting brows cast a broad *filmy shade* over the whole orbit of his eyes."[4]

Yet the president was not an unapproachable presence. For years he had known the identity of this serious boy. As a lad, young Peale had had the run of the city, often doing errands about town for his father. Some of them were messages to deliver to Washington, who recognized the boy on the street. Young Peale recalled a day years earlier when Washington had rested his massive hand on his head and kindly inquired, "How is your *good* father?"[5]

As he waited apprehensively, Rembrandt had the comfort of knowing that what he was about to attempt was very much in the Peale tradition. His father had painted the great man many times and knew him well. Only days after Rembrandt's birth, Charles Willson had packed his palette and shouldered his rifle to return to the Philadelphia militia, rejoining Washington's army at its encampment, a small city of rough-hewn huts at Valley Forge.

Having returned to full-time artistry in peacetime, Charles Willson had again painted his commander, this time as a delegate to the Confederation Congress, during the summer of 1787, when Washington had presided over meetings convened to modify the Articles of Confederation. Peale, his entrepreneurial instinct piqued, had asked his old commander to sit in order that he might make a painting that, in turn, he could scrape onto a copper plate to produce a fresh Washington mezzotint. The Virginian had agreed, and one July morning, before the day's sessions at the Pennsylvania State House, he duly came to Peale's Painting Room to be recorded.

The memory of that day remained vivid in Rembrandt's mind, since he himself, though only nine, had been in attendance. "My post," Rem-

brandt remembered, "had been behind my father's chair when he painted him."[6] Now, as Rembrandt contemplated standing alone at his canvas with the General before him, the clock ticked toward seven. But there it was, Rembrandt realized, the balm he required to ease his rising panic. His father's manner with the man had been easy as they talked of common friends and enthusiasms. The notoriously restrained Washington had relaxed. Rembrandt knew his father to be much liked, and his capacity for making friends quite evidently extended to Washington. As the son saw it, the explanation lay in his father's "traits of character, his amiable temper, and his talents as a painter, that engaged for him the enduring friendship of Washington."[7]

In the midst of his hour of nervous anticipation, Rembrandt found his solution. He immediately summoned his father and asked him to join him in the Painting Room. If he were to work at a second easel, suggested the son, the sitter would get the benefit of his familiar conversation, and both painters could record the sitter at his ease. The presence of the veteran painter would not only relax the sitter and boost the confidence of his protégé; it would also offer "assurance that the sittings would not be unprofitable, by affording a double chance for a likeness."[8]

Shortly the State House clock struck seven, and Mr. Washington arrived. As he entered the Painting Room, Rembrandt noticed, his subject was "in the act of putting his Watch into his fob." His pocket watch synchronized, the ever-punctual president was ready to have his picture taken once more.

———

THE MAN HAD aged in the six years he had served as president. To see him passing by in his yellow carriage was one thing. To observe him near at hand, in the intimate setting of the Painting Room, was another. This was a careworn face.

Rembrandt had set his easel before the Painter's Chair, providing him a frontal view slightly to Washington's left. His father's sightline

took in the left side of the face as well, but from a three-quarter angle, since he stood to Rembrandt's right and slightly behind his son. Knowing himself to be a slow and meticulous worker, the seventeen-year-old had chosen a small canvas. Just fifteen inches high and eleven wide, it was barely a quarter the size of his father's. He had sufficient space to paint a life-size head, but little more.

As the painters set to work, it was obvious that Washington had shaved himself before coming that morning but that he had not had his morning session with the barber. His hair, its daily dose of powder yet to come, was revealed as graying but still dark brown. Rembrandt found that he could study Washington without distraction. The fear that had unnerved him the previous hour faded, and he observed not an icon but an aging family acquaintance, one engaged in a casual conversation. In his usual way, Charles Willson painted and talked; Rembrandt remained largely silent, "enjoy[ing] the rare advantage of studying the desired countenance whilst in familiar conversation."[9]

The paintings had progressed well enough when the first session ended, three hours after it began. When Washington returned, two days later, his approach was observed from the Painting Room window. He was pacing, walking back and forth along the allée of linden trees in the State House yard. Only when the clock struck seven did he enter the Painting Room.

There he found that the number of painters before him had doubled. Rembrandt's uncle, James Peale, was permitted to take a miniature, and he painted his ivory from a position to Rembrandt's left. Raphaelle worked at a profile sketch. A visitor who happened by the Painting Room that day, Gilbert Stuart, described the scene to Mrs. Washington, whom he encountered as he departed. "Madam," said Stuart in his wryest manner, "the general's in a perilous situation. He is beset, madam,—no less than five upon him at once; one aims at his eye—another his nose—another is busy with his hair—his mouth is attacked by a fourth—and the fifth has him by the button; in short, madam, there are five painters at him,

and you who know how much he has suffered when only attended by one, can judge of the horrors of his situation."[10]

The father-and-son oils continued to take shape, but by the third sitting, following another off-day, Rembrandt began to worry once more. He noticed his father was working down, repainting the forehead first. With time running out, Rembrandt determined to work upward from the chin. Between them, he decided, they would be able to assemble a complete likeness even if the third and final session found their canvases incomplete.

Rembrandt's final result has the candor of youth. He had no time to devise a flattering way to record a likeness, producing instead an honest picture of a man weighed down by his years. Rembrandt knew his painting lacked sophistication; what it most certainly didn't lack was a willingness to paint according to what his eyes saw. This was no gloss; nor did Rembrandt have the time to labor over a final polish of this painting. Even before the slow-drying oils had fully set, he rolled and packed the canvas for shipment to Charleston. A deep-seated urge to see the world led Rembrandt to look farther afield, and he had already booked passage, along with his brother Raphaelle, to the wealthy southern city. Along with some sixty copies he and his brother had made of their father's portraits of other great men, Rembrandt would display his freshly painted *George Washington.*

He hoped the picture "would invite attention from its novelty and interest" among the rice and cotton planters who flocked to the port city during the winter.[11] The Peale brothers rented rooms in which to paint. They wanted to stimulate a taste for their own work; back in Philadelphia, the recent arrival of Gilbert Stuart had drawn off many potential Philadelphia commissions, making a journey to another market seem sensible. They found a venue to display all their pictures (admission price: twenty-five cents). They announced the exhibition at the South Carolina statehouse in a verse newspaper advertisement.

Rembrandt did indeed find commissions in the new city. There was

a strong demand for copies of his Washington portrait, and he painted ten of them. "In executing these," Peale noted, "I became familiar with whatever good it possessed, but also became still more sensitive to its deficiencies."[12] Only much later, almost a quarter century after the death of his subject, would he return to the task of producing a Washington likeness that would both supersede this one and become a major preoccupation of the last thirty years of Rembrandt Peale's life.

—

REMBRANDT PEALE'S TIME in Charleston was followed by a brief visit to Savannah, then a much longer stay in Baltimore. In Maryland, the two brothers established a museum of their own, featuring a range of curiosities including taxidermy (some two hundred specimens of birds, animals, and fish, duplicates borrowed from their father) and likenesses (advertised as "distinguished Philosophers and scientists [and] Miscellaneous Portraits").[13] Neither their willingness to paint pictures nor the twenty-five-cent admission fees to their museum proved sufficient to sustain them in Maryland. Less than two years later, they returned to Philadelphia.

Rembrandt tested the artistic waters of New York in 1798, mounting an exhibition he titled "American Pantheon or Peale's Collection of Portraits of American Patriots" (brother Raphaelle remained in Philadelphia, where he advertised himself as a miniature painter). Rembrandt spent the following winter painting in Annapolis, but he returned to Philadelphia in the fall of 1799, advertising his portrait skills using just one name. To differentiate himself from his family, he called himself *Rembrandt*.

He was commissioned to paint the newly inaugurated president, Thomas Jefferson, among others, but in 1801 and 1802, he invested much time working at his father's side to recover and reassemble the fossilized bones of two giant mammoths, which they promptly put on display in his father's Philadelphia Museum. Along with younger brother Rubens,

he traveled to London with a "Behemoth" skeleton. In England's great capital he, too, became acquainted with the venerable Benjamin West, just as his father had done so many years earlier. But Rembrandt's stay in West's Painting Room proved much briefer. Though his first trip across the Atlantic exposed him to the fashionable mode of English portraiture—he exhibited two new works at the Royal Academy, *Self-Portrait with Mammoth Tooth* and *George Washington as a Master Mason*—he returned to America with a sense of incompleteness, and a yearning to see Paris.

For several years he devoted himself to portraiture (in Philadelphia, New York, the Federal City, and the South), but by the summer of 1808 he determined to take his much-mused-upon trip to France. It was the place, he believed, where he could "exert himself to get to the head of the Art."[14]

II.

Summer 1808 . . . An American in Paris

R EMBRANDT PEALE ARRIVED in the French capital carrying letters of introduction from his father, the diplomat Joel Barlow, and others with French connections. With the deed to his house as collateral, he had borrowed $1,300 to help underwrite his trip to France. Another $500 came from Charles Willson, who expected in return that his son would paint a dozen portraits of eminent persons for his Museum. Jefferson contributed a special passport bearing his own presidential signature, as well as a list of celebrated Frenchmen whom Rembrandt might record.

A month-long sea journey was followed by a five-day ride through the French countryside. Rembrandt thought Versailles "Majic . . . worthy of the Heathen Mythology."[15] Rembrandt did not seek a place in anyone's studio. John Trumbull, Gilbert Stuart, and his own father had

settled into Benjamin West's studio in London, but in Paris Rembrandt sought a different sort of tutelage. Rather than setting up his easel in the Painting Room of a mentor, he chose to study at the Louvre. There the artists with whom he apprenticed were dead.

They included Raphael, Correggio, Titian, van Dyck, and Veronese. The works he examined were not copies, but original oils, and Peale studied the masterpieces daily. At the Luxembourg Palace he spent hours with a series of paintings by his favorite artist, Peter Paul Rubens, admiring the flamboyant colors. He visited the tapestry factory, the Manufacture Nationale des Gobelins, and the Palais Bourbon, with its array of classical statues. The dutiful son also asked around for fossils and arranged an exchange of birds to add to his father's natural history collections.

The younger Mr. Peale had painting to do, too, in order to fulfill his obligations to his father. One of those portraits would acknowledge the great favor that France's most admired sculptor had done for the United States. In America, Jean-Antoine Houdon was esteemed, linked as he was to the early patrons of early American art, Jefferson and Washington.

In a sense, this was a family affair. Despite having rejected the idea of working from Charles Willson Peale's canvas for his statue, Houdon had sculpted his Washington much as Peale had painted him in his 1784 *Portrait of Washington at the Surrender of Yorktown*. In the finished standing sculpture that now stood in Richmond, Washington's pose, waistcoat, jacket, and even his paunch closely resembled Peale's portrayal. A handful of artists had worked to establish a taste for sophisticated art in America, and the youthful Peale represented a maturing of the artistic passions his father and the others had sought to stir up. Here he was, closing the circle, a member of the next generation, painting a likeness of the first world-renowned artist to take America's taste for the fine arts seriously.

III.

1808 . . . Houdon's Atelier . . . Palais des Beaux-Arts . . . Paris

JEAN-ANTOINE HOUDON LIKED nothing better than an au-
dience. Even at the most intimate moments of creation, with his eyes
fixed intently upon his subject and his fingers caressing the clay, he
sought not privacy but the energy and attention of others.

He kept his *élèves* nearby. Often one or more of the students would
sketch as the master worked. Another might be at the ready to provide a
fresh cloth or refill the bowl he used to moisten the clay at hand. Behind
the sculptor might be several bystanders, artists who had come to observe,
perhaps collectors or curious onlookers. He opened his studio to the pub-
lic, advertising in the Paris newspapers that his premises were available
for inspection. For a small tip paid to the Swiss guard on hand, visitors
could view full-figured nudes and portrait busts. Male and female visi-
tors, French and foreign alike, visited his studio, as they did that of
painter Jacques-Louis David, since both had become essential stops on
the itineraries of Grand Tourists in town to see the cultural high points of
Paris. Houdon's work space was a gallery, atelier, and small manufactory,
too, since Houdon pioneered the production of multiple copies of his
works, delegating those labors to his assistants, who produced terra-cotta
and plaster casts. Each bore a red wax seal bearing Houdon's name to
demonstrate their authenticity.

Another and different sort of audience looked over Houdon's shoul-
der as he worked at his rotating sculptor's table. A distinguished gallery
of great men lined two sturdy shelves mounted on the walls of his
high-ceilinged studio. These were likenesses of many renowned person-
ages of the age, part of Houdon's personal collection of plaster busts ("I
always keep an exemplar for myself").[16] Diderot, Rousseau, Molière,
Voltaire, Lafayette, and dozens of others offered mute testament to his
skill and importance. For Houdon, his accomplishment could be plainly

stated: "I believed I would be allowed to take pride in these works, whose sole merit is likeness."[17] But the critics extolled his larger virtues. As one had written of his work in the Salon exhibit of 1783, "M. Houdon lacks only the means to make his portraits speak."[18] As Stuart did, he attempted in his art to penetrate his sitter's personality; though his mode was coolly classical, his subjects were acutely alive.

When Rembrandt Peale arrived to present himself to Houdon, he soon spotted the bust of Washington resting on the studio shelves. He also spied another, more peculiar object on a shelf in that same workroom in the Palais des Beaux-Arts. It was three-dimensional and, though truncated at the hairline and ears, it was unmistakably a foot-high face complete with chin. Though of thick and heavy plaster, it looked very much indeed as if it could be used as a mask; but it also looked remarkably like George Washington. It was the life mask that Houdon had made at Mount Vernon in 1785.

Rembrandt had come to take Houdon's likeness, the Frenchman having agreed to the flattering request. After the American had found himself quarters in which to paint, Monsieur Houdon came to take a turn in the Painter's Chair.

IV.

1808 . . . Peale's Painting Room . . . Paris

WHEN REMBRANDT PEALE studied his sitter, he found himself regarding another aging man. The wear and tear of arthritis had begun to make sculpting painful. Despite surrounding himself with assistants who did much of the preliminary carving and who cast the replicas, Houdon faced the prospect of creating fewer original works and devoting more time to teaching. His life did have other pleasures, as he and his wife of twenty-three years, Marie-Ange-Cécile Langlois Houdon, had three grown daughters.

Houdon's reputation was great, both in Europe and America. His American œuvre included busts of Washington, Franklin, Thomas Jefferson, naval hero John Paul Jones, Joel Barlow, and Robert Fulton, the Pennsylvanian who had gone to Europe to study painting and returned as a steamboat inventor and entrepreneur. Houdon's gallery of great Americans did not, however, include a second Washington commission; its absence was among the few disappointments of his great career. He had undertaken the arduous six-month journey to Mount Vernon more than twenty years earlier with the hope of being given a second Washington commission, namely the equestrian monument of Washington that the American Congress had resolved in 1783 to raise in honor of the General. Houdon had regarded a bronze of the great soldier on his horse to be an even more prestigious task than *la statue Pédestre* he made for Virginia. In attempting to win that job Houdon himself had taken the cast of the George Washington bust to Congress on his way back to France in 1785, and Jefferson had lobbied on his behalf with many in the government.

But the congressional commission had never come, and Houdon had made his peace with the disappointment, even cherishing his recollections of his Mount Vernon fortnight. He confided in a son-in-law that "his memory [of Mount Vernon] always shone with peculiar radiance, for, though not knowing English and having to speak through an interpreter, the pleasure of having been close to Washington left memories which he was fond of referring to when many others of various kinds had long been forgotten."[19]

As Peale put paint to canvas, he recorded Houdon in a head-and-shoulder view. His format was predetermined in order that his canvas would be of a piece with the others in his father's gallery. The painter rendered his new friend's face seemingly at the very plane of the canvas, but his subject's shoulders were turned away from Mr. Peale, his right arm raised. The hand was out-of-frame, since the conceit Rembrandt devised was to portray his sitter as if Houdon were at work on a bust.

In a role reversal, Houdon had become the model watching the artist at work, and Peale recorded a man whose lively countenance watched him intently. Houdon's regard of the viewer was confident but curious; his frank gaze never seemed to falter. As the likeness took on a life of its own from one sitting to the next, the face assumed a healthy, reddish hue, enhanced by the red velvet backdrop. The image was reflective, with one artist portraying another; the men's lives were reflections, too, Peale himself having made his likeness of Washington in 1795, and Houdon his bust and statue a decade earlier.

Mr. Peale completed his Houdon portrait and seven others on that visit to Paris, but he became deeply homesick before completing the full dozen his father had commissioned. Rembrandt's wife and daughters had remained in America, and after only three months in Paris, the young family man departed in such a hurry that the paint on the last of his Paris portraits was not yet dry. The canvas, depicting the chemist Antoine-François de Fourcroy, was in ruinous condition when Rembrandt opened the crate after returning to America. The others he had made while abroad, including the painting of Houdon, would prove more enduring.

Another by-product of his French sojourn was the genesis of a new idea. Peale had visited the atelier of Jacques-Louis David and seen his grand paintings of Napoleon, who had proclaimed himself emperor. David had become official painter to the court, and his canvases of the ruler, while true to details of the man's appearance and attire, depicted an icon that seemed to transcend the merely human. David's role was to glorify Emperor Napoleon, to make him a demigod.

Rembrandt looked at the work of David, and he considered the sculptural likeness of Houdon's *Washington*. The thought began to take shape in his mind that he, Rembrandt Peale, might one day fashion a definitive, even eternal, likeness of the General. The idea was not born in an instant, but over time it would become a preoccupation. If he could produce what he would come to call the *Standard National Likeness*, mightn't he establish himself as America's reigning *Old Master*?

v.

1823–1824 . . . Painting the Patriae Pater . . . Philadelphia

T HE TIME TO do it had finally come. Rembrandt Peale went into his Painting Room and shut the door behind him.

His motivation was clear. "No human being could have felt more devoted admiration of the character of Washington," he explained, "and no Artist ever found his pride more strongly excited by the magnitude and interest of his purpose than mine to rescue from oblivion the aspect of a Man who would forever be venerated as the 'Father of his Country.'"[20]

Inside the Painting Room, no one faced the artist from the Painter's Chair. His subject had been interred for almost a quarter century. Still, Rembrandt Peale believed he could create a likeness that would inspire his countrymen. Stuart's portraits of Washington had become the standard, but Rembrandt intended to do better. He had studied Trumbull's Washington paintings and found those insufficient. His sources would be Houdon's 1785 bust—everyone agreed *that* was the best likeness—along with his own life study and his father's portrait, both dating from 1795.

The new canvas would be larger than life, of a "size and style . . . expressly calculated for public Halls, to produce a grand and pleasing effect."[21] Pure and simple, this was to be public art, and the artist's goal was to create a patriotic likeness to elevate and excite the feelings of his countrymen. That said, Rembrandt Peale knew that if he succeeded with this painting of the patriot father, it would enhance his own reputation, and create an appetite for replicas.

The task was not a new one. Since returning from his first French visit, he had tried no fewer than sixteen times to make a composite likeness. While all of those "trial portraits" had been sold, none satisfied their creator. This time he surrounded himself with "every document representing in any degree the man who still lived in my memory."[22]

When his wife found him studying the materials arrayed around his Painting Room, she asked, her tone anxious, what he had in mind. In

the past she had seen him lose himself repeatedly in attempts to paint Washington; she found his distance, his frustration, and his failure upsetting. "When I told her," Peale recounted, "she burst into a flood of tears, & exclaimed with great emotion that Washington was my evil genius, & she wished he had never been born!"²³ Peale promised her that this attempt, canvas number seventeen, would be his "*last effort.*"²⁴

In the years since returning from his first trip abroad, Rembrandt had gone once more to Paris (in 1809–10) with his wife and children. On his return to Philadelphia, he had opened a gallery, the Apollodorian, and, inspired by what he had seen in Paris, he began painting grand history paintings. In 1813, he had moved his museum to Baltimore. To house the usual mix of art and natural history, he constructed the first purpose-built museum in the United States. During his nine years in Baltimore, he also painted portraits. Like his father, he was intrigued by advancing technology, and he founded the Baltimore Gas Light Company to light his adopted city. He went on tour with a new history painting, *The Court of Death* (the canvas was enormous, twenty-three feet wide and nearly twelve feet high). The principal figures in the allegorical painting included War, Conflagration, Famine, Pestilence, and Remorse, along with Consumption, Despair, Hypochondria, and, of course, Death himself. Only Faith and Old Age relieved the scene. Then, in 1822, determined to return to painting full time, Rembrandt had handed the keys of his Baltimore museum to his brother Rubens. He spent some months in New York and Boston, but finally, his homing instinct still strong, he returned to Philadelphia. Here he would perfect his National Likeness.

To make his new Washington he worked, Peale later recollected, in a "Poetic frenzy." He thought of nothing else; he painted nothing else. His father, whose encouragement had often sustained him, worried about his son. Days passed; weeks became months. Rembrandt dreamed of the painting at night and worked at it all day. His father's concerns turned to "grief," and he concluded that Rembrandt's Washington was "a hopeless effort."²⁵

When Rembrandt was not happy with his progress, he turned his father away at the Painting Room door. Finally, three months into the process, his elderly and bespectacled father was permitted to enter the Painting Room. Although several of his children painted very well, Charles Willson had come to regard his second surviving son as his greatest hope. As a boy Rembrandt had had the run of his Museum and while there had learned much from his father. During his later travels to England and especially France Rembrandt gained painting knowledge beyond his father's, and their roles were reversed, with the son becoming the father's artistic tutor. Charles Willson admired his son's dedication to painting; as a scientist himself he was intrigued with Rembrandt's study of the chemistry of paint. Most of all, perhaps, he was moved by the younger man's firm belief in the ability of art to celebrate such virtues as patriotism and filial piety.

Charles Willson studied the portrayal on the easel. Soon, he clapped his son on the shoulder and uttered the words Rembrandt wished most to hear from the man who had himself painted Washington from life and had known him for more than twenty-five years.

"You have it now—this is indeed Washington."[26]

———

THE ARTIST GAVE his new Washington the permanence of stone. In composing what he hoped would be the definitive bust portrait, he painted what appears to be a massive marble frame, decorated with a wreath-like oval of carved oak leaves, topped with a keystone bearing the face of Jupiter. Although the words *Patriae Pater* ("father of his country") appeared to be carved into the windowsill, the canvas was soon given a simpler name. It became the "Porthole Portrait."

Peale had fashioned a new—and, in his opinion, authoritative—likeness of George Washington. He had not painted it from life, yet the Washington pictured appeared to have more vivacity than the life portraits. The likeness only distantly resembled Peale's own 1795 study; in

the new portrait, the man is clearly younger, the flesh on his face firmer. This Washington owed more to the marmoreal vision of Houdon's 1785 bust than to any Peale portrait.

Peale's *Patriae Pater* was also an invention, a romantic portrayal that echoed the notion of Rembrandt's contemporary, the English poet William Wordsworth, who defined poetry as "the spontaneous overflow of powerful feelings from emotions recollected in tranquillity." A quarter century of contemplating the principal Founding Father had indeed led to Peale's period of composition, which he described as "an instance of Artistic excitement."[27]

Word of the portrait traveled quickly around the city, and Peale's fellow Philadelphians crowded his Painting Room for weeks, keen to see the painting that glorified the great man. He set about collecting testimonials to his canvas. Many of the men he solicited had known Washington and proclaimed the portrait excellent. Major Lawrence Lewis, the General's nephew and husband of Nelly Custis, wrote to Peale, "It is the only portrait of my uncle I ever wish to look at a second time; but on this I could gaze continually." Upon seeing the portrait, Lafayette exclaimed, "Gentlemen, this is the Washington I knew!"

Washington is seen through the stone oculus as if, walking down the street, the viewer has chanced to glance into a window. There our alert eye fixes him. His black cloak is near at hand, resting where he has thrown it, across the windowsill.

His face is illuminated from above, his chin casting a shadow on his neck. This man does not suffer from the somnolence that so often overtook Washington in the Painter's Chair. This is a man of action, of evident force and strength. He is not held hostage by the painter. He might be gone in a moment, in pursuit of the mission from which he was distracted. We're privileged to see him—looking, listening, about to launch himself again toward his objective. The surface of the canvas has a gleam; Washington seems almost polished, the sitter's skin waxed. Rembrandt had lost the painful candor of his 1795 portrait of an old man, that

is clear. In its place, he has made an icon that is fresh and forceful, if theatrical.

The painting was exhibited in the U.S. Capitol in late February 1824. Rembrandt then took the portrait on tour, showing it to crowds in Baltimore, Philadelphia, and New York. In Boston, he arranged for a lithograph to be made from it. In 1828, the year after his father's death, Rembrandt traveled to Europe and exhibited the *Patriae Pater* to acclaim in Florence, Rome, Naples, Paris, and London. In celebration of the centennial of Washington's birth in 1832, a special committee recommended that the U.S. Congress acquire the portrait. For $2,000, Rembrandt sold *Patriae Pater* to the nation to hang in the Senate chamber.

—

THE "PORTHOLE PORTRAIT" became a mixed blessing to the aging Rembrandt Peale. From his travels to Italy with his son, Michael Angelo, he returned with copies of Old Master paintings. He experimented with the new vogue of sublime landscapes, painting at least five views of Niagara Falls. He devised a drawing manual, a modest pamphlet titled *Graphics: a Manual of Drawing and Writing, for the Use of Schools and Families,* published in 1835. The book, revised and expanded in four editions, saw continuing sales and regular reprinting over the next several decades.

Despite his other activities, by the 1850s Rembrandt Peale's principal mission had become to acquaint younger generations with George Washington. Traveling widely to deliver a long lecture titled "Washington and His Portraits," he talked not only about his own Washington canvases but also displayed copies he had made of other artists' works, among them two of Stuart's portraits, Trumbull's 1792 full-length, several of his father's images of Washington, and a profile copied from Houdon's bust. The older he got, the more tightly entwined Rembrandt's reputation became with Washington.

His travels and talks inspired commissions for more "Portholes."

The very name by which they came to be known suggests how routin- ized the work had become (the labels often read "George Washington Copy"). They varied slightly in content; in some, Washington looks right, in others he looks left; the subject's attire varies from the civilian (as in the original) to the military. Most were not true replicas but smaller adaptations, typically painted on twenty-five-by-thirty-inch canvases.

At age seventy-seven, Rembrandt confided to his brother Rubens, "I have not many years to live, and feel that my Vocation is to multiply the Countenance of Washington."[28] That he continued to do, painting the last (seventy-ninth) version of his *Patriae Pater* when he was eighty-two, in the last year of his life.

Remembering the
Founding Father

The past is never dead, it's not even past.
—William Faulkner,
Requiem for a Nun, *Act I, Scene 3*

I.

Friday, October 15, 1824 . . . Arlington House . . . Virginia

IN 1778 A German-language almanac from the printing press of
Francis Bailey of Lancaster, Pennsylvania, referred to George Wash-
ington as *"Des Landes Vater."* Translated into English as "the father of his
country," the designation began to follow the man around like his shadow
on a sunny day. In time, the conceit of *Founding Father* would become
the principal metaphor of the revolutionary era.

While Washington's political paternity survived him, no biological
children did. Martha bore no more babies after marrying Colonel Wash-
ington in 1759 (she had given birth four times in seven years of marriage
to Daniel Parke Custis). Despite his lack of genetic descendants, how-
ever, Washington most certainly did not lack familial ties. His affection

for Martha's children and, later, her grandchildren ran deep. In his correspondence he was generous in offering life guidance to many young and inexperienced men and women within his purview.

Over the decades he had more than a few stand-in sons, young men he sought to mold into great men. Among them were Martha's unlucky and undisciplined son, Jacky; Alexander Hamilton, the aide-de-camp who later served as the nation's first secretary of the treasury; and Tobias Lear, the devoted secretary and confidant who was with Washington at the end. There were Washington nephews and other men in the extended Custis clan, many of whom came to regard Mount Vernon as the bosom of their family. They, too, were subject to the fatherly ministrations of the General.

Two men in particular stand forth from the crowd of surrogate sons. Both of them—one a near relation, the other a passionate partisan from abroad—would help to shape the general's legacy after his death.

———

I F H E H A D had his way, George Washington Parke Custis would have become master of Mount Vernon. He had grown up there after the premature death of his father, Jacky Custis, of "Camp Fever" (most likely typhoid) at age twenty-six. Though there was no provision in English or Virginia law for formal adoption, Wash and his sister Nelly shared Martha and George's domicile even when President Washington's public life took him to New York and Philadelphia. Before, after, and periodically during Washington's presidency, they regarded Mount Vernon as home.

The General set high expectations for his ward and step-grandson, and more than once despaired of the young Wash Custis. "From his infancy," Washington wrote to the president of the College of New Jersey when the sixteen-year-old encountered academic difficulties, "I have discovered an almost unconquerable disposition to indolence in everything that [does] not tend to his amusements."[1] After the boy failed in a second and a third attempt at college, Washington resigned himself to Wash's

seeming inability to mature into the public role he had foreseen. The General confided to another member of the extended family, "I believe Washington means well, but has not the resolution to act well."[2]

Even so, the aging Washington chose to believe that the boy's better instincts would eventually emerge. As his adoptive father, Washington entrusted the eighteen-year-old Wash with the role of co-executor of his estate in the will he wrote in June 1799. With Washington's death a few months later, Wash would begin to demonstrate that this trust had not been misplaced. The lad dutifully remained with his grandmother until she died in her garret bedroom in 1802 at Mount Vernon. Only then did things change.

Believing that inheritance should follow the "laws of nature," the General did not leave Mount Vernon to Wash Custis. With the death of Martha, the estate went to one of his blood relations, Bushrod Washington, the eldest son of the General's younger brother John Augustine.[3] Custis wanted to purchase the property, but Bushrod refused to sell. Young Custis then moved eight miles north to an eleven-hundred-acre property that was part of the legacy left him by his own father. He named it "Mount Washington."

Wash adopted as his bachelor quarters a four-room cottage standing near the bank of the Potomac. There he stowed the many Custis heirlooms his grandmother left him, along with a growing collection of Washington memorabilia. While everyone in Washington's extended family seemed to cherish his memory, Wash was the first to recognize that even quotidian items associated with Washington were important. After Martha's bequests had been distributed, most of the remaining contents of Mount Vernon were dispersed at auction. Custis bought so many items that his purchases left him with a debt that would require years to pay off (the total cost, $4,545, was the equivalent of roughly $150,000 in twenty-first-century currency).

After some of his cherished mementoes were damaged by vermin and dampness due to inadequate storage, he resolved to build a proper

repository in which to preserve and display his Washingtoniana. He dubbed his new home "Arlington House" after an earlier Custis plantation. In 1804, he brought home a wife, Mary Lee Fitzhugh. Wash and "Molly" resided in the completed north wing, and the rest of the structure, which included a tall main block and a second symmetrical wing, was completed over the next dozen years.

Although separated from his childhood home, Custis found other ways to honor his connection to George Washington. He regaled guests with stories of Mount Vernon, offering item-by-item explications of the Washington-related objects that filled Arlington. There was the "War Tent," stored in two leather portmanteaus, and other military equipment, including a camp chest. Custis owned the iron lantern from Mount Vernon's passage, which family lore held to have been the property of Lawrence Washington (1659–1698), the first American-born Washington. Custis's cupboards displayed many Washington porcelains and silver, and a reinforced document chest held papers. In an upstairs chamber he would point out the most moving object of all. Stripped of its dimity canopy was the bed on which the Chief had died.

Downstairs hung an array of Custis portraits that, taken together, constituted an informal history of English portraiture as America was being settled. A portrait of his great-great-grandfather, G. W. P. Custis told his visitors, was the work of Anthony van Dyck; another, this one of his great-grandfather, he believed to have been executed by the London portraitist Sir Godfrey Kneller.[4] Nearby hung the three John Wollaston portraits of Martha, her first husband (and G.W.P.'s grandfather), and Martha's two children, Patsy and Jacky. Advancing through time, canvas by canvas, elaborate baroque clothing and painting styles grew simpler as the generations passed, offering the viewer a short course on how art had changed since John Smibert's time. The climax of the sequence was the original of Washington originals, the Colonel Washington portrait that Charles Willson Peale painted in 1772, which heralded the arrival of American-born, European-trained painters.

As the historic repository for Custis's "Washington Treasury," Arlington House became an essential stopping place for those wishing to pay their respects to the memory of George Washington. One such visitor was Marie-Joseph Paul Roch Yves Gilbert du Motier, an intimate friend of the family. The Frenchman's portrait—this was, of course, Washington's old comrade in arms Lafayette—already hung at Arlington House, another canvas from the hand of Charles Willson Peale. It was a likeness commissioned by George Washington himself during the Revolution.

———

WHEN LAFAYETTE CAME to visit, much had changed in the quarter century since the death of Washington. Thomas Jefferson defeated John Adams in the Bostonian's bid for a second term as president in 1800. After Jefferson's eight years in the President's House, two other Virginians won two terms each. First was "Little Jim" Madison (Washington's constitutional confidant stood just five-foot-four); he was succeeded by James Monroe (who, as a seventeen-year-old lieutenant in 1776, had crossed the Delaware with General Washington). But the year 1824 would truly see a changing of the political guard.

A new generation of candidates—for the first time, none was a Founding Father—sought the presidency. Voters considered such regional favorites as John Quincy Adams of Massachusetts, Henry Clay of Kentucky, William Crawford of Georgia, and Andrew Jackson of Tennessee. But few Americans that autumn would pay close attention to the mud-slinging of electoral politics, in which Jackson was cast as an adulterer, Clay a drunkard, and Adams as slovenly (by then Crawford had suffered a debilitating stroke). In those months, the more edifying story line that newspaper readers simply could not get enough of was the national tour of the man President Monroe called "the Nation's Guest."

Monroe had issued the invitation the previous February. "The whole nation," Monroe wrote, ". . . ardently desire[s] to see you again."[5] An act

of Congress, passed unanimously by both houses, had authorized the communication, and from his home in France, The Grange, the invitee responded in the affirmative. He let it be known that he would be honored to return to America after an absence of forty years, although he no longer used the title that was his birthright. Instead, he favored the rank he had earned in the Continental Army. The former marquis wished to be known as *General Lafayette*.

———

BY THE TIME Lafayette readied to cross the Potomac on the mile-long wooden bridge, he was running late yet again. The plan had been for a midday visit, but the commandant at the Navy Yard had given him a most thorough tour. The hours spent reviewing ships and dry docks meant the Nation's Guest had been forced to go directly to the President's House. He had taken his dinner with James Monroe, an old friend from soldiering days, and had postponed his trip to Arlington House until the evening.

Lafayette had been back in America barely two months, but each day the American public embraced him anew. On first stepping ashore in New York, he had been greeted by a crowd of fifty thousand lining the parade route to City Hall. The unexpected welcome overwhelmed him: Standing in the Portrait Hall, with a tall *George Washington* by Trumbull nearby, Lafayette felt tears running down his cheeks. At one point he was so moved he had difficulty speaking and stepped into an anteroom to compose himself.[6] He had gone to Boston, where he was greeted by a crowd of seventy thousand, and been fêted in Albany, Philadelphia, Baltimore, and at villages and crossroads in between with banquets, receptions, speeches, toasts, and applause from the crowds that lined every mile of his route. On his journey south, he also revisited the scene of the 1777 Battle of Brandywine, where, though struck in the leg by a musket ball, he had fought until his boot filled with blood. Back in the day, upon learning Lafayette had been wounded, Washington ordered the battlefield surgeon to "treat him as my son, for I love him the same."

Despite having expired a quarter century before, George Washington seemed to be watching his old friend at almost every stop of his "Farewell Tour." In Boston, a Gilbert Stuart portrait of President Washington had been installed at Lafayette's accommodation on Park Street.[7] In Quincy, where he visited the eighty-eight-year-old John Adams, the 1790 portrait of Washington that Adams had ordered from the artist Edward Savage hung in a place of honor, as did a Savage likeness of Martha. In Philadelphia, Lafayette had embraced his wartime comrade Charles Willson Peale at the Pennsylvania State House, then insisted upon going upstairs for a guided tour of Peale's gallery of revolutionary worthies (more than one canvas portrayed Washington). Later, Lafayette visited the artist's Walnut Street Painting Room, where Peale sketched him once more.[8] In Princeton, as the Frenchman received a doctor of laws degree inside a circular pavilion constructed for the reception, General Washington looked on, this time the size of life, from one of Peale's replicas of his *Battle of Princeton*.[9] After arriving in Washington, Lafayette had toured the Capitol, where four giant versions of John Trumbull's history pictures, including *The Declaration of Independence*, had been contracted for but not yet installed in the unfinished Rotunda. At the President's House, grandly outfitted in the French style by President Monroe, Lafayette saw the Gilbert Stuart *Washington* that Dolley Madison had saved from the fire that gutted the mansion during the War of 1812.

With dusk falling that Friday evening, Lafayette heard the rumbling of the wooden roadbed as his carriage crossed the Potomac. Along with his son, George Washington Lafayette, he anticipated a very different evening from the recent days of grand public occasions with thousands of hands to shake. The bridge beneath them connected the Federal City with Alexandria, Virginia, and upon reaching the river's western shore, the horses soon began the climb to the heights of Arlington, through a parkland of tall oaks and elms. At the top of a bluff overlooking the city, Wash Custis and other surviving members of George and Martha's family awaited the Lafayettes.[10]

Decades earlier, the Marquis de Lafayette had delighted in calling the plump little boy, then just three years old, "Squire Tub," but the family connection had been renewed in the interim. After the American War of Independence had concluded, Lafayette had returned to France and played an important role in his own nation's revolution (in 1789, as commander of the citizen militia, he had ordered the demolition of the Bastille, a state prison and symbol of tyranny). When more radical factions came to power, Lafayette had been imprisoned during the anarchic days of the Reign of Terror. His son George, then fourteen, escaped to America, where he and his tutor found refuge with the Washingtons. The General had treated the boy more as his son than as a guest, so to George Lafayette, now a man of forty-four, this journey was also a fond return to familiar places and faces. Thirty years earlier he and Wash Custis, two years younger, had been playmates and friends; Nelly Custis called him "my young adopted Brother."[11]

When the carriages emerged from the woods, the majestic mansion stood before them. It was an immense Grecian temple, with light pouring out of the large windows that lined the façade. As the carriages grew closer, the splash of light from the open front door could be seen, illuminating the interior of the portico. Indoors Mr. and Mrs. Custis and other family members waited.

For Lafayette these people could only bring to mind his old friend. Washington had been a private man whose intimate relationships were closely guarded. But in twenty years of letters to "My dear Marquis," he was warmer and more immediate than he was with most people. As Washington himself had written to Lafayette many years before, "You know it always gives me the sincerest pleasure to hear from you . . . that your kind letters . . . so replete with personal affection and confidential intelligence, afford . . . me inexpressible satisfaction."[12] Washington had been given to strong feelings; he was alive to love and to loss (men of his time, including Washington himself, unabashedly cried real tears in public); and he was possessed of large hopes. Lafayette was one of few

people in his life with whom he was able to share these feelings and aspirations. Theirs was a friendship, Lafayette sensed, that endured even in death.

The man who stepped down from his carriage that evening little resembled the reedy nineteen-year-old whom General George Washington first met at a Philadelphia dinner in 1777. Lafayette had celebrated his sixty-seventh birthday the previous month, and the years had taken an evident toll on the fresh-faced but grave young nobleman. He had spent half the closing decade of the eighteenth century in prison. He still mourned his wife, Adrienne, who had died in 1807 of lead and laudanum poisoning, medicaments she had been given to treat ailments resulting from her own incarceration.

Lafayette walked with a cane; it was both stylish and practical, as an old injury to his knee left him with a pronounced limp. He maintained the firm, upright posture of the military man, looking taller than his five-foot, nine-inch stature, but he wore a coat and vest (never a uniform or any military decoration). Despite his simple broadcloth coat, his advancing age and creeping infirmities, his was an imposing presence. He was, wrote one who saw him that week, "a man of extraordinary attractions; in face, much changed within thirty years. His complexion, originally clear and white, is now sunburnt; his forehead, which is very high, is covered very low with a wig; but it is still most attractive . . . All that he says and does is distinguished by a singular taste and good sense. He never seems for a moment to overstep the modesty of nature."[13]

Wash escorted the Lafayettes into the drawing room to meet Molly, their daughter Mary, and the party assembled there. He was welcomed as a most honored yet familiar guest; in return, he was courtly and cordial. It was Molly Custis who presented General Lafayette with a fresh rose, one fetched that morning from Mount Vernon. Once more Lafayette was nearly overcome with emotion as he pressed the bloom to his heart.

October 17, 1824 . . . The Tomb of Washington . . . Mount Vernon

T HE TECHNOLOGY OF transportation having advanced since they last visited America, the Lafayettes boarded a vessel powered by steam, the *Petersburg*, for the next leg of the journey. As the ship prepared to leave Alexandria, a large party joined the father and son on board the *Petersburg*, including more than a dozen American military officers, Secretary of War John C. Calhoun, members of Congress, and other notable citizens. The Tent of Washington awaited them in Yorktown (it was indeed the late General's own campaign tent, from the Custis collection) but even by steamship, Yorktown would be an overnight passage. The passengers settled in below decks as the ship steamed south toward the Chesapeake Bay.

Barely two hours after losing sight of the Capitol, the travelers heard a cannon salute fired, and the ship slowed. The echoing of the guns from Fort Washington, Maryland, was a signal that the ship was approaching another destination, and, on cue, a military band on deck began to play a dirge. Slowly the passengers made their way on deck and gazed westward to the Virginia shore. Atop a gentle rise, a substantial white mansion soon came into view. "We were approaching the last abode of the Father of his Country," Lafayette's secretary Auguste Levasseur noted in his account of the day, ". . . [and] the venerable soil of Mount Vernon was before us."

After forty years, the sight of Mount Vernon, home of the man he had come to regard as his spiritual father, brought Lafayette to his knees in "an involuntary and spontaneous movement."[14]

The *Petersburg* dropped anchor and a barge ferried the crowd to the shore—this was a scheduled stop on the tour—where the Lafayettes *père* and *fils* were given seats in a carriage. While the other guests climbed the slope to the Mansion House, the Nation's Guest was greeted by Washington's nephew Lawrence Lewis, husband of Martha's granddaughter Nelly, and one of the General's great-nephews, John Augustine

Washington. (Another nephew, Mount Vernon's owner, Supreme Court Associate Justice Bushrod Washington, was in Philadelphia tending to court duties.) The younger Lafayette quickly reconnoitered the house where he had been welcomed as a teenage exile and declared it little changed. His father stood on the piazza—the wide covered porch that overlooked the Potomac with the vista of the Maryland hills beyond—a place where, on his last visit, he had drunk tea and shared remembrances with his "adoptive father" during Washington's period of retirement between the Revolution and his call to service as president.

The visit was another family affair, and G. W. P. Custis guided the visitors. He led Lafayette and a handful of others—the larger crowd remained at the Mansion—to the family tomb some two hundred paces from the house. Nearly hidden by overhanging cypress trees, the unmarked wooden door was opened. As Lafayette descended alone into the Washington vault (he bumped his head on the door lintel as he disappeared from sight), the cannon thundered again.

Lafayette reappeared a few minutes later, his eyes full of tears. Taking the hands of his son George and Levasseur, he descended a second time into the tomb, where the three Frenchmen knelt and kissed the coffin. When they emerged, Wash Custis presented Lafayette with a large gold ring that contained a lock of the General's chestnut hair, along with a few strands of Martha's.[15]

———

UPON RETURNING TO the Mansion House, the visitors noticed the key to the Bastille hanging in the central passage. Sent by Lafayette to his "Beloved General," it had arrived in 1790 along with a drawing of the "fortress of despotism" that Lafayette had ordered demolished. The key, Lafayette had written to Washington, "is a tribute Which I owe as A Son to My Adoptive Father, as an aid de Camp to My General, As a Missionary of liberty to its Patriarch."[16]

Elsewhere in the house the Houdon bust remained (in the inventory taken at Mount Vernon in 1800, it was listed as "1 Bust of General

Washington in plaister from the life," with an appraised value of $100).
But little else that had belonged to the General was still there. Like
milkweed seed carried by the wind, the contents of the house had gone
in many directions.

The visitors toured the house, including Lafayette's old bedchamber
at the head of the stairs. They walked the grounds, and as they returned
to the shore, they cut cypress branches from the trees by the tomb. The
travelers returned to the *Petersburg* in silence. Only after Mount Vernon
disappeared from sight did the time of quiet meditation end. Lafayette,
settled on the steamboat's quarterdeck, talked until evening, recollecting
Washington as the ship steamed toward Yorktown.

———

LAFAYETTE WAS AMONG the last survivors of a great genera-
tion. He had expected his American sojourn would last four months;
instead, the triumphal tour required thirteen months, covered five thou-
sand miles, and encompassed visits to all twenty-four states. His contri-
bution to the American War of Independence was celebrated: he had,
after all, risked his life, accepted no salary, paid the expenses of his men,
and helped persuade Louis XVI to support the American cause with
more money, men, and matériel.

An adoring American public saw in the Nation's Guest the per-
sonification of what the revolutionary generation had accomplished. Few
of the Founding Fathers survived, and Lafayette visited most of them,
including John Adams, infirm and nearly blind, and Thomas Jefferson,
hopelessly in debt, suffering with dysuria, but still mentally sharp (though
Lafayette's English was virtually flawless, Jefferson insisted they speak
French). In addition to renewing his acquaintance with the old guard,
Lafayette dined with presidential candidates John Quincy Adams and
Andrew Jackson. He was still in the United States when Adams, whom
Lafayette had known as a fifteen-year-old in France during his father's
diplomatic service, became president in 1825 (it had fallen to the House

of Representatives to decide the election when no candidate won a majority of the electoral vote). Lafayette thus bore witness to the constitutional process by which Americans chose their leaders by democratic means, demonstrating that the system worked, even in the absence of the Founders. The nation Lafayette revisited had been transformed. The economy was booming, the currency was sound, and a network of passable roads linked the spreading nation.

As he made his American circuit, he did so as Washington's surrogate. At almost every dinner, the first toast was drunk to George Washington, the missing but unavoidable presence. No one would confuse the elegant Lafayette with George Washington, but the Frenchman in 1824 was untainted by the partisanship of the Federalist vs. Democratic-Republican confrontations; those parties hadn't even been conceived when he had last been in America. The sun seemed to have set on the revolutionary generation but here was Lafayette, the man the newspapers took to calling "the Friend of Washington," an appellation that helps explain the extraordinary outpouring of emotion—nationalistic, patriotic, and nostalgic—that flooded the land.

———

WASH CUSTIS DECIDED to write an account of the visit. His multipart "Conversations with Lafayette" ran in the *Alexandria Gazette* and attracted national attention when it was republished widely. Among those who read the pieces with particular interest was a popular historian named John F. Watson. He immediately wrote to Custis, suggesting they might collaborate on a Washington memoir. Watson thought he might ask the questions and, working with Custis's answers, "develop, as by moral painting, the individual character of General and Mrs. Washington, as they appeared in domestic and everyday life."[17]

The project seemed tailor-made for Custis, who abbreviated his Lafayette series in order to set to work collecting his thoughts on the Chief. His first "Recollection of Washington" was published in May

1826, and, for many years thereafter, usually on the occasion of Washington's birthday or Independence Day, new memory pieces would appear in the pages of the *National Intelligencer* and many other papers.

Custis's writing expanded to other venues. Throughout his life, George Washington had been fascinated with the theater. His hours as an audience member watching the thespians of the day informed his native gift for making an entrance, his ability to draw attention to his striking presence, his use of silence. He had seen to it that his ward was exposed to the theater, too, arranging for the boy, along with Nelly and George Lafayette, to attend plays in Philadelphia. In manhood Custis returned the favor by writing a play that honored Washington.

Titled *The Indian Prophecy*, the story featured the young Virginia colonel and climaxed with the prophecy of the title. A Kanawha Indian chief predicts that the brave soldier will not die in battle but will live to found and lead a mighty empire. When the play was first produced, in July 1827, at Philadelphia's Chestnut Street Theater, the prediction had long since come to pass.

Custis also tried his hand at painting, though with largely unremarkable results (according to his own daughter, the value of his paintings lay in "their truthfulness to history in the delineation of events, incidents and costumes").[18] He painted the battle scenes at Princeton, Germantown, and Yorktown. One painting stands out from the rest. It quite evidently owes its inspiration to John Trumbull's portrait *General Washington at Verplanck's Point*, the canvas the artist had given to Martha and that had hung in the New Room at Mount Vernon. Custis coveted the original, but it had gone by Martha's bequest to another Custis relation, so he had made his own version (it can't truly be called a copy). His is primitive. The horse has a mythic quality, anatomically odd, rendered by an unschooled hand. Yet as painted by his step-grandson, the General has real dash. Custis's portrayal somehow manages to convey, as Trumbull had done, a sense of the man's physical power in repose. It hung in the entry hall at Arlington House, together with Peale's Virginia colonel.

—

GEORGE WASHINGTON PARKE Custis was a poet, playwright, antiquarian, painter, and most of all, family historian whose favorite subject was always the man he called the Chief. He was a curator, too, whose care for a range of Washington objects helped assure their survival (many later migrated back to Mount Vernon).

When he, in turn, went to his grave in 1857, he was the last of the General's immediate family (Nelly had died five years earlier). Custis left copious writings about Washington, and his daughter oversaw their publication in *Recollections and Private Memoirs of Washington by His Adopted Son George Washington Parke Custis* three years later. It would prove to be the most enduring personal memoir of the Chief. Despite the differences in their ages, G.W.P. knew the man intimately, at least in the paradoxical and sometimes subliminal way that a child understands adult affairs. He was family; he knew the inner dynamics of Washington's personal world very well. He was a writer and researcher, and he used his agreeable manner and family connections to gain unique access to the memories of others who knew his grandfather, among them Lafayette, Dr. James Craik (Washington's oldest friend from military service in the 1750s, as well as his personal physician); the freed slave, William Lee; and others. The man managed to be both the child of Mount Vernon and the sage of Arlington. He was a self-appointed memory keeper; his assemblage of miscellaneous memories remains an essential, if eccentric, source for historians.

Though technically childless, the General was survived by a spiritual son and a step-grandson. Long after the great man's death, Lafayette and Wash Custis showed the world something of the private Washington, the devoted family man and generous friend. They made him more accessible, revealing an aspect distinct from the stony-faced Founding Father, iconic and unapproachable, mounted on a pedestal.

III.

The Lives of the Painters

To HIS PORTAITISTS, Washington was a protean figure. The relaxed country squire whom Peale painted in 1772 became the tired and haggard man that Rembrandt Peale limned a quarter century later. The Virginian spent most of the intervening years in public service, initially at war, often in the line of fire. He experienced another kind of crossfire as president, which, though strictly speaking political, was no less heated, as Jefferson and Hamilton were forever sniping at each other within Washington's own cabinet.

The personalities of Washington and his recorders can be identified by looking at the canvases. Peale's paintings are always unmistakable from across a gallery or down a hall, and in Peale's round faces we can almost sense his own cherubic personality. In his first *Washington* we note the man's girth, because Peale liked to portray people in their stout, full-bodied prosperity. Trumbull shows us a more patrician view. For him, Washington is a figurehead. Trumbull's desire was to capture the heroic Washington, to precipitate with oil paints a semblance of the man's historical importance. Savage aspired to less, and as artisan and show-man he shaped workmanlike portraits. Stuart's genius for suggesting rather than reproducing what he saw seems to have suited the vagaries of a habitual drinker and snuff-user.

All of these men outlived George Washington, as did their images of him. CHARLES WILLSON PEALE painted Washington from life seven times, producing almost seventy likenesses. But the intellectually curious Peale spent more of his later life pursuing his fascination with the natural sciences and operating his Museum than he did painting. Even so, at his death in 1827, he left a vast body of work, including more than a thousand portraits. Taken together, they constitute the single best visual record of the revolutionary generation. Peale's pen produced an autobiography, dia-

ries, and voluminous correspondence (his selected papers fill five hefty volumes). He was also survived by a living legacy of painters. Of his seventeen children, several had an important artistic presence, including sons Raphaelle and Rubens, best known for their still-life paintings, and Titian Ramsay, who painted natural history subjects.

After his father's death, the best-remembered son, REMBRANDT PEALE, remained in pursuit of portraiture. Despite having made only one likeness of Washington from life (and that when he was seventeen), Rembrandt lived to paint almost eighty copies of his composite *Patriae Pater.* Even in his last days (he died in the autumn of 1860), he was working to complete two more Washington portraits and had achieved wide fame for his lectures on Washington.

Despite having determined to pursue other career paths in the 1790s, JOHN TRUMBULL periodically resumed painting in what proved to be a long life. When he returned to America after another European sojourn in 1815, his arrival coincided with the rebuilding of the Capitol after the British had burned the unfinished structure during the War of 1812. Trumbull took the opportunity to resurrect his Revolutionary War project, persuading Congress to commission four large-scale versions of his history paintings. He was paid generously, collecting a fee of $32,000 for *The Surrender of General Burgoyne at Saratoga, The Surrender of Lord Cornwallis at Yorktown, The Declaration of Independence,* and *The Resignation of General Washington.* They went on public view in November 28, 1826, in the Capitol Rotunda, where they remain today.

By 1830 Trumbull was once again in need of money, when he negotiated a sale of his personal art collection to Yale University for an annuity of $1,000 a year. He helped design the museum that opened in 1832. His paintings filled the North Gallery, while the works of others in the Yale collection, notably John Smibert's *The Bermuda Group,* hung in the South Gallery. In 1837, Trumbull began work on what would be the first published autobiography by an American artist. *Autobiography, Reminiscences and Letters of John Trumbull from 1756 to 1841* appeared just two

years before his death in 1843. His remains were interred at Yale's Trumbull Gallery, beneath one of his own full-length portraits of George Washington.

GILBERT STUART did not endear himself to Martha Washington, who had Tobias Lear write to him a few weeks after George's death asking him to send her the unfinished portrait of her husband. Stuart still had it years later when G. W. P. Custis once more asserted the family's claim, and even offered $4,000 as payment. Again, Stuart refused to hand it over. The architect William Thornton, familiar with all the principals, probably expressed the popular consensus when he commented to another artist, "The original of the General I think ought to be Mrs. Washington's—and I think Mr. Stewart has not acted honorably in disposing of it."[19] A client once said of Stuart, "Like many other men of preeminent genius, he is his own worst foe."[20] As if to demonstrate the truth of the observation, Stuart thumbed his nose at the world, hanging the portrait on the door of his Boston Painting Room.

All of which is not to say that Stuart failed to put the unfinished portrait to good use. In his Painting Rooms in Philadelphia, Washington (1803–1805), and thereafter in Boston, he painted some seventy-five head-and-shoulder replicas, depicting the sitter in his black velvet suit and a white shirt with a lacy ruffle at the neck. As the years went by, Stuart grew increasingly reluctant to paint them, and his execution became mechanical and more loosely painted. Despite their variability, the copies represented in times of need a source of income to the alcoholic and snuff-addicted Stuart. He disparagingly called the copies his "hundred-dollar bills" and was said to be able to knock one out in two hours. He painted the last of them in 1825, after which he gradually lost the use of his left arm due to paralysis. At his death in July 1828 the unfinished portraits of Martha and George were all he had to leave his widow and four daughters. Daughter Jane, herself a painter of considerable skill, negotiated a sale of the incomplete likenesses of George and Martha to the Boston Athenaeum for $1,500. Since 1918, the Athenaeum

likeness of Washington has been engraved on the one-dollar bill, making it almost certainly the most reproduced painted image in history.

EDWARD SAVAGE operated his New York museum, the Columbian Gallery, until 1810. Thereafter he installed his collection in Boylston Hall, Boston, which he called the New York Museum, before retiring to his farm in Princeton, Massachusetts. He died there in July 1817. His survivors inherited *The Washington Family*, which was valued at $550 in his probate inventory. After a century of ownership changes (it was often exhibited but remained privately held), it finally moved to its permanent home at the National Gallery.

Whatever its merits as a painting, engravings of *The Washington Family* became the iconic image of Washington and his family for two generations of Americans; its fame and popularity far exceeded the hopes of its creator in uncounted versions of Mr. Savage's 1798 print, an ever-evolving series of mezzotints, paintings, magazine engravings, and lithographs. The clothing changed, the columns in the background came and went, and, in the Civil War era, slave William Lee disappeared; but throughout the nineteenth century, Americans came to know the domestic Washington largely as Savage had pictured the president and his family.[21]

The image became a cultural fixture, and schoolgirls replicated Savage's family portrait in needlework samplers. By 1850 the average American hadn't a clue what the current president looked like (it was Millard Fillmore). The chief executives who served between Washington and Fillmore were similarly unrecognizable. Thanks in part to Savage's *The Washington Family* and, to a lesser degree, Stuart's Athenaeum portrait, the first president remained a familiar figure.[22]

Two of the principal characters in these pages never painted Washington. Still, this is unmistakably a book about the stepchildren of BENJAMIN WEST and JOHN SMIBERT. The latter died early (in 1751) but left behind him the entombed Painting Room that so many painters came to see. West lived two decades into the nineteenth century. He had tutored

Charles Willson Peale, made Stuart something of a partner, and employed Trumbull in his studio while encouraging the younger man's "National Work." Later, Washington Allston, Thomas Sully, Rembrandt Peale, Henry Sargent, Samuel F. B. Morse, and a dozen other painters came to him and found approval, encouragement, and guidance. Trumbull described West's friendship as "inexhaustible."[23] Indeed it was, and when West died, in 1820, his manservant gave voice to the question many were asking themselves: "Where will they go now?"[24]

Yet it is Washington himself who stands at the fulcrum. When he was born, the New World had virtually no artists, and few colonials had ever seen a painting. For centuries, European princes, philosophers, and statesmen had exercised a lively interest in the arts, but in the early eighteenth century, the life of the American settler remained a struggle for survival and, on behalf of European investors, for profits.

Within Washington's lifetime (1732–1799), a cultural transformation occurred. He helped engineer the introduction of neoclassical architecture as the nation's de facto style, as evidenced by both its new capital city and the homes of its merchant, landowner, and middle classes. In Philadelphia, New York, Baltimore, and even Boston where a puritan ban survived into the 1790s, theaters had opened their doors to eager audiences. Painting and sculpture assumed a broad new presence in a country whose citizens, possessed of both independence and a growing prosperity, explored the life of the mind by pursuing new intellectual and artistic tastes.

The artists West trained sought to establish the art of painting in America and to do it in a distinctly American way. To his core, Charles Willson Peale was an egalitarian, convinced that everyone should be exposed to art and science. Trumbull saw America's quest for independence as immensely noble, a cause worthy of paintings as great as those of the European masters. Stuart, as his daughter reported, stood in awe of Washington, the man they all painted, the central figure in the story.

These artists all struggled to survive on their artistic output. They

had no royal patronage as Benjamin West had had although, where they could, they aped aspects of West's economic models (he pioneered the sale of prints from his paintings, and each of these painters produced their fair share of mezzotints and other prints). If they each achieved a certain fame, none made his fortune. Only Gilbert Stuart influenced the practice of painting beyond the boundaries of the United States.

By the time Rembrandt Peale and Wash Custis died, in the years immediately before the Civil War, artists faced a fresh challenge. Portraiture was becoming the province of the photograph. At the same time, a broader public taste for art had made America's natural wonders the new favorite subject for painting (think John James Audubon and the landscapes of the Hudson River School). Rembrandt Peale had personal experience of the generational shift that was occurring. He sought a major commission to paint Lafayette during the "Farewell Tour," but he lost out to the younger Samuel F. B. Morse; Morse, in turn, would soon retire from portraiture (he had inventions to pursue), and he watched as his friends Asher Durand and Thomas Cole changed the focus of painting in America. The great era of American portraiture had ended as the new artists begin to paint pictures of America, not Americans.

I V.

Seeing Washington

A S VARIED AS the portraits are, certain Washington attributes are notably absent. For his time, Washington was very tall and large-limbed. As some big men do, he exuded a quiet strength with no apparent attempt to display his physical prowess. He had the air of a great natural athlete, who understands intuitively that it must be left to his public to describe his capabilities. To see him was to understand.

That quality of Washington is lost to us. In thinking of Washington we must *imagine* a man of unusual size, evident strength, and surprising

grace. Many of his contemporaries described his person and movements as *majestic* and *splendid*, words not often associated with physicality. He took great pains with his clothing, military and civilian. Appearances, Washington believed, set the tone for the meetings of men. He could never enter a room unnoticed. Since he cannot enter ours, we must take his physical presence on faith.

Another characteristic that a painted likeness can only suggest is the man's quietude. After being derided as a young soldier for a foolish remark about the sound of a bullet whizzing by, he made it a rule to keep his own counsel. By temperament, he was a private man, and his sense of educational inferiority (his schooling ended as he entered his teen years) reinforced his reserve. As a soldier he learned early that an officer cannot be a friend to his men. As president (both of the Confederation Convention and of the nation) he occupied a lonely seat at the top of the pyramid, apart from everyone else in the government.

Even in casual society he felt no obligation to fill silences. Mount Vernon guests reported that when an awkward quiet fell at the dinner table, Washington seemed quite content to eat in silence. He liked the company of women very much, and perhaps he relaxed with them in a way he did not with men. Unfortunately, aside from some warm and confiding correspondence, we have little evidence of these relationships. If George Washington had a reserve that was close to impenetrable, undoubtedly Martha had her means of getting through to him (Wash remembered his tiny grandmother grabbing her husband's waistcoat button to get his attention), but she left virtually no written evidence of their connection, having burned her correspondence with the man she referred to as "the General."

Washington's contemporaries recorded the pleasure he took in easy conversation and in the witticisms of others. The painstaking process of portrait-painting leaves us with no smiling images of the man (he is said to have laughed rarely but to have smiled often); undoubtedly his loss of teeth and primitive dentures account for the frozen and distorted gri-

mace characteristic of his later portraits. If we had a sense that his features sometimes relaxed and softened, we might feel as if we knew Washington better. But few smiling images of anyone survive from that time.

His gaze was attentive, even penetrating. He listened with great care to what was said to him. Some observers thought his intellect slow, but those who knew him best understood his intelligence was not of the rapid and clever sort. His thinking was deliberate, balanced, and considered. In his voluminous letters he constructs arguments with great care. Only rarely does he resort to metaphor.

Washington wasn't an idea man in the way that Jefferson and Hamilton were. He was, in an antediluvian sense, a *manager*. In an era before the business of America was business (then it was farming), he was learning the new art of managing men who were no one's subjects. He was mastering the governance of a country by consensus, collaboration, and, perhaps above all, his own good sense. He understood intuitively that every move he made as president set some sort of precedent, whether it was his conduct at afternoon levees or his creation of the body of advisers now called the Cabinet. He took a slow and thoughtful approach to everything as a systematic, deeply methodical man. As James Madison said of him, his tendency was to take things as he found them. He also had the self-confidence to recruit better-trained and faster-firing minds to work for him.

These latter facets of his character can be fairly seen in the portraits. In the inscrutable expressions on Stuart's canvas, for example, a man of great self-control wrestling with himself can be distinguished. His temper was rarely unchecked (those who did witness its detonation attested to its white heat); his black moods were less uncommon. He was a melancholy man. His first secretary of state, Thomas Jefferson, once described him as "inclined to gloomy apprehensions." Washington wished with all his heart for the great American experiment to work; but he had many lingering doubts. In his farewell address, he observed, "At this

auspicious period, the United States came into existence as a Nation; and if their Citizens should not be completely free and happy, the fault will be intirely their own." In his likenesses we read both doubt and duty.

Washington was a man of unquestioned bravery, but, as a general, he lost more battles than he won. He was not motivated by power, fame, or money (for most of his life, he had all three, though the land-rich farmer at times had significant cash-flow concerns). Washington embodied leadership. Here was a man who won people's trust and confidence in an instant. He was serious and somber. For a public man, he was remarkably private.

He never officially ran for office. There were no campaigns in his time, as the cacophony of electoral debate grew louder only after he left the stage. His electability was innate. His imposing presence was crucial, of course, but so was his desire to listen to others rather than himself. He had the invaluable gift of being able to remember people's names on brief acquaintance. He never had a great deal of cash at hand but he rarely extended an empty palm to those who asked; Washington's account books over the years recorded hundreds and hundreds of acts of charity, gifts to poor men, soldiers, widows, the wounded, schools, people who lost their homes in fires, orphans, and the aged. His manner simply suited the game.

———

OUR VIEW OF Washington is linked to the Athenaeum portrait, an image that has grown so familiar it has been called "the household Washington." The unfinished Stuart canvas is enigmatic, but with close study, the viewer begins to realize that the Washington in the portrait isn't simply iconic. The General, nearing the end of his life, has begun to relax. His duty is nearly done. We are looking at a man on his way home after a very long journey. Doesn't he seem to have his eye on posterity? The effort to intuit his character is important: To understand the America he contemplated, shaped, and helped to invent, we must seek to understand him.

He was the midwife at the birth of his country, and he was *the* unavoidable presence as American painting emerged. When Smibert came to America, most puritanical Bostonians regarded portraits as ungodly; in effect, there was no artistic culture in the colonies. In Washington's time art emerged from the drawing room and went on display in galleries and public buildings. Charles Willson Peale helped make admiring likenesses popular, as the obliging man painted likable pictures of the well-to-do to display in their homes and to assure they would be remembered after they were gone. The colonial Mr. Copley, before his premature departure for England (he never returned to America after independence), did the same. Trumbull's aspirations were loftier, and he prided himself on nothing less than painting history. Savage, whose flair as a showman was undoubtedly greater than his artistic gifts, reached a larger public. His audience was the emerging middle class, men and women who could identify with his big painting of America's great hero. They admired not just the man but Martha, too, together with their wards, in a resplendent setting that represented a collective American future.

Thanks to his own deeds, to the remembrances published by Wash Custis, and to the explosion of interest produced by the visit of Lafayette, "the Friend of Washington," new generations too young to recall the Revolution were introduced to the General. The stolid, determined, rugged, dogged man the painters recorded has endured because of what he accomplished, and also because of what he didn't do. Unlike the others he rarely stooped to political bickering. A man of stature in more ways than one, he always tried to look over other people's heads at the horizon, to a time down the road when the distractions of the moment blurred and a larger vision emerged.

Washington became the paradigm of the Founding Father, more than Jefferson or Adams or Hamilton or any of the rest. None of the others had the unimpeachable mix of gravitas, selflessness, and implied power. In the age before photography he left no negative legacy; he was,

as his friend Eliza Willing Powel told him, "the only man in America that dares to do right on all public occasions."[25]

The Washington we know today, through his words, the testimony of others, and in the pictures the painters made of him, offers proof positive of his instinctive, pragmatic, and quintessentially American character. He was also a man who always agreed, admittedly with an air of resignation, to sit for yet another portrait.

ACKNOWLEDGMENTS

T HE TASK OF looking at historic portraiture involves trying to insinuate oneself into a series of two-dimensional likenesses. Mime-like, I have tried to enter the picture spaces created by Messrs. Trumbull, Stuart, Peale, and the rest, and to push the boundaries in such a way that I could better glimpse the other man in the frame, George Washington.

This book is the result of those efforts. My research has taken me to the artists' Painting Rooms, as best I could reconstruct them in my mind. My own two feet, together with Amtrak and an automobile, have delivered me to many museum galleries to see the art these artists made as they measured and mused upon their common sitter. An understanding of the past is just that: One view, one appreciation, one set of perceptions. We cannot truly *know* a historic personage. But writing a book like this is about glimpses, about assemblages, about assuming other people's points of view long enough to triangulate a new understanding—and

many conversations, directives, and advice along the way helped me in my pursuit. Among those to whom I owe debts are James C. Rees, Jennifer Kittlaus, Dawn Bonner, and Christine Messing at the Mount Vernon Ladies' Association; Jennifer Tonkovich and Sylvia Merian at the Morgan Library; Carrie Rebora Barratt and Catherine Scandalis at the Metropolitan Museum of Art; Charles Greifenstein at the American Philosophical Society; Peggy Baker at the Pilgrim Hall Museum; Robert Harmon at the Pennsylvania Academy of Fine Arts; Wendy Kail at Tudor Place Historic House and Garden; and the staffs at the Sterling and Francine Clark Art Institute, the Boston Athenaeum, the Sawyer Library at Williams College, the Chatham Public Library, the New York Public Library, the New-York Historical Society, the Mid-Hudson Library System, and C/W MARS, the central and western Massachusetts library system.

My particular thanks go to Peter Ginna, publisher, and Katie Henderson, editor, at Bloomsbury Press for lending their unerring ears and insightful eyes to the manuscript; Gillian Blake, who, at the outset, asked the key question ("What do the painters have in common?"); my friend and agent Gail Hochman, always ready with her good spirit and critical acumen; Kathleen Moloney for her humor, kindness, and patience with my grammatical lapses; Jean Atcheson for her close and literate scrutiny of the manuscript; Greg Villepique for readying the book for the press; Sara Stemen for a design that feels of a piece with the General's era; and Peter Miller and Jason Bennett for their work in alerting the world to the presence of this book. Special thanks, as well, go to Mary V. Thompson at Mount Vernon, for sharing her deep and affectionate knowledge of the Washingtons and their home.

Finally, I must thank the women with whom I share my daily life: my wife Betsy, whose engagement with the past has helped shape my thinking; our daughters, Sarah and Elizabeth, for their patience with my dinner-table tales; and to the living spirit of my late mother, Ann D. Howard, who first gave me entrée to the world of the American past.

PROLOGUE: *An Accidental Gallery*

1. John Neal, *Randolph, A Novel* (1823), reprinted in *Observations on American Art,* Harold Edward Dickson (State College: Pennsylvania State College, 1943).

2. George Washington, *Diaries,* February 22, 1799.

3. George Washington Parke Custis, *Recollections and Private Memoirs of Washington by His Adopted Son George Washington Parke Custis* (1860), pp. 527–28.

4. Quoted in William S. Baker, *Character Portraits of Washington* (1887), p. 320.

5. George Washington to Wakelin Welch and son, August 16, 1789.

6. Julian Ursyn Niemcewicz, *Under Their Vine and Fig Tree: Travels through America in 1797–1799, 1805 with some further account of life in New Jersey* (1965), p. 96.

7. Tobias Lear, "The last illness and Death of General Washington," reprinted in *The Papers of George Washington,* Dorothy Twohig, ed., *Retirement Series,* vol. 4, p. 547.

8. Lear, "last illness," p. 550.

9. George Washington, *Last Will and Testament,* reprinted in *The Papers of George Washington,* Dorothy Twohig, ed., *Retirement Series,* vol. 4, pp. 479–92.

10. Lear, "last illness," pp. 550–51.

CHAPTER 1: *John Smibert's Shade*

1. Stuart P. Feld, "In the Latest London Manner" (1963), p. 297.

2. George Vertue, quoted in Feld, "London Manner" (1963), p. 296.

3. Horace Walpole, quoted in John Marshall Phillips, "The Smibert Tradition" (1949), p.ii.

4. Henry Wilder Foote, *John Smibert, Painter* (1950), pp. 53–58.

5. Foote, *John Smibert* (1950), p. 55.

6. *Boston News-Letter,* April 2, 1751.

7. Saunders, *John Smibert* (1995), p. 255.

8. Ibid., p. 100.

9. The source for much of this is also the source that proved to be essential to many early American painters, Robert Dossie's *The Handmaid to the Arts* (1758), a reference for artisans that was updated and republished often in the late eighteenth century.

10. Saunders, *John Smibert* (1995), p. 263.

11. Ibid., p. 102.

12. Foote, *John Smibert* (1950), pp. 90ff.

13. *Boston Gazette,* July 12, 1748.

14. *Boston News-Letter,* April 4, 1751.

15. John Singleton Copley to John Greenwood, January 25, 1771.

16. John Singleton Copley to Henry Pelham, March 14, 1774.

17. William Dunlap, *History of the Rise and Progress of the Arts of Design in the United States* (1834), vol. I, p. 104.

18. Charles Willson Peale, *Diary* in *The Selected Papers of Charles Willson Peale and His Family* (1983), vol. I, p. 39.

19. Foote, *John Smibert* (1950), p. 123.

20. Charles Willson Peale, *The Autobiography of Charles Willson Peale,* in *Selected Papers,* vol. V, (2000), p. 23.

21. John Trumbull, *Autobiography* (1841, 1953), p. 44.

22. Ibid., p. 45.

23. Foote, *John Smibert* (1950), p. 256.

24. Foote, *John Smibert* (1950), p. 126.

25. John Smibert, *The Notebook of John Smibert* (1969), p. 10; and Foote, *John Smibert* (1950), p. 41, fns. 17 and 47.

26. Smibert's *The Bermuda Group* will reappear later as the source for Edward Savage's *The Washington Family*. See Chapter 7, page 140.

CHAPTER 2: *The First Likeness*

1. George Washington to the Reverend Jonathan Boucher, May 21, 1772.

2. George Washington, *Diaries*, May 20, 1772.

3. *Maryland Gazette*, January 21, 1762.

4. Peale, *Autobiography*, p. 14.

5. Ibid., pp. 16–17.

6. George Washington to Jonathan Boucher, May 21, 1772.

7. John Laurens, *The Army Correspondence of Col. John Laurens* (1867), p. 138.

8. Custis, *Recollections* (1860), p. 484.

9. Peale, *Papers*, vol. I, pp. 141–43.

10. Custis, *Recollections* (1860), p. 519. There is some difference of opinion as to whether this transpired, as reported by Washington's step-grandson Wash Custis, in 1772 or in early 1774.

11. George Washington to Jonathan Boucher, May 21, 1772.

12. James Thomas Flexner, *George Washington and the New Nation, 1783–1793* (1970), p. 89.

13. Charles Willson Peale to Edmond Jenings, August 29, 1775.

14. George Washington to Burwell Bassett, June 20, 1773.

CHAPTER 3: *The General*

1. Charles Willson Peale to Edmond Jenings, August 29, 1775.

2. Peale, *Diary*, November 11, 1775, p. 155.

3. Flexner, *George Washington* (1970), p. 335.

4. Douglas Southall Freeman, *George Washington*, vol. III, p. 426.

5. John Adams to Abigail Adams, May 29, 1775.

6. Washington, *Papers, Revolutionary War Series*, vol. I, pp. 3–4.

7. John Adams, *The Works of John Adams*, vol. II, p. 417.

8. *Journals of the Continental Congress*, vol. II, p. 91.

9. Washington, *Papers, Revolutionary War Series*, vol. I, p. 1.

10. George Washington to Martha Washington, June 18, 1775.

11. Charles Coleman Sellers, *Portraits and Miniatures* (1952), p. 230.

12. Wendy C. Wick, *George Washington, An American Icon* (1982), pp. 9–13.

13. Jules David Prown, *John Singleton Copley* (1966), vol. I, fig. 95.

14. The word "limner," from "illuminate" meaning to embellish manuscripts, was synonymous at the time with "portraitist"; only later did it come to be applied to self-taught and, by then, old-fashioned itinerant artists. Peale, *Papers*, vol. I, pp. 45–46.

15. Robert C. Alberts, *Benjamin West: A Biography* (1978), p. 77.

16. Peale, *Papers*, vol. V, p. 32.

17. William Dunlap, *Diary, 1766–1823* (1930), pp. 542–43.

18. John Galt, *Life of Benjamin West* (1816–1820), vol. 2, p. 17.

19. Peale, *Autobiography*, *Papers*, vol. V, page 34.

20. Ibid.

21. Sellers, *Peale* (1969), p. 74; and Sellers, *Peale* (1947), vol. I, p. 88.

22. Peale, *Papers* vol. I, p. 189. The document known as the Declaration of Independence was formally adopted two days later and signed on August 2.

23. Peale, *Diary. Papers*, vol. I, p. 209.

24. Peale, *Autobiography*, p. 50.

25. For a richly detailed and learned study of the crossing and the subsequent battles at Trenton and Princeton, see David Hackett Fischer's *Washington's Crossing* (New York: Oxford University Press, 2004).

26. Washington, *Papers, Revolutionary War Series*, vol. VII, pp. 449–50.

27. Peale, *Diary*, January 2–3, 1776.

28. Peale, *Autobiography*, p. 53.

29. Resolution of Supreme Executive Council of Pennsylvania, January 18, 1779.

30. John Hill Morgan and Mantle Fielding, *The Life Portraits of Washington and Their Replicas* (1931), p. 15.

31. Charles Willson Peale to William Carmichael, October 1779.

32. Charles Willson Peale to Edmond Jenings, October 15, 1779.

33. Johann Joachim Winckelmann, *Writings on Art* (1972), pp. 72, 113.

34. Simon Schama, *Dead Certainties (Unwarranted Speculations)* (1991), pp. 26–27.

35. Peale, *Diary*, pp. 304–305.

36. Paul Leicester Ford, *The True George Washington* (1896), p. 195.

37. Sergeant R_____, "The Battle of Princeton." Wellsborough, Pa., *Phenix*

(24 March 1832); as reprinted in the *Pennsylvania Magazine of History and Biography,* vol. XXIX (1896), pp. 515–19.

38. For a more detailed discussion of Peale's Museum, see Joseph J. Ellis, *After the Revolution: Profiles in American Culture* (New York: W.W. Norton & Co., 1979), pp. 40–71; and Sidney Hart and David C. Ward, "The Waning of an Enlightenment Ideal," in *New Perspectives on Charles Willson Peale,* Lillian B. Miller and David C. Ward, eds. (Pittsburgh: University of Pittsburgh Press, 1991), pp. 219–35.

39. Peale, *Autobiography. Papers,* vol V., p. 53.

CHAPTER 4: *John Trumbull Takes His Turn*

1. Quoted in Dunlap, *History* (1834), vol. I, p. 351.
2. Much of the story of Trumbull's incarceration comes from his own account in his *Autobiography* (1841, 1953), pp. 63–72.
3. *The Remembrancer,* vol. I, pt. 2 (1780), pp. 277–79.
4. Trumbull, *Autobiography* (1841, 1953), pp. 22–23.
5. Ibid., p. 24.
6. Ibid., p. 44.
7. Dunlap, *History* (1834), vol. II, p. 178.
8. William Dunlap, *Diary, 1766–1823* (1930), p. 543.
9. Trumbull, *Autobiography* (1841, 1953), p. 61.
10. Ibid., p. 11.
11. Ibid., p. 11, fn. 30.
12. Ibid., pp. 52, 53.
13. Ibid., p. 62.
14. John Trumbull to James Thatcher, quoted in Carrie Rebora and Ellen G. Miles, *Gilbert Stuart* (2004), p. 307.
15. Quoted in Lewis Einstein, *Divided Loyalties* (1933, 1970), p. 373.
16. Trumbull, *Autobiography* (1841, 1953), p. 73, fn. 47; and Charles Allen Munn, *Three Types of Washington Portraits* (1908), p. 5.
17. Oswaldo Rodriguez Rocque in "Trumbull's Portraits," in *John Trumbull: The Hand and Spirit of a Painter* (1975), Helen A. Cooper, ed., p. 96.
18. Wick, *George Washington* (1982), pp. 26–28.
19. Alberts, *Benjamin West* (1978), page 136.
20. Trumbull, *Autobiography* (1841, 1953), p. 81.

CHAPTER 5: *"The Finest Statuary of the World"*

1. Anne L. Poulet, *Jean-Antoine Houdon: Sculptor of the Enlightenment* (2003), p. 24, fn. 80.
2. *Resolution of the General Assembly of Virginia,* June 22, 1784.
3. Thomas Jefferson to Governor Benjamin Harrison, January 20, 1785.
4. Thomas Jefferson to George Washington, December 10, 1784.
5. Charles Henry Hart and Edward Biddle, *Memoirs of the Life and Works of Jean-Antoine Houdon* (1911), pp. 184–85.
6. Thomas Jefferson to Benjamin Harrison, January 12, 1785.
7. Hart and Biddle, *Memoirs* (1911), pp. 187–88.
8. Alfred Owen Aldridge, *Benjamin Franklin: Philosopher and Man* (1965), p. 386.
9. Hart and Biddle, *Memoirs* (1911), p. 75.
10. Aldridge, *Benjamin Franklin* (1965), p. 374; and Jeanne L. Wasserman, ed. *Metamorphoses in Nineteenth-Century Sculpture* (1975), p. 61.
11. George Washington to Jean-Antoine Houdon, September 26, 1785.
12. Washington, *Diaries,* October 2, 1785.
13. Washington to Lafayette, February 1, 1784.
14. Washington, *Diaries*, October 6, 1785.
15. Ibid., October 10, 1785.
16. Letter of Eleanor Parke Lewis (Nelly Custis) to George Washington Parke Custis, quoted in "Genesis of a Portrait," in *The Mount Vernon Ladies' Association of the Union, Annual Report,* (1967), pp. 11–12.
17. Washington, *Diaries,* October 19, 1785.
18. John A. Washington to W. J. Hubard, October 8, 1859, quoted in Morgan and Fielding, *The Life Portraits of Washington and Their Replicas* (1931), p. 112.
19. Thomas Jefferson to Benjamin Harrison, January 24, 1786.
20. Thomas Jefferson to George Washington, January 4, 1786.
21. George Washington to Thomas Jefferson, August 1, 1786.
22. Gouverneur Morris, *A Diary of the French Revolution* (1939), pp. 107, 109.
23. Washington to Lafayette, February 1, 1784.

CHAPTER 6: *Three Friends of Mr. Trumbull*

1. Trumbull, *Autobiography,* pp. 82–83.
2. John Trumbull to Jonathan Trumbull Jr., September 23, 1784.
3. Trumbull, *Autobiography,* pp. 86–87. Whatever the imperfections of the

portrait, the boy portrayed would later marry Trumbull's favorite niece, Faith Trumbull, and become an important art patron (of Thomas Cole, among others), amateur artist, and founder of the Wadsworth Athenaeum in Hartford.

4. John Trumbull to Jonathan Trumbull Jr., August 15, 1784.

5. John Trumbull to Thomas Jefferson, June 11, 1789.

6. Alberts, *Benjamin West* (1978), pp. 106–7.

7. Ibid., pp. 107–108.

8. John Trumbull to Jonathan Trumbull Sr., November 3, 1784.

9. Trumbull, *Autobiography* (1841, 1953), p. 87.

10. Benjamin West to Charles Willson Peale, June 15, 1783. Quoted in Dorinda Evans, *Benjamin West and His American Students* (1980), p. 86.

11. John Trumbull to Jonathan Trumbull Jr., November 15, 1784. Yale University Library, Trumbull papers.

12. Jaffe, *Trumbull* (1975), p. 324.

13. "Miscellanies," in *The Artist's Repository and Drawing Magazine* 4 (1796), p. 25, cited in Trumbull, *Autobiography* (1841, 1953), p. 87, fn 11.

14. Trumbull, *Autobiography* (1841, 1953), p. 89.

15. Abigail Adams, *Letters*, vol. I, pp. 126–27.

16. Trumbull, *Autobiography* (1841, 1953), pp. 92–93.

17. Thomas Jefferson to James Madison, September 20, 1785.

18. Howard C. Rice Jr. *Thomas Jefferson's Paris* (1976), pp. 51–53.

19. Thomas Jefferson to Abigail Adams, September 4, 1785.

20. Thomas Jefferson to Col. Nicholas Lewis, July 11, 1788.

21. Trumbull, *Autobiography* (1841, 1953), pp. 102–103.

22. Ibid., p. 103.

23. Thomas Jefferson to Maria Cosway, October 12, 1786.

24. Much of the Jefferson-Cosway correspondence was published for the first time in *My Head and My Heart* by Helen Duprey Bullock, in 1945; Marie Kimball's *Jefferson: The Scene of Europe, 1784 to 1789* (1950) offers a particularly measured and detailed account.

25. Susan R. Stein's *The Worlds of Thomas Jefferson at Monticello* (1993) is an invaluable resource in understanding Jefferson's acquisitive instincts, both at home and abroad. For material regarding the Hôtel de Langeac, see especially pages 22–34. Again, Mrs. Kimball's volume, *Jefferson: The Scene of Europe, 1784 to 1789* (1950) offers a supplementary view (pp. 108ff.).

26. Trumbull, *Autobiography* (1841, 1953), p. 93.

27. Thomas Jefferson to Ezra Stiles, September 1, 1786.

28. Trumbull, *Autobiography* (1841, 1953), p. 146.

29. Ibid., p. 163.

30. Joseph J. Ellis, *His Excellency, George Washington* (2004), p. 193.

31. David Humphreys, *The Life of General Washington*, quoted in Flexner, *George Washington* (1972), p. 89.

32. George Washington to Patrick Henry, September 24, 1787.

33. George Washington to Lafayette, April 28, 1788.

34. George Washington to Henry Lee, September 22, 1788.

35. George Washington to Lafayette, January 29, 1789.

36. George Washington to George Steptoe Washington, March 23, 1789.

37. George Washington to Henry Knox, April 1, 1789.

38. John Trumbull to Jonathan Trumbull, December 27, 1786.

39. The thirteen he announced were the six already listed along with *The Surrender of Burgoyne at Saratoga* and *The Resignation of General Washington*. In time he would complete these eight, but in his initial offering he also listed five he would not execute: *The Treaty with France*, *The Signing of the Treaty of Peace*, *The Evacuation of New York by the British*, *The President Received by the Ladies of Trenton and The Arch*, and *The Inauguration of the President*. Later he would add still another, *The Battle of Eutaw Springs*, though that, too, would never be finished.

40. John Trumbull to Harriet Wadsworth, April 4, 1790.

41. John Trumbull to Lloyd Nicholas Rogers, November 10, 1825.

42. *Gazette of the U.S.*, July 8, 1789.

43. John Trumbull to Lloyd Nicholas Rogers (Eliza Custis's son-in-law), quoted in Edgar P. Richardson, "A Penetrating Characterization of Washington by John Trumbull" (1967), p. 22.

44. Trumbull, *Autobiography* (1841, 1953), p. 170.

45. John Trumbull to Daniel Wadsworth, September 7, 1803.

CHAPTER 7: *"The Washington Family"*

1. Joseph Willard to George Washington, November 7, 1789.

2. George Washington to Joseph Willard, December 3, 1789.

3. Josiah Quincy, *Memoir of the Life of Josiah Quincy* (1874), p. 51.

4. Louisa Dresser, "Edward Savage, 1761–1817" (1952), p. 195.

5. Smibert, *Notebook* (1969), p. 85.

6. Richard H. Saunders, author of this generation's authoritative book on the painter, *John Smibert: Colonial America's First Portrait Painter* (New Haven: Yale University Press, 1995, p. 173), notes the "pronounced influence" of *The Bermuda Group* on Robert Feke's *Isaac Royall and His Family* and John Greenwood's *The Greenwood-Lee Family*, painted in 1741 and 1747, respectively.

7. Foote, *John Smibert* (1950), p. 120.

8. Harold E. Dickson, "Artists as Showmen" (1973), pp. 4–6.

9. *Gazette of the United States* (Philadelphia), February 20, 1796.

10. *Columbian Gallery* (1802), pp. 3–4, cited in Ellen G. Miles, *American Paintings of the Eighteenth Century* (1995), pp. 156–57, fns. 11 and 48.

11. *Gazette of the United States* (Philadelphia), February 20, 1796.

12. Charles Henry Hart, "Edward Savage, Painter and Engraver" (1905), p. 11.

13. *Columbia Centinel*, August 8, 1798, p. 3.

14. George Washington to Clemont Biddle, March 19, 1798.

15. Wick, *George Washington* (1982), pp. 122–23.

16. Dunlap, *History* (1834), vol. I, p. 321.

17. Cash accounts in George Washington, *Papers, Colonial Series*, vol. VIII, p. 261.

18. Decatur, *Private Affairs of George Washington* (1933), p. 315.

19. George Washington, *Last Will and Testament*, reprinted in *The Papers of George Washington*, Dorothy Twohig, ed., *Retirement Series*, vol. 4, p. 480. See Henry Wiencek's *An Imperfect God: George Washington, His Slaves, and the Creation of America* (2003) for a thorough and thoroughly engaging examination of Washington's relationship to his slaves and slavery.

20. Harold E. Dickson, *John Wesley Jarvis, American Painter, 1780–1840* (1949), p. 54.

21. Rita Susswein Gottesman, "New York's First Major Art Show" (1959), pp. 293–305.

22. *Mercantile Advertiser* (New York), August 11, 1802.

23. Gottesman, "Art Show" (1959), pp. 291–92.

CHAPTER 8: *Stuart Slouches Toward Philadelphia*

1. Rebora and Miles, *Gilbert Stuart* (2004), p. 76.

2. *The World* (London), April 18, 1787, p. 3.

3. J. D. Herbert, *Irish Varieties, for the last Fifty Years: Written from Recollections* (1836), p. 246.

4. Stuart may have been bipolar; Dorinda Evans makes an intriguing case in "Gilbert Stuart and Manic Depression," *American Art*, vol. 18, no 1 (spring 2004), pp. 10–31.

5. Advertisement of Gilbert Stuart, Senior, in the *Newport Mercury*, November 16–24, 1766.

6. The manuscript memoir of Benjamin Waterhouse, quoted at length in Dunlap, *History* (1834), vol. I, pp. 165 ff.

7. Waterhouse, quoted in Dunlap, *History* (1834), vol. I, p. 166.

8. Jane Stuart, "The Youth of Gilbert Stuart" (1877), p. 642. Jane, Stuart's youngest daughter, born in 1812, proved to be both his artistic heir (she painted copies of his works after his death) and his biographer, as she collected in three articles various stories her father had recounted for the family. In addition to "Youth," the other pieces in *Scribner's Monthly* were "Anecdotes of Gilbert Stuart" (1877) and "The Stuart Portraits of Washington" (1876).

9. Stuart confided in H. M. Jouett, whose 1816 *Notebook* is reprinted in *Gilbert Stuart and His Pupils* by John Hill Morgan (1939), p. 87.

10. Waterhouse, quoted in Dunlap, *History* (1834), vol. I, p. 167.

11. Gilbert Stuart to Benjamin West, undated (December 1777?), Miscellaneous Manuscripts, New-York Historical Society.

12. Quoted in William T. Whitley, *Gilbert Stuart* (1932), pp. 27–28.

13. Jouett, *Notebook* (1816), p. 85.

14. Dunlap, *History* (1834), vol. I, pp. 178–79.

15. "Postscript Account of the Exhibition of Paintings, &c. at the Royal Academy," *St. James's Chronicle*, May 2, 1782, p. 4.

16. Quoted in Mason, *Gilbert Stuart* (1879), p. 277.

17. Whitley, *Gilbert Stuart* (1932), p. 39.

18. As quoted by his daughter, Martha Babcock Amory, in her *Domestic and Artistic Life of John Singleton Copley* (1882), p. 195.

19. Dunlap, *History* (1834), vol. 1, p. 193.

20. Ibid., p. 191.

21. The full stories of the children of Gilbert and Charlotte Coates Stuart—she gave birth to twelve—remain muddled. A number of useful clues are to be found in the brief biography of their daughter Jane by Berit M. Hattendorf, "Newport's First Woman Portraitist" (1996), pp. 145–69.

22. Jouett, *Notebook* (1816), p. 81.

23. Herbert, *Irish Varieties* (1836), p. 232.

24. Ibid., p. 248.

25. Stuart to Henry Pickering, in "Conversation with Mr. Stuart the Painter," Pickering Papers, Peabody Essex Museum, Salem, Mass., 1817.

26. Stuart family legend, in Rebora and Miles, *Gilbert Stuart* (2004), p. 101, fn 2.

27. Dunlap, *History* (1834), vol. I, p. 195.

28. Mason, *Gilbert Stuart* (1879), p. 183.

29. "American Painters," *American Quarterly Review*, vol. XVII, no. 33 (March 1835), p. 177.

CHAPTER 9: *A Plurality of Portraits*

1. Sarah Livingston Jay, August 2, 1794, quoted in Whitley, *Gilbert Stuart* (1932), p. 92.

2. Sarah Livingston Jay to John Jay, November 15, 1794, quoted in Whitley, *Gilbert Stuart* (1932), p. 92.

3. Gilbert Stuart to Joseph Anthony, November 2, 1794, Massachusetts Historical Society.

4. Henry Wansey, *An Excursion to the United States of North America in the Summer of 1794* (1798), p. 57.

5. Here and after, the primary source for information concerning the President's House is Edward Lawler Jr., "The President's House in Philadelphia: The Rediscovery of a Lost Landmark" (2005).

6. Jane Stuart, "The Stuart Portraits of Washington" (1876), p. 369.

7. Dunlap, *History* (1834), vol. 1, p. 197.

8. William Sullivan, *Familiar Letters on Public Characters, and Public Events, from the Peace of 1783, to the Peace of 1815* (1834), pp. 75–76.

9. Stuart, "The Stuart Portraits of Washington" (1876), p. 372.

10. Ibid., p. 374.

11. Custis, *Recollections* (1860), p. 522.

12. Dunlap, *History* (1834), vol. 1, pp. 197–98.

13. Gilbert Stuart, as quoted in Isaac Weld Jr., *Travels through the States of North America, and the Provinces of Upper and Lower Canada during the Years 1795, 1796, and 1797* (1807), vol. 1, pp. 1054–56.

14. Custis, *Recollections* (1860), p. 521.

15. Stuart, "The Stuart Portraits of Washington" (1876), p. 371.

16. Stuart, "The Stuart Portraits of Washington" (1876), p. 373.
17. William T. Oedel, "John Vanderlyn: French Neoclassicism and the Search for An American Style," cited in Rebora and Miles, *Gilbert Stuart* (2004), p. 147.
18. Abigail Adams to John Adams, December 30, 1804.
19. John Caspar Lavater as quoted in Mary Lynn Johnson, "Lavater Contemplating a Bust of Chatham," in *Physiognomy in Profile: Lavater's Impact on European Culture*, Melissa Percival and Graeme Tytler, eds. (Newark: University of Delaware Press, 2005), p. 60.
20. John Caspar Lavater, *Essays on Physiognomy, designed to promote the Knowledge and Love of Mankind*, vol. III (1798), p. 435.
21. Rembrandt Peale, letter of 1834, quoted in Whitley, *Gilbert Stuart* (1932), p. 95.
22. Eliza Willing Powel to George Washington, November 17, 1792.
23. George Washington to the marquise de Lafayette, March 16, 1793.
24. Abigail Adams to Mary Cranch, May 28, 1789.
25. Martha Washington to Fanny Bassett Washington, October 23, 1789.
26. Martha Washington to Mercy Otis Warren, December 26, 1789.
27. Dunlap, *History* (1834), vol. I, pp. 220–21.
28. Stuart, "The Stuart Portraits of Washington" (1876), p. 372.
29. Ibid., p. 370.
30. George Washington to John Greenwood, January 20, 1797.
31. As reported by Tobias Lear, in Stephen Decatur, *Private Affairs of George Washington: From the Records and Accounts of Tobias Lear, Esquire, his Secretary* (1933), p. 178.
32. Henrietta Liston, "A Diplomat's Wife in Philadelphia" (1954), p. 606.
33. Jouett, *Notebook* (1816), p. 83.
34. Gilbert Stuart, as recorded in Jouett, *Notebook* (1816), p. 81.
35. Stuart, "The Stuart Portraits of Washington" (1876), p. 371.
36. Custis, *Recollections* (1860), pp. 413–14.
37. George Washington to Gilbert Stuart, April 11, 1796.
38. Abigail Adams to Abigail Adams Smith, April 11, 1798.
39. George Washington, *Diaries*, May 21, 1787.
40. Stuart, "The Stuart Portraits of Washington" (1876), p. 369.
41. Ibid., p. 369.
42. Jouett, *Notebook* (1816), p. 84.

43. Quoted in Whitley, *Gilbert Stuart* (1932), p. 99.

44. Lord Lansdowne to Anne Willing Bingham, March 5, 1797, in Whitley, *Gilbert Stuart* (1932), p. 99.

45. Liston, "Diplomat's Wife" (1954), p. 606.

46. *American Daily Advertiser,* September 19, 1796.

47. George Washington, "Farewell Address," 1796.

48. Whitley, *Gilbert Stuart* (1932), pp. 99–100.

49. Stuart, "The Stuart Portraits of Washington" (1876), p. 370.

50. Dunlap, *History* (1834), vol. I, p. 218.

51. From *Annals of Philadelphia* (1830) by John Watson, quoted in Whitley, *Gilbert Stuart* (1932), p. 112.

52. Jenkins, *Washington in Germantown*, p. 302.

53. Washington, *Diaries*, January 7, 1797.

54. Jouett, *Notebook* (1816), p. 83.

55. Stuart, "The Stuart Portraits of Washington" (1876), p. 370; and Dunlap, *History* (1834), vol. I, pp. 198–99.

56. Dunlap, *History* (1834), vol. I., pp. 204–5.

57. Thomas Pym Cope, *Philadelphia Merchant: The Diary of Thomas P. Cope, 1800–1851* (1978), p. 124.

58. Dorinda Evans, *The Genius of Gilbert Stuart* (1999), p. 85.

59. Jenkins, *Washington in Germantown*, p. 304.

60. Stuart, "The Stuart Portraits of Washington" (1876), p. 373.

61. Dunlap, *History* (1834), vol. I, p. 199.

62. John Neal, *Observations on American Art* (1823), p. 2.

63. Stuart, "The Stuart Portraits of Washington" (1876), p. 369, and "Anecdotes of Stuart" (1877), p. 377.

CHAPTER 10: *Rembrandt's Washington*

1. Rembrandt Peale, "Reminiscences. The Painter's Eyes" (1856), pp. 163–64.

2. *Dunlap and Claypoole's American Daily Advertiser,* April 24, 1794.

3. "Rembrandt Peale's Lecture on Washington and His Portraits" (1858), reprinted in Gustavus A. Eisen, *Portraits of Washington* (1932), vol. I, p. 300.

4. Peale, "Lecture" (1858), p. 300.

5. C. Edwards Lester, *The Artists of America* (1846), p. 204.

6. Lester, *The Artists* (1846), p. 204.

7. Rembrandt Peale, "Reminiscences. Charles Willson Peale. A Sketch by His Son" (1855), p. 82.
8. Peale, "Lecture" (1858), p. 308.
9. Peale, "Lecture" (1858), variant ms. at Haverford College, p. 16.
10. Dunlap, *History* (1834), vol. I, p. 206. Stuart was never afraid to amplify an anecdote; the identity of a fifth Peale, if any, is unknown.
11. Peale, "Lecture" (1858), Mount Vernon variant.
12. Rembrandt Peale, "Lecture" (1858), p. 311.
13. *Federal Gazette and Baltimore Daily Advertiser*, October 25, 1796.
14. Charles Willson Peale to John Isaac Hawkins, July 3, 1808.
15. Rembrandt Peale to Charles Willson Peale, September 8, 1808.
16. Poulet, *Houdon* (2003), p 341.
17. Ibid., p.20, fn. 29.
18. Ibid., p 20, fn. 28.
19. Raoul Rochette, quoted in Hart and Biddle, *Memoirs* (1911), p. 218.
20. Rembrandt Peale writing to the Committee on the Portrait of Washington, March 16, 1824. Library Company of Philadelphia.
21. Rembrandt Peale in his pamphlet *Portrait of Washington*, quoted in Hevner, *Rembrandt Peale* (1985), p. 66.
22. Rembrandt Peale, "Lecture," Mount Vernon variant.
23. Ibid.
24. Peale, "Lecture" (1858), p. 313.
25. Ibid., p. 313.
26. Lester, *The Artists* (1846), p. 211.
27. Peale, "Lecture" (1858), Mount Vernon variant.
28. Rembrandt Peale to Rubens Peale, July 12, 1855; in Hevner, "Rembrandt Peale's Life in Art" (1986), p. 88.

EPILOGUE: *Remembering the Founding Father*

1. George Washington to Samuel Stanhope Smith, May 24, 1797.
2. George Washington to David Stuart, January 27, 1799.
3. "Jack" Washington had also been Mount Vernon's farm manager during some of Washington's military absences, so an understanding may have been reached earlier about the eventual bequest of the plantation.
4. Art historians have long since rejected his attributions.
5. James Monroe to Lafayette, February 24, 1824.

6. Jane Bacon MacIntire, *Lafayette, The Guest of the Nation*. Privately published, 1967, pp. 11–12.

7. Ibid., p. 45.

8. Peale, *Autobiography*, p. 482.

9. MacIntire, p. 92.

10. Some of the details in this retelling of Lafayette's visit to Arlington House on October 15, 1824, have been drawn from *La Fayette's visit to Arlington House*, an account of the evening by an unknown writer. The original manuscript is in the archives at Tudor Place Historic House and Garden, Washington, D.C. Although the narrative reads very much as if it were composed at the time, the manuscript is undated.

11. Eleanor Parke Custis, *George Washington's Beautiful Nelly: The Letters of Eleanor Parke Custis Lewis to Elizabeth Bordley Gibson, 1794–1851* (Columbia: University of South Carolina Press, 1996), p. 39.

12. George Washington to Lafayette, February 7, 1788.

13. Robert D. Ward, *An Account of General La Fayette's visit to Virginia, in the years 1824–'25* (1881), pp. 26–27.

14. Auguste Levasseur, *Lafayette in America in 1824 and 1825*, vol. 1 (1829), p. 181.

15. Custis, *Recollections* (1860), p. 592.

16. Lafayette to George Washington, March 17, 1790.

17. Benson J. Lossing, "Preface" to Custis, *Recollections* (1860), p. 120.

18. Mrs. R. E. Lee, quoted in William Buckner McGroarty, "A Letter and a Portrait from Arlington House," *The William and Mary Quarterly*, second series, vol. 22, no. 1 (January 1942), p. 51.

19. William Thornton to William Winstanley, January 4, 1800.

20. Thomas Pym Cope, *Diary*, June 10, 1802.

21. For a more detailed discussion, see Scott E. Casper, "First First Family: Seventy Years with Edward Savage's *The Washington Family*," *Imprint*, vol. XXIV, no. 2 (autumn 1999), pp. 2–15.

22. I owe this observation to Scott Casper's perceptive "First First Family" (1999).

23. John Trumbull to Jonathan Trumbull, May 24, 1786.

24. Leslie, *Autobiographical Recollections* (1860), p. 38.

25. Eliza Willing Powel to George Washington, November 17, 1792.

BIBLIOGRAPHY

I HAVE SOUGHT whenever possible to rely on primary sources. Thus, the papers of Washington, Charles Willson Peale, John Trumbull, and others shaped this book's narrative and give it much of its texture. In the same way, without John Smibert's *Notebook*, Jane Stuart's recollections of her father, G. W. P. Custis's memoir of the Chief, and William Dunlap's *History of the Rise and Progress of the Arts of Design in the United States*, this book might not have been possible.

The task has involved turning the pages of countless other books, too, since the literature concerning Washington is oceanic. It is possible to reach into time's depths and find biographies written in the revolutionary era and in every generation since; that I've done, too, though the points of view to be found are as wide as the horizon.

I learned from a range of scholars, too. Anyone who investigates the painters finds that the good people in each category seem to come in

pairs: Charles Coleman Sellers and Lillian B. Miller wrote the basic books on Peale; in the same way, Henry Wilder Foote and Richard H. Saunders have written of John Smibert; Theodore Sizer and Irma B. Jaffe of John Trumbull; Dorinda Evans and Carrie Rebora Barratt of Gilbert Stuart; and John Hill Morgan and Ellen G. Miles more generally on portraits of Washington. In studying Washington there is the key pairing of Douglas Southall Freeman and James Thomas Flexner.

A fuller list of the sources essential to this book is as follows:

Adams, John. *The Works of John Adams.* Vol. I–III. Boston: Charles C. Little and James Brown, 1850–56.

_____. *Papers of John Adams.* 13 vols. Cambridge: Harvard University Press, 1977–2006.

Alberts, Robert C. *Benjamin West: A Biography.* Boston: Houghton Mifflin Co., 1978.

Aldridge, Alfred Owen. *Benjamin Franklin: Philosopher and Man.* Philadelphia: J. B. Lippincott Co., 1965.

Amory, Martha Babcock. *The Domestic and Artistic Life of John Singleton Copley, R.A.* Boston: Houghton Mifflin Co., 1882.

Arnason, H. H[arvard]. *Sculpture by Houdon: A Loan Exhibition.* Worcester, MA: Worcester Art Museum, 1964.

_____. *The Sculptures of Houdon.* London: Phaidon, 1975.

Baker, William S. *Character Portraits of Washington.* Philadelphia: R. M. Lindsay, 1887.

Barratt, Carrie Rebora, and Ellen G. Miles. *Gilbert Stuart.* New Haven, CT.: Yale University Press, 2004.

Braider, Donald. *Five Early American Painters.* New York: Meredith Press, 1969.

Brooks, Van Wyck. *The Dream of Arcadia.* New York: E. P. Dutton & Co., 1958.

Bryan, Helen. *Martha Washington, First Lady of Liberty.* New York: John Wiley & Sons, 2002.

Bullock, Helen Duprey. *My Head and My Heart: A Little History of Thomas Jefferson and Maria Cosway.* New York: G. P. Putnam's Sons, 1945.

Cadou, Carol Borchert. *The George Washington Collection: Fine and Decorative Arts at Mount Vernon.* Manchester, VT: Hudson Hills Press, 2006.

Carroll, Frances Laverne, and Mary Meachem. *The Library at Mount Vernon.* Pittsburgh, PA: Beta Phi Mu Chapbook, 1977.

Casper, Scott E. "First First Family: Seventy Years with Edward Savage's *The Washington Family.*" *Imprint*, vol. XXIV, no. 2 (1999), pp. 2–15.

Chinard, Gilbert. *Houdon in America: A Collection of Documents in the Jefferson Papers in the Library of Congress.* Baltimore, MD: Johns Hopkins Press, 1930.

Christies, Manson & Woods International, Inc. *Property from the Collection of Mrs. J. Insley Blair.* New York: Christie's, 2006.

Cooper, Helen A., ed. *John Trumbull: The Hand and Spirit of a Painter.* New Haven, CT: Yale University Press, 1982.

Cope, Thomas Pym. *Philadelphia Merchant: The Diary of Thomas P. Cope, 1800–1851,* Eliza Cope Harrison, ed. South Bend, IN: Gateway Editions, 1978, p. 124.

Cox, Katherine Cabell. *Some Facts Regarding the Houdon Statue of George Washington in the Capitol at Richmond, Virginia.* Richmond, VA: Press of the Dietz Printing Co., 1925.

Craven, Wayne. *Colonial American Portraiture.* New York: Cambridge University Press, 1986.

————. *Sculpture in America.* Newark: University of Delaware Press, 1984.

Crowson, E. T. "George Washington Parke Custis: The Child of Mount Vernon," in *Virginia Cavalcade*, vol. XXII, no. 3 (winter 1973), pp. 36–47.

Custis, George Washington Parke. *Recollections and Private Memoirs of Washington.* New York: Derby & Jackson, 1860.

————. "Pocahontas: or, The Settlers of Virginia, A National Drama." Reprinted in *Representative American Plays*, Arthur Hobson Quinn, ed. New York: Century Co., 1917.

Dalzell, Robert F., Jr., and Lee Baldwin Dalzell. *George Washington's Mount Vernon: At Home in Revolutionary America.* New York: Oxford University Press, 1998.

Decatur, Stephen. *Private Affairs of George Washington: From the Records and Accounts of Tobias Lear, Esquire, His Secretary.* Boston: Riverside Press, 1933.

Dickson, Harold E. *John Wesley Jarvis, American Painter, 1780–1840.* New York: New-York Historical Society, 1949.

Dresser, Louisa. "Edward Savage, 1761–1817." *Art in America*, vol. 40, no. 4 (1952), pp. 155–212.

Dunlap, William. *Diary, 1766–1823.* 3 vols. New York: New-York Historical Society, 1930.

_____. *History of the Rise and Progress of the Arts of Design in the United States.* 2 vols. New York: George P. Scott and Co., 1834.

Einstein, Lewis. *Divided Loyalties: Americans in England during the War of Independence.* New York: Russell & Russell, 1933, reprinted 1970.

Eisen, Gustavus A. *Portraits of Washington.* 3 vols. New York: Robert Hamilton & Associates, 1932.

Ellis, Joseph J. *After the Revolution: Profiles of Early American Cultures.* New York: W. W. Norton & Co. 1979.

_____. *His Excellency, George Washington.* New York: Alfred A. Knopf, 2004.

Erffa, Helmut von, and Allen Staley. *The Paintings of Benjamin West.* New Haven, CT: Yale University Press, 1986.

Evans, Dorinda. *Benjamin West and His American Students.* Washington, DC: National Portrait Gallery/Smithsonian Institution Press, 1980.

_____. *The Genius of Gilbert Stuart.* Princeton, NJ: Princeton University Press, 1999.

_____. "Gilbert Stuart and Manic Depression: Redefining His Artistic Range." *American Art,* vol. XVIII, no. 1 (2004), pp. 10–31.

Fabian, Monroe H. *Mr. Sully, Portrait Painter: The Works of Thomas Sully (1783–1872).* Washington, DC: National Portrait Gallery/Smithsonian Institution Press, 1983.

Feld, Stuart P. "In the Latest London Manner." *Metropolitan Museum of Art Bulletin,* vol. XXI, no. 9 (May 1963), pp. 296–309.

Fielding, Mantle. *Gilbert Stuart's Portraits of George Washington.* Philadelphia, 1923.

Flagg, Jared B. *The Life and Letters of Washington Allston.* New York: Charles Scribner's Sons, 1892, 1969.

Flexner, James Thomas. *America's Old Masters: First Artists of the New World.* New York: Viking Press, 1939.

_____. *George Washington: The Forge of Experience, 1732–1775.* Boston: Little, Brown & Co., 1965.

_____. *George Washington in the American Revolution, 1775–1783.* Boston: Little, Brown & Co., 1968.

_____. *George Washington and the New Nation, 1783–1793.* Boston: Little, Brown & Co., 1970.

_____. *George Washington: Anguish and Farewell, 1793–1799.* Boston: Little, Brown & Co., 1972.

_____. *Gilbert Stuart: A Great Life in Brief.* New York: Alfred A. Knopf, 1955.

_____. *John Singleton Copley.* Boston: Houghton Mifflin Co., 1948.

Ford, Paul Leicester. *The True George Washington.* Philadelphia: J. B. Lippincott Co., 1896.

Foote, Henry Wilder. *John Smibert, Painter.* Cambridge, MA: Harvard University Press, 1950.

_____. "Mr. Smibert Shows His Pictures, March 1730." *New England Quarterly*, vol. VIII, no. 1 (March 1935), pp. 14–28.

Franklin, Benjamin. *Benjamin Franklin's Autobiographical Writings.* Carl Van Doren, ed. New York: Viking Press, 1945.

Freeman, Douglas Southall. *George Washington: A Biography*, 7 vol. New York: Charles Scribner's Sons, 1948–1957.

_____. *R. E. Lee: A Biography.* 4 vols. New York: Charles Scribner's Sons, 1934–35.

Galt, John. *The Life, Studies and Works of Benjamin West, Esq.* 2 vols. London: Cadell and Davies, 1816–1820.

Gardner, Albert Ten Eyck, and Stuart P. Feld. *American Paintings: A Catalogue of the Collection of the Metropolitan Museum of Art.* Vol. I. Greenwich, CT: New York Graphic Society, 1965.

Gottesman, R. E. "New York's First Major Art Show." *New-York Historical Society Quarterly*, vol. 53 (July 1959), pp. 288–305.

Hagen, Oskar. *The Birth of the American Tradition in Art.* New York: Charles Scribner's Sons, 1940.

Hallen, John S. "The Eighteenth-Century American Townscape and the Face of Colonialism." *Smithsonian Studies in American Art*, vol. IV, no. 3/4 (summer-autumn, 1990), pp. 144–162.

_____. "Houdon's *Washington* in Richmond: Some New Observations." *American Art Journal*, vol. X, no. 2 (November 1978), pp. 72–80.

Halsey, R. T. H. "Early Engravings in Colonial Houses." *Metropolitan Museum of Art Bulletin*, vol. XIX, no. 8 (August 1924), pp. 196–202.

_____. "Prints Washington Lived With at Mount Vernon." *Metropolitan Museum of Art Bulletin*, vol. XXX, no. 3 (March 1935), pp. 63–65.

Harley, R. D. *Artists' Pigments, c.1600–1835.* London: Archetype Publications, 1970, 1982.

Hart, Charles Henry. "Edward Savage, Painter and Engraver: and His Unfinished Copper-Plate of 'the Congress voting independence'": A Paper Read Before

the Massachusetts Historical Society, January 12, 1905. Boston: Cambridge University Press, 1905.

———. and Edward Biddle. *Memoirs of the Life and Works of Jean-Antoine Houdon*. Philadelphia: privately printed, 1911.

Hattendorf, Berit M. "Newport's First Woman Portraitist: Jane Stuart" in *Newport History*, vol. LVIII, no. 232 (winter 1996), pp. 144–169.

Herbert, J[ohn. D[owling]. *Irish Varieties, for the last Fifty Years: Written from Recollections*. London: William Joy, 1836.

Hevner, Carol E. "Rembrandt Peale's Life in Art." *Pennsylvania Magazine of History and Biography*, vol. CX, no. 1 (January 1986), pp. 3–11.

———. *Rembrandt Peale, 1770–1860: A Life in the Arts*. Philadelphia: Historical Society of Pennsylvania, 1985.

Idzerda, Stanley J., Loveland, Anne C., and Marc H. Miller. *Lafayette, Hero of Two Worlds*. Queens, NY: Queens Museum, 1989.

Inventory of the Contents of Mount Vernon, 1810. Preface by Worthington Chauncey Ford. Cambridge, MA: The University Press, 1909.

Jaffe, Irma B. *The Declaration of Independence*. New York: Viking Press, 1976.

———. "Found: John Smibert's *Portrait of Cardinal Guido Bentivoglio*." *Art Journal*, vol. XXXV, no. 3 (1976), pp. 210–215.

———. *John Trumbull, Patriot-Artist of the American Revolution*. Boston: New York Graphic Society, 1975.

Jefferson, Thomas. *The Papers of Thomas Jefferson*. Julian P. Boyd, ed. 33 vols. Princeton, NJ: Princeton University Press, 1950–present.

Jenkins, Charles Francis. *Washington in Germantown*. Philadelphia: William J. Campbell, 1905.

Kimball, Marie. *Jefferson: The Scene of Europe, 1784 to 1789*. New York: Coward-McCann, 1950.

Knapp, Samuel L. *Memoirs of General Lafayette*. Boston: E. G. House, 1824.

La Fayette's visit to Arlington House. Unpublished manuscript in the archives at Tudor Place Historic House and Garden, Washington, DC. No date.

Laurens, John. *The Army Correspondence of Col. John Laurens*. New York, 1867.

Lavater, Johann Caspar. *Essays on Physiognomy, designed to promote the Knowledge and Love of Mankind*, vol. III. London: John Murray, 1798.

Lawler, Edward, Jr. "The President's House in Philadelphia: The Rediscovery of a Lost Landmark," in the *Pennsylvania Magazine of History and Biography* (October 2005).

Lear, Tobias. "The last illness and Death of General Washington," reprinted in *The Papers of George Washington,* Dorothy Twohig, et al., eds., vol. 4. Charlottesville: University of Virginia Press, 1999, pp. 547–555.

Lee, Eleanor Agnes. *Growing Up in the 1850s.* Mary Custis Lee deButts, ed. Chapel Hill: University of North Carolina Press/Robert E. Lee Memorial Association, 1984.

Leslie, Charles Robert. *Autobiographical Recollections by the Late Charles Robert Leslie, R.A.* London, 1860.

Lester, C. Edwards. *The Artists of America: A Series of Biographical Sketches of American Artists.* New York: Baker & Scribner, 1846.

Levasseur, A[uguste]. *Lafayette in America in 1824 and 1825.* John D. Godman, M.D., trans. 2 vols. Philadelphia: Carey and Lea, 1829.

Lewis, Eleanor Parke Custis. *George Washington's Beautiful Nelly: The Letters of Eleanor Parke Custis Lewis to Elizabeth Bordley Gibson, 1794–1851.* Columbia: University of South Carolina Press, 1996.

Liston, Henrietta. "A Diplomat's Wife in Philadelphia: Letters of Henrietta Liston, 1796–1800," Bradford Perkins, ed. *William and Mary Quarterly,* vol. XI, no. 4 (October 1954), pp. 592–632.

Lopez, Claude-Anne, and Eugenia W. Herbert. *The Private Franklin, The Man and His Family.* New York: W.W. Norton & Co., 1975.

Lossing, Benson J. "Arlington House, The Seat of G.W.P. Custis, Esq." *Harper's New Monthly Magazine,* vol. VII, no. 49 (September 1853), pp. 433–454.

_____. *The Home of Washington.* New York: W. A. Townsend, Publishers, 1866.

_____. "Mount Vernon as It Is," in *Harper's New Monthly Magazine,* vol. XVIII, no. 56 (March 1859), pp. 433–451.

Lovell, Margaretta M. *Art in a Season of Revolution: Painters, Artisans, and Patrons in Early America.* Philadelphia: University of Pennsylvania Press, 2005.

_____. "Reading Eighteenth-Century American Family Portraits: Social Images and Self-Images." *Winterthur Portfolio,* vol. 22, no. 4, pp. 243–64.

McGroarty, William Buckner. "A Letter and a Portrait from Arlington House." *William and Mary College Quarterly Historical Magazine,* 2nd series, vol. XXII, no. 1 (January 1952).

MacIntire, Jane Bacon. *Lafayette, The Guest of the Nation.* Newton, MA: privately published, 1967.

McLanathan, Richard B. K. *The American Tradition in the Arts.* New York: Harcourt, Brace & World, 1968.

_____. *Gilbert Stuart.* New York: Harry N. Abrams, 1986.

McNutt, James T. "Plaster Casts after Antique Sculpture: Their Role in the Elevation of Public Taste and in American Art Instruction." *Studies in Art Education,* vol. XI, no. 3 (spring 1990), pp. 158–167.

Mahey, John A. "The Studio of Rembrandt Peale." *American Art Journal,* vol. I, no. 2 (autumn 1969), pp. 20–40.

Marks, Arthur S. "Benjamin West and the American Revolution." *American Art Journal.* vol. XI, no. 2 (November 1974), pp. 15–35.

McCoubrey, John W. *American Art, 1700–1960: Sources and Documents.* Englewood Cliffs, NJ: Prentice-Hall, 1965.

Messing, Christine H., et al. *A Son and His Adoptive Father: The Marquis de Lafayette and George Washington.* Mount Vernon, VA: Mount Vernon Ladies' Association, 2006.

Miles, Ellen G. *American Paintings of the Eighteenth Century.* Washington, DC: National Gallery of Art, 1995.

_____. *George and Martha Washington: Portraits from the Presidential Years.* Washington, DC: National Portrait Gallery/Smithsonian Institution Press, 1999.

_____. "Looking Back." *American Art,* vol. XIX, no. 2 (2005), pp. 19–25.

_____, ed. *The Portrait in Eighteenth-Century America.* Newark: University of Delaware Press, 1993.

Miller, Lillian B. *In Pursuit of Fame: Rembrandt Peale, 1778–1860.* Seattle: University of Washington Press, 1992.

_____. "In the Shadow of His Father: Rembrandt Peale, Charles Willson Peale, and the American Portrait Tradition." *Pennsylvania Magazine of History and Biography,* vol. CX, no. 1 (January 1986), pp. 33–47.

_____, ed. *The Peale Family: Creation of a Legacy, 1770–1870.* New York: Abbeville Press, 1996.

_____ and Ward, David C., eds. *New Perspectives on Charles Willson Peale: A 250th Anniversary Celebration.* Pittsburgh: University of Pittsburgh Press, 1991.

Moore, Charles. *Family Life of George Washington.* Boston: Houghton Mifflin Co., 1926.

Mooz, R. Peter. "Smibert's *Bermuda Group*—A Reevaluation." *Art Quarterly,* vol. XXXIII, no. 2 (summer 1970), pp. 147–57.

Morgan, John Hill. *Gilbert Stuart and His Pupils.* New York: The New-York Historical Society, 1939.

_____ and Mantle Fielding. *The Life Portraits of Washington and Their Replicas.* Philadelphia: privately printed for subscribers, 1931.

Morris, Gouverneur. *A Diary of the French Revolution.* Boston: Houghton Mifflin Co., 1939.

Morton, Susan Quincy. *Memoir of the Life of Eliza S.M. Quincy.* Boston: John Wilson and Son, 1821.

Munn, Charles Allen. *Three Types of Washington Portraits.* New York: Gilliss Press, 1908.

Neal, John. *Randolph, A Novel* (1823), reprinted in *Observations on American Art: Selections from the Writings of John Neal 1793–1876,* Harold Edward Dickson, ed. State College: Pennsylvania State College, 1943.

Nelligan, Murray H. *Custis-Lee Mansion, The Robert E. Lee Memorial.* Washington, DC: National Park Service Historical Handbook Series, 1950, 1956.

_____. *Old Arlington: The Story of Arlington House.* Burke, VA: Chatelaine Press, 2001.

_____. "The Building of Arlington House," in *Journal of the Society of Architectural Historians,* vol. X, no. 2 (1951), pp. 11–15.

Niemcewicz, Julian Ursyn. *Under Their Vine and Fig Tree: Travels through America in 1797–1799, 1805, with some further account of life in New Jersey.* Elizabeth, NJ: Grassmann Publishing Co., 1965.

Nolan, J. Bennett. *Lafayette in America Day by Day.* Baltimore, MD: Johns Hopkins Press, 1934.

Oedel, William T. "After Paris: Rembrandt Peale's Apollodorian Gallery." *Winterthur Portfolio,* vol. XXVII, no. 1 (spring 1992), pp. 1–27.

Peale, Charles Willson. *The Selected Papers of Charles Willson Peale and His Family.* Lillian B. Miller, ed. 5 vols. New Haven, CT: Yale University Press, 1983–1996.

Peale, Rembrandt. "Lecture on Washington and his Portraits" (1858), reprinted in *Portraits of Washington* by Gustavus A. Eisen, vol. I, pp. 297–323. Other variant mss. versions of Peale's "Lecture" survive in various archives, including an early draft, probably composed in 1857, at Mount Vernon and another at Haverford College.

_____. "Reminiscences. Charles Willson Peale. A Sketch by His Son." *The Crayon 1* (February 7, 1855).

_____. "Reminiscences. The Painter's Eyes." *The Crayon 3* (June 1856).

Phillips, John Marshall. "The Smibert Tradition." *Bulletin of the Associates in Fine Arts at Yale University,* vol. XVII, nos. 2–3, 1949.

Poulet, Anne L. *Jean-Antoine Houdon: Sculptor of the Enlightenment.* Washington, DC: National Gallery of Art / University of Chicago Press, 2003.

Prown, Jules David. *John Singleton Copley.* 2 vols. Cambridge: Harvard University Press, 1966.

Prussing, Eugene E. *The Estate of George Washington, Deceased.* Boston: Little, Brown & Co., 1927.

Quick, Michael, et al. *American Portraiture in the Grand Manner: 1720–1920.* Los Angeles: Los Angeles County Museum of Art, 1981.

Quincy, Josiah. *Memoir of the Life of Josiah Quincy, Junior, of Massachusetts: 1744–1775.* Boston: Press of J. Wilson, 1874.

Rasmussen, William M. W., and Robert S. Tilton. *George Washington: The Man Behind the Myths.* Charlottesville: University of Virginia Press, 1999.

Rather, Susan. "A Painter's Progress; Matthew Pratt and 'The American School.'" *Metropolitan Museum Journal*, vol. XXVIII (1993), pp. 169–183.

Reborra, Carrie, et al. *John Singleton Copley in America.* New York: Metropolitan Museum of New York, 1995.

Ribblett, David L. *Nelly Custis: Child of Mount Vernon.* Mount Vernon: Mount Vernon Ladies' Association, 1993.

Rich, Jack C. *The Materials and Methods of Sculpture.* New York: Oxford University Press, 1947.

Richardson, Edgar P. "A Penetrating Characterization of Washington by John Trumbull." *Winterthur Portfolio*, vol. 3 (1967), p. 10.

Roberts, Gary L. "The Chief of State and the Chief" *American Heritage*, October 1975, pp. 28–33, 86–89.

Saunders, Richard H. *John Smibert: Colonial America's First Portrait Painter.* New Haven, CT: Yale University Press, 1995.

————. "John Smibert's Italian Sojourn—Once Again." *Art Bulletin*, vol. LXVI, no. 2 (June 1984), pp. 312–318.

Savage, Edward. *Exhibition of the Important Oil Painting (9 feet long, 6 feet 9 inches high), Washington and His Family.* New York: Avery Galleries, 1892.

Schama, Simon. *Dead Certainties (Unwarranted Speculations).* New York: Alfred A. Knopf, 1991.

Sellers, Charles Coleman. *Charles Willson Peale.* 2 vols. Philadelphia: American Philosophical Society, 1947, 1969.

————. *Portraits and Miniatures by Charles Willson Peale.* Philadelphia: American Philosophical Society, 1952.

_____. "Virginia's Great Allegory of William Pitt." *William and Mary Quarterly*, vol. IX, no. 1 (January 1952), pp. 58–66.

Seymour, Charles, Jr. "Houdon's *Washington* at Mount Vernon Re-Examined." *Gazette des Beaux-Arts*, vol. XXX (March 1948), pp. 137–158.

Shadwell, Wendy J. "The Portrait Engravings of Charles Willson Peale," in *Eighteenth-Century Prints in Colonial America*, Joan D. Dolmetsch, ed. Williamsburg, VA: Colonial Williamsburg Foundation, 1979.

Siegfried, Susan L. *The Art of Louis-Léopold Boilly: Modern Life in Napoleonic France*. New Haven, CT: Yale University Press, 1995.

Silverman, Kenneth. *A Cultural History of the American Revolution: Painting, Music, Literature, and the Theatre in the Colonies and the United States . . . (1763–1789)*. New York: T. Y. Crowell, 1976.

Sizer, Theodore. *The Works of Colonel John Trumbull, Artist of the American Revolution*. New Haven, CT: Yale University Press, 1950.

Smibert, John. *The Notebook of John Smibert*. Boston: Massachusetts Historical Society, 1969.

The Smibert Tradition: The First Selected Showing of John Smibert's Paintings since 1730. New Haven, CT: Yale University Art Gallery, 1949.

Stein, Susan R. *The Worlds of Thomas Jefferson at Monticello*. New York: Harry N. Abrams, 1993.

Stetson, Charles W. *Washington and His Neighbors*. Richmond, VA: Garrett and Massie, 1956.

Stuart, Jane. "Anecdotes of Gilbert Stuart by his Daughter." *Scribner's Monthly*, vol. XIV (July 1877), pp. 376–82.

_____. "The Stuart Portraits of Washington." *Scribner's Monthly*, vol. XII (July 1876), pp. 367–374.

_____. "The Youth of Gilbert Stuart." *Scribner's Monthly*, vol. XIII (March 1877), pp. 640–646.

Sullivan, William. *Familiar Letters on Public Characters, and Public Events, from the Peace of 1783, to the Peace of 1815*. Second ed. Boston: Russell, Odiorne, and Metcalf, 1834.

Swem, E. G. *Brothers of the Spade: Correspondence of Peter Collinson of London, and of John Custis, of Williamsburg, Virginia, 1734–1746*. Barre, MA: Barre Gazette, 1957.

Templeman, Eleanor Lee. *Arlington Heritage: Vignettes of a Virginia County*. New York: Avenel Books, 1959.

Thistlethwaite, Mark Edward. *The Image of George Washington*. New York: Garland Publishing, 1979.

Thornton, William. *Papers of William Thornton: 1781–1802*. C. M. Harris, ed. Charlottesville: University of Virginia Press, 1995.

Trumbull, John. *Autobiography, Reminiscences and Letters of John Trumbull from 1756 to 1841*. New Haven, CT: Yale University Press, 1953.

————. *Papers*. Miscellaneous correspondence and other documents are to be found in the Trumbull collections at the Yale University Library and at the Connecticut Historical Society.

Tuckerman, Henry T. *Book of the Artists*. New York: G. P. Putnam & Sons, 1867.

Unger, Harlow Giles. *Lafayette*. John Wiley & Sons, 2002.

United States Congress. *Journals of the Continental Congress, 1774–1789*. Vols. I–X. Washington, DC: U.S. Government Printing Office, 1904–1937.

Van Tassel, David D. "Benson J. Lossing: Pen and Pencil Historian," in *American Quarterly*, vol. VI, no. 1 (spring 1954), pp. 32–44.

Wansey, Henry. *An Excursion to the United States of North America in the Summer of 1794*. Second edition. Salisbury, England, 1798.

Ward, David C. *Charles Willson Peale: Art and Selfhood in the Early Republic*. Berkeley: University of California Press, 2004.

Ward, Robert D. *An Account of General La Fayette's Visit to Virginia, In the Years 1824–'25*. Richmond, VA: West, Johnston & Co., 1881.

Washington and Lee University. *Washington-Custis-Lee Family Portraits from the Collection of Washington and Lee University, Lexington, Virginia*. Washington, DC: International Exhibitions Foundation, 1974–76.

Washington, George. *The Diaries of George Washington*, Donald Jackson, Dorothy Twohig, eds., vols. I–VI. Charlottesville: University of Virginia Press, 1976.

————. *The Diaries of George Washington, 1748–1799*, John C. Fitzpatrick, ed., vols. I–IV. Boston: Houghton Mifflin Co., 1925.

————. *The Papers of George Washington, Colonial Series*, W. W. Abbot, Dorothy Twohig, et al., eds., vols. I–X. Charlottesville: University of Virginia Press, 1983–1995.

————. *The Papers of George Washington, Confederation Series*, W. W. Abbot, Dorothy Twohig, et al., eds., vols. I–VI. Charlottesville: University of Virginia Press, 1992–1997.

————. *The Papers of George Washington, Presidential Series*, Dorothy Twohig, ed., vols. I–XIII. Charlottesville: University of Virginia Press, 1987–2007.

_____. *The Papers of George Washington, Retirement Series*, Dorothy Twohig, ed., vols. I–IV. Charlottesville: University of Virginia Press, 1998–1999.

_____. *The Papers of George Washington, Revolutionary War Series*, Philander D. Chase, ed., vols. I–XVI. Charlottesville: University of Virginia Press, 1985–present.

_____. *The Writings of George Washington*, John C. Fitzpatrick, ed. Washington, DC: Government Printing Office, 1939.

_____. *The Writings of George Washington*, Worthington Chauncey Ford, ed., vols. I–X. New York: G.P. Putnam's Sons, 1889–1893.

Wasserman, Jeanne L., ed. *Metamorphoses in Nineteenth-Century Sculpture*. Cambridge, MA: Fogg Art Museum/Harvard University Press, 1975.

Watkins, Walter K. "The New England Museum and the Home of Art in Boston," in the *Bostonian Society Publications*, vol. II (second series), 1917, pp. 102–130.

Weld, Isaac, Jr. *Travels through the States of North America, and the Provinces of Upper and Lower Canada during the Years 1795, 1796, and 1797*, vol. I. London: Printed for John Stockdale, 1807.

Whitley, Wiliam T. *Gilbert Stuart*. Cambridge, MA: Harvard University Press, 1932.

Whitmore, William Henry. *Notes Concerning Peter Pelham*. Cambridge, MA: J. Wilson and Son, 1867.

Wiencek, Henry. *An Imperfect God: George Washington, His Slaves, and the Creation of America*. New York: Farrar, Straus & Giroux, 2003.

Winckelmann, Johann Joachim. *Writings on Art*. David Irwin, ed. London: Phaidon, 1972.

Wilstach, Paul. *Mount Vernon: Washington's Home and the Nation's Shrine*. Garden City, NY: Doubleday, Page & Co., 1916.

Wick, Wendy C. *George Washington, An American Icon: The Eighteenth-Century Graphic Portraits*. Washington, DC: National Portrait Gallery / Smithsonian Institution Press, 1982.

INDEX

Hugh Howard's numerous books include *Dr. Kimball and Mr. Jefferson*; the definitive *Thomas Jefferson, Architect*; his memoir *House-Dreams*; and most recently the widely admired *Houses of the Founding Fathers*. He resides in upstate New York with his wife and their two teenage daughters.